Letting Go?

Sharing Historical Authority in a User-Generated World

Edited by
Bill Adair, Benjamin Filene, and Laura Koloski

The Pew Center for Arts & Heritage, Philadelphia

Published by
The Pew Center for Arts & Heritage
1608 Walnut Street, 18th Floor
Philadelphia, PA 19103
www.pcah.us

ISBN: 978-0-9834803-0-3 print
ISBN: 978-1-61132-790-8 electronic

Library of Congress Control Number: 2011935405

Distributed worldwide by
Left Coast Press, Inc.
1630 North Main Street, #400
Walnut Creek, CA 94596
www.LCoastPress.com

Supervising Editor: Joseph N. Newland, Q.E.D.
Design: Anthony Smyrski, Smyrski Creative
Proofreading: Elizabeth Hill
Index: Joan Green
Printed and bound in Canada by The Prolific Group

Table of Contents

Foreword
Sharing the Authority
of Knowledge

What is the work of The Pew Center for Arts & Heritage? We are perhaps best known as a multidisciplinary grant-maker, ourselves funded by The Pew Charitable Trusts as a primary component of their overall support for culture in the five-county Philadelphia region. As such, the Center itself provides funds in seven areas, including through the Heritage Philadelphia Program (HPP), the producer of this anthology. The Center's grants, determined through an annual adjudicatory process, reward artists and arts and culture organizations of excellence, imagination, and courage that also engage a broad range of audiences with meaningful cultural experiences. Such a strategy supports an overall vision that sees culture as critical to a vibrant civic ecology, and demonstrates how the arts and heritage contribute to the life of our communities today.

As evidenced by the volume you are holding in your hands, the Center also functions as a hub or thought leader for discourse around issues critical to practice in the fields that we serve. Through a dynamic program of professional development activities and events—as many as one hundred per year—the Center brings visionary thinkers and practitioners from around the world to interact in diverse ways with our community, through lectures, individual consultations, workshops, master classes, *etc.* In so doing, we strive to connect Philadelphia to the larger world of cultural practice and that world back to us, again raising the visibility of this region as an important cultural center.

As another part of our thought-leadership work, the Center's programs capture, analyze, document, and share information on important topics in culture. This takes the form of commissioning research and scholarship on various issues that emerge directly out of our grant-making experience and goals, and that are highly pertinent to the leading edge of thinking in the relevant disciplines. Indeed, the seeds for *Letting Go? Sharing Historical Authority in a User-Generated World* were planted when, as the Director of the Center's Exhibitions Initiative, I edited and we published in 2006 an anthology on curatorial practice, *What Makes a Great Exhibition?* That book's reception—now in its fourth printing—brought home to us quite strongly the value of publishing as an important adjunct to our grant-making. Rooted in the lessons directly learned from doing, this research provides an ongoing opportunity to contribute to the larger discourse around and to raise the bar for practice in our fields. It also allows us to make a contribution that has impact in a different way than the funding of time-delimited projects.

For a short period in my time at the Center, I had the privilege of directing the Heritage Philadelphia Program. My task was to guide HPP through a transitional moment marked by an effort to open up and to energize our approach to funding the interpretation and presentation of history projects. The refocusing sought to encourage area practitioners,

through their public projects and programs, to make compelling the connection of the present to the past and the pertinence of history to contemporary life. This goal readily lent itself to considering a volume of essays that would address a current, burning issue in the public history field: how to make history museums more relevant to their communities and, as the editors say in their introduction to this book, "more receptive to outside partners, voices, and interpretations."

A serendipitous encounter with Benjamin Filene—Director of Public History at the University of North Carolina Greensboro, who served as a panelist in our grant-making process in February 2007—introduced me to a public historian of talent and breadth who had a particular interest in this subject, and I invited him to collaborate in this enterprise. We began this anthology together, along with Laura Koloski, HPP's Senior Program Specialist. However, early in its development, I was named the Center's first Executive Director. This change in responsibilities permitted me the great pleasure of hiring the adventurous, knowledgeable, and highly creative Bill Adair to lead our history initiative, and of placing the further refinement and realization of this book into his hands.

The resulting collaboration among Benjamin, Bill, and Laura has succeeded even beyond our initial expectations. *Letting Go?* takes on a provocative issue—the risks and rewards of sharing authority in a user-generated world—and looks at it through a kaleidoscopic lens. The volume is itself imaginatively orchestrated and user-friendly—divided into thematic sections that encompass case studies, thought pieces, and conversations, it contains contributions from voices at the leading edge of thinking in public history. It maintains a rigorous level of scholarship but is accessible to what Virginia Woolf liked to call the "common reader" with an interest in history as well. It will no doubt have considerable impact, and is a gratifying exemplar of the type of thought leadership for which The Pew Center for Arts & Heritage strives to be known.

In 2011, the Center, through its seven initiatives—in artists' fellowships, dance, heritage, music, theatre, and visual arts exhibitions, as well as cultural management—made over 6.3 million dollars in grants; our initiatives have seen more than 72 million dollars invested in art and heritage in the last twenty or so years. Such an investment is indeed a tangible indicator of The Pew Charitable Trusts' exemplary commitment to the cultural life of this community. The year also marks the publication of this, the Center's second and HPP's first critical anthology, expanding our reach to the history field and indeed to museum practice as a whole.

None of the activities of the Center would be possible without the tremendous support and vision of our funder, The Pew Charitable Trusts, to whom our debt cannot be exaggerated. I wish to acknowledge in particular my colleagues Greg Rowe, Director, Culture Initiatives

and Deputy Director, The Philadelphia Program; and Doug Bohr, Officer, Philadelphia Culture Program, with whom I work closely on all aspects of the Center's operations. Their belief in the value and transformative potential of the Center's grant-making and research agendas bolsters our conviction in the importance of our work, and makes our contributions possible.

Paula Marincola
Executive Director

9

Introduction
Letting Go?
Sharing Historical Authority in a User-Generated World

The traditional expertise of the history museum seems to be challenged at every turn. Web 2.0 invites ordinary people to become their own archivists, curators, historians, and designers as they organize images on Snapfish, identify artifacts through Flickr, post text on wikis, and create websites with WordPress and Weebly. Bricks-and-mortar museums, meanwhile, in pursuit of "civic engagement," give community members more say in what stories the museum showcases and how they get told. Exhibitions frequently shun the authoritative voice. Two decades after Michael Frisch heralded oral history for enabling "shared authority," museums feature first-person voices with less and less narrative mediation. Contemporary artists, too, question the institutional authority of museums—sometimes lamenting, sometimes lampooning the illusion of objective curatorial interpretation. In this moment of flux, *Letting Go?* explores how public history practice is wrestling with issues of shifting authority in each of these realms—the Web, community-based programming, oral history, and contemporary art.

Digital technologies and social media only partially account for the willingness of museums to explore, at least tentatively, relaxing their control over historical authority. The current trend is in part a legacy of the New Social History of the 1960s and its interest in telling history "from the bottom up." Having worked for a generation to tell stories that de-center elites, museums now are de-centering elite storytellers, too. The anti-authoritarian bent may be as well a legacy of the so-called culture wars of the 1990s. The fierce backlash against revisionist historical interpretations in the Smithsonian's *The West as America* and in the planned *Enola Gay* exhibition may have made museum administrators more than happy to hand off interpretive authority to outsiders. Finally, we must consider the impact of changes in realms much broader than the museum world. The country's growing ethnic diversity and its economic crises have pushed museum leaders to recognize that the field's traditional business models need to be revamped. Instead of taking public support for granted, museums are desperate to prove their worth to their communities, a stance that makes them more receptive to outside partners, voices, and interpretations.

Emerging from the swirl of these forces, this volume began—and ends—with a question or, really, twin questions. First, do the changes that our culture is experiencing fundamentally challenge museums' traditional relationships to their constituencies? In other words, are we experiencing a tidal wave, a sea change, or just a summer shower? From that question closely follows the second: how much will be

washed away and what will the terrain look like afterwards? As our constituents have more avenues (and inclinations) for shaping, not just consuming, content, are museums actually being asked to let go of their position as historical authorities? Or is "letting go" an inexact formulation? For that matter, does the notion of "sharing" imply that historians have the prerogative to distribute historical authority, an implication that, Frisch suggests in this volume, would undercut the supposedly collaborative or "dialogic" nature of such work?

The authors here certainly do not all agree on the answers to these questions—the book is intended to mark a particular moment in the field, not to advocate or proselytize—but some patterns do surface. Most immediately, one senses the variety and vitality that has emerged around efforts to encourage audience participation. Case studies here show museum constituents joining in interpretation as storytellers, filmmakers, actors, and exhibit designers. Equally striking, though, these case studies show moments of rich engagement where audiences and users are not quite so center stage: writing a memory on a virtual city map, adding a Post-it comment to an exhibition wall, voting for their favorite object in the gallery. Allowing museum constituents to create meanings—what Tom Satwicz and Kris Morrisey in this volume call "public curation"—can take many forms.

A second key point emerges from the variety of public participation showcased here: whether online, on the streets, in the galleries, or in a recording booth, audiences express themselves more creatively and confidently if operating within, not beyond, boundaries. It may seem paradoxical, but the experiences documented in these essays suggest that constraints—word counts, canvas boundaries, time limits—encourage free-form work. The amount and quality of creative participation increases when visitors are guided by smart question prompts, stencils, or menus of choices.

Making these experiences work requires real talent on the part of the museum, leading to a third key point: public curation demands not less but more from history museums and their expert staffs. Many of the essays, for instance, talk about how the success of user-generated content—whether the online City of Memory mapping project or StoryCorps's recordings or the Brooklyn Historical Society's community-curated exhibitions—depends in part on that most traditional kind of expertise: editing. Likewise, museums still very much need deep content knowledge. The public wants rich interpretations and fresh, accurate information.

When museums embrace public participation, though, expertise may be deployed in different forms and alloyed with the talents of others. Laura Koloski envisions what she calls a "combined expertise"—a more thoroughgoing approach to collaboration in which practitioners from different fields not only share their skills but open themselves up to the varied perspectives and values of different disciplines. Kathleen McLean too says museums need to broaden their definition of "expertise" and what it entails: considerable skills are needed to encourage and enable visitors to join in making meanings. When a museum or site embraces public participation, staff members do not hand over the keys to the building and walk away. Instead of presenting visitors with a mess of objects or a mass of historical content, museum staff members lay the groundwork to enable visitors to participate successfully: they identify multiple pathways through the content; build bridges that visitors can cross between the stories from the past and their own experiences; and offer tools visitors can use to make new discoveries, cut new pathways, and build new bridges. Some visitors may want a detailed map of the historical terrain; some may want their pathways pre-paved; others will say "Hand me an ax" and charge forth.

Museum professionals, then, supplement content knowledge with expertise at interpreting, facilitating, engaging, listening, and learning with their visitors. And, importantly, the staff accommodates the reality that different visitors are drawn to different styles and degrees of participation. What the museum "lets go" of is not expertise but the assumption that the museum has the last word on historical interpretation. The museum instead is trying to prime the pump of interpretations, hoping that they will keep flowing on their own without the museum having to do all the heavy work and that new ideas will surface that the museum would never have come to on its own. This scenario involves letting go of the notion (usually illusory in any case) that one can or should control all outcomes in the museum. The staff becomes adept at living with, even relishing, uncertainty and unpredictability.

To say that the expertise of museum workers remains essential, though, is not to minimize the extent to which public curation challenges the ways that museums traditionally have operated. For starters, the usual "collect, preserve, and interpret" missions are not enough to encompass this work. Moreover, the very idea of inviting unpredictability challenges the field's preoccupation over the last several decades with best practices. How can one mandate professional processes and procedures when one doesn't have control

13

of the process? As the essays here show, even at places where the move to introduce new voices began with considerable support (such as the Rosenbach Museum and Library, the Brooklyn Historical Society, and the American Philosophical Society), the efforts frequently butted against institutional expectations about interpretation, audience, and professional polish. Even the usual evaluation criteria and methods do not apply to public curation. If one shifts away from declarative take-away messages and invites visitors to contribute new ideas and fresh conversations, how does one measure success? As Satwicz and Morrissey show, visitor research into this work is only fragmentary. Overall, as authors such as Melissa Rachleff point out, translating good intentions and idealism into sustaining practice is an institutional challenge that museums are just beginning to address.

Finally, in the midst of all this flux and upheaval, these essays point to significant strands of continuity in the movement toward public curation, historical precedents that have tended to be overlooked in the excitement over the new. Steve Zeitlin and Benjamin Filene note that for more than a century folklorists have pursued the idea of ordinary people telling their stories in their own words, a challenge to the expert voice that gained particular currency through the W.P.A. projects of the 1930s and then through the work of Studs Terkel. As well, the book identifies three more recent intellectual antecedents to public curation. In 1990 Michael Frisch published *A Shared Authority: Essays on the Craft and Meaning of Oral and Public History*. In 1992 John Kuo Wei Tchen's "Creating a Dialogic Museum: The Chinatown History Museum Experiment" was published. That same year artist Fred Wilson opened the exhibition *Mining the Museum* at the Maryland Historical Society. Each of these landmark works portrayed museum interpretations as contingent, not definitive, and museum authority as open and diffused, not cloaked and contained. Long before Wikipedia, in other words, museums were wrestling with the benefits and consequences of de-centering expertise. In new pieces for this volume, Frisch, Tchen, and Wilson revisit their landmark contributions in light of the proliferation of tools for public participation and find issues both new and familiar.

The enduring relevance of foundational public history works suggests that in one way "letting go" is perhaps not an apt metaphor. If we take the phrase to mean a sudden relinquishing, a dropping of contact, then clearly that is not what the field is seeing: instead of making a sudden break, the public history world has been deliberating about these issues of authority for decades, and instead of our

constituents losing contact with us, we find that audience participation demands closer involvement with our constituents, not more distance. In another sense, though, "letting go" means allowing to proceed without obstacle. Here the historical precedents only add meaning to the phrase: in fits and starts, the field has been coming to terms with the idea of relaxing control and allowing visitors to chart their own paths; path-breaking projects have tried to remove barriers to participation, to invite exploration, and to enable audiences to draw connections, make meanings, and share reflections.

If we let visitors go in new directions, they may take us to areas of fresh discovery, give our work more reach, and, along the way, forge stronger relationships with the museums that have enabled the journey. The question mark in the title stands, reflecting the uncertainty of the moment we face. The power of the question—and of the search for answers—only grows.

Virtually Breaking Down
Authority and the Web

As the notion of historical gatekeepers expands (or perhaps dissolves) with new technology, old questions have new meaning: who gets a say and how do their voices get heard?

No forces of change are impacting cultural practice, including public history, faster, deeper, and wider than technological innovation. Virtually overnight it seems, the cultural power center has shifted from the wizened and experienced practitioner to a younger, more nimble collection of experts and non-experts, all communicating with each other constantly and sharing their individual/collective productions with lightning speed. Attention spans are breaking down, and expectations are growing that everyone could and should arrange, direct, produce, curate, comment, and upload on any and all means of cultural production. This includes the interpretation of our shared and personal histories. Web 2.0 and social media may have forced the public historian's hand—and many of us greet these changes with mixed emotions, and a host of questions:

How significant and sustainable is this apparent transformation?

Can everyone be a storyteller? A historical interpreter? A curator or docent of their own history?

In the new virtual world do real objects still matter? Do "real" experts?

Can the real and virtual worlds learn from each other and be in dynamic dialogue?

We public historians stand on the threshold between the old and new ways, the virtual and the real, the raw and the expertly mediated experience. The view into the next room is still fuzzy.

Participatory Design and the Future of Museums

Nina Simon

Imagine, for a moment, the Web as a history museum. Vast open collections storage facilities, filled to the brim with personal journals, corporate advertising, and lots and lots of porn. While the majority of the collection is open to the public 24/7, most items are rarely accessed. The museum has the most lenient accessioning policy in the world. Donors, not institutional staff, are responsible for conservation and preservation of their contributions.

Imagine being named a trustee of this museum circa 2001. You oversee more than 550 billion documents. While some items in the collection were produced by professional Web developers for a mass audience, most are personal and of interest to only a few people. The content is of variable quality, relevance, and importance. While storage is becoming cheaper, it is by no means free, and as the collection grows, you and your fellow trustees are increasingly worried about the quality of the visitor experience at the museum.

At this point, looking at your endless warehouses of collection material, what path would you take next? What would your institutional vision be for the next ten years?

Most museum trustees would quickly change the accessioning policy. You might introduce more structure, so that the institution only collects things of particular quality or on a specific theme. You might more carefully vet the sources of collected material. You might require that contributors "freeze" their donations so they won't be altered or taken down without institutional consent. And frankly, given the size and disorder of what is already in the vaults, you'd likely suspend new collections altogether until you could get a clearer sense of what you have and what the institution might do with it.

On the visitor experience side, you might try to sculpt a more coherent exhibition out of the collection already in place. You might select the best of the existing content to put on display, paring the collection down to a few key artifacts that are distinctive, important, and appealing. You might make it easier for visitors to access the collection by separating the museum into galleries for different themes or time periods or experience types. You'd likely separate the acquisitions storage facility from the public-facing facility, both for the sake of efficiency and coherence of visitor experience.

Imagine this museum ten years later, in 2011. It would likely be a pleasant place to visit, full of interesting exhibits featuring compelling content. But the democratic principles that characterized its founding would be lost. It would be a curated space. It would be governed by the institution, not the users who had contributed its collection.

The real Web, the non-museum version, took a decidedly different path from 2001 to 2011. Rather than curate and restrict the growth of content, programmers stayed true to the inclusive ethos and open protocols of the early Web. They focused on two kinds of projects:

1. creating tools that make it easier for anyone to add new content to the Web
2. refining the ways that people can search for content on the Web, including search techniques that are informed (and in some cases steered) by users themselves

This is quite shocking. Imagine sitting with your fellow Web museum trustees around the board room in 2001, arguing that instead of harnessing the vast collection, you should actually make it larger. That you should make it easier for *more* people to share pictures of their cats and their vacations. That instead of organizing things according to top-down taxonomies or highlighting important objects in exhibitions, you should allow users' behaviors and preferences to determine what to prioritize. This is called a "folksonomy"—a user-driven cataloging system that is constantly in flux.

Web 2.0 developers can be described as both generous and realistic when it comes to user participation. Generous, because they believe it is possible for people of all kinds to make compelling creative work to share. Realistic, because they know that most of what people produce is of very little interest to mass audiences. That's not to say all user-generated content is low quality (though much of it is). Most participatory content is compelling to highly specific and limited audiences. I'm only interested in pictures from your honeymoon if we're close friends or I'm planning to visit the same island paradise. Otherwise, they're just more clutter.

Participatory websites are built to harness the power of diffuse collections, not by refining what's offered, but by making it easy for people to consume exactly the content they want. For example, the photo-sharing site Flickr uses keywords and tags to build a folksonomy that helps people search through photographs easily. As a consumer on the site, I'm not required to wade through millions of photos to find the ones that interest me. The site turns many kinds of user-generated content—photo titles, tags, comments, notes—into search terms, which help people navigate its vast collection. A million people can upload photographs of their children's first haircuts, and I can find the one image of a barber in Bangalore that satisfies my interest.

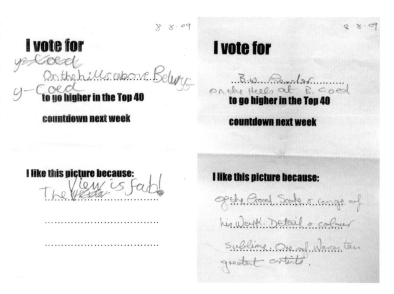

20

 This approach isn't just about egalitarianism; it's also an economic model for success. As Ian Rogers, former VP of Video and Media Applications for Yahoo! famously said in 2007, "Losers wish for scarcity. Winners leverage scale."[1] He and other Web 2.0 leaders have argued that the money invested in gatekeeping and protecting content—whether copyrighted music, films, or images—is wasted. Instead, institutions that control media content should be looking for ways to get that content out into as many environments as possible, to be shared, remixed, and discussed. Experiencing content in a social context helps people define their preferences, express their self-identities, and form new relationships with ideas and objects—which then may lead to deeper engagement in terms of time, money, and intellect.

 And this is where museums come in. In their public role, museums are places that provide an interpretative experience around objects. Traditionally, those experiences were constrained to the information and sensory elements designers and curators chose to provide around artifacts and exhibits. But we've all become familiar with copious research demonstrating that visitors bring their own contexts, expectations, and personal experiences to their museum visits. How can we reconcile the data about visitors' self-generated contexts with the rigid form of the stories and experiences traditionally offered in a history museum?

 One simple answer is to invite visitors to participate in the construction of the interpretation alongside professionals. At a basic level, this is the power of visitor participation: it leverages the knowledge, experience, and passions of everyone who walks through the museum doors to provide a diverse set of interpretations for each exhibit, object, or story presented. The benefit is not

just for the participants. It's for all visitors, who may benefit from perspectives that are more personal, diverse, and flexible than the traditional curated path.

The goal of participatory techniques is both to meet visitors' expectations for active engagement and to do so in a way that furthers the mission and core values of the institution. Rather than delivering the same content to everyone, a participatory institution collects and shares diverse, personalized, and changing content coproduced with visitors. It invites visitors to respond and add to information about cultural artifacts, scientific evidence, and historical records on display. It showcases the diverse creations and opinions of non-experts. People use the institution as meeting grounds for dialogue around the content presented. Instead of being "about" something or "for" someone, participatory institutions are created and managed "with" visitors.

Why would a cultural institution want to invite visitors to participate? Like all design techniques, participation is a strategy that addresses specific problems. I see participatory strategies as practical ways to enhance, not replace, traditional cultural institutions.

Participatory techniques are particularly useful when institutions are trying to connect with members of the public who are not frequent museum-goers, people who might feel alienated, dissatisfied, or uninspired by museum experiences. Participatory techniques address these commonly expressed forms of dissatisfaction with cultural institutions:

1. *Cultural institutions are irrelevant to my life.* By actively soliciting and responding to visitors' ideas, stories, and creative work, cultural institutions can help audiences become personally invested in both the content and the health of the organization.

2. *The institution never changes—I've visited once and I have no reason to return.* By developing platforms in which visitors can share ideas and connect with each other in real time, cultural institutions can offer changing experiences without incurring heavy ongoing content production costs.

3. *The authoritative voice of the institution doesn't include my view or give me context for understanding what's presented.* By presenting multiple stories and voices, cultural institutions can help audiences prioritize and understand their own view in the context of diverse perspectives.

4. *The institution is not a creative place where I can express myself and contribute to history, science, and art.* By inviting visitors to participate, institutions can support the interests of those who prefer to make and do rather than just watch.

5. The institution is not a comfortable social place for me to talk about ideas with friends and strangers. By designing explicit opportunities for interpersonal dialogue, cultural institutions can distinguish themselves as desirable real-world venues for discussion about important issues related to the content presented.

These five challenges are all arguments for pursuing participation, whether on the scale of a single educational program or the entire visitor experience. The challenge is how to do this well. Not every visitor has a powerful personal story to recount or dizzying expertise to share. Some projects initiated in the hopes of creating a dynamic space end up producing noise or dead air. To succeed with visitor participation, museum professionals need to think like Web 2.0 developers—finding generous yet realistic ways to solicit, sort, and present visitor-generated content and commentary.

HOW DOES THE PARTICIPATORY WEB WORK?

Web 2.0, or the participatory Web, was born in the mid-2000s to extend the Web's creative power to a broad audience of non-technical people. One of the simplest definitions of Web 2.0 is "software that gets better the more people use it."[2] This definition implies two things:

1. Users do something that generates information (they upload content, rate things, comment, buy things, or click search results).
2. The system adapts responsively to those participatory actions, providing customized experiences based on user behavior.

Museum professionals often focus overly on the first point and not enough on the second. Sites like Wikipedia, YouTube, and Facebook have promoted the idea that anyone can participate in knowledge creation, cultural production, and online socializing. But all of these participatory activities are only meaningful when combined with a system that will *respond* to users' actions. All those uploaded photos and videos and ratings and status updates would be useless if the websites that house them did not share them, showcase them, and use them to affect the visitor experience. As leading technical publisher Tim O'Reilly put it in 2006: "Google gets smarter every time someone makes a link on the Web. Google gets smarter every time someone makes a search. It gets smarter every time someone clicks on an ad. And it immediately acts on that information to improve the experience for everyone else."[3]

As an example, consider the online movie rental service called Netflix. Netflix provides movie recommendations based on users' ratings. When users sign in, Netflix can recommend specific "Movies You'll Love," which are based both on the films they have rated and how other users have rated those and other movies. Each new rating by a user can affect which movies will be recommend to everyone. The ratings provide more than just a personalized user experience; they also provide community value.

Think about the alternative. Imagine if Netflix encouraged users to rate movies but did not provide better recommendations based on their ratings. Or if YouTube allowed people to upload videos but gave them no information about when those videos would be available for viewing. Or if Wikipedia allowed people to submit improvements to articles with no transparency about whether those suggestions would be integrated. Such participatory activities would be seen as a waste of time. Why go to the trouble of creating content if nothing is going to happen because of it?

This sounds ridiculous, and yet it's the way many museums approach participatory projects. Institutions provide ways for visitors to contribute, but they don't always provide clear feedback mechanisms so that visitors understand how and where their contributions will affect the institution overall. Visitors make their contribution, drop it into the slot, and hope for the best. In some institutions, visitors' contributions can languish for years. In others, the moderation of visitor-created content becomes such a chore that staff members review contributions rarely or haphazardly. In many cases, staff members don't even bother to go through visitors' contributions. They erroneously assume that visitors want to participate "for the fun of it" and that the visitors don't care how or if their work will be used.

Why does this happen? It's easy to undervalue the importance of responsiveness. Many people look at participatory websites and see the user-generated content on the surface without noting the underlying website architecture that responds to user actions. Consider the activity of rating videos on YouTube. Why does YouTube allow users to rate videos? It's not simply because it's fun to rate things. YouTube invites users to rate videos because those ratings can then be used to prioritize which videos are judged as better than others. The ratings provide valuable information about the relative value of videos, and the system architecture then uses that information to sort and present videos to subsequent consumers. YouTube's programmers recognize that different content appeals to different users, and so the system gives people recommendations based on their unique preferences rather than solely on aggregate ratings. The ratings are useless without the architecture to support them.

From YouTube's perspective, it's as important that users rate videos as it is that they make them. YouTube, like the Web itself, is glutted with content of

So, if h's not happy with a
salary li e tha', the idea
thing ould b th in
down.
JOHN STREATON,
Worcester

Congratulations
on art exhibition

SIR – I would like to congratulate Worcester Museum and Art Gallery on its recent exhibition of paintings from its archive. I was half expecting that the most popular paintings chosen by the public would just be the more

representational works or just the "pretty pictures" and the more modern ones would be completely neglected. But, what a pleasant surprise. I got to see such a variety of styles in the top 10, including an abstract by Ayres.

Maybe Worcester Art Gallery could do this sort of thing again – or even an annual open exhibition, such as the Royal Academy does, and again, allow the public to vote.

SHANE PHELPS,
Worcester.

Like any good participatory platform, the *Top 40* exhibition spurred community dialogue and debate beyond the museum's walls. Image courtesy of Worcester City Art Gallery and Museum, UK.

limited value. When users rate videos, they improve the YouTube ecosystem by sorting content by value. The more content there is, the more content there is. In contrast, the more interpretation, prioritization, and discussion there is around the content, the more people can access the videos (and the conversations) that are most valuable to them. Rating videos isn't just a fun diversion for users. It's a core support mechanism that helps YouTube function.

This concept can easily be extended to participatory museum projects. Consider video kiosks in history museums that allow visitors to comment on exhibitions or share their own stories related to the content on display. These kiosks are frequently designed to make contribution as easy as possible. They are rarely designed, however, to "get better the more people use them." From the contributor perspective, such kiosks would get better if contributors were informed of when their videos would be reviewed and how their work might be displayed to subsequent visitors. And for the vast majority of museum visitors who don't make videos (like the vast majority of YouTube users), these kiosks should offer other participatory experiences. There is no participatory opportunity to rate other visitors' videos, to sort them by topic or tone, or to comment on them. There is no way for a visitor to sit down and watch videos based on his particular interests. There is no way for a visitor to flag an inappropriate or empty video. And there is no way for contributors to see how others have rated, commented on, and enjoyed their work.

The result is a broken feedback loop. Exhibition video kiosks are degraded to playthings for people who like to see themselves on camera. Occasionally, a visitor will record something truly special, but the review and display systems are rarely set up to highlight those gems, and they certainly aren't set up to do so based on visitor feedback.

If museums are serious about inviting visitors to participate, they need to design structures for participation that embrace the full spectrum of participatory behavior and provide responsive value to those who engage. It's already hard enough to ask a visitor to make a video or craft a sculpture or write a label in the course of her visit. These endeavors are considerably more successful when visitors understand how their participation will impact not just their own experience but the experience of subsequent visitors and of staff members. A participatory museum isn't just open to visitors' contributions. It is a responsive institution that acts on those contributions and adapts to better support them.

Consider, for example, the Worcester City Art Gallery and Museum in Worcester, UK. In the summer of 2009, this small institution decided to develop a short-term exhibition that would tap into the popularity of reality television shows like *Britain's Got Talent*, in which viewers influence the fate of on-screen competitors by voting for their favorites.

The museum launched *Top 40: Countdown of Worcester's Favorite Pictures*. The exhibition featured forty paintings from the institution's collection, hung in a gallery with minimal interpretive labels. In the middle of the gallery, there

24

were voting stations, where visitors could use paper ballots to vote for a favorite painting and explain their reasoning. The staff tallied the votes weekly, and they hung large labels by each painting indicating its position in the rankings. The local evening paper also published the chart each week.

The *Top 40* exhibition was a hit. As collections manager Philippa Tinsley explained: "Spontaneous discussions broke out in the gallery on the relative merits of different pictures; visitors of all ages came back again and again to see where their favourite was in the chart that week and to cast another vote—at times they were queuing outside before we opened. As well as our existing audience, new visitors came just because they wanted to be part of it. I was particularly pleased to see young children persuading their parents and grandparents to participate."[4]

While some visitors to *Top 40* advocated for paintings based on personal preference (i.e., "it's pretty"), others made art historical arguments for the significance of their favorite pieces. One visitor, Shane Phelps, wrote a letter to the local newspaper congratulating the museum on the project, and noting his appreciation for the "variety of styles in the top 10" including both abstract and representational works. While everyone could make selections for their own reasons, every vote contributed to a broader community conversation about the paintings and the relative value of art.

What made *Top 40* a success? It wasn't just the opportunity for visitors to vote. It was the fact that the institution was responsive to their votes. Each week, the physical labels for the paintings changed based on the participation. The paper reported the evolution of public opinion. People understood that their participation mattered to the outcome, which motivated them not only to vote but to discuss the paintings and return to the museum again and again. Their participation, while simple, was meaningful. And that made all the difference.

WHAT IS A PARTICIPATORY MUSEUM?

Top 40 is just one example of a cultural institution operating like a Web 2.0 system. But take a mental step back. Imagine a museum that encourages visitors to participate and then provides responsive value based on their actions.

What might that look like? Such an institution might:

- Display objects created by visitors
- Generate maps of most popular or provocative exhibits based on visitors' comments
- Help visitors find other people (staff or visitors) with shared interests with whom to engage in content-specific activities or discussions
- Provide a public forum for visitors and staff members to ask and answer each other's questions

When thinking about what it means to "provide responsive value" in a cultural institution, it's important to move beyond the worlds of the Web and reality TV. In those commercial venues, responsive value is based on one thing: salability. The more you like something, the more likely you are to purchase it. For online retailers like Amazon or a movie subscription service like Netflix, it's in the company's best interest to serve people more of the things they like, so they'll be more likely to buy. The same is true of ad-supported websites that don't sell anything directly to consumers. The more videos you enjoy on YouTube, the longer you spend looking at the ads that support the service. The more you use Google as a search engine, the more exposure you have to the ads that pop up with the results. And the more responsive those ads are to your specific interests, the more likely you are to click on them.

This form of responsiveness is called a "proximate" model, meaning the system is optimized to respond with items that are most similar to the things you've already selected or marked. If you are trying to sell things, a proximate model makes sense. If a customer always buys romance novels, you take a risk by recommending a mystery or business book.

But museums are not trying to sell things. They are trying to engage people, to excite and enlighten and educate them. The proximate model makes many museum professionals uncomfortable, because it suggests that visitors will only be exposed to the narrow window of things similar to those they already like and will not have "off path" experiences that might surprise, provoke, or challenge their preconceptions.

Fortunately, the proximate model is not the only option available. There are some responsive systems that work very differently. For example, Librarything, a Web 2.0 site for people to catalog and share their books, provides a service called the Unsuggester. The Unsuggester recommends books that are *least* likely to be found in your LibraryThing collection or the collections of other users who also have your books. The Unsuggester doesn't so much give you books you'll hate as books that you'd never otherwise encounter.

While the Unsuggester is silly, it's also a valuable set of responsive content. It's a window into a distant and somewhat unknowable world. And users have reacted positively. When Librarything programmer Tim Spaulding suggested that few people were likely to actually read books on the Unsuggester list, an anonymous user responded: "You underestimate Thingamabrarians. Some of us are just looking for new ways to branch out from our old ruts ... and something flagged as 'opposite' to our normal reading might just be what we're all looking for."[5]

After noting the patterns of opposition between philosophy and chick lit, programming manuals and literature, Spaulding wrote: "These disconnects sadden me. Of course readers have tastes, and nearly everyone has books they'd never read. But, as serious readers, books make our world. A shared book is a sort of shared space between two people. As far as I'm concerned, the more of these the better. So, in the spirit of unity and understanding, why not

enter your favorite book, then read its opposite?"[6]

Imagine an Unsuggester for museum visits. Visitors might be intrigued to learn that "if you always visit the mummies, you may never have explored the fish tanks." Visitors might appreciate the invitation to comment on the objects that challenged or repelled them instead of the ones they found most enjoyable. A responsive system doesn't have to deliver content that people are most likely to enjoy; it just has to deliver content that is in some way personalized to individuals' actions.

Visitors take a closer look at one of the community-generated exhibits produced for the Denver Community Museum's *Bottled Up* exhibition. Image courtesy of Jaime Kopke.

When we think about responsiveness broadly, it's possible to imagine all kinds of participatory structures that can reflect institutional values and educational goals. One of the most powerful examples is the Human Library project, an international program that gets strangers talking openly and directly with each other about prejudice.[7] While it's not a museum-initiated project, the Human Library demonstrates how a cultural institution might use participatory techniques to incorporate new, challenging ideas—a goal for many museums.

The Human Library was conceived in Denmark in 2000 as a way to engage youth in dialogue about ending violence by encouraging people to meet their prejudices and fears in a safe, fun, facilitated environment. Since then, Human Libraries have been produced all over the world at festivals, in libraries, in museums, and in workplaces. Visitors sign up with a staff member, look through a catalog of stereotypes, pick one of interest, and enter into a forty-five-minute conversation with a real person who embodies that stereotype. As its organizers put it:

> The Human Library works exactly like a normal library—readers come and borrow a 'book' for a limited period of time. There is only one difference: the Books in the Human Library are human beings, and the Books and readers enter into a personal dialogue. The Books in the Human Library are people representing groups frequently confronted with prejudices and stereotypes, and who are often victims of discrimination or social exclusion. The 'reader' of the library can be anybody who is ready to talk with his or her own prejudice and stereotype and wants to spend an hour of time

27

on this experience. In the Human Library, Books cannot only speak, but they are able to reply to the readers' questions, and the Books can even ask questions and learn themselves.[8]

While they started as one-off events, Human Libraries have increasingly been included in the regular slate of programming at major libraries and educational facilities. Some institutions have expanded their scope beyond the initial focus on prejudice to provide a peer network for learning. For example, the University of Arkansas's fall 2009 Human Library catalog included books like "Meditation 101" and "Learning about Table Tennis" alongside more traditional volumes like "Christian Female Soldier," and "I am an Atheist."[9]

Where evaluated, Human Libraries have been incredibly successful. In an evaluation of a Human Library in Istanbul featuring 21 books, 481 out of 484 readers said they would recommend that others try the reading experience.[10] Several readers praised the authentic nature of the encounters as "exciting" and "educational." One reader said: "I could find common grounds with the advocate of an opinion that I do not agree with 😊." Another Turkish reader commented: "I've never had a gay friend. It was unbelievably exciting to find myself facing him with his body, opinions and identity. It seems he was not very different from me and especially he was not an alien. From now on, I will not disrupt my communication with the gays, I will enhance it."

Unlike most online responsive systems, the Human Library does not function on a proximate model. It doesn't give readers books that are most "like them" or related to their lived experience. Instead, it challenges readers to connect with something foreign and unfamiliar. The value system that underlies the Human Library network is one focused on confronting long-held beliefs and moving outside your comfort zone.

In this way, the Human Library reinforces a key value that many museums espouse: the power of being introduced to ideas and stories that directly challenge visitors' preconceived notions about the world. Like libraries, museums are safe spaces for encountering new ideas. The Human Library extends that concept into a responsive program that powerfully connects people to each other. The Human Library is a project that extends the core value of a cultural institution to a new setting and social experience. But it is also possible—and powerful—to create responsive participatory environments for traditional museum artifacts and functions.

The United States Holocaust Memorial Museum has been experimenting with participatory history research with the *Children of the Lodz Ghetto* project, which invites people all over the world to help track the paths of several thousand Polish children affected by the Holocaust. Participation is decidedly not creative; users run searches for various spellings of individuals' names in a series of Holocaust-related databases, hunting down information about their whereabouts over time. The participatory task is a glorified form of data entry. But it's also important; participants understand that they are contributing to

The *Children of the Lodz Ghetto* project transformed this beautiful album from a private research holding into a public source of inspiration and data. Courtesy of the United States Holocaust Memorial Museum Photo Archives.

real museum research about the lives of real people during the Holocaust.

In alpha testing with university groups in 2008–9, student participants expressed high levels of engagement, skill development, and content learning through the *Children of the Lodz Ghetto* project. They commented that it helped them connect to the Holocaust on a personal level, and in turn, to better understand its overall impact. As one student wrote, "As we conducted our research we saw that people would seemingly disappear—as if they had never existed. The many dead ends made our research frustrating but it also provided us with more intimate feelings toward those who had lost their lives in the Holocaust."[11]

The *Children of the Lodz Ghetto* project was explicitly designed to "get better the more people used it." For example, the designers addressed the challenge of authenticating data by involving users in the vetting of each other's work. The project has many responsive mechanisms by which both staff members and users provide feedback and commentary on participants' research. These responsive mechanisms help verify the data submitted, but they also foster a sense of community effort and engagement.

The university students involved in the alpha version noted the responsive

element of the research platform as essential; as one student put it, "Much of the time, our peers [other participants performing research on the site] allowed our research to continue on without any dead ends. When we were stuck, it was comforting to know that the United States Holocaust Museum and our peers had our backs." Another noted, "By seeing how others think and conduct research, we can learn new techniques and see new things to look for in our future research."

This is not to say their research was perfect. Many of these participants were new to performing this kind of research, and alpha testing showed that only one-third of participant-generated data was validated by experts as accurate. The rest were invalid. However, despite the fact that staff researchers could have done this research more quickly and accurately on their own, the learning and social value of the project was deemed high enough to make the project worthwhile from an institutional perspective. Staff researchers engaged in ongoing discussion with participants and helped them learn how to be researchers themselves. As project director David Klevan put it: "I hesitate to refer to any data as 'bad' because each time a learner submits 'bad' data, they receive feedback about the submitted data that hopefully helps them to learn more about the history and become a better researcher."

Museum staff members are continuing to adjust the project as time goes on, and once it is opened to the public, they hope to encourage a community of self-motivated, more skilled researchers to sustain the project on their own. The staff vetting is the unscalable part of this project, and if the project gets flooded with bad data, it may not be able to grow easily. But Klevan believes that the research can improve in quality and the community can effectively self-police entries if the institution can find ways to reward participants for improving their research skills over time. Because the project was built to support and integrate peer review and active collaboration on individual research efforts, it has the potential to get better the more people use it.

Children of the Lodz Ghetto is a participatory project that was thoughtfully designed to reflect institutional values, provide participants with meaningful ways to contribute, and offer responsive value based on participants' actions. When a project can accomplish all three of these goals, it becomes valuable and appealing to both participants and staff members.

THE FUTURE OF PARTICIPATION

What does the participatory cultural institution of the future look like? I don't believe every institution is headed in this direction nor should be. But I do believe that most museums will incorporate participatory techniques into their design strategies over the next twenty years, just as they have incorporated interactive and multimedia elements to a limited degree. For traditional museums, embracing visitor participation probably means projects like *Children of the Lodz Ghetto* or *Top 40*—specific projects in which participation is clearly tied to both institutional goals and visitors' interests.

But imagine a "generous and realistic" approach to participation expanded from the scope of single projects to an entire institution. What would a museum look like that "got better the more people used it" across the board?

First, it would be a place that would be a pleasure to visit on crowded days. Rather than suggesting to friends that they come during the quiet months, staff members would enthusiastically look forward to the busy season, in which contributions would be most numerous and participation most active. Exhibits would not be optimized for individual use, with visitors waiting their turn to interact singly, but instead for social and collaborative use. Staff might draw more heavily on visitors' knowledge when giving tours or providing information about exhibits, encouraging visitors to see each other as partners in discovery. For many years, research has shown that visitors commonly report interactions with staff as the most enjoyable part of their museum experience. In a participatory museum, visitors would be just as likely to learn, play, and enjoy the content with other visitors as with staff or their own families.

Second, in a participatory institution, staff would continually seek out opportunities to improve the institution via contributions by and collaborations with visitors. When planning every new exhibition, program, or fundraising campaign, staff would ask themselves: how can visitors help? What can they provide to make this project better? The answer would not be uniform, though staff would likely develop some techniques that they deploy frequently, such as a community cocreation process for exhibit design, or a way to solicit, integrate, and respond to ongoing visitor feedback. Like the programmers behind Web 2.0 sites, participatory museum staff members would take a generous and realistic stance toward visitor participation, finding the most suitable ways to encourage and support visitor contributions. They would not give themselves excuses to exclude visitors or engage them in trivial ways. Staff would make sure that each time visitors were invited to participate in a project, it was for a real, tangible reason that provides value to the institution and the participants alike.

Finally, a truly participatory institution would be comprehensively responsive to visitors and community members. This doesn't mean turning over control to visitors, or making programmatic decisions solely on their preferences. It means finding a way to convert their contributions into action. This can mean putting visitors' objects on display. It can mean featuring a story or artifact that online visitors love to discuss. It can mean asking locals who don't attend what keeps them away, and working with them to develop programming that might support their involvement. It can mean responding to visitors' comments in a way that is accessible to everyone who walks in the door. It can mean getting back to people, saying thank you, and integrating their feedback into the work of the institution. A participatory institution adapts and changes based on the contributions of all stakeholders—staff, trustees, visitors, and community members alike.

31

Could such a place exist? Of course it could. It exists in institutions like the Wing Luke Museum of the Asian Pacific American Experience in Seattle, which develops its award-winning exhibitions in partnership with people from the neighborhoods that surround it. It exists in services like the Glasgow Open Museum, which makes objects from a broad group of collections available to community groups for their own exhibitions and educational use. It exists in temporary projects like the Denver Community Museum, which assembled each exhibition entirely from visitor-generated objects. It exists in projects like the Human Library, which encourages people to learn about prejudice by engaging in dialogue with other participants who are unlike them. And it exists in many of the projects explored in the rest of this book.

Encouraging visitor participation in museums has tangible, distinct benefits. It celebrates diverse voices. It makes the institution feel more dynamic. It provides alternative contexts for the content presented. It makes the museum feel like a creative and social place. And it introduces new opportunities for learning around cultural artifacts.

Pursuing participatory models isn't just about letting go of authority or expertise. It's about opening up the institution to the possibilities of what visitors have to offer.

1 For Ian Rogers's complete speech, see http://www.fistfulayen.com/blog/?p=147 (accessed January 21, 2011).

2 James Governor, Duane Nickull, and Dion Hinchcliffe, *Web 2.0 Architectures* (Sebastopol, CA: O'Reilly Media, 2009).

3 For O'Reilly's complete speech, see http://www.slideshare.net/GeorgeAppiah/tim-oreillys-commencement-speech-at-uc-berkeley-sims (accessed January 21, 2011).

4 See http://museumtwo.blogspot.com/2009/11/guest-post-top-40-countdown-at.html (accessed January 21, 2011).

5 See Spaulding's November 2006 blog post "Booksuggester and Unsuggester" as well as user comments at http://www.librarything.com/blog/2006/11/booksuggester-and-unsuggester.php (accessed January 21, 2011).

6 Ibid.

7 See www.humanlibrary.org for more information about this program (accessed January 21, 2011).

8 Ronni Abergel, Antje Rothemund, Gavan Titley, and Péter Wootsch, *Don't Judge a Book by its Cover! The Living Library Organiser's Guide* (Budapest: Council of Europe Publishing, 2005). Available at http://humanlibrary.org/downloads.html (accessed January 21, 2011).

9 The University of Arkansas Human Library catalogue is here: http://libinfo.uark.edu/diversity/livinglibrary/catalog.asp (accessed January 21, 2011). (Note that they use the name "Living Library" instead of "Human Library." The name was changed in 2010 by the Human Library organization in response to a copyright violation.)

10 Statistics and quotes from Turkish evaluation report produced by the Youth Studies Department at the Istanbul Bilgi University in 2007. Available at http://humanlibrary.org/downloads.html (accessed January 21, 2011).

11 Quotations provided by David Klevan, *Children of the Lodz Ghetto* project director, at the 2009 American

Association of Museums conference in a session entitled "Co-Creating Visitor Experiences" and chaired by Nina Simon. The project can be found at http://online.ushmm.org/lodzchildren/ (accessed January 21, 2011).

Where Are the Best Stories? Where Is My Story? Participation and Curation in a New Media Age

Steve Zeitlin

"This is a story I tell...to describe what it was like to live in New York when I first moved here," wrote Edward O'Donnell in his contribution to www.cityofmemory.org, City Lore's Web-based story map of New York City.

This would have been 1992, because my daughter Erin was two. When we'd walked around the Morningside Heights area where I was in graduate school, she began to collect from the sidewalk little plastic objects. They were brightly colored and about two centimeters long, with a head and a little stem. I thought that they were little plastic fasteners or rivets that I'd remembered from the telephone company when I was growing up.... One day my wife opened the *New York Times* and noticed a big story about the police seizing a million dollars of crack cocaine. And there in the midst of the article was a photograph of several crack vials with these as multi-colored stoppers in the top of them. She literally jumped out of her seat and ran down the hall to seize the stopper collection. Our daughter had been gathering crack vial stoppers as her first collection! I think we ended up discarding them because we feared contamination, but we thought it was just a hilarious story—partly a country bumpkin story, and partly one representative of how widespread crack was in parts of New York City in the early 1990s.

By way of contrast, I arrived in my office one morning, turned on my computer, and discovered a story contributed from a young

man recounting that he found a "Puerto Rican cat" on the street in Brooklyn. That was it: he found a cat on the street. As curator of *City of Memory*, I needed to make a decision on whether to enable the story to appear on the story map of New York. I decided that it fell below what I sometimes call the "T of I" (the Threshold of Interest). There simply wasn't enough to it. I did respond, asking the contributor to expand on the story for the site. He never did. The story contributed by historian Edward O'Donnell, on the other hand, was engaging and captured something about New York at a certain period. These two stories reveal the basic tension that underlies cityofmemory.org, a democratic arts initiative that invites participation, and is, at once, curated.

City of Memory is a participatory, dynamic story map of the city. It features highlights of City Lore's extensive documentation, invites viewers to post their own stories, and enables us to work closely with communities to place themselves "on the map." The project was developed collaboratively between City Lore and new-media designer Jake Barton, principal at the design firm Local Projects. As we brainstormed, Jake casually suggested an idea which became our mantra. Visitors to the site will be interested in only two things: "Where are the best stories?" and "Where is my story?" I recognize that these two questions have been asked long before the advent of the Internet. But they served as our guide as we shepherded www.cityofmemory.org to its virtual spot on the World Wide Web.

The tension between curation and participation played out in a number of key decisions we made in constructing the *City of Memory* site. From the start, we distinguished between contributed stories and curated stories. Curated stories would be represented by a blue dot, while contributed ones would get an orange dot. We argued and went back and forth about whether a contributed story should automatically appear on the site and we would vet it later, or if we editors should see the contributed stories first and then "enable" them, as we ultimately decided. Our overarching goal was to be inclusive and participatory but not at the expense of creating an artful, beautiful site and a rich, engaging experience for visitors. We decided that a Website that simply allowed all contributions to stand as-is would become simply the sum of its parts—an uneven and ultimately unsatisfying experience for visitors. Guided by an artful vision and committed to accuracy and contextualization, *City of Memory* strives to be more than that. The site connects stories geographically as well thematically through virtual "tours," creating synergy among them. Over time, I have come to recognize that *City of Memory* is the dynamic, public face of the City Lore archives, which are far more extensive in their breadth.

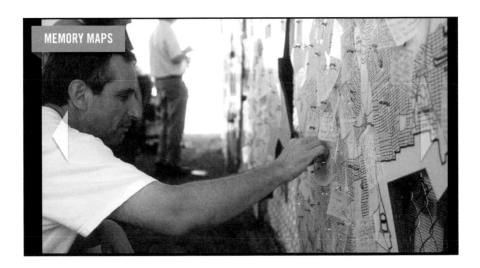

MEMORY MAPS

City of Memory had its inception in 2001, when the Smithsonian Folklife Festival in Washington, DC, spotlighted New York City, and Jake Barton, then an exhibit designer, collaborated with City Lore to bring large Styrofoam maps of the five boroughs to the National Mall. At this outdoor festival, visitors pinned memories written on small pieces of acetate to the spot on the maps where their stories took place. In the years that followed, Barton began working with new media, and the project was transformed for the Web with grants from a National Endowment for the Arts technology initiative and the Rockefeller Foundation. Our virtual experiment in popular curation, in other words, began at a populist outdoor festival, a grounding that we find revealing. We sometimes think of our mapping project as the evolution of the push pin. At City Lore, we see the clarion call to "tell us your story," now ubiquitous on the Web, as an invitation emerging from historical precedent.

HISTORICAL CONTEXT

Web 2.0 began in the 21st century, but it evolved from the 20th. The invention and dissemination of recording devices and phonographs in the early years of the 20th century, of movies and radio in the 1920s and '30s, and of television in the 1940s and '50s created industries that broadcast music and entertainment from centralized locations. Where were the best stories? In the United States, they were in Hollywood and New York City. Now, the best singers and storytellers, the finest entertainers in the entire nation, were accessible at the click of a button, though folklorists often lamented the loss of songs and stories told on back porches and in family parlors.

But technology developed on two parallel tracks. The same kinds of advances that created radio and television were harnessed to enable individuals to document their own lives and stories.

Cameras became inexpensive and ubiquitous in the 1940s and '50s, and home movies and then home video enabled people to become their own myth-makers and visual storytellers. Cassette tapes enabled individuals to create their own mixtapes even before CD-burners and iTunes. Now, in the 21st century, citizens of a new global culture can record, transmit, and broadcast their own stories, worldwide. They tell and share their videos on YouTube, their songs on MySpace, and even what they ate for breakfast on Twitter and Facebook. The Web has become a major democratizing force in American culture.

Folklorists utilized the new technologies to assure that many of the stories told on porches and in parlors indeed were not lost. A hundred years ago, in 1910, John Lomax, at the urging of his professors at Harvard, returned to Texas to collect cowboy songs, one of the first efforts to collect the songs and stories of ordinary Americans. In the 1930s, after he lost his bank job during the Depression, he traveled with his son Alan to collect songs and stories from blacks in the American South. Together they uncovered America's regional musics at a time when Tin Pan Alley dominated the airwaves. Alan Lomax later wrote of a "cultural grey-out" and devoted his life to recording song traditions that he considered threatened. To folklorists like the Lomaxes, the recording machine was an antidote to the mass media.

In the 1950s, Allan Nevins at Columbia argued that modern communications, notably the telephone, were swamping the great repositories of the American past, the letter and diary, and suggested that the tape recorder could fill in the gap in the historical record. Again, technology was harnessed as an antidote to the onslaught of technology.

The 1960s spawned a number of initiatives that celebrated the stories of ordinary people. These included that era's folksong revival, the establishment of the American Folklife Center, the Smithsonian Institution's Festival of American Folklife (where the early version of *City of Memory* was featured), the National Storytelling Festival, and the appointment of folklorists to work in most states, funded by the National Endowment for the Arts. In addition, the work of psychiatrist Robert Butler and anthropologist Barbara Myerhoff in gerontology suggested that reminiscence should no longer be considered a pathway to senility–that older people's stories should be valued. In the 1970s, I worked with the Smithsonian's Folklife Festival to create a tent in which anyone could come in and record family stories with a team of graduate student interviewers.

When I moved to New York City and started City Lore in 1986, I had the opportunity to work with David Isay, as his non-profit sponsor. Isay helped bring the interest in the stories of ordinary people to public radio, and, after winning a MacArthur Fellowship, initiated StoryCorps. (*City of Memory* designer Jake Barton went on to design the StoryCorps booth.) At the time, a number of individuals were developing "booths" to collect stories, but these only had a video camera in a booth, and asked people to talk directly into it; they never quite succeeded. Isay's brilliance was threefold: first, StoryCorps allowed anyone and everyone the opportunity to tell their stories and become part of a permanent record; second, it carefully curated the best of these stories for the radio; third, it created an interviewing process that was person-to-person, asking people to bring their loved ones or those who have interesting stories into the booth as well as providing a facilitator for the interaction.

Throughout, Dave Isay is uniquely conscious of "the best stories." In the years leading up to StoryCorps, City Lore hired a cultural specialist to locate stories for the American Talkers series that we cosponsored with him. She worked for six months and suggested probably fifty stories; not one met Dave's standards for the radio. StoryCorps struck a balance between participation and curation, giving Americans a chance to tell "my story" and hearing "the best stories" on the radio.

CURATED VS. CONTRIBUTED STORIES ON CITY OF MEMORY

City of Memory was conceived as a way to bridge the populist "tell your own story" and the expert-driven "preserve the finest stories" approaches to technology and storytelling. Our goal was and is to work with New Yorkers to bring out the best in their stories and create a home for reminiscences, tours, and images of the city's folklife. We evolved a way of inviting and soliciting contributors to the site and working to do justice to the vitality, power, and effervescence of New York City's living cultural heritage. Early on, we realized that the stories needed to be vetted to avoid vapid or pornographic entries. To that end, the site was designed so that when a person submits a story through the "Add a Story" function on the site, an email is sent to the contributor saying that the story is being reviewed and will be up shortly. We then have the chance to vet the story and send an email confirmation when it is up. We also edit the grammar slightly, and mention that to the contributor.

For *City of Memory*, the notion of "letting go" applies not only to the process of accepting contributed stories, but also to the process of curating the site, which is enormously labor intensive. We rely on a constantly changing pool of interns to edit pieces for the site and to

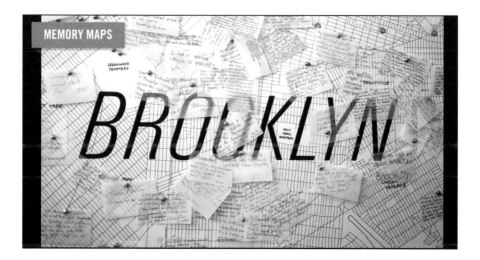

MEMORY MAPS

BROOKLYN

draft written materials. Although I consider myself the curator, I often can't oversee all elements without making the site my full-time job. As an open-ended site, the work on *City of Memory* is never finished and never perfect.

We have had touching contributions to the site, as visitors post evanescent details of memory: Stan Solomon recalls bringing heavy wooden folding chairs to sit out on the sidewalk on summer nights on Leggett Avenue in the Bronx, circa 1950; Marc Wallace tells the story of watching a man bury his beloved dog in Riverside Park.

We also encouraged contributions of "ghost sites," places whose absence from the landscape leave a dramatic, gaping hole. These places continue to have a palpable existence in the virtual city—places like Dorothy Day's cottage in Staten Island, razed by real estate interests in 2001, and contributed to the site by Jim O'Grady. Kathryn Adisman created the virtual tour "K's New York: Going Going Gone," which includes her favorite places in the West Village that are no longer there: the Vegetable Garden, Moondance Diner, Bleeker Luncheonette. She calls it "the world of things disappearing."

Conversations with contributors to the site suggest that participation in *City of Memory* is meaningful for them:

Nicolas Weinberg, who wrote about being in a small surrealist art museum in France and watching the towers collapse on 9/11 on a TV screen, thinking it was a surrealist installation: "I'm very happy you liked the story and you put it online. I've been thinking about this day for so many years."

Marc Wallace: "Where else would I ever get a chance to tell my bizarre tale about a dog being buried in one of my favorite

Memory Maps 2001. Maps of the New York's boroughs on reams of paper allowed visitors to share their stories by pinning acetate sheets to specific locations. Photo by Jake Barton.

Opposite: The
faces behind
City of Memory
welcome you to
chronicle your
story.

Members of the
*Brooklyn Elite
Checker Club*, who
were recorded in
the 1990s, live on
in the 21st cen-
tury on the *City of
Memory* site.

green spots in the middle of Manhattan than on a place like *City of Memory*? In fact, the only reason I remembered the story at all some ten years after it happened was because reading what others had posted about their magic moments in the midst of this wondrous city had prompted me to search through my own attic of urban recollections."

Lonnetta M. Taylor-Gaines: "Most neighborhoods in Manhattan evoke specific memories for me; that's how old I am! When I was invited to post a story on the *City of Memory* story map, I jumped at the chance! I chose to write about Clark Center for the Performing Arts because it meant so much to so many dancers and friends of the dance. An African proverb teaches us that when a person dies, as long as we tell the story, the person will continue to live. Well, I believe that about places, too! So for me, writing about Clark Center helps to keep this incredible place alive, not only in memory, but as an actual location on the *City of Memory* story map. Thank you, City Lore, for your vision!"

Some of the contributions to the site, though, are less than impressive. Although these don't dramatically detract from the site, we plan to re-curate the site periodically, leaving only the more interesting and substantive entries up permanently. Will visitors be appalled if their stories are deleted at some point? We don't believe so, because the stories we will eliminate are precisely those to which the contributors did not give significant time or thought.

The real strength of *City of Memory* lies in the networks City Lore creates through our ongoing projects and our "living archives." In addition to the stories contributed cold through the "Add a Story" feature on the site, we solicit stories that we learn about through our networks and ongoing projects. Historian Ed O'Donnell's story, which opens this essay, was solicited after we heard him tell it as part of a program we were conducting for teachers. We often work with New Yorkers to help with videotaping, editing, and uploading their sto-ries. These stories for the site are based on personal interviews and carefully edited. They also attract a visitorship averaging three times higher than the pieces contributed cold.

TOURS AND TALES

As we worked with Jake Barton to create cityofmemory.org, the site began to feel like a creature with a life of its own, with life-affirming instead of life-effacing strengths. We came to think of cityofmemory. org as a giant brain, encompassing memory and humanity in ways that constantly surprise its creators—and the stories and memories are accessed in multiple ways, like synapses in the brain. As it is,

40

Google memory extends my recall several times each day; perhaps online memory is part of the brain's evolution.

Throughout its creation, Jake and I talked about trying to capture the cognitive maps of the city each of us carries in our heads, so we envisioned stories being linked together as "tours," connected by a dotted line on the site. Some of these evolved into our new-immigrant tours, where spokespeople lead visitors on a tour of Places that Matter to their community. But the site also includes a Local Character's Hall of Fame tour linking disparate characters from different parts of the city and different points in time: a scene from a late 1990s Rob Maass documentary depicting the Polar Bear Club who swim on Coney Island in winter; and Dave Isay's work with the Brooklyn Elite Checker Club, a club that we included in our City Play exhibition twenty years ago.

City of Memory enables us to work closely with communities to place themselves "on the map." Our methodology for working with community groups is to ask a spokesperson to locate and video-tape two or more spots for a prospective Web-based tour of places significant to that community. The spokesperson working with us then invites twelve to fifteen key members to each workshop. At the workshop, the spokesperson and the Place Matters team use the online "draft" of the *City of Memory* virtual tour as a starting point for a discussion that focuses on identifying places that matter to the community and the reasons for their importance. For groups that are new to the concept of preservation, identifying sites for the Web exhibition and documenting them leads naturally into a discussion of other potential preservation and commemoration initiatives. Links to some of the tours and stories are:

www.cityofmemory.org/map/#/tour/40 (Russian New Immigrant Tour, led by Rita Kagan)

www.cityofmemory.org/map/#/tour/ 36 (South Asian Tour led by Madhulika Khandelwal)

www.cityofmemory.org/map/#/tour/65 (Indo-Caribbean Tour led by Pritha Singh)

At City Lore, we see *City of Memory* as an outgrowth of the participatory curated projects that we use in our education programs: students often design a quilt square or a mosaic tile that become a part of a larger vision developed with a visiting artist. We see it as related to projects like the AIDS quilt, which invites individual squares and produces artful exhibitions utilizing individual pieces in a collective whole. With roots in the artists' "happenings" of the 1960s, cityofmemory.org is a populist initiative in which anyone can participate by contributing to a curated framework that ensures that the whole has an artistic integrity and a vision that can incor-

porate disparate elements. It draws together a wide swath of City Lore's documentation, and yet still conveys a powerful and inclusive picture of a city that exists simultaneously in different points in time linking stories and experiences through the power of place.

Cityofmemory.org creates a web of interlocking memories, chronicling the city's inner life. It links stories and memories in ways that cut across chronology, sparking connections and enabling visitors to rediscover the city through the memories of others. Our hope is that New Yorkers from many walks of life and cultural backgrounds will be able to place themselves on the map and garner a deeper appreciation of the shared experience of urban life. As the site's wide-eyed creators, Jake and I watch in amazement at how the new Web technologies enable us to use computers in ways that are profoundly human, extending the boundaries of consciousness and memory.

As a writer of books and a filmmaker of documentaries that have long since been completed, projects for which "the book is closed," I find that *City of Memory* enables us to create an open-ended cultural work—having all the elements of a book or film, but with endless potential to change and grow and yet still retain the vision we had for a virtual home where New Yorkers could find many of the best stories and add their own.

43

The tension between curation and participation is often difficult but ultimately fruitful. I'm reminded of the tension that always existed between the ways two iconic folklorists, Pete Seeger and Alan Lomax, approached music. Lomax, it's been said, wanted to collect the best stories and put them on the radio; Pete Seeger wanted to get everybody singing.

Online Dialogue and Cultural Practice: A Conversation

Matthew Fisher and Bill Adair

The following is a conversation between Bill Adair, director of the Heritage Philadelphia Program, The Pew Center for Arts & Heritage, and Matthew Fisher, president of Night Kitchen Interactive. Night Kitchen designs interactive exhibitions, educational websites, and online communities for museums and cultural institutions.

Bill Adair: You've developed some wonderfully inventive Web-based projects for museums that encourage visitor interactivity. Do you believe that the Web has allowed a new kind of shared authority in cultural practice?

Matthew Fisher: Absolutely. My job is to translate museums' missions and goals—whether curatorial, educational, or promotional—online. As museums shift more and more toward visitor and audience engagement, there begin to be limits to fulfilling these missions exclusively in the physical space. Particularly with the advent of Web 2.0 and social media, there is enormous potential for museums to effectively realize their objectives online through a dialogic relationship with their visitors.

Bill Adair: Public historians have attempted to be in dialogue with our audiences for decades now—how is this any different?

Matthew Fisher: This is true. And yet, occasions for true dialogue between historians and the public have traditionally been very limited. But new technologies support opportunities previously unimagined.

There are a lot of interesting projects out there that are embracing social media and creating dialogic opportunities by balancing both traditional curatorial content and visitor-contributed content. We recently finished a

project with the Historical Society of Pennsylvania, the *PhilaPlace* project, which presented over a hundred historical stories painstakingly gathered by ethnographers, folklorists, and public historians who crafted the research and interviews into authoritative stories told by the institution.

In addition to those authoritative perspectives, the Historical Society also embraced dozens of stories told by visitors about themselves and their own histories relevant to the two neighborhoods of Philadelphia that the project is focused on. By making visitors' stories distinguishable from, yet on par with, their own, the *PhilaPlace* site invites its visitors to engage in a shared sense of history.

An online tool allows site visitors to upload stories, images, and videos and place them onto historical maps, so it's a growing and ever-changing project. That's one of the really interesting things about social media projects: an exhibition doesn't just have to end. An exhibition can continue to live, grow, evolve, stay green, and bring people back for multiple visits, because it continues to change with that public participation. That's a radical way of looking at exhibitions.

Bill Adair: So social media at its core allows museums to more easily and effectively present visitors' voices alongside their institutional voice?

Matthew Fisher: Yes. And when we talk about visitor-curated content, we're going way beyond just contributing stories and comments. Given the opportunity, visitors are able to shape much of the curatorial experience. The *21st-Century Abe* project that you and I did together is a great example. For Lincoln's 200th birthday we wanted to look at what he might mean to a 21st-century audience, particularly a younger demographic, in order to gather some sort of a national zeitgeist on Lincoln.

The project represented a wide range of different perspectives on a single topic, a single historical figure, who may be the most recognized historical person in the world. It certainly, in part, presented a conventional authoritative model through interpreting a series of Abraham Lincoln's documents in the Rosenbach Museum & Library, and the stories around them. There was a wonderful historian, Douglas Wilson, who contributed to that component of the project. So the classic scholarly interpretation was present.

The next level out was the commissioning of artists—a visual artist, a multimedia group, a musician, and a theater group. Each of them engaged directly and deeply with the Rosenbach's curators and the documents as well, and then they contributed in their own medium, in their own way, to the project, reflecting their unique perspectives on Abe in the 21st century, and what Abe means to them.

This turned out to be a terrific way of not only providing some really interesting and, at times, amusing and engaging reflections

45

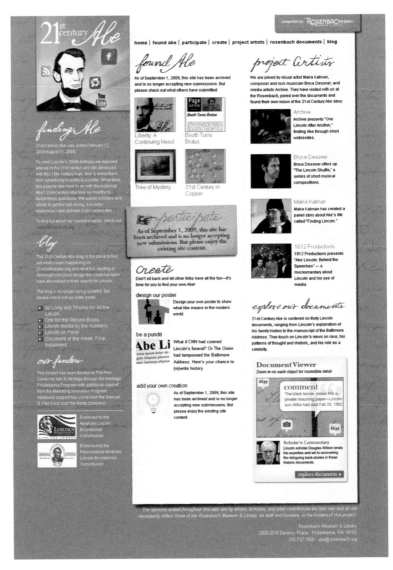

Screenshot of homepage, *21st Century Abe*, 2009. A Web project produced by the Rosenbach Museum & Library in Philadelphia for the 200th anniversary of Lincoln's birth, it includes a dynamic combination of scholarly analysis, artist commissions, and visitor-uploaded contributions. The site was live for the six months following Lincoln's birthday and regularly monitored by museum staff. The project is archived at www.21stcenturyabe.org.

on Abe, but also an excellent way to model the sorts of engagement that we were trying to cultivate with the project. It basically told our visitors it was okay to play around with Abe and what he means to us today. And, in fact, we're encouraging it.

Finally, we had site visitors contribute their own perspective on Lincoln by posting appearances of Lincoln as "found objects." So in the "Found Abe" section of the site visitors submitted a wealth of contemporary perspectives on Lincoln, from artistic to humorous, from pop culture to scholarly works. This became a central part of the project—all of the digitized representations of Abe that visitors uploaded.

This project takes the sense of shared authority even further than *PhilaPlace*, inviting artists and site visitors to contribute in wildly creative ways.

Bill Adair: You obviously have strongly held beliefs in the power of building interactive relationships between cultural organizations and audiences. Are there theoretical underpinnings to your thinking?

Matthew Fisher: Hilda Hein, in her book *Public Art: Thinking Museums Differently* suggests that museum practice should never be simply about the objects themselves. Museums need to be constantly thinking about creating a meaningful relationship between the object or artwork and the visitor.

Bill Adair: You mean the relationship between the object and the viewer—the dialogue between them? That's not really a new idea, is it?

Matthew Fisher: Years ago Marcel Duchamp said the creative act is not performed by the artist alone—that the spectator, by deciphering and interpreting the work, adds his own contribution to the creative act. Hein suggests one model for museums to consider is the public art model, in which both the object, or in this case the museum, and the public, engage and participate to create the experience. But for many museums I think this is still very challenging.

Developing a creative relationship between objects and visitors—whether it's in history museums or any other—is what I think about all the time. That transformative experience should be a dialogue, an engagement, where you let go of the outcomes. You enter into it with an open mind, with a capacity for a variety of voices to be heard. A truly engaging exhibition not only provides a transformative experience for the public—it transforms the museum, its staff, and the exhibition itself. And the power of social media to incorporate multiple viewpoints into the overall voice is just unprecedented.

Bill Adair: Ideally then, new technology allows for every dialogue to be different, so each visitor has a unique creative experience?

Matthew Fisher: Exactly. In setting up a dynamic dialogue, the museum clearly recognizes an individual's ability to have an impact. I'm interested in a model that operates in this energized space between the traditional, authoritative voice and the crowdsourced,

democratized voice of non-experts. There can be a respectful back and forth.

Another writer that has had a big impact on my practice is the education philosopher Paulo Freire and his concept of critical pedagogy. Here, teachers create a classroom environment that empowers students to understand the models of knowledge and power that pervade the education system, not only to be critical of it but also to explore and reach beyond it.

Bill Adair: The teacher shares intellectual authority with students—a relationship of give and take?

Matthew Fisher: Yes. And he's not just re-describing the Socratic Method. There is no absolute truth or authoritative viewpoint that is understood to be the final word. The teacher provides guidance, informs the classroom environment with expertise and knowledge, and encourages the students to look beyond their own viewpoint or the teacher's viewpoint—and collectively the participants identify a broader, more complex and perhaps more nuanced view of the subject at hand.

Bill Adair: So how does Freire's teaching philosophy translate into museum practice?

Matthew Fisher: Well, one example is another social media project that you and I also collaborated on, the *Franklin Remix* project. This project was a classroom-based remix of two real-space exhibitions around Benjamin Franklin's 300th birthday. We worked together with a small group of middle-school students at The Philadelphia School to experience those exhibitions and then reinterpret their experiences into their own online exhibition. It began by exploring the curatorial process and the skills required to be a curator, which was as much what that project was about as it was about Benjamin Franklin and American history.

But what was interesting and compelling about that process was that once we turned over the reins to middle-school students to share their own perspective on Benjamin Franklin, we came up with a very different kind of big idea for an exhibition than we would have had, perhaps, if the story was being told by historians: *Benjamin Franklin: The Good, the Bad, the Ugly*, was the students' tagline.

For the *Franklin Remix* project, there certainly was an interest within that group to identify strengths and weaknesses, warts and all, of this founding father, and through that process, come up with a much more nuanced, and, ultimately, sympathetic understanding of Franklin. The students' use of technology was at the core of the project. Mastering these tools led to their empowerment, and their empowerment facilitated a dialogic engagement in the classroom. So while the dialogic engagement was very much a traditional framework—in that we were in a classroom with them—the technology played a key role in facilitating their sense of authority.

But, I believe that by simply giv-

ing them control, and telling them that this was their own story to tell, albeit somewhat moderated by the educators working with them, that they were able to bring a perspective that they would not have brought otherwise. And I think that's an important aspect—empowering audiences. I think we sometimes underestimate the power of that.

Bill Adair: Isn't there a way to translate this approach to real-space traditional museum exhibitions?

Matthew Fisher: That's a real challenge. Translating Freire's approach to a conventional museum exhibition experience is basically impossible. This is why the groundbreaking capabilities of new technology change everything. Early Web-based museum projects were still very one-sided. They took information and put it on the Web, made it accessible, and that was the primary goal. "Let's get the collections online. Let's make our resources available." That was a great first step. But the next step, which is a really powerful one, is about supporting a variety of voices and viewpoints across the museum community, including the visitors, instead of limiting museum websites to a single authoritative voice. These viewpoints can come from different perspectives and departments throughout the museum and, of course, the public. There are hierarchies in place that inform any sort of knowledge paradigm, and unless we acknowledge and recognize those in the museum,

we're always talking within a very safe and isolated environment. If we break out of those paradigms and acknowledge them, we can have a more enlightened, nuanced, and inclusive discussion.

Bill Adair: So your goal, then, is to use new technology as a vehicle for bringing multiple voices, in conversation around objects and ideas, to the table. Is it really that simple?

Matthew Fisher: Yes and no. Introducing differing perspectives is vital, but simply criticizing or undermining dominant or authoritative viewpoints is ultimately limited. I've been asking myself a lot lately: "to what end?" Then I struck on a wonderful piece by Margaret Lindauer entitled "Critical Museum Pedagogy: A Conceptual First Step" from the compendium *Museum Revolutions: How Museums Change and Are Changed*. She articulated beautifully what was missing from a lot of critical discourse, and that's a language of hope. This language of hope ties into this concept of transformative experiences. We still want to have a critical, intellectual discourse, to identify hegemonic paradigms. We want to get underneath and expose dominant narratives. We want to explore a variety of different viewpoints. But ultimately we're doing this so that we can better read the world and expose a more nuanced and complex understanding of history and ourselves.

Bill Adair: I hear you advocating for a real and rich dialogue between expert and audience here.

49

So there's still an important role for the content expert in this model?

Matthew Fisher: Definitely. There is a deep tradition of knowledge, content expertise, and curatorial research that are components critical to the conversation. And museum objects are an essential part of this dialogue. If you don't have objects and that expertise, then the discussions are limited, thin. I am a huge proponent of the power of objects and spaces to engage and inspire audiences. There is no replacing that and I wouldn't want to try.

But social media can facilitate very robust and sophisticated dialogues between experts and non-experts inexpensively, effectively, and in an asynchronous environment. Everybody doesn't have to all be in the room at the same time. Again, I think this opportunity is unprecedented, but only if we embrace it.

Bill Adair: To be clear then, you're not saying anyone can be an expert on any subject. What I hear you saying is that many people can have an interesting, valid response to and perspective on any subject, and that a rich and meaningful conversation can emerge by linking those that do have true expertise with those alternative perspectives and new voices.

Matthew Fisher: It facilitates a real wide range of discussions, and we can't even begin to predict what all of them will be. It has the potential to create a dynamic dialogue that traditional, hierarchical adherence to expertise would not allow.

Bill Adair: How do audience needs and expectations inform this approach? Common wisdom dictates that audiences are now demanding this interactivity. Do you really think that this is true?

Matthew Fisher: Yes. If museums don't embrace these new paradigms, they are in danger of becoming irrelevant. We all expect to participate more actively in our experiences today—young people in particular. But it is not just young people. Whether we comment on and rate books on Amazon or not, we rely on the comments and the ratings of others as we choose what books we're going to buy. We take it for granted that we have the wisdom of the crowd at our fingertips when we seek information on the Internet. For the growing and active group of people who participate—from commenters, critiquers, and collectors to contributors and creators of content—the expectations are shifting toward having these kinds of participatory relationships with all of their channels in life.

Bill Adair: What are some simple and not-so-expensive approaches that museums can take to move toward this kind of practice?

Matthew Fisher: There are some really basic fundamental components of social media that allow for some very interesting things to occur.

It allows for "favoriting"—adding that little star or heart that you can put next to things—of collections and of stories on a website. On one level, this feature is the same as we've seen on various museum sites, where you're able to

Web cartoon by students, *Franklin Remixed*, 2006.
A collaboration between the Benjamin Franklin
Tercentenary,the Rosenbach Museum & Library, University
of the Arts Museum Communication Program, Night
Kitchen Interactive, and The Philadelphia School. Middle
school students responded to real-space exhibitions
about Franklin and created a "remix" of the objects in a
new Internet-based exhibition produced from their own
perspectives. The project also includes creative work by
students about Franklin and uploaded to the site. It is
archived at www.franklinremixed.com.

save your own collection.

Bill Adair: The oldest kind of response to a museum's collection is to choose one's favorite, right, so this is giving structure to that process through new technology?

Matthew Fisher: Yet it's the public view of the aggregate of that action that leads to some very interesting experiences. It also allows this action to have meaning for the larger group. You can see what everybody else's favorites are and these choices become part of the discourse.

Tagging is a bit more nuanced. With tagging, you're able to allow the public to describe the characteristics of your objects. It allows for a multifaceted means of indexing your collection in ways that museum curators would never even think to do, let alone have the time to do, on their own.

Commenting is a familiar feature for making a response to blogs or articles. I'm encouraging our clients to think about commenting in a more holistic way, providing an opportunity to allow members of their own staff, the community, and the greater public to provide additional viewpoints around their collections, around their stories, around their articles. We're still on the tip of the iceberg in terms of what people can do with that. It's not difficult to employ. Inexpensive tools allow you to put a comment function on basically any site. All of these tools are very straightforward, easy to implement from a Web development standpoint, easy to use for visitors, and can make for

some really dynamic dialogue.

Bill Adair: What about a museum's blog? Do you think that blog posts by curators, directors, or educators—whether they're talking about a particularly interesting object that they've come across or something about their practice— are productive?

Matthew Fisher: I think blogging is probably the best vehicle for beginning the dialogue, because it allows you to establish, first and foremost, that expert voice. And it allows that expert voice to be freed from the constraints of your typical 200-word label copy, your wall panel, or some of these other buttoned-down environments. It allows a lot more freedom for discourse on a variety of different ideas, especially if a number of people in the organization contribute to the blog. If there is just a single contributor, often it's a product of the marketing department.

Bill Adair: Right, but public-relations-based promotional blogs are not the kind of dialogic blogs that you're talking about?

Matthew Fisher: Not in the traditional marketing sense. Blogs can be opportunities to build and sustain relationships between museums and their communities. You host a lecture, for example, and you have your lecturer post to your blog before and after the lecture, and you encourage audience members to comment as well. So you capture all of that great follow-up dialogue, instead of what otherwise would be a single instance, single audience conver-

sation. When curators, educators, and directors—by all means, directors—start blogging, they have an opportunity to engage a broader public in a dialogue. A blog is a great platform for that because people may feel more comfortable commenting on a blog post than they might on a collections detail page or on more scholarly material.

Bill Adair: Okay, so tagging, bookmarking, favoriting, and blogging are all inexpensive and relatively simple ways that organizations can begin to give a voice to our audience—let's call them mini curatorial interventions. But I wonder, if everybody can be a curator on some level, what do professionally trained curators do in this new model?

Matthew Fisher: First and foremost they continue to engage with the rest of us around objects and ideas based on their knowledge and expertise, as they always have. Curators have deep knowledge and understanding of the material that they're working with and are able to process, organize, and arrange objects in ways that the rest of us aren't trained to do. They can teach us the skills and processes of curating—they can help us to be better curators ourselves.

I envision curators entering into that dialogue with the public and providing all of us an opportunity to flex our curatorial muscles in a supportive and mutually respectful environment. Online, curators are able to scaffold visitors' experiences and help them make meaning out of objects, which is fantastic.

But ultimately I don't think the curators' role is undermined. Even though the rest of us are learning to do the same sorts of things, that doesn't diminish their expertise. If anything, it gives us a newfound respect for how challenging their work is, and an appreciation for it when it's done well.

Bill Adair: There is still a lot of organizational fear about this kind of work. What do you think people fear the most?

Matthew Fisher: Of course there is. We've worked with a number of organizations that have had a fear of this new system: "What happens when we open the flood gates to let people start commenting and dialoguing, and asking questions on our website? We'll never be able to keep up with it all." In reality, I don't think that tends to be a major problem. That happens in some rare instances when there's a particularly hot topic. In most cases, however, there's just a greater potential for audience engagement.

Bill Adair: So they fear a kind of virtual storming of the gates from this theoretically massive public, newly able to access them through technology.

Matthew Fisher: Yes. And they fear a loss of public trust, by not being able to control the dialogue. But my experience is that when organizations become more transparent, when they enter into respectful discourse with their audiences, when they bring in people from all walks of life to participate in this dialogue, this builds trust, it

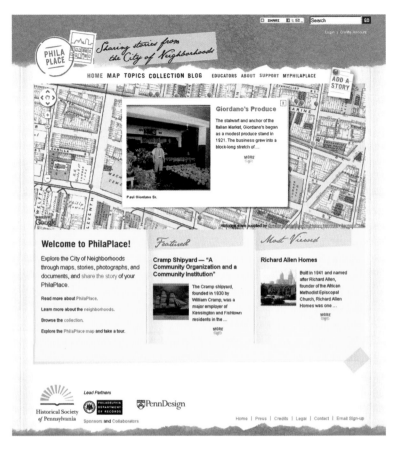

Screenshot of homepage, *PhilaPlace*, 2009. An Internet-based neighborhood history project produced by the Historical Society of Pennsylvania, it combines historical scholarship with everyday stories uploaded by visitors. The site also includes maps, educational materials for teachers, and an active blog: www.philaplace.org.

doesn't undermine it.

Bill Adair: In the last twenty or thirty years, much of the practice of history has moved away from an emphasis on facts and a single historical truth to a much more fluid view of history, one in which history is acknowledged to be a collection of truths. It certainly seems to me that technology-based projects that invite multiple perspectives have an opportunity to really lay bare this view of history, an opportunity to allow the field to fully embrace multiple perspectives.

Do you see it that way?

Matthew Fisher: Definitely. Historians and curators of all kinds make choices everyday about how they tell stories—what to leave in, what to take out, and beyond that. There is so much speculation and educated guesswork that often goes into filling in the blanks—it's detective work.

Those who are involved in historical practice understand this, but it's difficult even for dedicated experts to always keep in mind that their unique perspective comes

into play in their interpretation, no matter how objective they might be trying to be.

I don't think that most people recognize the extent of the interpretation that public history practitioners engage in on a regular basis. The public often has this simplified sense that the facts are known and exist to be told, end of story.

By sharing our experiences and perspectives as historians and educators, we can broaden the public's perspective, and we can reveal to them, even invite them, to join us in this wonderful detective work that we're doing. I think that technology lowers the barrier for entry. And there is a profound potential to pull back the curtain on this process. The very same facts, or objects, or documents, interpreted through a variety of lenses, take on greater meaning and deeper significance.

And what is interesting and easy to forget when your job is to interpret history—the world—to the public on a regular basis, is that audiences don't typically expect to do that sort of interpretation themselves. Most of them are not interpreting history and objects routinely in their daily lives. So when we invite them to engage in that interpretive process with us, then we're opening a door for them, behind which are enormous possibilities. In my experience it's a responsibility that many visitors, when they choose to accept it, don't take lightly.

History provides us with endless wealth of vestiges from which we can craft multiple narratives and derive many truths. New technology provides us with an infrastructure within which we can safely and collectively investigate and debate these many narratives. And anyone can be invited to the party. In my mind, this is wholly freeing, hopeful, and tremendously exciting.

55

Get Real! The Role of Objects in the Digital Age

Matthew MacArthur

These days, the chances of encountering any given museum object online are much greater than seeing it in person. The advantages of digital collections—findable, searchable, replicable, manipulable—have by now been well documented. The sheer volume of collection information available digitally is staggering when compared to the number of objects that could realistically be accessed in person. Not only that, users now have an ever-increasing number of ways to tag, share, annotate, rearrange, and recontextualize these digital collections. Artifacts that would otherwise be hidden away in storage are reclaimed and rejuvenated by gaining a second life as digital objects. New technologies also make it easier for the community in whose trust the objects are held to help define their meaning and significance—or at least participate in a conversation about them.

For the time being, the process of collecting, preserving, and exhibiting physical objects continues. The cost of doing so becomes ever more dear as collections accumulate and age. Choices must be made about what to keep, what to display, and where to put limited conservation resources. Even in the digital realm where space is less of an issue, resource decisions must be made about what to photograph, research, describe, and publish. By and large, these decisions are still in the hands of a relatively small number of curators and administrators. Now that physical and digital collections have coexisted for a number of years, it seems appropriate to ask: What have emerged as the peculiar strengths of each format? What effects are digitization and the participatory Web having on the care, study, interpretation, and display of physical objects? And what have we learned that can inform our efforts to appropriately balance these activities moving forward?

To help frame a response, we might look to George Brown Goode, director of the United States National Museum (then the collections arm of the Smithsonian Institution) in the late 19th century and one of America's preeminent museum administrators. Goode's career coincided with another transformational time for museums as they moved away from being exclusive semiprivate enclaves enjoyed mostly by scholars or the wealthy, and

toward a model of wider civic education and engagement. In this context, Goode pioneered new forms of accessible exhibits first at the famed 1876 Centennial Exhibition in Philadelphia, and later at a new purpose-built museum facility (now the Arts and Industries Building) next to the Smithsonian Castle. In his writings, Goode proposed that museums serve three particularly valuable functions as repositories of reference material, places of public education, and preservers of collective memory. As these functions seem relevant to an examination of the role of museum objects today, let us examine each in turn.

George Brown Goode, c. 1880s. Courtesy of Smithsonian Institution.

OBJECTS AS REFERENCE COLLECTIONS

The first (and original) function of the museum is as a place of research, complete with reference collections. Goode stated: "In every properly conducted museum ... provision should be made not only for the exhibition of objects in glass cases, but for the preservation of large collections not available for exhibition, to be used for the studies of a very limited number of specialists."[1] These collections, rarely seen by the general public, form what historian Steven Conn has called an "alternative" or "parallel museum universe." He further notes, "We know very little about that world not on display, at least not as much as we know about the famous collections that are.... These museum basements may represent for museum scholars a vast undiscovered country."[2]

For this reason, it seems that these rarely seen objects have the most to gain from being exposed in digital form. Scholars and other interested parties can learn a great deal simply from browsing online collections for items of interest, cataloguing and comparing similar objects from multiple institutions, and examining digital photographs. Without the online access, it would be nearly impossible to discover the location of these objects, let alone travel to see them all in person. Even well-known artifacts can be hard to access due to their value, fragility, storage conditions, or other factors.

Digital exploration can enhance the study of objects in other ways as well. Curator Nancy Davis of the National Museum of American History describes how she is able to gain new insights by manipulating digital images and zooming in to narrow her focus on particular features of an artifact. But relying on digital imagery can also have its down side. Davis relays a cautionary tale about a colleague who wrote a paper on a particular painting. Using a digital

facsimile as his source, he turned out to be mistaken about its actual size by several orders of magnitude. The error undermined his entire argument.[3]

Few people if any are suggesting that digital surrogates can replace physical artifacts entirely. However—mirroring a conversation in the library world—some are questioning the wisdom of unnecessary duplication across institutions when access to good digital records will suffice for most purposes. Some of this concern is about maximizing cost efficiency, while others argue that museums should become more selective in what they collect for environmental reasons. Because storing and preserving objects in climate-controlled conditions requires a great deal of energy and other natural resources, museums might consider shifting some of their preservation focus from the physical to the digital.[4] However, this reliance on technology only partially solves the problem, as anyone who manages digital data will tell you. Even fragile objects may have a longer shelf life if left undisturbed than today's digital storage media and file formats, and storing data has significant resource requirements as well. Like physical collections, digital assets require professional care and adequate institutional commitment to ensure their long-term preservation.

OBJECTS AS LEARNING RESOURCES

The second main function of the museum described by Goode is as a place of democratic education, "adapted to the needs of the mechanic, the factory operator, the day laborer, the salesman, and the clerk, as much as to those of the professional man and the man of leisure."[5] Goode's attitude toward education (despite its outdated gender-bias) is worth further examination as it has some fascinating parallels to modern-day approaches to digital collections.

For Goode, museum education meant the systematic display of lots of objects and good labels: "[Museum] specimens must be prepared in the most careful and artistic manner, and arranged attractively in well-designed cases and behind the clearest of glass. Each object must bear a label, giving its name and history so fully that all the probable questions of the visitor are answered in advance."[6] Thus displayed, museum collections "cultivate the powers of observation, and the casual visitor even makes discoveries for himself, and, under the guidance of the labels, forms his own impression"; further, objects are a "powerful stimulant to intellectual activity."[7]

Goode considered his carefully-constructed arrays of objects as catalysts to individualized meaning-making. In some ways, this impulse is echoed in contemporary discussions around the presentation of online collection databases. As the amount of available raw collection data has increased, technologists inside and outside museums have been working to design information structures, interfaces, and tools that help users personalize their interactions with, and extract meaning from, sets of descriptive data. Taken to its limit, this impulse has led a growing number of museums to simply publish a version of their entire collection dataset in a downloadable format that allows users

59

themselves to design a customized interface or mash it up with other kinds of data in various ways.

Like Goode, proponents of this type of self-directed exploration assume that a significant portion of the "meaning" generated from experiencing an aggregation of museum objects, or even a single object, stems from the user's own intentions and behavior and not the museum's. This is even more true with digital data when technology can help users to more easily search and sort objects in myriad ways, discover related items of interest, apply customized descriptive terms, or repurpose museum content in other contexts. Such activities may be what these authors had in mind when discussing the online presentation of natural history specimens: "New generation Web sites provide a retrieval mechanism that is sophisticated enough to take the data in natural sciences collections and add meaning through automation…. Interfaces that permit users to frame their own questions and interpret the answers using their own frames of reference are likely to encourage the users to stay longer and are also likely to attract a wider variety of users."[8]

What do users make of such opportunities when offered to them? The results are decidedly mixed. For example, Sydney's Powerhouse Museum has been a leader in making collection data available and designing "user-centred navigation and exploration tools" that facilitate serendipitous investigation. They have moved in this direction in conscious opposition to more static and

labor-intensive "exhibitions and 'expert-led' storytelling through narrative arrangement of objects" or even "small 'curated' sets of objects deemed to be of interest to the public."[9] While their collection interface has received a good deal of both traffic and attention, the Powerhouse has reported disappointment that some of the more advanced features have not received as much use as they anticipated, particularly for education purposes. Rather, teachers and students continue to gravitate toward selected objects that have particular relevance to the school curriculum as well as traditional, narrative microsites.[10] Whether this is owing to lack of awareness and knowhow among educators and others, or simply lack of interest, is something that even the Powerhouse admits is still an open question.

Another active area of experimentation is the development of tools that let users build, annotate, and/or share personalized "galleries" of digital artifacts. Sometimes these tools are meant to be an online-only experience, or they may be combined with mechanisms that let users "bookmark" items on display before or during a visit to the museum. Research shows that a relatively small number of people make use of the ability to create their own galleries, and when they do, an even smaller number ever return to them. A few examples that have been designed for very specific uses, such as facilitated classroom activities, have been somewhat more successful.[11]

These experiments can be seen as part of a larger debate about what specific role museums and their content experts should play in mediating or directing the individualized discovery process described by Goode. He himself identifies one key role: to anticipate and answer questions. "What is it?" "When and where and by whom was it used?" "Is it the real thing?" "How do you know?" (And of course, "Can you tell me if the one I have is real and how much it is worth?") Staff inside museums may not be the only, or even necessarily the best ones to answer these questions for a given object. In that sense the Internet has great potential to facilitate the exchange of information with others who possess deep knowledge in specialized areas. Other types of knowledge are contributed by people who may not be subject-matter experts but who can provide additional historical, cultural, or aesthetic perspective.

Managing this type of collaborative knowledge-sharing, and the increase in public inquiries that typically attends an increase in published collections information, is a huge challenge for curatorial staff who are already stretched thin.[12] However, given that the Internet is changing the way that knowledge is constructed and exchanged in nearly every discipline, museums must take this responsibility seriously or risk a loss of relevance and diminished presence in the larger marketplace of ideas. For now, the most sought-after type of interactivity in the learning process still seems to be real communication by and with those who know the collections best—not only curators, but artists, creators, collectors, and users of objects. Any effort to directly or indirectly facilitate such communication, and do so openly so anyone can benefit from the exchange, will enhance museum learning experiences.[13]

Another role of curators is to make selections: what to display, what to juxtapose, what bits of context to provide. Curator Nancy Davis feels that the ability to make these kinds of selections in interesting ways and add new perspectives that others might not have thought of is a useful role for curators, and one that is often appreciated, while allowing that hers is not the only perspective that matters.[14] As long as there have been museums, viewers of objects have constructed their own meanings around them, as Goode recognized. The difference today is that (whether sanctioned by museums or not) the participatory Web gives visitors the opportunity to "publish" their perspective alongside that of museums in unprecedented ways.

Paradoxically, a crowded information space may even enhance the value of interpretive content from museums, rather than diminish it. In one informal survey at the National Museum of American History, 72 percent of participants said that the role of museums as trusted sources of online information would become more important in the digital age. Only about 9 percent thought it would become less important, with the remainder saying it would remain about the same. Even so, to succeed in this new information environment, it is imperative that museums ensure that their content can be easily found, accessed, and used, as well as actively reach out to others with like interests.

And what of the objects themselves? Conn puts forward an argument that over the 20th century, as museums increasingly focused on their educational role, "the place of objects in museums has shrunk as people have lost faith in the ability of objects alone to tell stories and convey knowledge."[15] Whereas "museums of the late nineteenth century used a strategy of visual abundance to underscore whatever story they set out to tell," in today's exhibits "serendipity has been replaced with carefully chosen curation."[16]

Among advocates for digital access to collections and user participation, there is a sense that these things can in some way combat the hegemonic control over interpretation by museum experts and re-introduce some of the serendipity, material profusion, and self-discovery that characterized previous eras. In our experience at the Smithsonian, users themselves seem to express an interest in both self-directed access to raw information (especially combined with the ability to ask questions) and the more passive enjoyment of mediated experiences. In other words, just as some visitors to the physical museum want to take the tour and some just want to grab the map and bounce around on their own, traffic analysis and other forms of evaluation show that online visitors follow similarly divergent use patterns.

The mass of online museum data that is becoming available certainly has the potential to increase knowledge in important ways. However, there is more to learning than simply accessing information. A different type of learning or meaning-making happens in the presence of actual objects. Audience researchers Susie Wilkening and James Chung have shown that this is true even at a very young age. When they interviewed adult museum buffs (whom they refer to as "museum advocates"), most could recall a seminal museum

61

experience from childhood—seven being a typical age—that was highly evocative and helped cement a lifelong love of museums. These "sticky" experiences typically occurred not in highly interactive hands-on environments, which we often assume are most appropriate for children, but in "'old-fashioned,' static, object-based exhibits that created internal narrative and internal activity."[17] Theirs is not the only data showing that, even in this technology-obsessed age, museum visitors still gravitate toward the basic elements that Goode was advocating more than a hundred years ago: a variety of compelling objects supported by well-written labels.[18]

OBJECTS AS COLLECTIVE MEMORY

That leads us to Goode's third function of museums: to serve as witnesses to the past whose objects provide "permanent landmarks of the progress of the world."[19] When he penned those words, it was in the context of grappling with a category of museum collection that was relatively new in the late 19th century but growing fast, that of cultural and ethnographic artifacts. Goode and others were attempting to use such artifacts to systematically organize and describe human culture and technology, as had been done in other scientific disciplines. But the Smithsonian, having been designated as the official custodian of the U.S. government collections, was also home to a growing assortment of miscellany termed "Historical Relics"—everyday objects having an association with both famous figures like George Washington and, increasingly, common folk.

In 1884 Goode was quoted by the *New York Times* as saying that it was the role of the museum collection to "enter into every detail of human life, not only of the present but of the past, and … to be the custodian of the future. It will show our great-great-grandchildren how their forefathers dressed, how they lived, cooked, and ate their food, how they amused themselves."[20] This was quite a departure from the origin of the U.S. National Museum as a repository of specimens from exploratory and scientific expeditions. After Goode's time, the types of "landmark" objects deemed worthy to collect by the Smithsonian, and other museums, continued to expand to include everything from costume to decorative arts to machinery of all kinds, to cite just a few examples. Certain objects, such as the Star-Spangled Banner, the first ladies' gowns, or the Wright flyer, would acquire a special significance, described by sociologist Sherry Turkle as being "marker[s] of relationship and emotional connection," in the collective psyche.[21]

There is a pair of black slip-on shoes in the collection of the National Museum of American History that nicely illustrates the ability of some objects to be at once both ordinary and extraordinary. Taken at face value, the shoes provide a mildly interesting record of early 21st-century office fashion. When you find out that the owner of the shoes carried them down twenty-five flights of stairs as she fled the south tower of the World Trade Center on September 11, 2001, they take on a whole new significance.[22]

62

Shoes worn by World Trade Center evacuee Maria Benavente on September 11, 2001. Courtesy of Smithsonian Institution.

Just as most of us treasure objects of personal significance to our own lives, so we value museums for preserving objects of collective importance. Here is where digital surrogates seem to have the least potential to replace or reproduce the sense of wonder, emotional connection, nostalgia, or witness to history that we feel in the presence of an evocative object—whether a rock from the Moon, a thought-provoking work of art, or the hat that Abraham Lincoln wore the night he was shot—as well as object-rich settings that transport us to another time and place. Many have described such objects as having an "aura" that is almost completely flattened and lost in translation when viewed on a computer screen. So far, their availability in digital form has only seemed to whet the appetite of visitors who want to experience such artifacts firsthand.

Technology can come into play when visitors share their in-person experiences with others by posting online photos, blogging or tweeting about their visit, and similar activities. For museums, this is a wholly new form of unsolicited feedback that can reveal much about our visitors and their impressions, if we take time to listen. At the National Museum of American History we actively engage these visitors where appropriate by answering questions, responding to suggestions, or just thanking them for their interest. Sometimes this interaction takes place on the museum's own digital turf, but often it's happening out on other sites. While it's impossible to give every visitor this level of attention, such efforts cumulatively generate goodwill by demonstrating a willingness to listen and value external input.

Simple interactions can satisfy the desire that many visitors have to just socialize and express their thoughts about objects or experiences that they

find significant. Some museums are going further by using technology to include visitors in conversations about what to collect or exhibit. These decision-making processes, which can be complex and a bit messy, have not typically been conducted in public view. However, today's Internet offers a variety of useful ways to either cast a very wide net if that is useful for soliciting input, or target very specific communities of interest—or both. For example, at the National Museum of American History, one curatorial team used the museum blog to hunt for specific regional artifacts and stories for an upcoming exhibit on Chinese restaurants.[23]

The Liberty Science Center has employed an even more ambitious strategy for their upcoming *Cooking* exhibition. Using the Ning social networking platform, they have established a site to share information, collaboratively generate ideas, test concepts, and, in their words, "open source, as much as we can, the exhibition design and development process."[24] The long-term effects of such experiments are not yet known, but they show how digital interaction and collaboration might enhance the process of collecting culturally significant artifacts and even designing—or at least complementing—experiences which are intended to be, in the end, highly visceral and personal.

PHYSICAL AND DIGITAL OBJECTS AS EQUAL PARTNERS

By all accounts, museums have entered a fruitful phase of experimentation as we learn how to use online and mobile technologies and social applications to enhance both the visitor experience and professional practices around the collection, study, and interpretation of objects. This is important to do, since the line that divides the physical and online worlds, particularly for younger audiences, is increasingly blurred. So too should the care and presentation of physical and digital collections in museums be seen as interwoven strands of a single strategy, rather than competing priorities carried out independently of each other.

An excellent example of this kind of unified strategy occurred at the National Museum of American History for the first anniversary of the September 11, 2001, terrorist attacks. The museum had acquired a significant collection of September 11 artifacts, which were to be displayed in an exhibit and shared online. The unique nature of the project—the events had hardly passed into history at that point—required that the museum rethink the usual approaches. In the end, the various project elements played to the strengths of each medium. The physical exhibition was relatively spare and focused on the inherent power of the objects (like the shoes mentioned above) and the stories behind them. Knowing that the emotionally charged nature of the physical experience could not be translated online, the team instead used the website to provide more descriptive information about the full collection in a searchable database. Throughout, the project took an inclusive stance that everyone was a witness to history that day. Both onsite and online, visitors had the opportunity to post their thoughts and experiences (and the more than

20,000 handwritten cards collected in the museum were digitized and made available online). On the website, curators shared their own stories about the experience of acquiring artifacts in the aftermath of the disaster.

The fresh, holistic, inclusive approach taken by the September 11 project is one that should be applied to every museum project, and indeed to every museum's core institutional strategy. Too often we have worried about whether onsite and online experiences are competing for the hearts and attention of our audiences. Judging from recent experience and considering the variety of roles that museums play, as I have attempted to do here, clearly there is a proper place for both. On the one hand, despite the giddy enthusiasm that we rightly feel over the possibilities opening up for digitally based interaction and knowledge creation, we continue to value, in the words of Steven Conn, "the simple pleasure of looking at and the thrill of being in the presence of real things, made by human hands through time and across space or fashioned by nature in all its astounding variety."[25] On the other hand, we recognize the power of digital technology to broaden access and facilitate connections in ways that both quantitatively and qualitatively increase the value of museums and their collections.

All that being said, we must also acknowledge that these newer forms of digital outreach compete in a very real way for a finite pool of resources, primarily money and staff time, with other, more established institutional priorities. While it may be possible to find additional resources, the more likely scenario is that museums must reallocate resources in ways that recognize the strengths of both mediums—deciding, in effect, what they will not do in physical space so that something worthwhile may be accomplished online, or vice versa. Avoiding these hard choices by simply giving staff more work, which is too often the approach, is not a long-term solution and typically leads to mediocre results as well as counterproductive bad feelings.

While making substantive changes to entrenched practices can be painful in the short run, it may be necessary if museums wish to retain their cultural influence in a changing world over the long run. The good news is that museums, unlike some other casualties of the information superhighway, still appear to earn high marks as trusted sources of information, focal points for cultural exchange, and venues for meaningful, authentic experiences. Let us view the digital revolution not as the death knell for the museum as we know it but as an opportunity to enhance the relevance of our collections in the lives of the public that we serve.

1 George Brown Goode, "The Museums of the Future," in *A Memorial of George Brown Goode Together with a Selection of His Papers* (Washington, D.C.: Government Printing Office, 1901), 255.

2 Steven Conn, *Do Museums Still Need Objects?* (Philadelphia: University of Pennsylvania Press, 2010), 23.

3 Interview with the author, May 2010.

4 See Elizabeth Wylie and Sarah S. Brophy, "Saving Collections and the Planet," *Museum*, November/December 2009, 52–59.

5 Goode, "The Museums of the Future," 248.

6 Goode, "The Museums of the Future," 248.

7 George Brown Goode, "Museum-History and Museums of History," in *A Memorial of George Brown Goode Together with a Selection of His Papers*, 75.

8 Elycia Wallis, Basil Dewhurst, and Alan Brooks, "Deriving Meaning from Specimens: Making Zoological Data Available on the Web," in *Museums and the Web 2005: Proceedings*, ed. J. Trant and D. Bearman (Toronto: Archives & Museum Informatics, 2005), http://www.archimuse.com/mw2005/papers/wallis/wallis.html (accessed May 19, 2010).

9 Sebastian Chan, "Tagging and Searching—Serendipity and Museum Collection Databases," in *Museums and the Web 2007: Proceedings*, ed. J. Trant and D. Bearman (Toronto: Archives & Museum Informatics, 2007), http://www.archimuse.com/mw2007/papers/chan/chan.html (accessed May 19, 2010).

10 Sebastian Chan, "Spreadable Collections: Measuring the Usefulness of Collection Data," in *Museums and the Web 2010: Selected Papers from an International Conference*, ed. J. Trant and D. Bearman (Toronto: Archives & Museum Informatics, 2010), 189 (also available at http://www.archimuse.com/mw2010/papers/chan/chan.html).

11 Paul F. Marty, "My Lost Museum: User Expectations and Motivations for Creating Personal Digital Collections on Museum Websites," working paper (electronic copy), School of Library and Information Studies, College of Communication and Information, Florida State University, 2010.

12 See Chan, "Tagging and Searching," for a case study.

13 For specific ideas on stimulating inter-actions with online visitors, see Dana Allen-Greil and Matthew MacArthur, "Small Towns and Big Cities: How Museums Foster Community On-line," in *Museums and the Web 2010*, 219 (also available at http://www.archimuse.com/mw2010/papers/allen-greil/allen-greil.html).

14 Interview with the author, May 2010.

15 Conn, *Do Museums Still Need Objects?*, 7.

16 Conn, *Do Museums Still Need Objects?*, 23.

17 Susie Wilkening and James Chung, *Life Stages of the Museum Visitor* (Washington, DC: American Association of Museums, 2009), 43–44.

18 For another case study, see Peter Samis and Stephanie Pau, "After the Heroism, Collaboration: Organizational Learning and the Mobile Space," in *Museums and the Web 2009: Proceedings*, ed. J. Trant and D. Bearman (Toronto: Archives & Museum Informatics, 2009), http://www.archimuse.com/mw2009/papers/samis/samis.html (accessed August 12, 2010).

19 James Conaway, *The Smithsonian: 150 Years of Adventure, Discovery, and Wonder* (New York: Knopf, Smithsonian Books, 1995), 129.

20 Sally Gregory Kohlstedt, "History in a Natural History Museum: George Brown Goode and the Smithsonian Institution." *The Public Historian* 10, no. 2 (1988): 14.

21 Sherry Turkle, "Introduction: The Things that Matter," in *Evocative Objects: Things We Think With*, ed. Sherry Turkle (Cambridge, MA.: MIT Press, 2007), 5.

22 See http://americanhistory.si.edu/sep-

tember11/collection/record.asp?ID=46
(accessed August 12, 2010).

23 See http://blog.americanhistory.si.edu/
osaycanyousee/2010/08/chop-suey-san-
francisco.html (accessed May 19, 2010).

24 See http://cookingexhibitchefs.ning.com
(accessed August 12, 2010)

25 Conn, *Do Museums Still Need Objects?*,
57.

Throwing Open the Doors
Communities as Curators

So can anyone be a curator? Public history institutions are wrestling with this question as they feel external and internal pressures to share interpretive authority with audiences of all kinds. Even as digital media collapse geographic distances, museums are deepening their relationships with local communities. This new intimacy between museum staff and their constituents may help to break down perceived audience barriers that museums have struggled with for years—exclusion, intimidation, elitism, and disconnection—but it brings new questions and challenges that museums now must face:

Is the definition of expertise in the museum context being radically transformed? Whose expertise is now valued?

How much content authority can or should be shared in community-shaped programming? Do visitors now expect to see their own cultural productions on the walls and in the collections of their local museums?

What is the role of the museum curator in these new enterprises? Guide? Mentor? Content-provider? Technical assistant? Does the museum educator still "educate"?

Finally, does the desire to respond to local needs change how museums measure success? What do excellence and quality look like within this new paradigm?

Whose Questions, Whose Conversations?

Kathleen Mclean

Why is it that the most interesting and meaningful conversations among museum staff usually take place without the presence of visitors? When dreaming up exhibition and program ideas, framing the questions for research, and articulating future visions for our museums, we explore with colleagues our passionate interests and burning questions. Only rarely, though, does this passion and energy make it into the public arena.

It's not that museum professionals are opposed to interacting with visitors. Museum calendars are filled with receptions to meet the curators, lectures with question-and-answer periods, behind-the-scenes tours, and programs where artists-in-residence talk to the public as they work. And most museums incorporate some form of visitor participation—from comment books to make-and-take activities—into their exhibitions and programs. While these activities may indeed elicit visitor participation, they mostly preserve the usual novice-expert construct: the museum pushes content toward the visitor, and the visitor reacts.

True interaction, by contrast, requires an exchange of some sort, a reciprocity that creates new knowledge and insights. This is where the notion of *conversation*—the most essential of human interactions—can help museums create more meaningful relationships with their visitors. At their best, museums are places of inquiry that nourish the exchange of ideas. From historic house to national treasures house, from art gallery to science center lab and natural history display, museums are places to contemplate, celebrate, and share perspectives on human understanding. It naturally follows that all people have a narrative role to play in the exploration of human experience.

THE PROBLEM WITH EXPERTS

But museums, conceived and perceived as sites of authority, still embody the "information transmission" model of learning that developed in the late 1800s, with museums as the source of expert knowledge and visitors as the recipients of that expertise. Many of the people who work in museums today still see themselves as experts and see their visitors and communities as uninformed

novices in need of guidance. (I recently heard an art museum curator liken his expertise to a medical doctor's and equate visitor-contributed exhibition content to "a gardener operating on one's children.")

Even within the ranks of museum professionals, a novice-expert tension prevails, as certain professionals are designated the creators of knowledge and others are not. While some museums have embraced new exhibition-development processes that challenge outdated hierarchical models of practice, they are in the minority. I still meet people with the word "curator" in their job title who insist that *only they* have the qualifications to frame the issues and develop the ideas in exhibitions. Other museum staff, such as designers and educators, may have as much content expertise as their curator colleagues, but they are still usually not considered knowledge-creators in the expert sense and are rarely given a voice in content decisions.

Given these ongoing struggles over power and expertise among museum professionals, it's not surprising that attending a museum might feel more like a visit to the home of the authorities than the home of the muses. In the midst of writing my first book, struggling with voice and verb, I turned to a writing coach for help. A gifted writer with a doctorate and several books under her belt, she was articulate and devoted to the creative spirit of writing. And she was intimidated by museums. "I don't know the rules. I know there's a code of behavior, but it eludes me."

She encouraged me to write a book for potential museum-goers that could help them navigate and feel more at home in a museum environment and better understand their role in the museum-visitor relationship. That suggestion stayed with me over the years: Why would such a creative and well-educated member of the public feel unschooled in the art of museum going? Why did she feel a need for a user's manual? (And she is not alone—I've encountered dozens of intelligent people with similar concerns.)

BEYOND AUTHORITY

Clearly, museum power structures and the people who work within them reinforce and benefit in some ways from perpetuating a novice-expert polarity. But this dualistic notion of learning just doesn't map onto today's Knowledge Age, with its dynamic flow of information and new forms of meaning-making contributed by people from all places and of all persuasions.

This is not to say that we should abandon our respect for expertise. Quite the contrary. We need to embrace the contributions of expert knowledge and at the same time expand our definitions of "expert" and "expertise" to include broader domains of experience. And we need to consider new roles for visitors as they engage more actively in our programs and exhibitions. Rather than perceiving visitors as novices, we would do well to consider them "scholars" in the best sense of the word—people who engage in study and learning for the love of it.

We also need to separate our own notions about expertise and knowledge-generation from the associated concept of "authority" derived from the ancient

Roman *auctoritas*—meaning the power conferred by authorship or socially recognized knowledge. The assumption that expertise *inherently confers authority and power* makes it almost impossible to support the open invitation to conversation and exploration that is essential to the life of the museum. Successful conversations require reciprocity and a mutual respect among participants, as well as mutual interest and a balance of contributions. This balance is difficult to establish when the authority of the expert is predominant.

Most museum exhibitions and high-profile programs grow out of curator-driven questions. Curators determine the scope of inquiry and parameters of content, and disciplinary boundaries abide: an art museum curator determines content about art, a history curator about history. Often the scope is quite narrow, particularly when curators think of exhibitions as their opportunity to create three-dimensional monographs. At the same time, educators, as visitor experts and "audience advocates," develop interpretive questions that attempt to "hook" people into being interested in curator content. Yet both these practices leave little room for the voices of visitors and community members. I find it curious that educators spend so much time trying to develop engaging questions to help visitors make sense of curatorial content, when visitors bring their own questions to their experiences in museums.

COMMUNITIES OF LEARNERS

Museums, at their core, are learning environments, and much of the work of museum professionals—administrators, curators, educators, and designers alike—is to understand and support the learning process in our visitors *and in ourselves*. We at least need to be aware of current learning theory, which takes us beyond "information transmission" to more sophisticated and nuanced notions of learning. Today, it is generally accepted in the world of learning research that knowledge-generation is complex, is socially situated and learner-centered, and requires interaction, conversation, and reflection.

We need to think of visitors as partners in a generative learning process within a dynamic community of learners. In describing a museum-learning research project at the Exploratorium in San Francisco, educational researchers Josh Gutwill and Sue Allen "imagine an ideal world in which communication is so fluid that each person can bring his or her expertise and curiosity to a global 'ecosystem' of learning, moving among the roles of teacher, participant, and learner as the situation changes."[1] Staff and museum organizations as a whole need to participate in learning *along with* their communities and visitors, and *embrace the possibility of change* as a result of that learning.

It's not as radical as it might sound. Increasingly, museums are employing visitor research and evaluation to better understand how their programs and exhibitions affect their end-users. Often driven initially by funder requirements, these studies are prompting rich exchanges between museums and their constituencies, and some museums are incorporating visitor research into their ongoing organizational work. As research and evaluation give voice

to visitor questions and ideas, these exchanges are having profound effects on museum practice.

BROADENING THE CONVERSATION

The Oakland Museum of California (OMCA), for example, is transforming its presence and practice through a series of initiatives that embrace public conversation and co-creation. With the receipt of a major grant from the James Irvine Foundation's Arts Innovation Fund, the museum developed a program of visitor research, prototyping, and project experimentation designed to inform the 2010 reinstallation of its Gallery of California Art. One of the resulting projects was *Cool Remixed*, a temporary prototype exhibition co-designed in 2009 by local teenagers and education curators.

Entry signage created a dialogue between the two exhibitions *Cool Remixed: Bay Area Urban Art and Culture Now* and *Birth of the Cool: California Art, Design, and Culture at Midcentury* at the Oakland Museum of California. Photo by Michael Temperio. Courtesy of Oakland Museum of California.

Conceived as "a cultural and historical counterpoint"[2] to the Orange County Museum of Art's traveling exhibition *Birth of the Cool: California Art, Design, and Culture at Midcentury*, *Cool Remixed* explored a contemporary definition of "cool" from Oakland teenagers' perspectives. The two exhibitions, installed simultaneously in adjacent galleries, set up an interesting dialogue of call-and-response, with visitors going back and forth between them.

The design of *Cool Remixed* experimented with new installation techniques suggested by the teenagers based on the outcomes of a focus group about the attracting power and accessibility (or the lack thereof) of the former Gallery of California Art. The exhibition, with its brightly colored walls, plenty of lounge spaces, plywood and hand-painted furniture, and "Loud Hours" programmed with music, provided an interesting contrast to the '50s cool sensibilities of *Birth of the Cool*. Before the two exhibitions opened, some museum stake-holders considered *Birth of the Cool* the main attraction, and *Cool Remixed* a "community exhibition" not worth serious marketing attention or funding. But visitor response suggested something quite different. The freshness of the

Lounges designed by local teenagers embodied a contemporary take on the notion of "cool" for the *Cool Remixed* exhibition. Photo by Michael Temperio. Courtesy of Oakland Museum of California.

content and the activated spaces in *Cool Remixed* attracted a broad range of visitors who stayed and engaged in the ongoing programs. Many of the design experiments in *Cool Remixed* ended up being incorporated into the reinstallation of the new Gallery of California Art.

74

Reflecting back on the overall process, I think the vitality of the exhibition grew out of its conversational nature: its origins in talks with teenagers about engaging with works in the art gallery, its position in dialogue with the *Birth of the Cool* exhibition, and its design that encouraged discussions among visitors in the exhibition. Working with education curators, teens joined the curatorial process and developed the questions: What does "cool" mean today? How does it look? What does it sound like and feel like? How can we create an exhibition that brings today's cool to life for everyone?

COMMUNITIES AS EXPERTS

Conversation also shaped the Native Californian section of the new OMCA Gallery of California History. But in this case it was an ongoing dialogue among curators, project staff, and the museum's Native Advisory Council. During review of an early curatorial plan for a "First Peoples" display, one of our Native advisors remarked, "We are *not* the First People. The First People were the rocks and the animals and the trees." Native People were, he told me, the second and third people. I asked the advisors what they called that pre-contact time period, and they replied, "Before the other people came," which is now the name of that section of the gallery.

Rather than structuring the exhibition around the anthropology curator's perspective and subject interest, we reorganized exhibition concepts around what our Native partners thought most important. They determined the focus of content; selected the Native participants; interviewed, videotaped, and edited all the commentary; and participated in selecting and placing the

Native Californians and museum staff worked together to select and install California baskets from the Oakland Museum of California collections. Photo by Terry Carroll. Courtesy of Oakland Museum of California.

objects. Curators responded to and supplemented the Native content, and designers and Native artists shaped the installation. While much of the exhibition content remained similar to the original curator's plan, the emphasis, voice, and aesthetic shifted considerably.

Admittedly, this is not a new idea—the National Museum of the American Indian and other cultural history museums use similar approaches in developing most exhibits and programs about Native People today. But they often end up feeling like fixed presentations, delivering messages very similar from one to the next. The challenge for OMCA going forward will be to find ways to encourage ongoing dialogue among visitors and the Native participants that might, in turn, alter the look and feel and content of the exhibition.

Yet another conversational model shaped the section of the OMCA history gallery that focuses on the period from 1960 to 1975—a truly iconic and intense time in California. Here again, community members played expert roles. Design of the section, called "Forces of Change," also began with curatorial ideas, but the museum's Latino, African American, Asian Pacific, and Teacher Advisory Councils quickly dissuaded us from those intentions: the advisors felt that the conceptual plan did not accurately depict the chaotic and diverse spirit of the times. With their help, we identified twenty-four people from across California who lived through the 1960s and early '70s, and invited them to design and create individual displays that embodied their personal experiences and memories of that time. Participants attended several workshops with the exhibition team to explore potential design ideas and installation constraints, and then worked with staff to create their own displays.

The resulting installation, which includes a light show, music, a staff-compiled "Top 100" list of major events of the period, and a place for visitors to leave their comments and stories, creates a gestalt that more adequately represents the collective memory and history of this period. In exit interviews

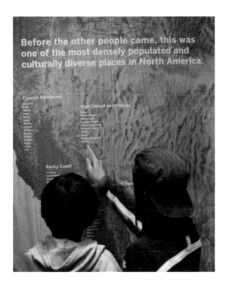

Before the other people came, this was one of the most densely populated and culturally diverse places in North America.

Coastal Rainforest

High Desert and Plateau

Rocky Coast

Previously untold stories of Native Californians inspire visitors in the OMCA History Gallery. Photo by Daniel Kokin. Courtesy of Oakland Museum of California.

soon after opening, some visitors cited the "1960s memory boxes" as their peak gallery experience. Perhaps even more telling were the hundreds of comment cards contributed by visitors during the opening weekend. Visitor stories, questions, and even messages to the creators of the displays covered literally all the empty wall space, extending the "voice of the people" sensibility of those times into the gallery.

FRAMING THE QUESTIONS

While much of the work described above can be characterized as encouraging "visitor-generated content," the fundamental intention goes deeper than that, to the generation of *questions*. All meaningful museum experiences grow out of compelling questions asked: "I wonder who…?" "What happens if…?" "Why is it that…?" Museums need to stretch beyond existing channels of communication and find ways to include visitors more interactively, even in the articulation of core questions. Besides conducting focus groups to ask visitors what they think about our ideas, we should be figuring out how we can bring them to the table as questions are posed and ideas developed.

Conversation isn't any easier for visitors than it is for museum experts—many visitors have difficulty articulating questions at the drop of a hat. Josh Gutwill and Sue Allen spent over five years at the Exploratorium learning how to encourage family groups to participate in active inquiry around science museum exhibits. Although their research focused on interactive exhibits of natural phenomena, their experiments helping visitors to work together to articulate "juicy questions" can help us model what we should be asking ourselves: How can museum programs and exhibits better support visitor-generated inquiry? What skills do visitors need to engage more deeply? How can visitor questions inform museum practice?[3]

In discussing her use of artworks in history displays, Louise Pubols, OMCA chief curator of history, also focuses on questions: "The content of an exhibition depends on who is asking the questions, whether it is a curator, an educator, or a visitor. I brought history questions to the art: Who paid for the art? Where did they hang it? What did they want people to look at and why? Historians may choose an artwork for its impact on society, and to understand what people were thinking about at the time. These are valid questions, and potentially interesting for visitors as well."[4]

Arguably the most dynamic conversations and exhibitions take place around the edges, in the margins, in the overlap of disciplines, and in the

From stories about the Black Panther Party Food Program to depictions of hootenannies and hippies, personal voices came alive in the "Forces of Change" community displays. Photo by Dirk Dieter, Dieter Design.

framing of questions in surprising new ways. Extending that idea even further, Pubols suggests that intriguing questions can come from anywhere. "Take for example, an exhibition about salmon. A scientist might ask, 'What is the role of salmon in the health of a riparian community?' A philosopher might ask, 'What is the proper relationship between humans and salmon?' A historian might ask, 'What was the role of salmon in establishing the cannery industry?' An artist might ask, 'How does the salmon symbolize California wilderness?' And a visitor might ask, 'How can we protect salmon for future generations?'"[5] All of these questions suggest different conceptual frameworks that could form the basis of different exhibitions and require different methods of inquiry.

LEARNING TO LISTEN

I am not suggesting that museums *replace* curator expertise with public chat. Twitter, Facebook, and other social media take care of those exchanges quite nicely. At the same time that visitors expect to engage more actively in their museum experiences, they also expect and want to hear from museum experts. Visitors want to know what the experts think, why experts value some ideas or objects over others, and how that expertise can help them make meaning and find significance in the world around them (or at least at the museum). But visitors are just not interested in *monologues*. This means that museum experts need to learn how to *listen* and *respond*, share the inquiry process, and change perspectives as new ideas emerge.

Engaging in conversation is an acquired skill, an art form that requires practice and experimentation and a willingness to fail, or at least to stumble around a bit. When the new OMCA galleries opened, I wasn't prepared for the responses of some of my colleagues, who thought the Native Californian display was

On 3" x 5" cards attached to the walls with masking tape, hundreds of visitors comment on the "Forces of Change" community displays. Photo by Terry Carroll. Courtesy of Oakland Museum of California.

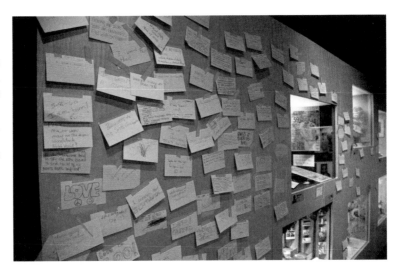

uncomfortably dissimilar from the rest of the gallery. And not all visitors appreciated the community approach employed in the "Forces of Change" display:

78

> "Wow! I am extremely disappointed! Instead of an honoring of... political and cultural upheavals, I found a cheeky little collection of panoramas of 'my summer vacation' in the 60's by mostly non-political, non-Bay Area folks. Yes there was something interesting about the zeitgeist captured there ... but it felt completely void of our amazing collective historic struggle!"[6]

Because these installations are designed as prototypes, we actually have the opportunity to adjust and change them in response to visitor comment. For example, we went back to the "Forces of Change" participants and asked them to write a short description of the social and political context of the times from their perspective. Their writings, now included in the gallery, have added a depth of content and a palpable sense of personal witness that was missing from the original installation.

TOWARD RECIPROCITY

Let's face it. We live in a world interconnected in ways unimaginable just a few short years ago. On the radio in the morning I can listen to a song that's creating a sensation in Nairobi nightclubs, contact the Congolese musicians and their fans by noon, and engage them in a lively discussion with museum visitors in San Francisco that evening. As people around the world "log on" and weave together increasingly interconnected patterns of knowledge, they expect museums to be players.

And people expect to be able to take more active roles in shaping their own learning activities, from co-designing the programs they attend to asking their

own questions and contributing their own expertise and opinions. The issue isn't *whether* we should provide opportunities for people to choreograph their experiences in museums; it's how we embrace these opportunities *ourselves*. If we don't take people's expectations seriously, they will simply "vote with their feet" and go elsewhere.

We need to find ways to bring the museum's expert knowledge *into conversation* with the people who attend our museums—people who bring with them their own expert knowledge. And this means letting go of the notion that we, museum professionals, are a class apart from our visitors. And we need to find new ways to create narratives in common, narratives that will change over time as the world around us changes. As the news each day reminds us, these are not always easy or comfortable conversations. But they will breathe new life into our museums.

1 Joshua P. Gutwill and Sue Allen, *Group Inquiry at Science Museum Exhibits: Getting Visitors to Ask Juicy Questions* (San Francisco: Exploratorium; Walnut Creek, CA: Left Coast Press, 2010), 3.

2 Evelyn Orantes, "Listening to Teens," in *How We Visitors Changed Our Museum: Transforming the Gallery of California Art*, ed. Kathleen McLean and Barbara Henry (Oakland: Oakland Museum of California, in press).

3 Gutwill and Allen, *Group Inquiry at Science Museum Exhibits.*

4 Conversation with author, December 2009.

5 Ibid.

6 Letter to the history curators at the Oakland Museum of California, May 28, 2010.

The "Dialogic Museum" Revisited: A Collaborative Reflection

John Kuo Wei Tchen and Liz Ševčenko

In May 2010, Jack Tchen and Liz Ševčenko sat down over soup noodles to reflect on their early experiences and subsequent struggles with the idea of "dialogue-driven" practices, and its implications for museums. This collaborative essay began with that conversation's transcript and then layered subsequent thoughts and edits.

Jack (John Kuo Wei) Tchen is a historian, curator, and dumpster diver. In 1980 he co-founded the New York Chinatown History Project, now called the Museum of Chinese in America. He co-curated the museum's new core exhibition in its new space that opened in 2009. He is the founding director of the Asian/Pacific/American Studies Program and Institute at New York University.

Liz Ševčenko is founding director of the International Coalition of Sites of Conscience, a network of historic sites that foster public dialogue on human rights and social justice issues, and inspire visitors to address their contemporary legacies. Before launching the Coalition, she spent over ten years developing dialogic public history projects in New York City and around the country.

How did you come to your original idea of "dialogue"?

Jack: In 1989 I wrote "Towards a Dialogic Museum" reflecting on nine years of work with the New York Chinatown History Project (NYCHP), now the Museum of Chinese in America (MoCA). It marks a certain moment with all the possibilities of that moment.

We were a part of the emergence of the "new social history" movement, which pioneered a variety of ways to document the story

Mr. Lee, a retired laundry worker, explains how this heavy coal-heated iron was used to press shirts, 1997. Such dialogues with New York's Chinatown History Project staff were how the experiences of Chinese hand laundries, once ubiquitous and now largely gone, were documented. Museum of Chinese in America Archives.

81

of people who had not been part of dominant historical narratives.

The Chinatown History Project related to how history, politics, and citizenship/power emerged in New York. In New York City we have the New-York Historical Society or the Museum of the City of New York—they both represent a historical formation of white Anglo American institutional power that emerged in the 19th century. But what was/is not collected? What is not exhibited? What dialogues are not going on? And therefore, in that absence, why must different collections begin to emerge in that breach?

Another reason for the formation of the NYCHP was a disconnect between new immigrants from Hong Kong and Canton and the older rural Cantonese

The Lower East Side Tenement Museum re-creates the apartments of former immigrant residents of 97 Orchard Street, such as the Levine family, who ran a dressmaking shop out of their home in the 1890s. Photo by Battman Studios.

immigrants who had been through the era of the Chinese Exclusion Act (1882–1968) and survived it. When new immigrants arrived, they did not know about the Exclusion Laws. They were not familiar with the anti-Chinese/anti–East Asian racism of the U.S. So part of the NYCHP's goal was to create that bridge to communicate back and forth within the Chinese New York community. It wasn't a project that was meant to be just going out to the larger public.

For me, to be dialogue-driven is a work process where documentation, meaning, and re-presentation are acknowledged to be co-developed with those whom the history is of, for, and about. Conventionally, curators are trained to become experts of a collection already deemed valuable to a historical enterprise or university. When we wanted to explore the formation of New York Chinatown in the 19th

century, we realized it was founded by the thousands of small hand laundries scattered in the New York metropolitan region. There was not documentation about this low-status, racially excluded community. There were not collections. There were no academics studying this experience, except for one. There were no Chinese American historical groups. This was a subaltern history best understood by those who lived the experience and came from it.

As young, college-educated smart alecks, we quickly became humbled. To be dialogue-driven was to admit what was actually going on and to demystify the knowledge formation process. Mike Frisch's theory of "shared authority" is critical to this working process. Issues of power are always at stake. And fundamentally, the understanding of the significance of a past time/place from the van-

Following their tours of re-created immigrant apartments, the Lower East Side Tenement Museum hosts public dialogues on pressing contemporary immigration issues. Photo by Greg Scaffidi.

tage of the present moment, what Mikhail Bakhtin called chronotopes, are always at stake.

That one scholar—who did a brilliant ethnography of Chicago area hand laundries—was Paul Chan Pang Siu, a University of Chicago sociology Ph.D. student who was the son of a laundryman. When he sought to publish his dissertation, the University of Chicago Press turned him down. I'm proud to say that thirty-six years later I was able to get *The Chinese Laundryman: A Study of Social Isolation* published (1988). He passed away just months before the book came out, but Professor Siu was delighted to finally have his study gain the recognition it deserved.

Liz: I read your essay in college, and it was totally mind-blowing and inspirational to me. I was seized by the hidden histories that could emerge in what I understood to be your definition of a dialogic museum: one whose narrative is developed entirely through the diverse stories and perspectives of those who lived it, not as a master narrative written by a historian. This inspired me to try my own small dialogic museum project: a history of Hillhouse High School in New Haven composed only of objects donated by different generations of students, from the 1920s through the present, and the memories they wrote. What interested me most was what happened when they all came together to see the exhibition, and were so surprised to see that others had such different experiences at the same place: like many urban public schools, it had totally transformed from the fifties to the seventies to the nineties. This made me think that community-curated exhibitions provide the opportunity for another type of dialogue: exchange across

difference about the different ways people can experience the same thing, why they did, and why it matters.

But by the time I started working in New York in the mid-nineties, I assumed that uncovering marginalized histories was a basic responsibility of museums—that particular idea of "dialogue" was no longer radical in the field. But many museums began embracing the idea of opening a space for "the community" to tell their stories without raising the questions of power, access, and voice that were so central to NYCHP's approach—questions of who was speaking, who was not, and what we mean by community—were not raised. In some cases, when the "public" were invited to shape the narrative, they could even reinforce existing inequalities. When I started at the Lower East Side Tenement Museum, for instance, many visitors felt honored to have their ancestors' experiences of working-class tenement life validated as American history for the first time in a museum. But many spoke out to distance themselves from new immigrants living in similar conditions. The idea of "dialogue" we pursued drew connections between groups with different experiences. But we also wanted to facilitate discussion on the deeper issues underlying social conflicts. This was harder.

So the museum's president, Ruth Abram, decided to reach out to museums across the world to see if others felt that they had a similar mission. What started as a meeting among nine historic sites from radically different contexts has become, a decade later, an international exchange community collaborating on these issues.

From the beginning, the idea of "dialogue" brought museums in very disparate contexts together. The group decided to call themselves "Sites of Conscience" and to create a deliberate definition of a new kind of museum form. One of the main foundations of Sites of Conscience was this commitment to "stimulate dialogue on pressing social issues."

Over the last ten years, "dialogue" has been the idea that binds us, and at the same time, what's most hotly debated, in a wonderfully productive way. There are at least three different ideas, or layers, of a "dialogic museum" circulating, with different implications for sharing authority.

The first idea of a dialogic museum is one that promotes public discussion of a truth that has been forgotten or deliberately suppressed. This is a particularly critical goal for museums working to expose a truth that the state has denied for decades and make it incontrovertible—for instance that 30,000 Argentineans were disappeared, or that the US government authorized and practiced torture. Here the goal is to get people to recognize and talk about something that's critical for their understanding of their society and their place in it, to make this truth part of an accepted portrait of who we are. In this "dialogue," it's public officials, the media, and perhaps

84

Salvaging the signage of the Mee Heung Chow Main Co. in 1992. Long a Chinatown fixture and supplier to New York–area restaurants, by this time it was one of the few old Chinatown stores and storefronts remaining. Museum of Chinese in America Archives.

educators who are doing the talking, supporting a single story and establishing its credibility, so that they shape the way the nation collectively talks about the past. This is not so much about sharing historical authority, but seizing it—taking it out of corrupt hands and using it for social good.

The second idea of a dialogic museum is based on the kind of community curation pioneered by the NYCHP and theorized in your article. Here it seems "dialogue" is between academic historians and people with lived experience; the established exclusionary narrative and the individual story that challenges it; and between the different perspectives of each individual story. Face-to-face discussions among people with shared experience can also help to unearth new memories, or develop new collective understandings. This is sharing museums' and historians' traditional curatorial authority, tapping into the knowledge and perspectives of

people who have been marginalized. It also shares the authority of a single narrative, embracing multiple perspectives that together create a larger truth.

The third idea builds on both of the first two, but goes a step further, opening the museum as a space for using new truths about the past as the starting point for discussion about their unresolved legacies, and what we should do about them. Here, "dialogue" is more literal, direct face-to-face discussion among visitors—tourists and those with direct experience alike—on questions of shared concern, such as Who is American? and What responsibilities do we have to each other? Questions on which, because of their different past experiences, they may have very different perspectives. Here, sharing authority is about serving as a forum for open discussion of the implications of the past for the present, as opposed to imposing a single conclusion or moral.

Jack: I agree all three ideas are operative. The Chinese Exclusion Laws are not taught as a major issue in U.S. history and are unknown to the great majority of Americans. We've sought to collaborate with the bearers of this knowledge, Chinese Americans subjected to exclusion and racism, as the laws violated their human rights, to document their stories and then accurately contextualize them. And once affirmed, we've fashioned public programs for the larger public. This question of what social histories necessitate all three layers of dialogue is what defines a subaltern experience, in other words, to be legally and culturally non-beings, not just non-citizens, but in the case of Chinese in the U.S. during the Exclusion era defined as "alien ineligible for citizenship" or fundamentally un-American.

In effect, this has been the ongoing challenge of the Museum of Chinese in America—to keep all three dialogues alive with different constituencies. For MoCA that founding, internal Chinese American dialogue is incomplete. The fact of the matter is that post–Exclusion Era Chinese Americans continue to be impacted by perceptions of alienness or racialized otherness. The legacy? After so many years of social, cultural, and political marginalization, New Yorkers finally elected the first Chinese American to represent the Manhattan Chinatown/Lower Manhattan district in 2010—190 years after the first arrival. Can MoCA serve both the historical community defined by the struggle with Exclusion and the post-1968 immigration reform community who have enjoyed a new era of official desegregation?

To add another layer, then, is perhaps the most daunting challenge. The formation of an organization that can juggle these multiple dialogues which also operates in a humble dialogic fashion. The conventional hierarchy of 19th- and 20th-century decision-making, with the curator ruling the collections roost, creating a "permanent" interpreted exhibition, then handing it off to educators to bring in schoolchildren, has long needed upending. In the late 20th and early 21st century, the difficulties of fundraising have forced an additional top-down layer—that of the tyranny of constant fundraising, fundraising boards, and private donors and their explicit and implicit agendas. Can a participatory social history be fostered in this era of flat public-sector support and the growing dependence on benevolent donor wealth? Unfortunately, the wealth of laundry-worker stories—basic human stories, truly—doesn't pay the bills. Yet their wealth, now embodied in MoCA's collections, cannot be simply taken for granted. Both Exclusion-era and post-Exclusion-era stories and dialogues must go on.

What are the tensions around dialogue in museum spaces?
Morality in museums: Dialogue vs. truth-telling

Liz: One major shift in my own personal understanding of dialogue came from the intense debate among Sites of Conscience in different contexts about the relationship between dialogue and truth-telling. I was trained that there was one liberatory way of dealing with the past, and that was to understand it not as an objective reality that one could apprehend with the right sources, but instead as something that's continually constructed and reconstructed.

It was very challenging to me to meet people who were struggling so hard to establish objective facts: that someone had been raped, or that thirty thousand people had been disappeared, or that six million people had been killed—and most importantly, by whom.

These were truths that had been denied vigorously by powerful forces for so long that it was critical for people to absolutely understand them as fact, not as a construction of anything. These were museums based on the primacy of truth. For them, dialogue meant ensuring that people were talking openly about truths that had been silenced. The idea of opening dialogue from or about different perspectives smacked of moral relativism.

For other Sites of Conscience, dialogue meant debating different perspectives on the past. The foundation of their notion of dialogue was an acceptance of the past as something inherently constructed in the present by different individuals and through different individuals' experiences.

Both forms had a goal of developing critical thinking about dominant narratives, but one sought to replace a false narrative with a true one, and the other sought to encourage analysis of how narratives are constructed in the first place. I think both forms are equally important in the US and in international contexts, and create a really productive tension. So far the sites have begun to connect about an idea of dialogue that affirms the forensic truths of the past, while opening debate on the implications of those truths for the present and future.

Jack: In the US, too, we know that histories are contested, but there are certain realities we're hoping to document. How many Native Americans were here before European contact? How many died from disease, wars, and violence? How many enslaved Africans died on the ships, from violence on plantations?

How can we honestly look at all that and accept it all? I mean, we read it in the textbooks, but do we really understand the fullness of these interactions in all their human dimensions? Given that it is not in living memory, how can we own that past and recognize it?

Liz: And then do something with that recognition. I also feel that asserting a truth that's been uncovered or demanding a recognition may not always complete what we're trying to do. The question is, "Why is it so important to recognize what happened, and how can it shape how we go from here?"

87

In 1984 the "Eight Pound Livelihood" exhibit at the State Museum in Albany and the New York Public Library and the press coverage it received helped build the foundations for the Museum of Chinese in America today. It began as a project documenting the history of Chinese laundry operators, who were excluded from other jobs and ran tens of thousands of "Chinese hand laundries" throughout North America. In New York City, these small shops created the need for a commercial district to supply their needs—hence the development of what was later called "Chinatown." Museum of Chinese in America Archives.

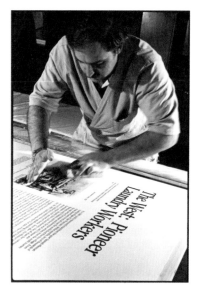

A museum could say it's about encouraging that kind of recognition or making it impossible not to recognize something once you've been through the museum. But the opportunities lie in creating space for people to confront the implications of their recognition in their own way, without instrumentalizing that recognition for some narrow lesson that the museum itself determines. And exploring those implications must be done together with people with other perspectives. That's where dialogue comes in for me.

Jack: But, in fact, these moments of genuine documentation and genuine truth-telling represent a different kind of dialogue than simply: I can say something, and then it's your turn to say something, and then it's your turn. That's how dialogue is oftentimes seen in this culture, right? Everybody has a right to say some-

thing. And everybody's right is the same.

Liz: Right, and that raises a question we're always wrestling with in the Coalition: in our debates, what's up for debate? Should a museum set limits on what people have a right to say? In other words, what is the moral or political role of museums in dialogue?

When we say "dialogue on contemporary issues" a lot of museum folks hear "the museum taking a stand on a contemporary issue," and say they can't conduct dialogues because the museum can't advocate for a particular position. It's disappointing that so few people can imagine that a museum could raise a question on a current issue and have an open dialogue on that question that invites diverse perspectives—when so many museums are doing so very successfully—which is totally different from a museum taking a stand.

But of course if museums are going to raise sensitive questions, they do have an obligation to protect the visitors they invite into dialogue by creating a safe container. Some museums set boundaries to protect forensic truths—to correct people if they make patently false claims—or to protect people against hurtful comments.

Jack: Two quick comments. Did the Nazi exterminations of Jews, Romas ("gypsies"), gays, lesbians, and others happen? Certainly, despite what fringe anti-Semitic Holocaust deniers still maintain. Is anti-Semitism a shifting, constructed racist practice that is a bit

different from place to place, and changes over time? Yes. As historians, scholars, and informed publics we have the responsibility to keep both truths alive. A book, an exhibition, a dialogue are always engagements of a present moment with explorations of various understandings of contested pasts—such productions mark a publicized knot of that present-past exploration. And as the present shifts and we gain more visceral distance, we lose certain opportunities of understanding and we also potentially gain greater perspective. In democratic participatory cultures, better, more rigorous interpretations emerge and ideally become widely accepted as more truthful. Yet, the ongoing challenge reemerges: what happens when certain truths are quickly glossed over and yet their ongoing inequitable consequences live on?

Storytelling and sharing authority in the dialogic museum

Jack: The dialogue-driven museum is not simply a technique, and shared authority is not simply a technique. These practices raise foundational questions of history and also trust. How can we trust what's being written by a historian? What are the sources? Are the sources based in archives that are truly resonant with the lives of people who are victimized by some of these laws or on the other side of power?

I think historians have an important role to play in contextualizing individual stories; in helping to parse out what likely happened, what's the difference between a mythical recounting of an event or a policy and something that is more complex and more accurate. But it's not simply the historians who have the authority here. It's also people who have lived the experience. And what about those communities of people who did not have that power to document and archive their perspectives, to develop historians and institutions that would then represent their point of view?

This is the foundational question of authority and trust: what's the basic stuff that historical explorations and meaning can be made from? And when you have two very different perspectives and two very different parts of the power struggle, how do we, in a dialogic context, sort these questions out? Can there be a trusted public venue? This is particularly challenging online, where anyone can blog about anything. Just like we all need to learn "street smarts," we all need to learn history smarts.

Liz: I feel like the most common way museums have worked to become dialogic and share authority is to create a space for people to come and share your story, to have your experience validated, to give people a place in history. This has amazing transformative potential in the context of something like the NYCHP. But based on my experience at the Tenement Museum, I think it's also important to recognize that creating a space for

89

untold stories does not necessarily challenge existing power structures; in fact, it can reinforce them. Honoring the story of a second-generation Ukrainian who grew up in a tenement and believes Chinese immigrants are un-American may validate working-class struggle but also racism. The conclusions people draw from reading other people's stories or telling their own can be all over the map. It can confirm their worst prejudices; promote tolerance; or have no effect at all. So what's a museum's role here? I think museums have to be very deliberate and reflective about how they are serving as spaces for story exchange, and to what end.

There is definitely the StoryCorps model, which argues that creating an open space for the exchange of stories with absolutely no comment or mediation allows amazing, unpredictable things to happen. But I think museums do have the potential to do more than just validate everyone and everything, and instead to tease out some of the power dimensions or the political questions that people's stories raise. This is absolutely not to take everyone's very nuanced experiences and stick them into some teleological narrative. Rather, it's to respect that complexity by drawing connections and raising questions that help people see something different in the familiar. It's to link stories together in interesting ways, both ones that are totally different from one another and ones that have amazing resonance that the individuals might not have realized. And then,

perhaps most important, just ask the questions of, Why do you think they're different? Why do you think they're the same? Why does it matter?

How has your thinking about "dialogue" and museums evolved? What are the issues you're struggling with now? *Complicating who dialogue is between*

Jack: Since my initial ideas of dialogue in museums, the questions for me now are, What kinds of spaces are we creating? How are we curating spaces for people to have more in-depth reflection and deliberation, instead of creating a binary of one stark position versus another and asking people to choose one? We're talking about a more complex, more internal self-reflection, asking, "Why do I think this way?"

When we think of dialogue between ourselves and others, we should think about how "otherness" is in some ways within ourselves as well. We tend to have surface notions of what kinds of people are like us—whether it's defined by narrow notions of skin color or hair color or whatever it may be—and then who is outside of that. The more interesting question, in this encounter between the self and the other, is: What's really going on? Within oneself? Between our notion of the self and an other? But especially across differences and across cultures?

Liz: I agree! I think the word dialogue, for most people, connotes an exchange between you

as this coherent person and somebody else outside you. But one of the big goals of many Sites of Conscience is to provide a space for each participant to recognize and reflect on their own assumptions. The questions facilitators ask at the sites encourage people to have a dialogue with themselves, to question themselves, as a starting point for having any encounter with others. But it's a constant dialectic: it's about what kind of reflections you can have about yourself when you're confronted with a very different perspective. The facilitator starts by asking each person to share their personal experiences and then reflect on how those experiences shaped the opinions or perspectives they are bringing to the table.

Dialogue in museums: Is it better to feel strange or familiar?

Jack: How do museum spaces play with those tricky boundaries between self and other? Part of the virtue of a museum is that it's a contained space—as opposed to other spaces of encounter, like neighborhoods or schools —in which a certain kind of concentration of focus is enabled.

Liz: Museums can serve as safe places to confront difference. It can be done in a way that cuts off opportunities for real engagement, or in a way that provides possibilities for exchanges that wouldn't otherwise happen. A museum can sort of neatly label all of the kind of "foreign" things people want to learn from, in a contained environment. Or it can be a place where

you would come within your own neighborhood to meet and have discussions with other people that wouldn't take place in some open-ended kind of space, like out in the street. On the one hand, I think our ultimate goal is to make museum spaces an extension of everyday life—places for ongoing engagement with the concerns of everyday life. But our dialogue facilitation trainer always stressed that dialogue is an incredibly unnatural process; and that actually, that's a helpful thing. "Artificial" doesn't have to mean uncomfortable: it can just offer a space for people to explore things in a way they're not able to in other spaces—where they may have circumscribed roles they feel they can't break out of—in order to delve into sensitive questions in deeper ways. But at the same time, if you make dialogue into a totally strange experience, then it will feel alienating to people and no one will want to do it, or no one will open up. So it's a balance between building on the familiar while tapping the possibilities of what's different about museum dialogue.

Jack: Early on at the NYCHP, we seized on the idea that reunions are really great spaces for dialogue. All groups have reunions of different kinds. They are a familiar form of making sense of our experiences. But usually reunions are organized in a very thin way that doesn't allow for the more meaningful explorations you're actually seeking at the reunion—to explore those past–present questions that are always there.

At Constitution Hill in Johannesburg, a former apartheid prison has been preserved as a historic site and museum, developed in collaboration with former prisoners and guards. Photo by Oscar G.

Liz: That's a great example: should museums replicate existing forms of dialogue, or create a totally artificial space that taps into familiar vocabularies of dialogue, but structures it differently, to do the things that the organic forms don't?

In Johannesburg, Constitution Hill—a prison museum trying to open new conversations on justice in South Africa today—calls their dialogues *lekgotla*, a word that recalls Botswana village council deliberations, tapping into a reference to a sort of indigenous form of democracy. When I was still there, the Lower East Side Tenement Museum's dialogues were called "Kitchen Conversations," and were held in a space with mismatched wooden chairs, conjuring images of friendly family exchanges. But both *lekgotla* and Kitchen Conversations try to open more space for equality and exchange than an all-male village council or a hierarchical family table actually have.

Other sites try to break away from existing spaces for exchange altogether, as part of their effort to subvert what they see as a repressive culture or system: the Liberation War Museum in Bangladesh wanted to teach the founding of the Bangladeshi Constitution and its principles of human rights and democratic engagement to students in rural villages. But the culture of learning and exchange in the classroom was so hierarchical that they would bring a bus with a portable exhibition and set it up in the schoolyard, creating a space for more open exchange among students.

One size does not fit all: Adapting different forms of dialogue for different ends

Jack: Part of the question is, how long are museum tours and how much time do you get to spend with visitors? Can enough trust develop over a short amount of time that they can begin by having identified where they or their

own family may fit into a larger story; and also open up to thinking about other people's experiences? Is there a way of bringing them into some kind of sustained dialogue past the one visit, given staffing and other resource constraints?

Liz: I think it's also important for institutions to think about dialogue as a tool that can be used in very different ways for very different ends. There's a whole range of achievable goals from modest yet still very powerful, to more ambitious, that can be sought through the adaptable tool of dialogue. The most successful institution I think is one that integrates dialogue in a whole bunch of different ways and doesn't just have everything be didactic, and then this one little space for dialogue.

For example, traditional interpretive planning for exhibitions is organized around themes, which are usually expressed as a series of factual statements, or learning objectives. The Tenement Museum began developing its interpretive plans around questions—questions rooted in the history being interpreted, but equally urgent today—like Who is American? and How are we responsible to each other?—and organized its tours to raise those questions with visitors, including training educators to pose some of those questions during the tour.

If the principle is to pose questions, to allow visitors space to respond to them and to learn from each other's responses, then this can be achieved in all kinds

of ways. Exhibitions can invite visitors to respond to questions in written posts, talk-back booths, or voting mechanisms. Educators can pose questions during tours. Short exercises can be conducted during school programs (the Tenement Museum, for one, has about twenty minutes to spend with each school group). The museum can provide one-time, hour-long, facilitated, face-to-face dialogues for walk-in visitors. And going deeper, it can also offer a six-month or ongoing series of dialogues for community leaders or people sitting on different sides of a significant divide, to explore their histories and the issues before them and actually forge ways to work together. Each of these different forms will have different goals, different audiences, and different expectations for outcomes. But they all complement each other.

Change over time: Adapting different forms of dialogue for different moments

Jack: I just want to point out the work of Eric Yamamoto, a legal scholar at the University of Hawai`i-Manoa. In *Interracial Justice, Conflict and Reconciliation in Post–Civil Rights America*, he theorizes from efforts people have made to dialogue and communicate across racial divides. He focuses on instances of flashpoints between groups literally at each other's throats.

We tend to think of these flashpoints as exceptional moments; but they embody ongoing simmer-

ing tensions that are happening between these crisis moments. How do we then begin to have dialogues between moments of crises, if we think of crises as not so much some exceptional, rare kind of occurrence but as eruptions of unresolved issues?

Yamamoto talks about four phases: recognition, responsibility, reconstruction, and reparations. Each leads to a deeper stage of trust-building, contributing to a fuller and fuller mutual understanding; but also going from simply strictly recognizing and understanding, empathizing, to actually trying to create concrete ways in which understandings change; real investments begin to happen so change happens.

What's next?

Liz: It's extremely heartening to reflect back on the time since I first read your essay and to see how much these ideas of dialogue, civic engagement, and sharing authority have taken hold. From my experience working with hundreds of museums trying to implement these ideas, it's clear that there's still an urgent need for diverse tools and training on *how*. But I think we also need to keep the conversation alive about *why*. In some cases, I feel like the urge to share authority becomes a little tendentious—"we should engage visitors so that more visitors are more engaged." The moral, ethical, or political dimensions—and potential—of the many very different ways of sharing authority are always there, but are not always confronted or tapped

into. What is the larger social goal we have as museums, and how, on our small scale, can we contribute to it? What are the transformative possibilities of dialogue we seek—what are we trying to make happen? How can a change in museum practice actually contribute to social change in society?

This doesn't require museums to take on changing the world by themselves. Museums can think of themselves in relation to other spaces, institutions, and practices in the wider society. What kinds of exchanges among people in the wider society do we want to reinforce, by replicating them at our museum? What new kinds of exchange do we want to introduce, because they're not taking place in the wider society? In either case, what are the institutions or spaces we can partner or connect with to give what we do more impact?

Another aspect of dialogue that could provide more support to museums, but also increase their impact, is if sharing authority is reimagined as instilling collective responsibility. Sharing authority doesn't need to mean asking museums to do more with less. If a museum is collaborating with a community on developing an exhibition, then there needs to be both a collective ownership of that exhibition and a collective responsibility for maintaining and promoting it. And creating that sense of collective responsibility could be a powerful catalyst for broader social action.

Jack: So what's next? How can we learn from our various efforts, from our various subject positions,

94

and develop more powerful models to reorganize cultural work, human rights, and knowledge production? High-culture Euro American modes of organizing spaces are too constricting. How can we create much more democratic, participatory research, meaning-making, and cultural productions across local, linguistic, and cultural divides? In person and using new media? The issues of growing inequities in the US and internationally continue to haunt globalization and sustainability. These are the urgent questions.

Our dialogic work, whether in museums, educational institutions, online, or wherever honest curation can happen, is now more important than ever. We have to continue our local/global work, bring together folks doing this work to learn from each other, and democratize conventional top-down practices wherever we are.

I am now most excited about using new social media to create heightened dialogues even as we walk the streets of New York City. At the Asian/Pacific/American Institute and with my students, we're experimenting with "augmented reality" uses of smartphones and GPS tablets. The new MoCA space is located nearby, where Robert Moses sought to build the crosstown expressway that would have wiped out all we love about lower Manhattan—Little Italy, Chinatown, the Jewish Lower East Side, Soho, etc. A coalition of community organizations and individuals such as Jane Jacobs successfully fought Moses's grandiose plans for "slum clearance." Today that same neighborhood is confronted with a different kind of displacement—that of urban hipsters and Wall Street brokers seeking to live in what Sharon Zukin refers to as an "authentic" historic inner city. And complicating Chinatown, but also all of Manhattan, is the investment of foreign monies into the NYC real estate market.

The contestation for the rights to the city now and the current moment's relation to past fights is what New Yorkers don't yet have the dialogic spaces and context to understand. Do we need brick-and-mortar history organizations to engage with these issues? Perhaps our smartphone and other new technologies are better suited for these new dialogues to come. I believe this is the future form museums will have to take on—a provocative remix of the real and the digital.

Works Mentioned:

Paul Chan Pang Siu. *The Chinese Laundryman: A Study of Social Isolation*, edited by John Kuo Wei Tchen. New York: New York University Press, 1987.

John Kuo Wei Tchen. "Creating a Dialogic Museum: The Chinatown History Museum Experiment." In *Museums and Communities: The Politics of Public Culture* (papers presented March 21–23, 1990), ed. Ivan Karp, Christine Mullen Kreamer, and Steven D. Lavine, 285–326. Washington, DC: Smithsonian Institution Press, 1992.

Eric K. Yamamoto. *Interracial Justice: Conflict and Reconciliation in Post–Civil Rights America*. New York: New York University Press, 2000.

Reccomendations for Further Reading

Tchen, John Kuo Wei. "Back to Basics: Who Is Researching and Interpreting for Whom?" In special issue on the Practice of American History. *Journal of American History* 81, no. 3 (December 1994): 1004–11.

———. "Constructing Identities, Bridging Dialogues, and the Potential Relevance of Historical Organizations," commentary on John Higham, "The Ethnic Historical Society in Changing Times." *Journal of American Ethnic History* 13, no. 2 (Winter 1994): 45–52.

———. "On Forming Dialogic-Analytic Collaborations: Curating Spaces within/between Universities and Communities." In *Identity Politics Reconsidered*, edited by Michael Hames Garcia and Paula Moya, 193-208. Hampshire, UK: Palgrave MacMillan, 2006.

———. "Homeland Insecurities: Crisis & Fighting for the American Dream." *Foreseeable Futures #5*, Positions Paper, Artists and Scholars in Public Life. Ann Arbor: Imagining America, University of Michigan, 2007.

———. "Off-Kilter: Adventures in Surplus Practice & Surplus Theory," Dewey Lecture, University of Michigan, Ann Arbor, Michigan, September 2007, ginsberg.umich.edu/downloads/Tchen_Dewey_Lecture.doc.

———. "30 Years and Counting: A Context for Building a Shared Cross-Cultural Commons, Community Arts Network," 2007, http://www.communityarts.net/readingroom/archive-files/2007/11/30_years_and_co.php.

Ševčenko, Liz. "Sites of Conscience: Heritage of and for Human Rights." In *Cultures and Globalization: Heritage, Memory, Identity*, edited by Helmut Anheir and Raj Isar, 114–23. London: Sage Publications, 2011.

———. "Dialogue as a Resource for Heritage Management: Stories from Sites of Conscience." In David Myers and Stacie Smith, eds. *Consensus Building, Negotiation, and Conflict Resolution for Heritage Place Management*. Los Angeles: The Getty Conservation Institute, forthcoming.

———. "Sites of Conscience: Lighting Up Dark Tourism." In *Rites of Return: Bodies, Sites and Archives of Attachment*. Edited by Marianne Hirsch and Nancy K. Miller. New York: Columbia University Press, forthcoming.

96

———. "Sites of Conscience: New Approaches to Conflicted Memory." *Museum International*, no. 245–246 (2010): 20–25l.

———. "Sites of Conscience: Reimagining Reparations." *Change Over Time* 1, no. 1 (2011): 6-33

Liz Ševčenko and Maggie Russell-Ciardi. "Sites of Conscience: Opening Historic Sites for Civic Dialogue." *The Public Historian*, 30, no. 1 (February 2008): 9–15.

Works by Other Authors

Abram, Ruth J. "Kitchen Conversations: Democracy in Action at the Lower East Side Tenement Museum." *The Public Historian* 29, no. 1 (Winter 2007): 59–76.

Americans for the Arts, 2008 *The Arts and Civic Engagement Tool Kit: Planning Tools and Resources for Animating Democracy in Your Community*. http://ww2.americansforthearts.org/vango/core/orders/product.aspx?catid=2&prodid=961

Bakhtin, M. M. *The Dialogic Imagination: Four Essays by M. M. Bakhtin*. Translated by Caryl Emerson and Michael Holquist. Austin: University of Texas Press, 1981.

Frisch, Michael. *A Shared Authority: Essays on the Craft and Meaning of Oral and Public History*. Albany: State Universiy of New York Press, 1990.

Gratz, Roberta Brandes. *The Battle for Gotham: New York in the Shadow of Robert Moses and Jane Jacobs*. New York: Nation Books, 2010.

Korza, Pam, Barbara Schaffer Bacon, and Andrea Assaf. "Civic Dialogue, Arts & Culture: Findings from Animating Democracy," Americans for the Arts *Civic Dialogue, Arts & Culture: Findings from Animating Democracy* (Americans for the Arts). http://ww2.americansfort-hearts.org/vango/core/orders/product.aspx?catid=2&prodid=203

Korza, Pam, and Barbara Schaffer Bacon, eds. *Museums and Civic Dialogue: Case Studies from Animating Democracy* (Americans for the Arts, 2005). http://ww2.americansforthearts.org/vango/core/orders/product.aspx?catid=2&prodid=207.

History as Catalyst for Civic Dialogue: Case Studies from Animating Democracy (Americans for the Arts 2005). http://ww2.americansforthearts.org/vango/core/orders/product.aspx?catid=2&prodid=204.

Leighninger, Matthew, and Mark Niedergang. *Confronting Violence in Our Communities: A Guide for Involving Citizens in Public Dialogue and Problem Solving*. Pomfret, CT.: Study Circles Resource Center, 1994.

McCallie, Ellen, et al. "Learning to Generate Dialogue: Theory, Practice and Evaluation." *Museums & Social Issues* 2, no. 2 (Fall 2007): 165–84.

Zukin, Sharon. *Naked City: The Death and Life of Authentic Urban Places*. New York: Oxford University Press, 2010.

97

Moving Pictures: Minnesota's Most Rewarding Film Competition

Randal Dietrich

Moving Pictures was an open film competition and, really, a leap of faith. The Minnesota Historical Society invited short submissions— no more than ten minutes—from professionals and amateurs alike, and of all ages. The only requirement was that the film be a documentary about a member of Minnesota's "Greatest Generation." The festival was held annually from 2006 to 2009 by the Minnesota Historical Society (MHS), as part of a five-year multifaceted project dedicated to exploring the lives and legacies of the World War II generation in Minnesota. The project involved lectures, publications, school programs, and a major exhibition that opened at MHS's flagship building, the Minnesota History Center, in 2009.

Each year as I scanned the pictures in the film festival program, I was always struck by the photographs—the faces of those in "starring roles" as well as those behind the camera. Taken together, these photos reveal at least two generations—the first, who came of age during the Depression and World War II, and a second, later generation who answered our call to document through film the lives of the men and women who have been called our "greatest generation." The intersection of these lives produced an extraordinary body of work—more than 150 short films.

From the beginning, we at MHS made a strategic decision to democratize the film component of this project by inviting contributions from the general public. Two factors influenced our decision to share authority with so many. The first, which was not in our favor, was time. We weighed how quickly members of the generation were passing away. We also weighed the limited number of our own

The Riverview Theater box office in October 2007 on the evening of the $10,000 Awards Program, replete with red carpet and searchlights.

staff who could make a more traditional, long-form documentary compared to the nearly limitless number of potential storylines to consider. It was daunting, given that more than 300,000 Minnesotans served in the war, to say nothing of the stories from the home front. At this time, coincidentally, Ken Burns, a documentarian rich with resources, was trying to defend many of his own omissions about World War II prior to the release of his epic *The War*. The second factor, which was in our favor, was technology. The increasing availability of the software and hardware needed to make films suggested that we could call upon a cadre of mostly first-time filmmakers to cover the geographical distance we could not cover on our own. We had faith that this growing community of filmmakers would accept our call for entries as a labor of love. Essentially, we were looking for volunteers. We did not pay anyone to make a film, although we did offer other indirect incentives (access to our film and photo archives, free filmmaking workshops, one-on-one consultations with leading filmmakers, our promise of their film appearing on the big screen, etc.) and cash awards totaling $10,000 for the winning entries.

While the expertise of the filmmakers varied widely, they all shared a love for their subjects. The father-daughter team of Tom and Ali Drube, who shared their story of Ali's grandmother, was representative of the many novice filmmakers. The other entrant represented here, Matt Ehling, is an accomplished filmmaker and owner of ETS Pictures. He crafted a beautiful retelling of his grand-father's service in the war.

Each year, a September submission deadline yielded an October festival that showcased the short films, filmmakers, and their subjects. At the screenings, audiences were encouraged to cast their votes for the Audience Choice Awards while a panel of historians and film instructors convened in advance of the festival to judge the best films in five cash categories ($5,000 Best Film; $2,000 Best Coming of Age Depiction; $1,000 Best Collaborative Effort; $1,000 Best Film by a First-time Filmmaker; $1,000 Legacy Award).

Nationally, there is nothing else like this film festival. Simply put, it has been the product of collaborations—between organiza-tions, between individuals, between young and old. The generosity of many funded the festival and enabled us to annually award $10,000 in prizes. Our libraries, schools, theaters and even the Mall of America hosted dozens of statewide screenings. And finally, our partners at Comcast and Twin Cities Public Television collaborated with the MHS to ensure that the films were available to a wide and varied audience.

Along the way, we were reminded that the World War II genera-tion is passing at an alarming rate. In fact, we lost several of our

Tom Drube (center) and his daughter Ali (right) discuss with festival director Randal Dietrich and the audience their filmmaking choices for their award-winning film *My Grandma Lucy.*

leading men and women over those years. But in these films you can see them traveling back through time and memory, becoming "forever young" through the historical photographs used by our younger filmmakers.

We also learned that it would be a mistake to believe that reliving these sixty-year old stories always came easily. As one of our leading ladies told me, she didn't sleep so well after working to recall traumatic times of Depression and war. Still, one of the best experiences of this festival was to be drawn into a short film, to see someone filmed at their kitchen table or in their backyard, and then to find them sitting next to you in the theater.

Many of the filmmakers reported that they had always meant to do something like this—to document the life of someone dear to them—and that this competition provided the incentive to finally do it. The cash award sets this competition apart from many festivals, but ultimately the most rewarding part was in the doing. One of the filmmakers put it this way:

> I showed my Dad the film last night and it made him cry. It was a powerful moment between us, so I must say I have already won something that is most precious.... I am emotionally raw from it in a way that I have not felt with my work in some time. I know the work I am most proud of over the years is the work that has come from the deepest places in my soul, and this film certainly found a new place at the top of this list.

Ultimately, our strategy to democratize the filmmaking process proved empowering: filmmakers responded with passion and purpose that far exceeded our expectations. We collected many more stories, and garnered a far wider audience, than we would have had we just made a single, long-form documentary.

Perhaps the most rewarding outcome was an unintended one. Those in the starring roles and those behind the camera came to serve as amazing ambassadors for the Minnesota Historical Society. They helped spread the word in communities across the state, spoke to their local newspapers, e-mailed their friends and gathered their families. Through their experience, they gave voice to why we do what we do. No marketing message or public relations campaign is as true as their authentic appreciation for the opportunity we afforded them. It was endorsement of our commitment to preserve Minnesota's history—a history and commitment we all share.

My heartfelt thanks go out to the generation who so evocatively shared their stories and to the generation of filmmakers, including Matt Ehling and Tom Drube, who so lovingly recorded it.

Remembering Grandma Lucy
Tom Drube

My impression of history prior to my involvement with the Minnesota Historical Society came from watching the History Channel. I felt that history was reserved for the fantastic, that such stories and data were the reason for history museums. I fully bought into the tired cliché that those who didn't understand history were destined to repeat it. History, in this more serious context, was reserved for policy makers and social leaders. I had license to treat it as an escape and entertainment. I could draw on it when I wanted to as one might enjoy a game of golf or a fantasy movie at the theatre. This would change when my daughter Ali brought home a flyer from an event she participated in as part of her history class at school.

The flyer called on normal folks like us to make a ten-minute film on someone from Minnesota's greatest generation. When Ali's grandma Lucy had passed away, a movie much like that had been prepared as part of the memorial service. It seemed like a remake might serve a purpose for both Ali's school projects and as a means for us to work together.

My mother's story is anything but fantastic, as it was typical for a large number of folks growing up in the 1920 s and '30s. As a youth she was in and out of various sanitariums in Minnesota as she battled tuberculosis. She spoke very little about this time as I was growing up, but as I became an adult she spoke more freely. Eventually a musty shoebox of pictures was shared that showed her as a young girl and what was "home" for her in her formative years. She was at the Ah-Gwah-Ching Sanitarium for Consumptives near Walker, Minnesota,as a teenager. Several years before she passed away, I accompanied her to a class reunion in Ortonville, Minnesota. On the return, we stopped at the then-vacant Riverside Sanitarium, where she had finished her recovery. It was there that she revealed that she had met my father there when he was a patient. My father, much more private than even my mother, had never shared this information. Large gaps in understanding where I had come from slowly began to have the fog lifted from them, and now I had a chance to lift them for Ali.

We started with the VHS tape put together for Mom's service and the box of pictures. Sorting through them we realized that we had an opportunity to make this seem even more real for Ali by visiting her grandmother's first sanitarium home. Ah-Gwah-Ching is a nursing home now, but when Lucy was there it was full of TB patients. We

Ali behind Building
B at Ah-Gwah-
Ching, as featured
in the short film.

Grandma Lucy at
Ah-Gwah-Ching
when she was a
patient there, (left)
at the same door-
way as Ali and
in bed.

took a summer road trip to Walker and photographed the site. With the nearly seventy-year-old photographs in hand, we were able to replicate the shots for a then-and-now effect. One such picture was to include Ali sitting on the very bench that my mother had sat on decades ago. Comparing the two, I can see my mother's teenaged face smiling at me through Ali's.

In order to get our dates right, we visited the Minnesota History Center in St. Paul. After several hours of online searches, we came across several boxes that stored Ah-Gwah-Ching records. In one was the original patient-admittance record book. There, in the original handwritten ink, was my mother's name, the date and time of her arrival, and the names of those dropping her off. A chill went through me, as though I was transported in time. And then another revelation: immediately next to her name was my Aunt Florence's. I had not known that she, too, had been admitted to the "San." Yet another layer of fog lifted.

Both my mother and her sister were subsequently discharged, but my mother was readmitted. Shortly after being readmitted there was yet another discharge and readmittance, which we had trouble understanding. We then visited the death certificates for my mother's family and verified that her mother had in fact died of TB and that her older brother Leo had also died from the infection, although his was meningitis tuberculin. My mother had always professed that Leo did not die from TB, but rather meningitis, but that was apparently only half true. My grandfather's death certificate verified that he passed while Mom was at Ah-Gwah-Ching, which explained the short discharge, as she was permitted to leave to attend his funeral.

Ali and I spent priceless hours discussing Lucy's time growing up and how it may have shaped who we were as a family. Ali quickly realized that the TB that had killed several in her grandma's family and had almost killed her grandmother was also what had brought her grandparents together. Without the tragedy of the TB, Ali would not be here. She also grew to understand that the defining characteristic of the greatest generation was not the circumstances that they endured, but rather the hope they had for a better tomorrow.

It was around these themes that we began to assemble our film. Like all projects, the approaching deadline for submittal was a necessary threat to make sure something got done. We knew that we would essentially be creating a narrated slide show, so we organized the presentation into sections and began to write a narrative. Since Ali was to narrate, she was the final editor on the choice of words. In the end, we had a bit of trouble with the sound and were ever reminded of how much we missed the opportunity to capture Lucy's story in her own words. We would learn, however, that the only important thing is the story itself.

105

Completing the film with Ali was more rewarding than I could have imagined, and yet there was more reward in store. The evening of the film presentations challenged my long-held feelings about history. I came to realize how important an audience was for a story. Each contributor to the film festival was given this gift of a venue for their work to be seen. As such, the day became more of a conversation than a presentation. I found myself more intrigued with the simple, honestly delivered stories of my peers than I could ever be by the History Channel. I remember the film by Roger Bindl. His subject, Terrence Brennen, tells how he worked all summer for 50 cents, only to lose it as he ran home. I remember Samuel Hendersen's film showcasing his grandfather, whose wit in telling simple stories of managing a farm drew me in. These stories were very personal and so very familiar in their human connection. These people's lives were built on a collection of interpersonal relationships that I could understand because they were not that different than my own. It became apparent that our technical shortcomings could not undermine the impact we could have by simply making a film and telling a story. In the end we also were rewarded in knowing that the stories would be preserved at the History Center and as such would not simply be lost.

In the end, my attitude toward the History Center changed. I no longer saw it as a museum of the spectacular, there for my amusement, but rather a library of our common bonds. I was not a customer demanding to be entertained, but a part of it. We were the history. While I don't reject the tired cliché that we must understand history so as not to repeat it, I now see both the role of our history museums and

my own in documenting who we are in a much different light. Each of us has an obligation to future generations with our stewardship of the past. We have a basic need to feel safe and to belong. If we feel separate from other groups, we push ourselves from them and our ability to relate as people fades. If we feel a part of something larger, we tend to communicate and draw closer.

History, it seems, has a half-life. What we remember diminishes with time. By documenting what we know, we preserve the truth for more generations. This increases the number of generations that can, in turn, find that sense of belonging. The History Center has continued its campaign to collect real and personal stories in the years following our submittal of *My Grandma Lucy*. Each year I have been eager to participate again. Each year I have found a personal subject within my own family in hopes that our story will resonate with the others in the festival. Each year I look forward to the conversation.

107

From Book to Film—The Artifacts of Wartime History
Matt Ehling

The book was a thin volume—light gray and gently worn at the binding. On its title page, the following was written:

> This is a testimonial without names, and with just one number: The 60th.[1]

My grandfather Bill served in the 60th Infantry Regiment—part of the First Army's Ninth Infantry Division. Bill joined up with the 60th in England, shortly after the Allied assault on Utah Beach. The next day, he found himself in combat in Europe. He remained there until well after the war was over, as part of the American occupation army.

Three years later, a small commemorative volume entitled *Follow Thru* was mailed to my grandfather. Written by Morton J. Stussman of the U.S. Army, the booklet chronicled the exploits of the 60th Infantry's "Go Devils" in pictures and in text. This book soon joined the other artifacts that Bill kept from the war years, including his dress uniform and a pair of German officer's swords. It was through this collection of items that I came to know the history of the Second World War.

I had other relatives who fought in the war. Many on my mother's side had served, mostly in the Pacific. Some talked reluctantly about their experiences in combat. Some would not talk at all. Bill never hesitated in this way. As a child, I spent many summers at his farm, and heard long tales from the European campaign. For me, his stories, his uniform, and his book were not conduits to history—they were history. They made the war indelibly real, and established a connection with that time period that has never left me.

In the late 1990s, I decided that someone in the family needed to preserve my grandfather's stories. One fall afternoon, I packed a microphone and audio recorder into my car and drove south to my grandfather's farm. Around his kitchen table, we shared tales from his wartime experiences: the Battle of the Bulge, the taking of the Remagen bridge, the assault that killed every man in his unit except for him.

The tape sat on a shelf in my office for the next several years; an archival record of family history. Its main use, I assumed, would be in the years to come, when Bill was no longer with us.

In late 2006, I came across a notice for a film competition that the

Matt and his grandfather Bill, as Matt accepts the Best Film Award of 2007.

Minnesota Historical Society was sponsoring. They were soliciting short films and videos about the experiences of the fabled "greatest generation" of the 1930s and '40s.

After the publication of Tom Brokaw's *The Greatest Generation* compendium a decade before, my grandfather had mentioned to me that its celebration of World War II veterans was gratifying because such sentiments had not been widespread when he returned from Europe. Most people in his small, rural community wanted to forget and to simply move on. It would be fitting, I thought, to use the Historical Society's contest as a way to craft a public tribute to my grandfather's service—the kind that he had never received.

Slowly, I built a film around the audio recording of Bill's stories. The final production, entitled *Coming Home*, was screened at the Minnesota History Center in the fall of 2007. Its emotional impact was clear. My grandfather's taut storytelling delivered the audience to the war's front lines, and presented an experience that was not easily forgotten. The recorded recitation of his tales won the competition's top prize in 2007, and led to two years of screenings across the state.

The film's impact on Bill has been marked. Its broad exposure—through the Historical Society and on public television—has led to many instances where strangers have stopped him in public to talk. Sometimes they have asked questions about his service. Mostly they have thanked him.

Much mythology surrounds the Second World War. This is understandable, for these myths rest upon truly astonishing events in American history. For the most part, the combatants in that war were

Three generations of the Ehling family—including World War II veteran Bill and his grandsons and filmmakers Mark (left) and Matt (right), and Matt's son Joseph—were represented at the Minnesota History Center when their film *Coming Home* earned the Best Film Award in 2007.

110

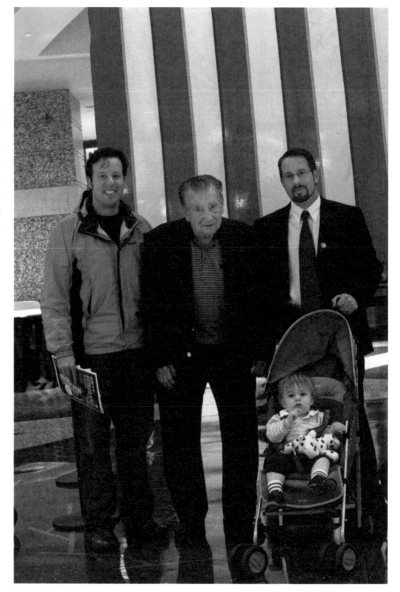

not professional soldiers. They were farmhands and factory workers. They were given six weeks of basic training and a rifle, and were placed on a boat bound for combat. A handful of years later, they had defeated Fascism across the globe.

On its own, an individual's oral history cannot provide a complete picture of such an event. Nor can it always extract accurate details from decades-old memories. However, its value lies in providing a visceral connection to a historical moment. For the generations that cannot experience the original event, oral histories, video compilations, and other artifacts can bridge great distances and make the intangible real. This is what my grandfather's war stories—and his book—did for me. Perhaps his short film has done the same for others.[1]

Recently, the book passed into my hands. A couple of years after the film first screened, my grandfather approached me at a family gathering. In his hands was the slim gray volume I had read as a child. "You should have this," he told me.

I first set eyes on my grandfather's book many years ago. There have been births and funerals since. Now, I have a son of my own. One day, when he is old enough to understand, we will head south to my grandfather's home town. We will sit on a bench in the late afternoon and read from the book.

111

Inside, amidst photos of combat and dead men, one can still see the scrawl of my father's colored pencils in the margins—remnants of his childhood attempts to write. The pages have yellowed, but the pigments are still vibrant. The book's sole color photograph is reproduced on page twelve. It is a picture of a graveyard, bathed in the day's waning light. Underneath it, the following is written:

"It was a tough grind, cruelly out of proportion for sports loving youngsters when pitted against bitterly fanatical men who knew no rules. And yet they won."[2]

1 Morton J. Stussman, *Follow Thru* (Stuttgart: Chr. Scheufele, n.d.).
2 Stussman, *Follow Thru*.

Community as Curator: A Case Study at the Brooklyn Historical Society

Deborah Schwartz and Bill Adair

Since 2006 the Brooklyn Historical Society (BHS) has held a Public Perspectives Exhibition Series in its Independence Community Gallery, providing a forum for Brooklynites to have an active voice at BHS by presenting community-curated exhibits. Topics have included Chinese immigration, Italian Catholic culture, storefront façades, gentrification, and affordable housing. The following is a conversation between Deborah Schwartz, director of the Brooklyn Historical Society, and Bill Adair, director of the Heritage Philadelphia Program, The Pew Center for Arts & Heritage, reflecting on the BHS's community-curated exhibitions program.

Bill Adair: Can you tell me how the Public Perspectives gallery got started? I know this is something that you initiated when you came to the Society. How did it begin, and what was the thinking behind it?
Deborah Schwartz: I knew that it was important for the Brooklyn Historical Society to signal to Brooklyn's incredibly diverse and complicated communities that this was a place that was for everyone, that the history that was told here

was not just a very narrow slice of history. We are located in a very beautiful, very well-to-do neighborhood in Brooklyn Heights, surrounded by beautiful 19th-century brownstones, and frequently people perceive this to be the Brooklyn Heights Historical Society rather than the Brooklyn Historical Society (BHS). So the question was what do you do to change that, and so I began to think and talk with my staff and trustees about what we

could do, what kind of project we could construct that would really allow us to give a welcoming signal.

And that's really what the Public Perspectives project was born from. Theoretically we wanted to say to people that we don't think we always have the definitive version of history here. And as a practical matter, we certainly don't have the time or the resources to go into the nooks and crannies of Brooklyn and pull out all that history, reveal it to people, and help them think about it and be engaged with their own history. We need their help— their input. So we then set up this project, and fortunately we had a couple of funders who were very excited about it. The concept was to put out an open call to people in Brooklyn who had ideas about how to tell history—what history they wanted to tell, sometimes in a very small way, a very small slice, and at other times a more ambitious look at pieces of history related to Brooklyn. We worked very hard to create a set of guidelines that we thought were smart, that would be clear to people, not so complicated that they would be put off by it. We were trying to reach all kinds of people—definitely not just people who already knew how to curate exhibitions. We knew that we were going to put in a certain amount of time and energy to facilitate these projects once they were chosen in order to make good projects, and off we went.

Bill Adair: So how does this process play out?

Deborah Schwartz: The first thing we did was we set up an advisory group; it changes year after year, but the group basically consists of historians, folklorists, artists, and, at this point, somebody who has been through the process before—

Bill Adair: From the Brooklyn community?

Deborah Schwartz: Professionals from the community, including a traditional art curator who is part of the process. The advisors rotate, so there are always some people who have been through the process before and others who are new.

Bill Adair: Any society staff on that advisory committee?

Deborah Schwartz: There is nobody from the society on that advisory group.

Bill Adair: That sounds scary.

Deborah Schwartz: There are two staff members who facilitate the process, so they bring in the proposals, they review them, they put them together, they send out packets to the advisors in advance. And they are there in the room as the advisors are making their decisions, and there's a very clear set of criteria. What are we looking for in these shows? The criteria are broad, but very clear. The staff is there to remind the advisors about the criteria and the priorities of the program.

Bill Adair: So you send out a call for ideas.

Deborah Schwartz: There's an RFP—a form that people have to fill out. It's on the website so anybody can see it at any time, and that form requires certain compo-

113

Photographer and curator Delphine Fawundu-Buford (center) speaks with Tivoli building residents at the opening of *Tivoli: A Place We Call Home*, Brooklyn Historical Society, February 2010.

nents. You have to articulate the idea you have. You have to show us some images. You have to give us a sense of what your preliminary checklist would be. There are certain kinds of proposals that are disallowed. You can't be one individual artist, because we knew we would get lots of proposals like that, and that's not the point of the project. The advisors review all the proposals, and then they come together for a day, and they sit in a room together, and they review things. And they pick three proposals for the year, and have backups in case for some reason somebody falls through on us. And then their work is done. At that point we make contracts with the groups and decide on a schedule.

Bill Adair: How does the budget work?

Deborah Schwartz: We have stipends for the groups. The stipends can be used in any way they want for putting up the exhibition. They can buy framing supplies, they can pay designers with it, they can do whatever it is they feel they need. They can't have any more than we give them—it's $2,000. And we make it clear that there's not going to be more if you come back to us and say, "Oops." And then we provide funds for a postcard announcement and an opening reception for the exhibition. The guest curators design the postcard and then we send it out to our patrons and members, and they send it out to their own mailing lists. This is a crucial piece of audience building for BHS.

Part of what organizers have given us in their original proposal is some sense of ideas for public programs that they want to run in tandem with the exhibition, and that's an important criterion

for judging the projects. We want to see that it's people who are interested in engaging with the public beyond the actual exhibition experience.

So the process is interesting, because once we're really rolling up our sleeves and doing this, the community groups have learned a great deal about what it means to put up an exhibition. And we, the staff, put a lot of energy into it, not to shape their exhibition or their ideas as much as to shape what they know about the possibility of the exhibition as a medium.

Bill Adair: So you see the staff's contribution as technical assistance rather than conceptual or content assistance?

Deborah Schwartz: Right. I think one place we get a little closer to conceptual input is that we give the community groups the option of including things from the collection. Some people are savvy enough and come in thinking about the artifacts. They'd like to use X, Y, and Z from the BHS collection. Other people haven't even thought about that, and we will present this as an option. If they say no, it's totally fine. So it's not very interventionist.

Bill Adair: So any content is acceptable?

Deborah Schwartz: The one place I've seen my staff be a little bit heavy-handed is on the occasion when somebody has come in with an idea that turns out to be more of a book on the wall. We had somebody who had been writing a dissertation on a topic and wanted to do the show. Great topic, great

show, fabulous work, fabulous history, but the person did not know how to translate that. So we put a lot of energy into that, helping the curator to think about how to represent some of these ideas using artifacts and images and less text.

Bill Adair: Design and fabrication of an exhibition is such a big deal in contemporary museums, so how much are the groups involved in design and fabrication?

Deborah Schwartz: It really varies. Ultimately, they are the ones who put up the show.

Bill Adair: Physically?

Deborah Schwartz: Physically. Again—we are present. Sometimes they ask for our advice about designers or art handlers and that's not a problem for us—but they have to pay these people from their stipend and the groups themselves are doing the work and making decisions.

Bill Adair: When you founded this program did you have as an explicit intention the goal of sharing historical and curatorial authority with your audiences?

Deborah Schwartz: Very, very much so. It was absolutely the purpose of this, to signal to people, "This place belongs to you. We as an institution and as a professional staff don't know everything there is to know about Brooklyn's history, about your history, about your church's history—whatever it is. And we are interested in honoring your assessment of that history." And we do not assume that we are actually going to completely agree with everything that gets put out there, but we insist on a pretty

115

rigorous process. If we see that somebody's ideas seem very sloppy or unformed, that's not likely to be one of the exhibitions our advisors would select.

Bill Adair: What about offensive or potentially offensive ideas? Or even controversial? Have you faced that yet?

Deborah Schwartz: The current exhibition [summer 2010] is about a particular set of subsidized, affordable housing in Brooklyn, now in the throes of a lot of political controversy with huge financial implications for the tenants and the developers. This exhibition was put together by some of the tenants who are also very vocal activists. It's their point of view, and we knew that, and we're totally okay with that. We've had people do a project around Atlantic Yards, where the new Nets Stadium will be built—also highly controversial. These are all very hot topics in Brooklyn.

Public Perspectives projects are about giving a lot of voice to a lot of different people, and it took me a while to make sure that I was ready for any confrontations, should they come. So far, any confrontations I have had have been very private. People call me up and say, "Why'd you do that show? That's not right." And the most interesting thing for me is that I get to say, "This is part of a program that is very deliberately about letting people have voices here. And it's not your voice—it's okay that it's not your voice. It's their voice, and that's very clear in the exhibit,

in the way it's set up," and so far that works.

Bill Adair: Were you looking at other models of similar practice when you developed this program, or do you think it's really a new kind of model? How radical is this kind of practice, where you turn over the exhibition content to your audience?

Deborah Schwartz: I actually don't think it's radical. I think there've been versions of community-driven galleries in museums for decades. It's interesting to me, however, that there haven't been more of these recently. I think this work is largely being done on the Internet these days.

But I've had a couple of colleagues call and say, "I'm taking your idea. Is that okay?" and I say, "Of course it's okay. It's fabulous." We weren't looking at a particular model when we began this program. As a practical matter, we were mostly building from scratch.

Bill Adair: Has there been pushback from the staff or the board at all in terms of the process or any of the content?

Deborah Schwartz: No. The staff and board have been very happy with this project. The only issues that have come up have been around the amount of physical space that we give it. And that is the dilemma of being a small institution, because when we turn over space for a big chunk of time to these shows, it means there's something else we're not doing. So the board is eager to see us show off more of our permanent col-

lection, and they are totally right about that. We have a gorgeous and fascinating permanent collection. The felt need to continue Public Perspectives AND show more of the collection has led us to create a new configuration of the first floor of the building and the lower level, and probably a year and a half from now we'll have another really nice exhibition space carved out of the building. This will include a better gallery space for Public Perspectives.

Bill Adair: That's a real commitment on the part of the institution.

Deborah Schwartz: Yes, and that's very exciting. There's no question we're very different from a brand new history center with a new large facility. So we've got to be really creative about how we think about our space and how we use the space.

Bill Adair: Do you think the project has truly worked as a community building exercise? Do you think it's worked in terms of building new audiences, maybe even bringing new members? Do you think it's built a sense of community between the institution and the neighbors or among community members? How has that played out?

Deborah Schwartz: I think it has definitely served to bring new people to the Historical Society who have not been here, hadn't known about the place. A major dilemma that so many museums face—if you do something that resonates for a group of people who have otherwise been alienated, does

that instantly turn them into regular, engaged members? A little hard to tell. A little hard to track. I do think a lot more people know we're here. They know our resources now. We've built important relationships through this program.

Bill Adair: You have many tentacles out there in the community now as a result of Public Perspectives?

Deborah Schwartz: That's right, but it's a little hard to quantify. I don't think that we've done everything we can to keep these folks close to the organization. On the other hand, we've had people who participated in Public Perspectives who then turn out to be regular members of our freelance education staff—they do talks and tours and have become actively engaged in the institution. That gives us a great feeling.

Relationships, programs, connections, networks—that is very appealing and it's what a small history center such as this one can and should be at this moment in time, with the limits we have on space, on resources, on staff. We've found a way to be vibrant for people.

Bill Adair: I think many people in the public history field are wondering right now about these kinds of projects. We're all interested in them and noticing this trend among ourselves, but are our audiences noticing it? Does it make audiences more attached to an institution, or could it make them more suspicious of an institution? If we're sharing authority with our

117

visitors, then the other visitors that come in are being asked to hear from peers rather than historical or curatorial experts. Is that something that they want?

Deborah Schwartz: These are really important questions and we haven't yet done any systematic evaluation. I think it's time to do that. It probably needs to be a longitudinal study in that you can't do it for just one show. You've got to do it for three, four shows or you won't really get a sense because the shows are so different from one another. Sometimes we hear "I'm not sure I like the point of view of that show," which is one way that people talk about it. They know that it's a very distinctive point of view, and it's not one they share. We are very deliberately sharing authority with some of our visitors and we need to evaluate the impact on everyone. We need to do that study.

Bill Adair: The value that the society now places on sharing authority with its communities—it's got to emanate from the leader of the institution, right? Certainly one of your roles as director is to clarify and communicate the value system of the institution. How do you set the tone for shared authority with your board, with your staff—and, of course, your audience?

Deborah Schwartz: We're a very small staff, and so we're in the very wonderful position of being able to communicate very efficiently and deeply in small groups—there are fifteen of us here. So when an idea is gestating, you throw it out

to your colleagues and you have a healthy discussion and debate about it. It's not that everything is done as a democracy. But there is definitely a sense that we're in this thing together and everyone has a voice. I think the staff that's here is drawn to the vision that we've developed since I've been here.

When we were looking for a new archivist—a professional who is charged in part with the job of protecting the collections—we asked candidates about their interest in public access—not just access to scholars, but to lay people. We told them about Public Perspectives. I asked people how they felt about working in an archive where young teenagers were just as welcome as anybody else to come in. I listened very carefully to the answers, and we now have an amazing staff here who totally loves what we're doing. So, you put the right people in the stew pot together, and it's not that hard. I haven't felt as if we were dragging people kicking and screaming into this process of sharing authority.

Quite frankly, I also have some very trusted funders that I run things by. That makes a big difference, too, if somebody's going to invest in your value system. We've had very good luck with funding Public Perspectives. People understand it. It's not hard to explain. Our track record is pretty interesting, and so it continues to have legs. It might at some point get tired, and that would be okay. You have to pay a lot of attention and

Curator Delphine Fawundu-Buford speaking with an unidentified guest.

know if you've spent an idea.

Bill Adair: You mentioned that several other institutions are doing community curating projects like yours but are doing them online. Quite a few organizations are beginning to experiment with sharing curatorial authority online, but doing it in real space is a very different thing. How important is it to you that these exhibitions be real space projects and not virtual projects?

Deborah Schwartz: Very important. The reason that I think we care so much about doing this physically is because we want to signal to people that this building in this particular place is full of surprises, is not what you expect it to be. It is a place that really is co-owned by the community. And you can't do that by just having it play out online. That is about the physical place. And even though I may complain at times about having too small a place, it is very important

that some of our space physically be turned over to the public so that their voices can be heard.

Bill Adair: Do you think it validates people's stories and histories to have them presented here in this grand building?

Deborah Schwartz: I hope so. For us it's about saying, "We really want you to know that this is here for you. You might not think it's here for you, you might not even know it's here, you might never have been in Brooklyn Heights, but come check us out, and here's a really good reason to come check us out." So that's an agenda that is somewhat self-serving. But I also think for an institution like this one to be a gathering place for the community is a very good way to use this building. And you can't do that, obviously, if it's all virtual.

Bill Adair: Has the program evolved or changed in response to the feedback you've gotten from the participants?

119

120

Deborah Schwartz: There are a few things that have changed. We clarified some things about what we were looking for. We gave people more time. We changed the makeup of the advisory committee a little bit. We found some new places to publicize the program. And we put the shows up for a little bit longer now than we did at first. But I think otherwise the project has been pretty steady. I think the staff has learned a lot about what to expect. We've had what I think are really instructive moments that were not always easy: with community curators not meeting deadlines, or showing up late for meetings. People who don't work in the field don't always understand (or care) about deadlines, and don't have any idea about the consequences of delays. Occasionally this is really hard on the staff and they get frustrated. But the process of give and take, of learning to know and respect stylistic and cultural differences and expectations is all a part of what it means to share authority. So, it turns out that we are teaching our community curators how to make exhibitions, but we are also learning about tolerance and openness ourselves. The process requires an adjustment for staff. And I think that makes us a more interesting and community-engaged institution.

Bill Adair: So there have been some cultural barriers. Do you think there might be ways in which this curatorial process doesn't translate cross-culturally? What about language barriers?

Deborah Schwartz: We have not yet had a group participate in Public Perspectives who was not English speaking, and we haven't really figured out how to address that. I think we know that we have some serious limitations in what we could respond to, and so then the question becomes how do we find the resources to pay translators, etc.

I would say one of my real disappointments was when we did a Public Perspectives exhibition about the history of the Chinese immigrant community in Brooklyn. We worked closely with the Brooklyn Chinese-American Association and they helped us with publicity, and we brought on a Chinese speaking intern who translated exhibition texts into Chinese and who wrote a press release in Chinese. But with the exception of the opening we didn't get a lot of the Sunset Park Chinese community here. And that was a big disappointment. There are probably a lot of reasons why that didn't work, some of which we might have been able to rethink and some of which in retrospect is not so surprising. I think it's partly about, again, a lack of resources—not being able to put full-page ads in Chinese in the local Chinese newspapers and things like that. That could've made a difference; we'll never know for sure.

Bill Adair: How far do you think that the society could go, and institutions like this—in terms of sharing authority with visitors? Are there next steps? Are there other boundaries and barriers between staff and visitors that are still to be broken down, do you think?

Deborah Schwartz: Yes, I think we will always be looking at interesting ways to share authority, to use a constructivist approach to what we're doing, not just in education, but in everything we do. I think it's very interesting, appealing, smart, a little unpredictable in the good sense, and fits well in a place where, even if you wanted to run a really old-fashioned, authoritative place, you actually aren't terribly well-equipped to do so. So, am I always seeing exactly where it's going to go next? No. But I pay a lot of attention to the lessons that you can learn from each of these things that we do. I think we are always asking how we want to position ourselves in a world in which we are looked to as some sort of authority.

I think we do keep pushing the boundaries. I hope we will always push them, because I just think it gives us such incredibly interesting results.

Bill Adair: So you've never had a sense that you've opened a Pandora's box? That this very open process is leading you to potentially uncomfortable places and you're going to lose control completely? Where's this authority sharing going to end? Certainly a lot of organizations fear that.

Deborah Schwartz: In fact, I actually think it's almost the inverse of that. The more we do this, the less fearful we get. What happens is a relationship gets built between the staff and the group, and there is a lot of back and forth. By the time staff and community have been working together for several weeks there is a lot of trust on both sides.

The staff and community groups use each other as sounding boards. You see curators do this with each other all the time, right? In the end, there's not really a lot of fear here. Maybe someday we'll run into a really tricky spot, but not so far.

Bill Adair: So all of the Public Perspectives projects have been a success?

Deborah Schwartz: Of course it depends on your definition of success. We're obviously very focused on process—our engagement with the groups, the evolution of their thinking and knowledge about how to put up an exhibition. And sometimes those lead to final products—exhibitions—that are fabulous, and sometimes they lead to exhibitions that are less than fabulous. And so the question is—Is it okay that in the end the audience who's coming to see this project has a less-than-fabulous experience of an exhibition? Because we have chosen to cede our authority to some extent, we live with a certain discomfort—knowing that there are going to be times when the *process* of creating these exhibitions is better than the end product. That may be the most controversial part of this. That may be the part that for some people is just simply not acceptable—particularly people in the history and museum fields. And I have had those arguments with people.

Bill Adair: But for you it's okay?

Deborah Schwartz: For me it's

okay, and for this institution it's okay. It also isn't the only thing we do. There are moments when we assert our authority and there are other moments when we take an institutional back seat. In the future we may want to take up a topic that comes to us originally through Public Perspectives and we'll present a different version—our version of it—complete with scholarly advisors and authoritative narrators. A lot of fabulous ideas have come out of Public Perspectives that I could imagine revisiting any number of subjects with additional resources and expertise. Wouldn't it be fascinating to see some of the Public Perspectives stories played out using utterly different methodologies?

Bill Adair: So there's still room for the traditional curator-curated exhibition at the Brooklyn Historical Society?

Deborah Schwartz: Of course—a little.

Hearing Voices
Sharing Authority through Oral History

Who gets to tell history's stories? Even a century ago, the recording machine offered an enticing way to capture people narrating their lives in their own voices. While folklorists started making recordings before the turn of the 20th century, it was in the 1940s that historians began to systematically collect eyewitness testimonials. In the 1960s and '70s, social historians used oral histories to understand experiences not documented in paper-based archives. By the 1980s and '90s, public history practitioners realized that gathering stories—listening instead of lecturing—suggested a fundamentally different way of thinking about the role of historians in constructing the past. Museums began using first-person audio to make history personal and to convey alternate perspectives.

Oral history, then, was the first wave in the recent series of challenges that have buffeted traditional historical authority. After decades, though, questions remain:

To what extent has the promise of oral history been realized? Do first-person testimonials really challenge expert authority, or do professionals fundamentally control how recollections are gathered and deployed?

What are the potentials and pitfalls in bringing participants' voices center stage in museum interpretation? Do first-person accounts need to be corrected and contextualized, or can they stand on their own?

Does hearing voices change how audiences understand their relationship to the past? Do ordinary people's testimonials remain distant, or do they inspire visitors to see themselves as potential history-makers?

Finally, how do all of these dynamics shift if visitors can contribute memories on their own, with only minimal intervention from professionals? Can everyone become his or her own (oral) historian?

From *A Shared Authority* to the Digital Kitchen, and Back

Michael Frisch

This book's fascinating and provocative title raises some very large questions, draws on some very broad assumptions, and frames a very expansive field of inquiry. In the "thought piece" that I've been invited to contribute, I'd like to ground that inquiry in some concrete contexts, challenge some of the informing assumptions, and somewhat reframe the questions. In this manner, I hope to sketch a productive way to engage the excitingly centrifugal energies currently responding to and shaping what I'm not sure it's necessarily helpful to call our "user-generated world."

My remarks draw from experience that is in one sense exceptionally current. I am among those working in new digital modes to liberate oral history from constraints that until recently have, paradoxically, rendered the recordings that define the method largely unreachable and underutilized in all but a few corners of documentary and public history practice. Focused on content-management capacities to index audio and video recordings, this work speaks directly and resonantly to the broader practice and theory examined elsewhere in this volume.

But I have also been asked to take a long look backward, through the lens of *A Shared Authority: Essays on the Craft and Meaning of Oral and Public History*, the collected reflections on applied work in oral and public history that I published in 1990.[1] Over some twenty years, the book has seemed to play a useful, or at least regularly visible, role in crystallizing discourse in these fields. Though I am not always sure how much it is actually read, it is gratifying that the title itself is so frequently referenced as a way to open critical space for considering oral and public history choices and their implications. And, indeed, it has been invoked in just that role to help frame the concerns of this volume as it was being planned.

This being the case, let me begin with that book title and then springboard to comments on contemporary and emerging practice in what can seem a dramatically transformed world of oral and public history possibility. I will then

conclude by circling back to *A Shared Authority* and resituating the crucial concerns of the present volume, arguing that "Letting Go" is not necessarily the answer, and, more to the point, that "Letting Go?" is perhaps not the most helpfully formulated question, here on the 21st century's mercurially advancing digital frontier.

WHAT'S IN A WORD?

In 2000, the International Oral History Association's biennial meeting featured a panel on collaborative community projects, which generated considerable interest and many calls for a fuller treatment and publication. The result was a special forum section of *The Oral History Review* in 2003, under the title "Sharing Authority: Oral History and the Collaborative Process," for which I was asked to provide some commentary.[2]

This was a great honor, and of course it was deeply satisfying that a dialogue I had helped to initiate was living on in so much richly imaginative and publicly significant new work, in areas far beyond anything I had been able to reach in my more limited earlier practice; I was privileged, in my comments, to celebrate the energies and engaged intentions represented by these practitioners. But it was somewhat more delicate to point out, in a sense also quite relevant to the present volume, that the forum's invocation of my book was missing if not "the" point, then at least "a" point worth noticing. This came down to a single word.

"Sharing Authority" was the forum title, with the syntactic implication that this represented something we should be doing and something the projects in their various ways were trying to do. Most invocations of my oft-quoted title have had this same feel—sharing authority is a good thing; let's do more of it. This same feeling animates the present volume's focus on "Letting Go," question mark notwithstanding.

But as I regularly point out in graduate seminars, authors give a great deal of thought to the title of their books. To start by interrogating the title carefully is never a bad approach to getting at an author's intention, whatever one wants to make of that critically. In this spirit, I asked readers of the *Oral History Review* forum to notice that the book had not been called "Sharing Authority," and to reflect on the difference between that term and "A Shared Authority."

The difference I had in mind was this: the construction "Sharing Authority" suggests this is something we do—that in some important sense "we" have authority, and that we need or ought to share it. "A Shared Authority," in contrast, suggests something that "is"—that in the nature of oral and public history, we are not the sole interpreters. Rather, the interpretive and meaning-making process is in fact shared *by definition*—it is inherent in the dialogic nature of an interview, and in how audiences receive and respond to exhibitions and public history interchanges in general. In this sense, we don't have authority to give away, really, to the extent we might assume. Thus I argued that we are called not so much to "share authority" as to respect and attend to this definitional quality. We need to recognize the already shared authority in the

documents we generate and in the processes of public history engagement—a dialogic dimension, however implicit, through which "author-ship" is shared by definition, and hence interpretive "author-ity" as well. We need to act on that recognition.

The point is illustrated by a simple example from way back, one that ended up on the cutting room floor when assembling *A Shared Authority*. Early on, I was part of a team doing a humanities grant review of an in-process radio documentary series, a sequence of half-hour programs on race relations in the South. We were asked to evaluate a sample program about railroad workers. It was terrific, well researched and produced, with evocative detail all around. But there was one compositional aspect in its exemplary construction that seemed just a little bit "off."

The first half of the program featured interviews and discussion among black and white workers, and the second half consisted of a panel discussion among scholars with expertise in the areas of concern. Halfway through the program, you could almost hear the group of workers being let out one door of Studio A while the scholars filed in through another door and sat down in the still-warm seats to put everything in historical perspective.

My partner and I both noticed this, and had exactly the same reaction: might it not have been even more interesting to have these two groups talk *with* each other, bringing their different authority and perspectives together to explore the program's content and meaning for its listeners? The reason for doing this, we felt, was not some abstract political commitment, not some gesture to "share" authority. The reason was that the conversations already had so many points of connection, so many shared interpretive dimensions, however different the registers, not to mention the accents. Here history-making as an act was already shared, however implicitly, and the program could have generated even more power by recognizing and leveraging that quality through a more dialogic structure.

Such experience did much to shape my sense of oral and public history. This is not to mystify the distinction between vernacular understandings and professional scholarship, but rather to suggest the value of genuine dialogue between them, "experience" and "expertise" being words with a common root and an instructive resonance when you stop to think about it. We can imagine sharing authority more easily and more broadly if we recognize that interpretive "author-ship," and hence "author-ity," already share more than our usual approaches and postures let us recognize

BEYOND RAW AND COOKED

Let me now jump forward to the digital work I first began in 2002, carrying me into what seemed dramatically different territory with very different challenges—a landscape that only gradually revealed itself to be presenting some of the same issues I had been wrestling with all along.

As some readers will know from other publications arising out of this work,

I have been applying digital tools directly to audio and video documentation, part of an unfolding approach in many quarters to put the "oral" back into oral history.[3] The goal is to make the actual recordings reachable and to re-center them as the defining primary source for oral history—for the archive, for the researcher, for "users," for public presentation, and for civic and community engagement. Like many people drawn into new technology and media, I wandered into this work almost accidentally. But through the domino effect of a sequence of small projects, it has become more and more central to my practice and to my thinking about oral and public history.

What drew me in deeper was the excitement of moving past what I came to call "the Deep Dark Secret" and "the Unexamined Assumption." The Deep Dark Secret was that while voices, faces, and embodied expression are at the core of what makes oral history compelling and why we are drawn to "do" it, until recently relatively few researchers have spent much time actually listening to or watching the recorded oral histories; rather, text transcription has provided the basic ground for engagement. The Unexamined Assumption was that while almost nobody seriously contends that transcription is a "better" representation of an interview than the recording itself, its limits have been taken as the necessary price we pay—like some kind of portal admission fee—to circumvent the cumbersome intractability of recordings and the overwhelming demands of examining them in linear real time.

But digitization, combined with a wide range of new software tools, has dramatically loosened these constraints. Researchers can now move around in media sources fluidly and efficiently; text transcriptions need not be the only guides in exploring such media primary sources. Together, these developments have led me, along with many others, into a range of new modes for working with digital oral history media, with or without wholesale text transcription: we can annotate, mark, catalogue, index, and keyword-search digitized interview recordings, and export selected passages for flexible use, online and otherwise. This has been part of what is now an even broader explosion of interactively accessible audio and video, very often oral-based, that appears in archives, websites, social networks, museum and public history installations, digital multimedia publication formats, and "apps."

Perhaps because my background and orientation are anything but technical, doing this work has, for me, continued to speak more compellingly to the oral- and public-historical practice with which I was more familiar and to what this might be coming to mean in a new context. Moving into these new modes has helped me appreciate the extent to which traditional practice in oral history, especially, has long been governed by an implicitly dichotomous regime of "raw" and "cooked." We store relatively unmediated oral history collections in libraries and archives, as relatively "raw" source documents; even transcription is understood as a representation of this whole, original, "natural" oral history state. And we rely on scholars, documentary producers, exhibition curators, and the like to find and process things out of this raw mass,

resulting in a well-cooked, receivable presentation of some kind—a film, a research article, an edited text documentary, an exhibit label or kiosk loop, a podcast, and more, all of which are the form in which oral history generally reaches broader communities of receivers or consumers.

The gap between the raw and the cooked is substantial, embodied in various problematic and productive tensions between the many poles holding up the public and oral history tent—between curators and designers, archivists and teachers, scholar "experts" and filmmakers, and so on. In this sense, one of the things that has excited me about the digital content-management work into which I have been drawn is its location smack in the middle: these new modes of access make the raw collection a legible and explorable hub, and in so doing make the framing and fabrication of usable cooked products more dispersed as a capacity and more open-ended, fluid, and continuous as a process.

Gradually, I have come to see how this way of understanding digital work has echoes in the shared authority discussions that I had thought were behind me. Conventional oral history archives, both physically and in their intellectual organization, are uniquely forbidding and inaccessible for general users who might bring to them very particular (and informed) inquiries and curiosities. Likewise, conventional documentary films or museum exhibitions, even when informed by progressive politics and community concerns, could not be more "author-itarian": the film or exhibition represents an assembled construction and reduction. It is a singular, usually linear ordering and path through a mass of material—a story, but only one story out of the innumerable ones that might be found and told by others.

With this realization, I began thinking about how digital modes might help to overcome the dichotomy between knowledge creation and knowledge consumption. Even as our work still requires management of collections and attention to usable meanings and outputs, I came to see the possibility of new approaches to making meaning. This is what I've termed a "post-documentary sensibility," a stance directed less toward the either/or of collection stewardship and fixed outputs, and more toward the active in-between—a more creative, more open-ended, less linear, and hence a more sharable space.[4]

In a recent paper, my associate Doug Lambert and I played some with the image that the kitchen is where the raw becomes the cooked. Might it be productive to imagine the space for oral and public history practice through this metaphor? Professionals and "users" can together go "messin' in the kitchen," to quote an old blues song. We can find things in the cupboards and larders of oral history collections and mess around with the meanings we may find in them, seeing what, together, we can cook up for everyone who might come to be sitting out there in the dining room.[5]

INDEXING AND EXPLORING
The audio-video content management work I have been discussing is being engaged in many converging approaches linking information technology

and oral/public history. A number of aspects seem especially germane to the concerns I have been discussing here.

Among the greatest challenges of bringing audio and video into usable form in our imagined kitchen, especially in necessarily long-form oral history interviews, is that most collection-management systems are essentially cataloging tools. These systems are good at identifying documents and their location. But for media collections, there is little real utility in guiding users to a three-hour interview that they then have to explore on their own. Generally, the result is media collections that are not actively accessed at all, or are used with minimal effectiveness.

In print documentation, the traditional solution to the limits of catalogue access is the index: once we have a book in our hand, the index permits us to explore what's in it. Along with tables of contents, running heads, introductions, and the like, the index enables non-linear access to the content. Such reading-management tools free us from having to start on page 1 and trudge through to the end: in this sense, at once obvious and surprising, they reveal the ancient book to be the original hypertext modality.

Much of the excitement in current work in oral history revolves around approximating such capacities in working with interview media, referencing and cross-referencing recordings within the expansive space of an interview, and tracing threads that run through different interviews in a collection. These capabilities are beginning to shift the center of practice from the back room of collection-management cataloging to the open, sharable space of the content-management kitchen I invoked—to the place where a broad "we" can explore material in fluid and instrumental modes, finding things of interest and making something new of them. Moving to the kitchen in this way is consistent with the broadened notion of user participation at the core of *Letting Go*'s concern.

But there is an aspect of this shared meaning-making that somewhat qualifies or reconfigures our understanding of user engagement. Consider the generally unexamined assumption that searches and searching are the fundamental modes for engaging the vast information landscapes made available by digital technology. Google, of course, makes this seem utterly natural, since the most casual question yields instant and usually helpful informational returns. But searching is a significantly bounded notion, however powerfully the process can be deployed. Among other things, it presumes and requires a query, to which a response or responses can then be provided. However wide the field, searches are funnels. They select and focus information, changing the space of the field through every iteration and refinement, so as to generate a narrowing stream of responsive output.

But this is not the only way to imagine how we come to know and find value and meaning in an expanse of information. It is certainly not how most productive research and learning happens. For this, something closer to the notion of exploration is required—we may have some broad curiosity or

objective, but we usually enter a landscape and need to be alive to what we may notice, discover, bump into, stumble across, pick up by mistake, and so on. Exploring, I think, is more interesting than searching, and it suggests a non-linear spatial imagination rather than a linear, funneled one: one inhabits a space that is being explored rather than simply forging a narrowing path through it. Lewis and Clark are more important because of what and how they explored than because they answered a search engine's request for the Pacific Ocean.

In this sense, what I find most exciting in new modes of engaging digital information is the unfolding capacity to present such explorable spaces in imaginative, expansive ways, and the deployment of tools for their fluid, non-directed navigation. Both oral history and a range of digital realms are focusing more on creative exploration than on the dutiful provision of answers that can only be as good as the questions. This trend contributes significantly to the broader landscape of "letting go" and sharable authority that the essays in this book explore.

THE LURE OF TEXT AND OTHER TEMPTATIONS

There are, however, some significant countercurrents through which the very power of digital technologies may be constraining what is most transformative in new digital capacities, exerting a sometimes truly reactionary influence. I will mention two that are consequential for oral and public history at the cusp of a new digital age: the role of transcription text, and the temptations of scale.

Digitization makes all information modes effectively the same and hence equally reachable through indexing and cross-referencing, there being no inherent difference between digitized text, sound, and image. Among many other implications, for oral history these tools bring within reach all of the content and meanings in interviews not easily captured in transcription. Now we can see, hear, study, and select nuances that are not readily representable in transcripts, and often not lexical at all. This is what it means to say that the orality of oral history is moving excitingly back into primacy.

At just this open-ended point, however, the traditional reliance on transcription is being reinforced by the ease and utility of instant searches of transcripts, not to mention the anticipation—always around the next corner—of voice recognition software able to produce adequate transcriptions with minimal effort. Ironically, transcription, an arguably outdated modality, is coming to seem more rather than less requisite, with enormous consequences in project cost and labor, because of the instantly enhanced access seemingly promised by searchable texts.

It is the temptations of scale that make the cost and inherent limitations of transcript-based access seem acceptable. A central archival tendency of late is to leverage the unbounded capacity of cyberspace to post large, complex collections to the Web so they can be instantly "accessible" by anyone, anywhere. The larger these collections are, however, the more difficult it is to imagine

providing anything approaching meaningful access beyond the usual listing of interview-level descriptors and, perhaps, themes. More attractive is an increasingly practical route: linking transcriptions to audio or video files by time-codes, so that transcript searches instantly connect to a point in the recording.

This approach can be very helpful for users, and the approach is proving increasingly attractive for many libraries and archives. But it still offers a limited, and limiting, kind of access. Even accepting the practical value of searchable transcriptions and the loss of access to non-transcribed meaning beyond lexicality, the stubborn fact is that people in interviews do not say: "And now I will tell a story about the social construction of gender," or "about class consciousness." They just tell a story about their mother, or a strike—and in so doing they may not actually use the word "mother" or "strike."

Similarly restrictive is the reliance of these modes on searching, rather than on broader mapping of the interviews to permit meaningful exploration and browsing. Considering that we are only beginning to understand how to make fifty hours of interviews explorable at a useful, instrumental level, it may not represent a very significant advance to put thousands of unmapped interviews online, even if accompanied by rudimentary text searches linked to media files. There is a sense in which arriving at the Port Authority Bus Terminal gives one access to the New York City—but without meaningful maps, routings, destination listings, and navigational capacity, not to mention resources, it's not clear what this abstract access can mean. Too many oral history websites, I'm afraid (and an increasing number given funding incentives to make collections accessible online), are closer to the Port Authority than to the Shared Authority I've advocated. Although new digital modes have the capacity to engage oral history users in open-ended, dialogic ways, for the reasons noted here this potential is at risk of being short-circuited by what otherwise seem significant advances in archival capacity.

In this sense, the often unexamined claims of large-scale online "access" makes me wonder whether the "user-generated" (or perhaps more accurately "user-driven") world has really moved all that far past the raw-cooked divide that has been holding back a more meaningfully interactive, dialogic oral and public history. There is much to suggest that this and other currently fashionable digital interface enthusiasms may actually constitute a powerful undertow in the "user-generated" world.

Take, for instance, crowdsourcing and tag clouds, which are increasingly celebrated as both facilitators and expressions of interactive knowledge development, and a way to provide the kind of mapping overview I have been calling for. These can be very productive, powerful, and even inspiring in their capacity to circulate ideas and sustain communities of cumulative knowledge-building. But for online oral histories, the results have been much less impressive. I have seen many sites that offer, with manifest pride in their up-to-dateness, a user-generated tag cloud as the major resource for entering into and exploring the posted documents. While the tagging process may

have been inclusive and exciting, the results are often strikingly the opposite: a screen filled with dense text, a random grab bag of whatever terms anyone offered, arranged alphabetically, which is perhaps the least helpful array imaginable unless you are looking for some very specific term. That use aside, consulting such a cloud list is like looking for a plumber in the (fast-disappearing) white pages.

The much-vaunted digital feature of the form, changing a term's font-size display to reflect the strength of user interest via "hits," provides what is frequently a highly misleading map generated by the limits of crowd psychology. A browsing user confronted with a forbidding wall of microscopic terms among which are three or four lifted into legible size will predictably click on one of those terms in order to find out "what's up." Over time, that term becomes much larger and attracts still more attention, none of which is necessarily informed by genuine user interest in the term. The resulting cloud drifts out to sea, far from any credible claim to be a gauge of the information's significance for users.

I offer these as cautionary observations: new information modalities and capacities are not inherently solutions, and may indeed be part of a continuing problem; they may not help us move beyond the paradoxes of raw and cooked, leaving us still searching for how to create a genuinely active kitchen in which the act of history-making can be truly shared and dialogic in interactive ways. This dilemma remains whether the communities of interaction are localized and embodied or virtually assembled by participants across the trackless wastes of cyberia. The challenge of recognizing, finding, imagining, and enacting a 21st-century shared authority is, in this sense, a more complex and demanding challenge than designing the next app.

KITCHEN TALK AND *A SHARED AUTHORITY*

I'd like to draw the threads of this essay together through some comments on two projects, one of them a major national effort known to almost everyone, and the other a very modest local project in which I'm a participant.

The well-known one is StoryCorps, the exceptionally high profile oral and public history project that is discussed extensively elsewhere in this volume. For many, StoryCorps probably comes closest to embodying the challenge this book poses—a mode of history-gathering and -sharing that has immense popular appeal, involving participants and reaching audiences that more formal oral and public historians can hardly imagine.

StoryCorps has proven very challenging to professional historians, and not just because of the mix of grudging respect, critical concern, and outright envy its phenomenal popularity can hardly avoid inspiring. There has also been estimable skepticism about the value and meaning of the kind of interviews collected and how these are being turned into public commodities, in the full range of meanings that term can have. This mix proved volatile when the StoryCorps founder, David Isay, presented a keynote address at the 2008

annual meeting of the Oral History Association, and was stunned, as was much of the audience, by the barrage of sharply critical comments that erupted in the Q&A following his presentation.

Responsibility for this outcome was broadly shared: Isay had not really prepared a presentation for this audience, out of which points of convergence and difference could have been identified and usefully engaged. Rather, he offered what seemed his standard road-show overview of the project, its mission, and its accomplishments, complete with a large assortment of highlight clips, almost all of them propelled by the poignant emotion of vivid voices and stories that is the hallmark of StoryCorps programs. Whatever their value as radio "driveway moments," these examples proved counterproductive for many in the audience anxious to engage the important issues StoryCorps presents for oral history.

Not hearing these issues addressed in Isay's generic presentation, critics raised them in what many (though not all) found a graceless assault from the floor. Most of the fireworks involved issues of professional authority—can or should StoryCorps really claim to be oral history at all, and if so (or if not) what does that tell us? Others saw in the emotional power of StoryCorps programming evidence of a highly problematic, manipulative, even voyeuristic sensibility even further removed from oral history standards. The result was an unpleasant and not very productive exchange, a great many hurt feelings all around, and a lingering feeling that a needed conversation between professional oral historians and a popular oral history movement, operating almost wholly outside of their professional realm, simply had not happened.

Some of these issues figure in the way the project has been discussed elsewhere in *Letting Go?*, and engaging them directly does not serve the purposes of this essay. But there is one aspect of the StoryCorps challenge that does. It was implicitly present in the discussion, and it has always been part of the mixture of fascination and frustration that make up my own response to the project. I'm struck by how, for all its "letting go" relevance, StoryCorps has been stuck—unnecessarily and not permanently, I hope—in precisely the outdated raw vs. cooked dichotomy that I've identified as the classic fate of 20th-century oral history. This has been explicit in the conception and marketing of StoryCorps. It starts with "raw" in the extreme: interviews can be about anything; there is the populist promise that, once recorded, "your interview will be archived in the Library of Congress," as if a mass of some 30,000 interviews there were in any way a meaningfully accessible or usable resource. (As of today, they are not, despite extensive efforts beginning to be made in this direction.) And at the other end of the spectrum, we have the highly polished, well-crafted "cooked" reduction that appear on NPR every week, selected and refined for presentation by a superb producer and staff in the black box of the studio.

Here is one example of the great opportunity for a post-documentary sensibility, for how raw and cooked might meet in the kitchen: StoryCorps

recorded hundreds of interviews in my home city of Buffalo several summers ago. Our public library would love to make them into an interactive resource, since the interviews contain so many threads of interest and history and local texture. StoryCorps would like this as well, but for now, here and elsewhere, that sharable open kitchen in which others could enter, explore, find, and use things in such a rich mass of documentation is a distant and unreachable dream. The current choices are narrow and binary: raw interviews in a distant archive with uneven metadata and almost no exploratory capacity, and highly polished extracts of a tiny, tiny, fraction of that rich documentation.

The reference to our public library offers a segue to my final example, one that suggests where a post-documentary, open-kitchen sensibility can lead in oral and public history. Recently, I was a small part of a successful effort organized by the Buffalo and Erie County Public Library to obtain a NEH Digital Humanities start-up grant. Called "Re-Collecting the Depression and New Deal as a Civic Resource in Hard Times," the funded project is integrating digitized primary source collections, artifacts, manuscripts, oral histories, photographs, music, art, and site-specific field documentation into community-specific multimedia digital databases; as well, it is beginning to use these resources actively as a core for public programs.

Central to the grant proposal was a statement that could not speak more directly to the concerns animating this book: "While our project will include an interactive web presence, our defining goal is a different kind of interactivity: digital humanities content-management tools that enable the resources to directly support intensive civic discussion and reflection centered in public libraries throughout our community, exploring the links between this legacy [of the Depression] and current challenges. Though locally focused, our project will be a demonstration model of how digital humanities can help a public library mobilize collections to address the civic purposes central to its mission." I can't be sure, of course, but I think what put the grant proposal over the top in an exceptionally tough competition was this somewhat unexpected invocation of active, embodied, public dialogue between people brought together in social space—as something needed, of value, and supportable through innovative digital approaches.

This emphasis on the power of face-to-face dialogue cycles me back, with a kind of shock of recognition, to the perspective I first consolidated in *A Shared Authority*, as I reflected on a range of similarly concrete engagements and contexts. It suggests the surprising relevance of such dialogic notions in a "user-generated world" so often focused on isolated interactions between individuals and computer screens or smart phones and, through those, to other individuals in isolation, however socially networked they may seem to be on their screens. It suggests the continuing importance—even, or perhaps especially, in a digital age—of shifting our focus from the *either/or* of "letting go" vs. "holding on" to the *both/and* of shared authority, finding ways, in all the new modes expanding so rapidly, to enact an active dialogue between experience and expertise, between people working together to reach new understandings.

1 Michael Frisch, *A Shared Authority: Essays on the Craft and Meaning of Oral and Public History* (Albany: SUNY Press, 1990).
2 Michael Frisch, "Sharing Authority: Oral History and the Collaborative Process," *Oral History Review* 30 no. 1 (2003), 111–13.
3 Michael Frisch, "Oral History and the Digital Revolution: Towards a Post-Documentary Sensibility," in *The Oral History Reader*, ed. Robert Perks and Alistair Thompson (2nd ed., London: Routledge, 2006), 102–14; Michael Frisch, "Three Dimensions and More: Oral History Beyond the Paradoxes of Method," in *Handbook of Emergent Methods in Qualitative Research*, ed. Sharlene Nagy Hesse-Biber and Patricia Leavy (New York: Guilford Press, 2008), 221–38.
4 Frisch, "Oral History and the Digital Revolution; Frisch, "Three Dimensions and More."
5 Michael Frisch and Douglas Lambert, "Beyond the Raw and the Cooked in Oral History: Notes from the Kitchen," in Donald A. Ritchie (ed.), *The Oxford Handbook of Oral History* (New York: Oxford University Press, 2011), 333–48.

137

Make Yourself at Home–Welcoming Voices in Open House: If These Walls Could Talk

Benjamin Filene

Michelina Frascone sat down at the kitchen table like she owned the place, and for good reason. Michelina was at the opening of *Open House: If These Walls Could Talk* at the Minnesota History Center. This exhibition told the stories of a single ordinary house in St. Paul, 470/472 Hopkins Street, and the families who made their lives within it from 1888 to the present. Visitors explored roomlike settings showcasing stories from different eras of the house's history. Michelina had moved onto Hopkins St. fresh from Naples, Italy, in 1931, at age 11. She got married in 1943, and she and her husband stayed in the house, raising children, until moving to the suburbs in the late 1950s. On this winter's morning in 2006, Michelina saw the 1940s-era kitchen setting at the History Center and felt like she had come home. She stayed at that kitchen table for eight hours, dispensing hugs and kisses to family, friends, and startled museum visitors alike. From her table, she could hear recordings of her own voice telling stories, and could see photos, quotations, and public records representing herself and her family. "Oh, you got it just right," she exclaimed.

On that January day, the History Center's incarnation of 470 Hopkins belonged to Michelina and the other former residents who came to the raucous exhibition opening. But it was theirs only for the day. Soon others—our museum visitors—took charge of the house, and they did so more decisively than we could have hoped. Perhaps more than in any other previous exhibition at the History Center,

The *Open House* dining room From the 1920s onward, first-person voices tell the stories in the exhibition. Visitors who sit at the dining room table are rewarded with a surprise—images surface in the glass plates and audio tells stories of family dinners during the house's Italian era. Courtesy of Minnesota Historical Society, www.mnhs.org.

visitors made *Open House* their own. The exhibition's floor plan, use of media, and approach to interactives all encourage visitor exploration and spur reflection. But as well, these design strategies derived their power from a more abstract source: the project's approach to story and narrative authority. *Open House* started as an effort to give voice to forgotten people in history; in the end, it allowed visitors to recognize that they themselves have something to say.[1]

No one famous slept in 470 Hopkins, and it isn't architecturally significant (the architecturally minded often gasp in pain at the then-and-now photos). From the start, the project set out to tell the stories of ordinary people in ways that represented them as actors in history. Whereas most historians seek patterns and set out to represent people in aggregate—"the working class," "the immigrants"—this project set out to capture singularity: we wanted to show the rich multiplicity of ordinary people's lived experience and to represent it to our visitors in three dimensions. Behind this approach was a question: how much can a single slice of history reveal about the whole?

The question in itself represented something of an institutional departure for the History Center. Opened in 1992 as the flagship building of the Minnesota Historical Society, the History Center had won acclaim for building exhibitions around what it termed "universal themes"—broad concepts such as family, work, communities, weather, music. Since every visitor comes into the building with *some* connection to these concepts, these broad themes could serve as ready-made bridges for making connections between past and pres-

ent. Indeed, visitors responded with enthusiasm to exhibitions that shared stories about these topics from different time periods, ethnicities, and ages. After a decade, though, some of us on staff wondered whether the "universality" of the themes inadvertently smoothed out history's rough edges: in the exhibitions, past and present started to look almost interchangeable, and individuals sometimes seemed like stand-ins for abstract concepts more than flesh-and-blood people who shaped their own lives in unpredictable directions. *Open House* set out to capture history's inherent messiness—to tell a story that was not a straight line with ready-made lessons, to let the lives of real people from the past guide us in directions that we had not mapped out in advance.

Indeed, for this project, the building at 470 Hopkins was just a frame for a set of stories of the people who had lived in it. That doesn't mean, though, that we chose it without forethought. From the start, I wanted to find a house that had seen change over time and one that could help the History Center address the most significant development in Minnesota's recent history—the arrival of new immigrants, who had transformed the Twin Cities in recent decades.

I began by looking for a promising neighborhood. I wanted an area that was still intact, one that I-94 hadn't bulldozed through; a place that had seen significant shifts in ethnic composition over time, including settlement by recent immigrants; a neighborhood that didn't tell a simple story of gentrification or economic decline; and one that hadn't been researched to death. The answer was Railroad Island, on St. Paul's East Side. Almost completely encircled by rail yards, this neighborhood for generations has been a portal for new arrivals to St. Paul. From the 1870s through much of the last century, its residents came for jobs with the railroad and the nearby brewery. Over the years the neighborhood was dominated by Germans and Scandinavians, then Italians, then African Americans and Hmong. Just a mile and a half from the History Center, it had been mostly overlooked by local history scholarship.

If selecting a neighborhood involved thoughtful research, finding the house proved to be almost as simple as opening a phone book. I began by searching our library's photo database for images of Railroad Island.[2] One of the very first pictures I found was a 1925 photo of a house with some sober people standing in front of it: 470 Hopkins Street. I looked up that address in city directories and saw some names suggesting different ethnicities. At this early stage, that seemed good enough; I could use this house as an example to test out the "one house" approach. But the example stuck! Five years later, I knew the history of the people who lived at 470 Hopkins far better than that of my own family.

Telling the story of 470 Hopkins Street's residents required new

kinds of research. At the outset all we had were names. Associate exhibit developer Ayesha Shariff and I combed through death certificates, birth certificates, wedding certificates, census records, probate records, police records, building permits, fire-insurance maps, and commitments to mental hospitals. Gradually people began to reveal themselves. City directories showed that Albert and Henriette Schumacher, German immigrants who built the house in 1888, opened a pharmacy in town that same year. Church records showed that Henriette died in 1894 of "sugar sickness"—diabetes—after ten months of bed rest. The Schumachers moved out in 1908, and after that, building records show they converted the house into a duplex. The Schumachers then began renting it to a decidedly more working-class and transient series of tenants, first- and second-generation immigrants from Sweden, Canada, Ireland, and Russia who show up in tantalizingly as names and job titles in the census and city directories: James Doyle, depot foreman, Northern Pacific Railroad; Frank Appleton, night watchman. The death certificate for brewery worker Charles Bourne (a 470 Hopkins resident from 1907 to 1917) lists "age and hard work" as contributing causes of death. "Mother tongue: Jewish," states the 1920 census record for postal worker Harry Levey and his wife, Eva. These were the traces of human experience we were seeking.

The turning point in the research, though, came when we began to make direct contact with people who had lived in the house. Through conversations at the local community center, five blocks from Hopkins Street, we found Michelina Frascone at the weekly meeting of a sewing circle that had been gathering at the center for sixty years. In 1931, Michelina had sailed from Italy with her mother, Filomena D'Aloia, and settled on Hopkins St. It had taken Michelina's father, Dominic, ten years of work as a railroad car-repairman in Minnesota to earn the money to send for them. Michelina showed us pictures of the neighborhood when it was like an Italian village: her mother and a relative pose in front of the community earthen bake oven down the street on Hopkins, holding huge round loaves, like boulders, on a tray between them. After Michelina's uncle died in 1945, she and her husband, Russell Frascone, converted the house from a duplex into a triplex to house her aunt upstairs. The Frascones had five children in the house, but in the 1950s they felt impelled to follow Michelina's brother to the suburbs: "I almost had a nervous breakdown," Michelina recalled. "She almost had a heart attack," interjected her husband, Russell. "A nervous breakdown, for sure," Michelina continued. "Moving up here (to Hazel Park), I thought you'd have to put on, you know, the dog and I didn't have any dogs to put on."

Further digging in directories, word-of-mouth links, and bracing

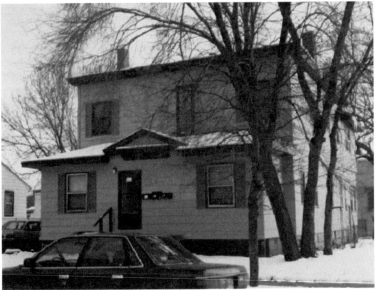

470/472 Hopkins St. in about 1925 (top) and in
2001 (bottom). Bottom photo by Eric Mortensen.
Courtesy of Minnesota Historical Society.

cold calls ("You don't know me, but I'm really interested in a house you used to live in ...") turned up additional contacts. The names on our list gradually began to take shape as real people, and the house came alive with stories. Michelina led us to Angie Krismer, a distant cousin of Michelina's, and her husband, Dick. In the 1950s and '60s the Krismers had raised four children in the house while Dick worked in the South St. Paul stockyards. The neighborhood was no longer so Italian then, but the lives of the triplex residents were no less intertwined. The Krismers had a balky bed that would periodically crash down in the middle of the night, and the neighbors upstairs would tease them the next morning about nighttime adventures. The Krismers also matter-of-factly recalled alcoholism, black eyes, and fights among their triplex neighbors, including an incident when an upstairs neighbor, Evelyn Berry, in a rage threw money at her husband. The coins went raining down into the yard, to the delight of the Krismer children. June Cramer and her daughter, Diane Hegner, confirmed this story, but Diane added, gently, that Evelyn taught her to play cribbage and paid her with change to clean her kitchen.

By the 1980s, the ethnicities in the house and the neighborhood had shifted again. The African Americans and Hmong arriving on the East Side could barely communicate with each other, but they had more in common than it seemed. The populations of both groups were surging in Minnesota—African American people migrating from Rust Belt cities like Chicago, Gary, and Detroit; Hmong fleeing postwar Laos. Both found that long-time residents did not always welcome them with open arms. Both had a hard time finding work. Both sometimes used social services to get their footing—welfare, housing subsidies, Goodwill. Instead of living in 470 Hopkins for twenty years, many did not stay twenty months. Since these groups were not as tight-knit (and since we didn't have access to census records, which remain closed for seventy years), finding these people was our biggest challenge. Through the help of a translator who made a series of phone calls and knocked on a series of doors, we finally made contact with Chia Her, one of the first Hmong refugees to have lived in the house. We arranged an interview at the History Center, and prepared with lunch and toys for her grandchild to play with. "So you remember this house," we began, showing her the photo. "No," she shook her head. Wrong Chia Her.

Eventually, though, we did find the right Chia Her. She and her son, Tommy Kong, told us of growing traditional Asian vegetables in the yard—the same plot where the Frascones grew grapes—and of holding graduation celebrations in the yard. All of these goings on were watched with interest by John Shaw, an African American living in the adjacent unit with his Native American girlfriend. Both

Her and Shaw depended on public assistance in a desperate effort to stay afloat, further complicated, in Shaw's case, by a lengthy criminal record.

By the late 1990s, Shaw (and Her, too) had moved on, and the house (and the neighborhood) was dominated by Hmong refugees: three different Hmong families filled the triplex. I spent the most time with Pang Toua Yang and his wife, Mai Vang. Born in Laos, Pang Toua had fought as an American ally during the Vietnam War. Afterwards, the couple and their children had been forced to flee. Mai's parents had been shot and killed in the forest en route. The family spent four years on a Pathet Lao work farm and two more in a Thai refugee camp before confronting a choice: stay in the camp, with its continual food shortages and cramped conditions, until it closed; return to Laos and face likely persecution; or come to America. Reluctantly they left their homeland, and arrived in Minnesota in 1986.

In St. Paul, Pang Toua and Mai raised vegetables and took care of their grandchildren, but speaking no English made finding a job difficult at their age. Pang Toua always wore a bandage around his arm. He told me that he had dreamed that some children had poked a bee's nest with a stick, causing them to swarm him; the next week he was grilling in his backyard and the bottle of lighter fluid he was using had a hole in it, causing flames to shoot up and burn him severely. To Pang Toua, these stories—the dream and the accident—were connected. And so he consulted both American doctors and Hmong shamans to treat the injuries he suffered. The first thing one saw upon entering the Hopkins St. house was a shaman shrine. "If it's a disease," Pang Toua tells me, "then doctors can cure it, but if it's spiritual, then you need shamans."

Pang Toua and Mai's oldest daughter, Mee Yang, settled into America much more easily. She became a local real estate entrepreneur, owning the house and fourteen other properties, including the house at 470 Hopkins that housed her parents. Tired of mispronunciations, she changed her name to Elizabeth Young.

All told, fifty families lived in 470 Hopkins across 120 years as it shifted from single-family home to duplex to triplex. Eventually Ayesha and I completed three dozen interviews with former residents, gathering first-person recollections dating back to the 1920s. What should we do with these fragments, these voices, these lives? It felt like both an opportunity and a responsibility. What sort of history should this be?

For the exhibition, we decided to showcase voice and memory as directly as possible, keeping the explanatory "historian's voice" to a minimum. We didn't have objects from the house. Occupants had moved too frequently to hang on to much and, of course, the "real" house remained on Hopkins St., busily occupied by Pang Toua

144

and Mai's family. For this project, though, "historic" objects were not essential: our artifacts—our vehicles for authentic connection to the past—were stories. Every story would be from a specific, real person—no fictionalized dialogue or generic accounts, nothing made up. We would embed the words of the house's residents in fully realized three-dimensional settings and invite visitors to uncover them. Visitors would "meet" residents through a series of rooms arranged in sequence over time, each revealing stories about a different family or cluster of families.

When visitors walk into the "rooms" of 470 Hopkins at the History Center, they feel as if they have entered another time, with period furniture, wallpaper, flooring, and lighting. Every space is open for exploration. The 1890s sitting room is salted with stories of the Schumachers. Inserting slides into the magic lantern projects images of the Schumachers and charts their journey from Germany to St. Paul (the first slide triggers a voice: "*Wie geht's?*"). The kitchen showcases the several Italian families who lived in the house from the 1930s to 1950s—Michelina Frascone and her relatives. Opening the lunchboxes on the counter reveals quotations, photos, and tools, each of the twelve boxes profiling one of the manual laborers who headed off from the house each morning to the brewery or the railroad shops. Sitting at the dining-room table triggers a media piece within the dinner plates: Michelina recalls the Thanksgiving Night train accident that killed her uncle, Filomeno Cocchiarella, a track repairman. Touching an illuminated silver dollar in the 1960s bedroom launches home movies and the Krismers' recounting of how they saved coins for their family vacations across Minnesota. When visitors sit on the bed, they hear Angie Krismer recall its tendency to collapse. At just the right point in the story, it falls—a six-inch drop that, in its suddenness, feels like a plummet. As visitors approach the couch in the 2005 living room, the view out the window to Hopkins St. dissolves into scenes of Laos and the Thai refugee camps, and visitors hear Pang Toua narrate his family's journey to America. Across the gallery, quotations from oral histories curve across slices of bread, run across aprons, are cranked out on sausages through the meat grinder, and dance in lights across the walls.

By themselves, the array of voices conveys an interpretation of the past: ordinary people made history. Their stories count, and they deserve a hearing. Beyond this fundamental point, the assortment of stories comments on the fluidity of identity. The exhibition's narrow focus enabled us to represent multiple aspects of people's lives: Russell Frascone was an Italian, a husband, a father, a fire marshal for the Great Northern Railway, and a basement wine-maker. This is how people live their lives, shifting roles to fit the context at hand. Rarely, though, do we historians acknowledge these multiple identi-

ties, especially the more quotidian ones. Historical actors are usually known just for their grandest roles. Inadvertently, then, we reinforce for our audiences the message that history happened to—and, certainly, is shaped by—someone else, people bigger than you. *Open House* set out to counter this message by centering on first-person voices as storytellers and having its main players appear in multiple cameo appearances.

Beyond their number and variety, though, what truly gave these voices power was the substance of their message. The house's residents told stories that not only revealed their lives but reached beyond themselves. Take the example of Dick Krismer. In the backyard setting, visitors can pull down a kite from the ceiling and on the kite itself read Dick's recollections of kite-flying on a weekend afternoon.

> I would probably have three or four rolls of string and that kite would just start going up and up and up and up and I'd start running out. Up on the corner of Payne and Hopkins, there used to be a little confectionery store. I'd send the kids to get a couple more rolls of string and they'd come back and I'd tie it on and we'd let it out further and further. Then all of a sudden, the string would break and away it would go. My kids and the neighbor kids would all pile in the car and we'd follow it.

In one hundred words, this story animates themes of neighborhood, community, leisure, and working-class resourcefulness. Its good-old-days quality is usefully complicated by another story, five feet away. The visitor sees a crusty-looking pair of work clothes hanging from the porch. A label explains that when Dick came home from the stockyards Angie wouldn't let him hang his clothes inside. Approaching the work clothes triggers a motion-activated audio excerpt. If written in curator's voice, it would have read like this:

Concerns for Safety
With increased industrialization, more and more workers worked in close proximity to fast-moving machines. Workplace safety was a common concern for laborers, and injuries were common. With less oversight and regulation than is common today, people worked long hours in uncomfortable and, sometimes, dangerous conditions.

But we didn't need this label: Dick, in twenty seconds of audio, makes the point in a way that visitors are not likely to forget. The clip starts with the squeal of a pig, followed by Dick's voice saying,

146

Until the Humane Society stepped in, they used to take a shackle, flip it around and hook it, pull 'em right up, and the pig would be hanging upside down live, squealing. When you have in a closed area 500–600 pigs, all squealing and stuff like that, that's where I lost my hearing. My hearing is real bad.

Through stories such as these, *Open House* illustrates for visitors that individuals make history and that individuals' experiences can speak to broader historical patterns. This is the exhibition's central insight. When we convened a group of outside advisors, however (through our National Endowment for the Humanities grant), the historians pushed us to consider a broader historical context, too.[3] Individuals have agency in their lives, but we needed also to show that their actions are often shaped by forces bigger than themselves. Dick Krismer's hearing problems illustrate workplace conditions, but they also, indirectly, speak to the limits of federal regulation in the mid-20th century (and the union movement's inability to push for such regulation).

To suggest a broader context for our narrow history, we placed in each room a "window" that looked at the world beyond 470 Hopkins St. Simply a window-framed label on a sky-colored backdrop, the text (titled "A Look Outside") outlines the constraints that the families of each era had to navigate as they led their lives. The Schumachers, for instance, were not operating in a vacuum when they moved out and began renting their house to new arrivals. The window in the hallway leading out of the Schumachers' sitting room reads:

A Look Outside
Many Americans during the early twentieth century looked at new immigrants with suspicion, put off by their foreign ways and, during World War I, fearing subversives in their midst. At the same time, Americans needed immigrants to dig the ditches, lay the tracks, and run the machines that drove the industrial economy. When Albert Schumacher turned his family home at 472 Hopkins Street into rental units, both he and the working-class people who rented from him were playing parts in the new economy. Those with money used it to produce more money; those without worked with their hands and gave part of their wages to landlords.

Likewise, the journey that Pang Toua Yang's family took to Minnesota is a harrowing tale of individual hardship, but the trek was set in motion by forces bigger than his family and his village, as the window label suggests:

A Look Outside

There's a difference between immigrants and refugees. Immigrants leave their homeland voluntarily; refugees flee in fear. The Hmong refugees who settled in St. Paul beginning in the late 1970s had fled Laos to escape being killed for having fought on the U.S. side in the Vietnam War. St. Paul could have been the moon. The language, the climate, the plants, the money, the food, the values, the technology, the houses—nothing made sense at first. Gradually, though, Minnesota began to feel like home, especially to the younger generations. The 2000 census showed 24,000 Hmong in St. Paul, more than in any other American city.

Most visitors don't read labels, of course. Summative evaluation, however, suggests that the interpretive labels in *Open House* are read more frequently than in most exhibitions.[4] Why? The exhibition has only two types of interpretive labels: in addition to the window text, each room has a label on its entry doorway that says what time period the room represents, lists all the house residents at that time, and states the key themes that the room addresses. The doorway to Michelina's kitchen, for instance, lists the many family members and tenants who occupied the house in this era and adds this summary of the room's main idea:

Transplanting the Village

In 1923, the Schumachers sold the house they had built on Hopkins Street to Filomeno Cocchiarella and his cousin Antonio. By the 1930s, the neighborhood was a Little Italy, with many residents hailing from a single village, Fragneto L'Abate, near Naples. Relatives occupied both sides of the duplex (and, after 1945, the triplex) at 470/472 Hopkins. Primarily manual laborers, the Italians depended on their families and neighbors to make ends meet, sharing lodging, food, good times and bad.

Visitors circle back to these labels, reading them aloud to each other.[5] Part of the reason, I believe, lies in the design and content of the text. The labels in "curator voice" are very few in number, are consistently placed, and answer just a few central questions, ones that visitors want answered: Who lived here? When? What is this space about?

Just as important, though, in driving visitors to explore the text may be what the labels—and, by extension the rest of the exhibi-

tion—do *not* say, what they leave out. The exhibition treats these labels as the first words, not the last, about the lives depicted in these rooms. *Open House* mostly leaves the work of making sense of these rooms to the visitors themselves. That is not to suggest that the exhibition makes a pretense that these quirky period rooms are unmediated: squealing pigs, dropping beds, and dancing lights playfully accentuate that these environments are highly *designed*. Yet, appropriate to its title, the exhibition presents interpretation as an open-ended, indefinite process. Visitors are encouraged to explore, but even more they are invited to uncover clues, draw connections, and make meanings.

What makes this detective-work approach work is the exhibition's treatment of evidence. The rooms in *Open House* are embedded with primary sources—period maps, building permits, neighborhood newspapers, census documents, naturalization papers. These sources are printed on tabletops, placed loose on sidetables, pasted inside bookcovers, and affixed to bottles inside the icebox. And visitors discover voices. Touch the piano keys and a voice says "Just-Don't-Ask-Me-to-Play." A label on the piano's music stand explains Martha Schumacher's concert-quality piano-playing skills and her descendants' recollections of paralyzing stage fright. Open the stove door and hear Michelina's brother, Jerry, recount how when meat was rationed during WWII he raised seventy-five chickens in the basement to feed the guests at Michelina's wedding. Step into the bathroom and hear Dick and Angie Krismer giggle about how bathing their four children in the tiny space required an "assembly line" approach. Peer "down" into the basement (an illusion accomplished with mirrors) and hear Russell Frascone fondly recall that his wine press was there—"as big as a table"; Diane Hegner, a generation later, remembers just the press's absence ("a big scary hole"); John Shaw notes that his Hmong neighbors used the same space to slaughter chickens.

What about the people we couldn't find—the voices that couldn't be heard? Inevitably, the research process ran into a host of dead-ends. The 1910s were a particularly challenging period, since the working-class renters passing through the house had sometimes stayed just a few months. The residents had come and gone so long ago that we had only a few fragmentary oral recollections. We had to rely on terse public records that mainly provided names, ethnicity, and profession. Following our "make nothing up" credo, instead of artificially covering over the gap we tried to *represent* the gap as best we could. For each resident, we made a uniform reflecting the resident's job and then screened directly onto the uniform the tantalizing pieces of evidence we did have. The uniform for hatmaker

149

Doris Dahlstrom includes a large red ribbon with text that features a line of data from Dahlstrom's entry in a 1918 *Industrial Survey of Women Employed Outside the Home*: it reads simply "54 hours a week; wages—$9.00." The profile of railroad clerk George De Silva and his wife Daisy features a death notice, a document of a family tragedy lost to history: "De Silva, Saturday, March 4, 1916, at the family residence, 470 Hopkins St. June Eloise, age 2 years 9 months, only child of Mr. and Mrs. George De Silva...." Do these fragments give us any insight into Dahlstrom's weary fingers or the De Silva's heartbreak? We let the visitors decide.

Sometimes we salted rooms with juxtapositions, rewards for the curious visitor. The dining room table features a bound reproduction of the 1940 citizenship exam, in Italian and English, and Michelina Frascone's recollections of its terrifying importance:

> My papa could understand (English) pretty good. Mama, I kind of tried to teach her when I was trying to learn myself. A lot of Italian people got their citizenship papers and I took them. I taught them how to answer the questions and everything. It was all in English. It was kind of scary. They didn't even know how to write in Italian. They never went to school. I'd try to teach them how to write their names.

The living room features the 2005 citizenship exam, and Pang Toua's recollections of its terrifying importance:

> The citizenship exam was quite difficult. Many of my classmates could not pass the test and broke up in tears. We studied constantly for three months. It was translated into Hmong. There was no other way we could have done it. But the names of the lakes you must answer in English and the word "light bulb." The Mississippi River must be answered in English as well. Now I've forgotten it all.

Almost nothing is behind glass.[6] There are forty-two separate places to sit within *Open House*—chairs, stools, couches, loveseats, benches, and beds. Rather than running across the gallery to the next flashing light and the next button to push, visitors uncover layers in the room around them, piecing together information, noting patterns and resonances and tensions.

What message do these layers of primary sources send visitors? They say that not only do ordinary people make history; they can be *historians*. The assortment of sources pulls back the curtain on the history-making process and reveals its contingency, its inherent

Michelina and Russell Frascone, newlyweds, on the steps of 470/472 Hopkins St., about 1943. Courtesy of Nellie and Russell Frascone.

Michelina and Russell Frascone, 2001. Photo by Benjamin Filene. Courtesy of Minnesota Historical Society.

incompleteness, the art of the craft. The remnants of the past are everywhere, enticing yet inconclusive; how the story comes together depends on how you assemble the pieces and who does the assembling. History is a process of discovery, drawing connections, telling tales and making meaning from incomplete evidence.

Even as the museum relaxes interpretive authority, then, it still conveys meaning: "letting go" need not feel like giving up. The museum still consciously thinks of itself as an educational institution and works to create environments that guide visitors to understandings. The messages delivered, though, are less declarative, more open-ended, and more subject to personal inflection.

Visitors seem to get the idea. For the summative evaluation of the *Open House* exhibition, outside evaluators analyzed conversations among forty visitor groups that agreed to have their gallery conversations recorded by wireless microphone; the evaluators conducted more than 130 pre- and post-visit interviews as well.[7] The most striking pattern in the summative findings is how much *Open House* visitors *personalized* history. Yes, they learned something about the Italians or the Hmong in St. Paul, but more they used the exhibition as a setting in which to reflect on their personal pasts. Almost three-quarters of visitors cited connections that they made between the exhibition and their own lives. They linked the exhibition's historical stories to recollections about their families—what the evaluators called their "internal histories."[8]

When one visitor opened the icebox and read about "Fatty Joe," Hopkins Street's ice-delivery man, the story reminded the visitor of his own experience, which he shared with his companion:

(Visitor 1): One of the things that was fun when I was a kid...is when milk was delivered, he had chunks of ice in the back of the milk truck, and in the summer if we were out, he would chip off and give you a piece of ice to suck on.... Well, it was hot![9]

At other points, visitors made emotional connections that reached beyond their own lived experiences. Two visitors exclaimed over a "storybook" in the exhibition that features pages from 19th-century medical manuals along with church records, newspaper articles, and certificates relating to Henriette Schumacher's death:

(Visitor 2): Well, so Henriette died....
(Visitor 3): Ten months she was confined to her bed. Wow!.... Diabetic, oh!
(Visitor 2): She was diabetic.

(Visitor 3): The treatment of diabetes ... but see, they didn't have insulin to treat it.... Wow ... Ugh.... So, well, she was 60 years, 7 months, and 22 days.... Okay, I'm getting unhappy.... I'm wondering if they're going to give her name (in the obituary) or just keep calling her "Mrs. Schumacher" ... [10]

Other visitors created their own stories from the evidence at hand:

(Visitor 4): Crazy. What is this? ... the deed? ...
(Visitor 5): They've got the original building permit right there ... copy of the original building permit. So they made it into a duplex and started renting it ... Oh look at this, this is the first people ... This is so sweet!
(Visitor 4): So he moved in and the hat maker ... I'll bet there's some weird stories here.
(Visitor 5): That's crazy! That's so cool.
(Visitor 4): (This one worked in the) brewery. I'd like to be his friend because I bet he brought good beer home ... [11]

The storytelling in *Open House*, in other words, is not confined to the former residents of 470 Hopkins. The gallery becomes a setting for visitors to tell their own tales and reflect on their own pasts. Indeed, the summative evaluation suggests more lingering in the *Open House* than in other comparably sized exhibitions.[12] And there are hints that perhaps visitors carry this interest in exploring their pasts with them beyond the gallery. In the months after the exhibition opened, the History Center's library reported increased interest in house history and a rise in demand for house-history classes.[13] Perhaps visitors went home with new determination to interview their grandmothers or to decipher the names on the dusty abstract from the purchase of their house?

Does a personalized and poked-around-in past count as history? *Open House* did not set out to explicate the intertwined economic, social, and political forces that shaped mass immigration to America. That was not the point of this project (and, I would argue, not particularly the strength of exhibitions as a medium). *Open House* aimed to tell stories in ways that helped visitors imagine themselves as historical actors and encouraged them to take charge of making meaning from the past. By this standard, the hubbub of chatting, exclaiming, pointing, and explaining was our surest sign of success. Across 120 years, scores of residents had made 470 Hopkins St. their own, but now their voices were reaching outwards, offering a collective invitation: Come on in, and make yourself at home in history.

1 I would like to express my gratitude to the exhibit-development team at the Minnesota Historical Society that created *Open House*: associate exhibit developer Ayesha Shariff; designers Terry Scheller, Brad Thiel, and Earl Gutnik; media developers Jesse Heinzen, Mike Mouw, and Dan Beck; museum educator Danielle Dart; and the director of the History Center Museum, Dan Spock. Thank you especially to the dozens of people who generously shared their life stories with us for this project. Portions of this essay appeared in different form in "Hearing Voices in *Open House: If These Walls Could Talk*," *History News* 63 (Spring 2008): 19–23.

2 Minnesota Historical Society, "Visual Resources Database," http://collections.mnhs.org/visualresources (accessed November 12, 2010).

3 *Open House* received both planning and implementation grant support from National Endowment for the Humanities.

4 Kirsten Ellenbogen, Beth Janetski, Murphy Pizza, "Summative Evaluation Report: *Open House: If These Walls Could Talk*" (unpublished, prepared for the Minnesota Historical Society, 2006), 38.

5 "Reiterative codes frequently captured visitors reading content from labels. Visitors were either recorded as reading labels to themselves or reading out loud to other group members. The objects that most frequently led to reiterative comments were the doors with time period and resident information" (Ellenbogen, Janetski, and Pizza, "Summative Evaluation Report," 38).

6 The exception is a shaman's altar in the Hmong-era living room, made from paper.

7 Ellenbogen, Janetski, and Pizza, "Summative Evaluation Report," 8.

8 Ellenbogen, Janetski, and Pizza, "Summative Evaluation Report," 4. Evaluators found that connections to these "internal histories" surfaced, on average, more than three times per transcript, significantly more often than conversations related to "external histories," the wider history beyond the visitor, which on average appeared once per transcript (4). Ellenbogen adds that as visitors "place themselves within the larger historical narrative,... both internal and external histories simultaneously acquire relevance, which is key to constructing personal meaning...." (7).
 The evaluation notes (41–42) that 71 percent reported making personal connections to the exhibition content. Of these, 61 percent connected the historical stories to personal experiences of their own:

Experience	Percent
Experiences similar to stories told	13%
Grandparent's house	13%
Lived in an old house/architecture	11%
Growing up experiences	9%
Family were immigrants	8%
Moved a lot	7%

9 Ellenbogen, Janetski, and Pizza, "Summative Evaluation Report," 23.

10 Ellenbogen, Janetski, and Pizza, "Summative Evaluation Report," 23.

11 Ellenbogen, Janetski, and Pizza, "Summative Evaluation Report," 36.

12 Evaluators found the median time spent in the 5200-square-foot exhibition to be thirty-three minutes, seven minutes longer than visits to a comparably sized adjacent gallery, with the longest being over eighty minutes (Ellenbogen, Janetski,

and Pizza, "Summative Evaluation Report," 14). Impressionistically, the gallery seems to suffer less damage than others in the History Center. Could it be that people sense the space's "houseness" and therefore treat it more gently?

13 The library reported that among first-time registrants there, the numbers of people who cited "house history" as their purpose nearly doubled, from 96 to 163. The library offered an extra class in the spring after the exhibition opened, making statistical comparisons inexact from year to year (Minnesota Historical Society, "Final Performance Report, *Open House: If These Walls Could Talk* (for implementation grant)," Submitted to the National Endowment for the Humanities, August 2006).

155

The Black Bottom: Making Community-Based Performance in West Philadelphia

Billy Yalowitz

Graphic art by Pete Stathis

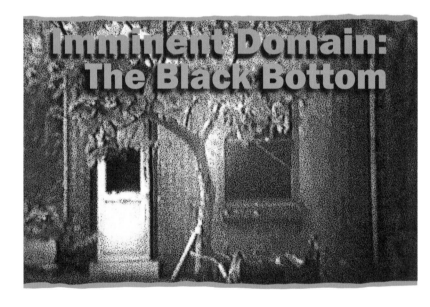

We live in a magnificent universe in which we must play our humble part. The City is among man's most important physical creations: therefore we are under a particular obligation to make our cities places of which we can be proud.

The area known as the Black Bottom contains an assemblage of skid row habitués, who spend their days and evenings lounging in Franklin Square when they're not panhandling, and cast a depressing shadow over the City, living in a morass of decayed and decaying buildings, some nondescript apartments, and vacant lots.... The Redevelopment Authority is a public agency whose mission is to restore neighborhoods. This often requires tearing down bad houses to insure that the residential character of neighborhoods can be maintained for the future.
—*Philadelphia Redevelopment Authority brochure, 1954*

The Black Bottom neighborhood was dynamic and alive. People were employed by area hospitals, small factories, as domestic helpers and maids, by the now-defunct Pennsylvania Railroad, and the defense industries during WWII.... Picnics, block parties and other social functions were common; churches were active social and civic forces, and there were numerous self-help and music and writing societies.

This was the era of walking and visiting, no invitation required; locking front doors was unheard of. Though many were poor, Black Bottom children had music and dance lessons, and took full advantage of nearby cultural resources. Black-owned businesses in the area included barbershops, dressmakers, restaurants, beauty shops and variety stores.
—*Dr. Pearl Simpson, former Black Bottom resident, "The Black Bottom Picnic," May 1997, Institute for Africana Social Work*

How can community voices, telling stories of the past, challenge official histories and address legacies of inequity in the present? In this essay I'm going to explore this question by telling the story of one community theater project in one city, the Black Bottom Performance Project, created in West Philadelphia in 1997–2000.

The Urban Renewal Act of 1954 spurred municipal policies that destroyed working class and poor communities, particularly communities of color, in cities throughout the U.S. In West Philadelphia, the Black Bottom was one such community, destroyed by the Philadelphia Redevelopment Authority and the University of Pennsylvania in the

1950s and '60s. People who were uprooted and displaced by these policies have an important tale to tell to those of us who are interested in economic justice and housing policy in urban communities today.

As a theater artist who works with communities to create participatory public history projects through community-based performance, I look for a key story—a story which, when told, will help unlock forces of progressive change. Key stories are collective memories that may be untold, hidden, half-forgotten, and which often embody underlying tensions and ongoing oppression between different groups within a community.

When I arrived at the University of Pennsylvania (Penn) as an adjunct faculty member in the Theater Arts program in the fall of 1997, I started listening for what the key story might be in the relationship between the community and the university. It quickly became clear that in the relationship between West Philadelphia and Penn, that story was the destruction of the Black Bottom, an African American neighborhood that was located in an area immediately bordering the Penn campus. As I began to investigate, a key storyteller was introduced to me, Walter Palmer. Palmer grew up in the Black Bottom, became a leader in the Philadelphia Civil Rights and Black Power movements, and now teaches courses on American racism at Penn's School of Social Work. Through him I began to meet the people of the Black Bottom.

I read through some transcripts of interviews that Palmer had conducted with elders of the old neighborhood. Their stories jumped off the page with urban adventures of the 1940s and '50s, complete with colorful nicknames—Too Tight the Cop, Peachie the Newspaper Man, Fish, Munch, Eddiewood, Boss, Peanut, Snake, Rock. With address lists from Palmer, my students and I began to set up interview dates with some of them. Thirty years after being exiled into different locations in and around Philadelphia and beyond, people from the Black Bottom are still in contact with one another, gathering several times a year for church services, cabarets, mutual support, and, more frequently now that the community is aging, for funerals of old friends. Up to 5,000 Black Bottomers and the several generations of their descendants gather each year in Fairmount Park for a picnic reunion. As my students and I got to know them, it became apparent that the leaders of the Black Bottom community were interested in two things: having their story told, and receiving some kind of restitution from the University of Pennsylvania. After an initial period of checking me out—understandably, since I was employed by one of the institutions that destroyed their neighborhood—once they saw that I could listen, they became increasingly interested in the idea of creating a performance based on the story of their community.

Foreground (left to right): University City High School student in *Taking A Stand*; a Black Bottom resident. Background: mosaic mural by Andrea Zemel at UCHS.

With this preliminary research, we began the project in the spring of 1998, when I taught a course called "Community Performance in West Philadelphia." Drawing students primarily from the Theater and Urban Studies programs, the course began by giving students a brief introduction to the theory and history of the emerging field of Community Arts, and then shifted into a field internship in which the students would work with me in the local community. We would have two partnering groups in this project—the people of the Black Bottom and their organization, the Black Bottom Association, as well as a group of students and teachers from the local University City High School (UCHS), which was built at the geographic center of the former Black Bottom neighborhood, after its destruction. The Penn students and I walked through the neighborhood with former Black Bottom residents; each sidewalk square evoked stories of the life of their community. We drew also from the writing of Dr. Pearl Simpson, a social worker who grew up in the Black Bottom and wrote about the community (see the second epigraph p. 157). We learned that the community was made up mostly of African Americans who had come to Philadelphia from the Carolinas and Virginia in the migration north between the two world wars, in search of jobs, economic opportunity, and to escape the Jim Crow South.

As we proceeded with our research, we discovered that the two very different histories of the Black Bottom are still tangling with each other today. From the Black Bottom residents' point of view, theirs was a community rich with culture, mutual aid and fellowship, extended

159

family, and the pleasures of urban life. They were proud of their neighborhood, and fiercely loyal to it. They felt fortunate indeed to call the Black Bottom home.

The Philadelphia Redevelopment Authority and the University of Pennsylvania, however, painted a very different picture of the neighborhood in the 1950s, seeing it through the lens of "urban decay" (see first epigraph). These very different perspectives on the neighborhood set the stage for what was to follow.

Mention the University of Pennsylvania to many African Americans living in West Philadelphia and you may receive an angry stare, perhaps a bitter tirade. For good reason: the Black Bottom was completely destroyed by the so-called urban renewal programs of the 1950s and '60s. Residents were denied home repair loans and mortgages, duped into signing relocation papers, told they would be moving into brand new housing units close to their old homes. In fact, the universities in the area (Penn, and nearby Drexel) had requested land for institutional expansion and in 1948 the request was quietly granted by the Philadelphia Redevelopment Authority. The university administrators' and city planning officials' version of urban renewal was to build a corridor of science research buildings—which employ almost no one from the immediate neighborhood—while much of the land of the former Black Bottom is vacant, or used as parking lots. (The area of the Black Bottom was about thirty city blocks, bounded

by 34th St. to the east, 40th St. to the west, Sansom St. to the south and Powelton Ave. to the north.) Market Street and the surrounding area now look and feel like an urban ghost town. Looking at the geography of the university, it is clear that the Black Bottom was destroyed in order to create a kind of border zone between the campus and the community. In the process, the former residents of the Black Bottom were scattered all over the Delaware Valley and beyond.

MAKING *BLACK BOTTOM SKETCHES*

Coming nearly thirty years later, our collaboration with UCHS was initiated through Penn's Center for Community Partnerships (CCP) which develops partnerships between the university and local schools and organizations. In our project, Penn students were involved in helping to teach UCHS students acting skills and oral history interviewing, in the context of a social studies class. Black Bottomers were invited to the high school to tell of their neighborhood, beginning with stories about themselves as young people in the 1930s to '50s—vivid accounts of childhood games, block parties, the whole neighborhood listening on the radio to Joe Louis's victories and celebrating. The community's powerful sense of trust, safety, and communal responsibility for raising children were described, as well as the various forms of cultural and community organizations that thrived in the Black Bottom at its

Previous spread:
Black Bottom
Sketches, speakers:
Cecilia Harris and
her grandmother
Sarah Davis (left);
Minnie Burnett
Morton (right).

height. The destruction of the neighborhood was also recounted, giving a clear picture of how the public policy of this era forcefully destroyed their community. In describing urban renewal, one of the Black Bottomers sardonically called it "Negro removal," quoting James Baldwin's appellation from the early 1960s.

These interviews were transcribed and became the basis for script-writing, which was a three-step process. The Penn students created composite characters and wrote scenes based upon the transcribed stories; the high school students improvised scenes and characters of their own. We then took the draft scenes to rehearsal sessions with the Black Bottomers at local churches and community centers, where they were read and critiqued. The Black Bottomers had final say about which scenes to change and to include in the performance. Some cast themselves in roles that were created from their own stories, and Dr. Simpson, who had become an important advisor in the project, performed in the piece as well. Some played their own parents, or themselves as young people. The high school students also chose roles that interested them. We decided upon seven scenes, composed to make a "sketch" of the neighborhood.

162

A few months into the rehearsal process, the Penn students and I were invited to attend the Black Bottom's Valentine Cabaret, an annual social event where families set up tables in a large church parish hall in a kind of indoor block-party/dance, which seemed to me to be a kind of re-creation of the neighborhood. Families—sometimes four generations' worth—bring their best food dishes and drinks to share, and visit until the wee hours of the morning. I prepared my students by emphasizing participation, not observation, even past the point of extreme awkwardness for some of us as white middle-class people at a working-class African American event. The cabaret proved to be a good opportunity to make friends with the people of the Black Bottom. Our presence was warmly welcomed and appreciated, and friendships began that night that continued throughout the project. And by participating, we learned a great deal about the community of the Black Bottom—its inclusiveness, generosity, styles of dance and fashion, and sense of humor.

In April 1998, a forty-person cast comprising Penn students, UCHS students and teachers, and Black Bottom community members performed Black Bottom Sketches at the local Metropolitan Baptist Church, which many Black Bottomers remembered as the site of teenage dances and socials. We designed the piece as a kind of living installation, an adaptation of the Black Bottom Valentine Cabaret style of sitting, visiting, and "performing" with people seated banquet style in a large fellowship hall. We began the performance by having people introduce themselves to one another at the tables,

where we'd appointed a "storyteller" from the Black Bottom to host the invited guests from Penn and the high school. Each table functioned as a kind of storytelling circle, as between scenes we stopped the action so guests could ask Black Bottomers about the events and characters portrayed. Around the space were five video monitors, on which were shown edited home movies gathered from Black Bottomers, which interspersed the scenes and live music created by professional musicians, most of them from the Black Bottom. The standing-room-only audience included Black Bottomers and their children and grandchildren, high school students, parents and teachers, along with a smaller group of students, faculty, and administrators from Penn. It was an exuberant community event, marked by inspired improvised additions to the written script by the performers and enthusiastic outbursts of recognition and support by the audience. At one point, during a missed cue, Black Bottom Association President "Pest" Wilson took things into his own hands: he signaled the lighting board operator to turn the lights down low and the band to play a slow dance number, and called an old friend up to dance. Their duet, doing the neighborhood dance called the "Slow Drag" (see p. 166, top left), was met with cheers and whistles.

After the performance, a number of Black Bottom leaders got up to spontaneously address the audience, greet friends, and speak to the new relationships built between community residents and Penn students and faculty. Afterward we shared food together, and audience members from the Black Bottom, UCHS, and Penn spent another two hours continuing to get to know one another in the hall.

163

THE COMMUNITY IMPACT OF *BLACK BOTTOM SKETCHES*

The process of *Black Bottom Sketches* gave the Black Bottomers a chance to voice some of the most important stories from their lives, as well as to get across important information about the destructive effects of urban renewal policies on them. They were proud and spirited in proclaiming the goodness of their community. They could see the importance of their life stories for younger people, most of whom have not had the good fortune of living in a community like the Black Bottom. And performing for the first time was an invigorating challenge for the Black Bottomers who chose to act in the production. The high school actors similarly responded to the performance opportunity, having had input about the script and learned about the history of their neighborhood. The two generations compared notes about street games, exchanged dance steps, and enjoyed contact with each other; the relationships between them felt like a re-uniting between long lost family members who had been separated by the historical circumstance of the destruction of their neighborhood.

Black Bottom Sketches: U.Penn student actor Sam Fuchs as City Planner.

In one scene, set in the 1950s, a "city planner" character gave a sales pitch to the audience, explaining why the Black Bottomers should give up their homes to make way for the "new metropolis." The text was adopted from Philadelphia Redevelopment Authority's brochures of that era. Black Bottomers in the audience shouted out their outrage at these descriptions of their community, and their refusal to go along with the plan. It was an enjoyable, boisterous, and poignant moment, as many in the audience had a kind of group catharsis about a very painful moment in their history. Being dispossessed of their homes was especially hard on the elders of the neighborhood, many of whom endured deep feelings of loss, grief, and bitterness. From Dr. Simpson I began to understand how the entire social structure of their lives had been dismantled, with few opportunities to reassemble it. Most found themselves in unfamiliar sections of the city where they were unable, at that point in their lives, to develop anything like the community they had built in the Black Bottom. One older woman, Sarah Davis, performed a scene in which she told her granddaughter about her youth in the Bottom, reflecting on the changes that being forced out of the neighborhood meant for her life (see p. 160, middle left).

For the Penn students, the project provided an opportunity to form relationships with people from whom they had been systematically separated and about whom they had been taught a pack of lies. They became familiar with the neighborhoods near Penn that they had learned to fear. They were able to use their skills in real ways.

Boy watching bull-dozer destruction Photograph: Walter Joseph, 1967. Background: mural by Andrea Zemel.

During the performance, some of the Penn students cried as they watched their efforts as acting coaches, teachers, and writers bear fruit. The Black Bottom leaders made them "honorary members" of their community. In short, a real exchange of different kinds of knowledge and intelligence took place among the project's participants.

In working with the Penn students, I emphasized that we were in most ways to be led by the people from the Black Bottom. We would best understand our roles as listeners and learners—taking in their stories and their lives, and offering skills we had in creating performances. Understanding our project as an exchange challenged elitist notions of art-making for the Penn students, and encouraged Black Bottom participants to value their own knowledge. Having the goal of creating a performance created a group discipline, within which the white and African American participants got to appreciate each other's efforts, to watch each other take on challenges. And, while it was already clear to the Black Bottomers, the Penn students developed an understanding of the university's role as a real estate developer, essentially a large corporation that furthers its own self-interest at the expense of local working-class people of color.

DEVELOPING TRUST, AND *TAKING A STAND*

After the success of *Black Bottom Sketches*, I met with members of the Black Bottom Association to form a more cohesive Community Advisory Council to evaluate the project and consider next steps. In the process of creating *Black Bottom Sketches*, I had become aware

of a submerged narrative of resistance to the destruction of the neighborhood—a series of sit-ins at City Hall, community meetings at churches, neighborhood tours given by community residents, negotiations with city planners, and an occupation of Market Street and of one of the university buildings. I presented these stories to the Community Advisory Council, most of whom had not been aware of these events, and discussed ideas to create a new piece based on them. The Council reacted positively to the proposal to create a performance based on these activist stories. So we began work on a next piece, to be called *Taking a Stand*.

Taking a Stand was performed in a black box theater at the university's performing arts center. In staging *Black Bottom Sketches* at a community site, the idea had been for the community to host the university. For *Taking a Stand*, the Black Bottomers were interested in a more conventional performance venue, with more professional production values, utilizing the university's resources to make the Black Bottom story more visible to a wider audience. This was a step in the direction of the community articulating its need for university resources in order to accomplish its own goals.

Taking a Stand was also marked by a different kind of participation by Black Bottomers. One former neighborhood resident, Walter Joseph, came forward with

slides he had taken of a bulldozer destroying a home in the neighborhood, taken while he was a soldier on leave from Viet Nam in 1968 (see pp. 165, 171 top right, and 172). We included these slides in the production, accompanied by the UCHS Gospel Choir singing "Sometimes I Feel Like A Motherless Child" and monologues read by Black Bottomers, written by Penn students based on their oral histories. Other scenes were performed by the cast of fifty—UCHS students, Penn students, Black Bottomers, and several guest artists—based on the stories of activism we had gathered.

Community ownership of the performance went further. Walt Palmer brought his own semi-improvised scene into the play, a stream-of-consciousness monologue punctuated by his tap dancing, for which he had been known as a teenager in the community (see opposite, middle). The monologue began with commentary on the relationship between the university and the Black Bottom, and went on to celebrate some of the leaders of the Black Bottom, the "good, the bad, and the ugly" of the community, as Walt likes to put it. He called audience members by name—some of who had been his boyhood neighborhood heroes—asked them to stand and told stories about them. Walt finished his monologue with a call-and-response invocation and memorial to the ancestors, those Black Bottomers who had died since the destruction of the neighborhood more than thirty years prior. Audience members called out the names of their deceased family members.

And Walt called *me* out during this piece. In his improvised monologue, he recounted his relationship with me: "Billy Yalowitz, this white guy from Penn, came into my office two years ago, to ask about the Black Bottom." I wondered what he was going to say about me. As he tapped, he continued, "I don't trust white people. I wanted to see what Billy wanted from me, from us." He didn't resolve his story as to what he had decided about our working relationship or about me. My response at the time a fear of public criticism mixed with a recognition that by acknowledging the process that we had gone through together, he was in effect showing a growing degree of trust in me.

Walt's tap dance–monologue is an excellent example of the complex, multicoded performance dynamics that can occur when academics and artists share authorship with community members. In both form and content, this piece interrogated my agency as its director—introducing "unrehearsed" content not previously agreed upon, and also holding me accountable for any ways in which I, and by extension the university, might be repeating the historical pattern of institutional racism in the project's very process. In the case of a theater performance, such institutional racism can take the form of appropriation. Who gets the credit, who gets the publicity, who gets

Opposite: From top, *Black Bottom Sketches*: John "Pest" Wilson and Mable Johnson Brown; Pearl Simpson and UCHS student Muffy Echevarria; Walter Palmer (twice); Reggie Height and Penn student actor Brandale Randolph. Far right: UCHS and Penn cast of *Taking a Stand*.

167

paid and who doesn't? These questions are certainly present in all university activity in the community, including real estate dealings, academic research, and community-based arts. Walt was marking the territory of the Black Bottom on the stage, posing the question— who will gain advantage by the telling of our story, in this transaction between the community and the university? To be able to ask these questions directly to an audience made up of Black Bottomers and Penn students, faculty, and administrators was perhaps in and of itself a small step forward in community-university relations.

TOWARD A WIDER AUDIENCE, AND *EMINENT DOMAIN*

After *Taking a Stand,* the Black Bottomers continued to be interested in having their story told more broadly, and I was interested in tapping into the more universal aspects of their story of dispossession, resistance, and the desire for restitution. I was looking for a hybrid form which would continue to be community-based but would also allow the project to go forward more independently of the UCHS's involvement and Black Bottom leadership, which had begun to decrease as the rapidly aging members of the Council—many in their late 80s, or infirm—became less able to participate. I began to formulate a plan to develop a professionally written piece that would be performed by a cast consisting of professional performers, along with some of the most motivated UCHS acting students, and Black Bottomers who were interested in continuing to perform.

So in 1999–2000, the Black Bottom Performance Project commissioned Philadelphia playwright Ed Shockley to write a new script with the working title *Eminent Domain,* which aimed to place the story of the Black Bottom into larger historical and allegorical contexts. I introduced Ed to the Community Advisory Council, shared with him the transcripts of the oral history interviews, and he began work on writing a script. To engage faculty, students, and community members in the writing process, in March 2000 we coproduced with the Penn Humanities Council a forum called "Narratives of Dispossession, Exile, and Return," which included Penn faculty members from the departments of History, English, African Studies, and Social Work, Black Bottomers, and guest artists. The faculty members spoke on the forum themes, bringing a rich array of perspectives to the playwriting process. Local actors performed excerpts of the evolving script of *Eminent Domain,* which began with a monologue based on the day on which the Philadelphia City Council declared a Black Bottom Day. The forum took place at the Civic Space of WHYY, Philadelphia's public television and radio station. "Narratives of Dispossession, Exile, and Return" became a university-wide and citywide event, and an excerpt was recorded and broadcast on the local edition of National Public Radio's "Morning Edition" on April 28, 2000.

168

OUTCOMES

Following spread: *Taking a Stand.*

At the outset of the project, in conversations with Walt Palmer, and with John "Pest" Wilson, Stanley Edwards, Pearl Simpson, and others from the Black Bottom Association, many former residents of the community talked about their desire for reparations from Penn for the destruction of their community. This meant different things to different people. The stated hopes ranged from a gathering space at the university or in the neighborhood, to college scholarships for their grandchildren, to retirement housing. At different points in my work with the community, the issue of reparations would be raised, but without a clear direction forward. Besides the need for legal resources and the means to finance them, the question of how to organize the effort was a daunting one. And organizing was made more difficult, it seemed to me, by internal divisions among the Black Bottom leaders. I supported the Black Bottomers in their goal of pressing for some kind of reparations. It seemed to me that my contribution was to bring attention to the issue and help to activate various constituencies through the means of community-based performance, and to help bring to the table whatever resources I could.

In fact, in concert with and building on some of Walt Palmer's ongoing efforts, during the three years of the performance project the story of the Black Bottom became more widely known at Penn and in Philadelphia. Walt's tireless efforts working for reparations included the initiation of a declaration of an annual Black Bottom Day by the Philadelphia City Council. A large contingent of Black Bottomers turned out at the City Council chambers on the day the declaration was made, and text from the declaration was performed as part of *Taking a Stand:*

169

> Whereas the Black Bottom was designated as an impoverished area for urban renewal and eminent domain, it should be remembered that the Black Bottom was wealthy with courage, love, spirit, and soul.
>
> We formally designate the last Sunday of August as the Black Bottom Day in the City of Philadelphia, in fitting tribute to the history and legacy of this great and historic community.

While there were some mixed feelings among the Black Bottomers about the real value of this declaration, I saw it as part of voicing the Black Bottom story more widely throughout the city, which could help in efforts toward reparations.

The project also helped to create strong and trusting relationships among Black Bottom community members, Penn faculty and students, and UCHS students; the initiation of a Theater Arts pro-

gram at UCHS; the spawning of other Black Bottom projects and courses conducted by Penn faculty, including the creation and installation of a ceramic mural about the history of the Black Bottom (see pp. 159, 165, backgrounds) and a course on the sociology of the neighborhood. The project did create increased awareness among Penn students and faculty about the history of the Black Bottom and the university's role in destructive urban development practices. I saw *Taking a Stand* as "dressing up the present in the clothing of the past," as community performance director Richard Geer puts it—that is, telling the relatively safer story of Penn's past injustices as an allegory for its current expansionism in the neighborhood, and in this way raising the issue in a public forum.

And the Black Bottom Performance Project became very much a part of citywide discourse about Penn's plans for further expansion in West Philadelphia in 1998 and 1999. A series of Philadelphia *Inquirer* articles in 1998 and 1999 discussing Penn's plans for further expansion into West Philadelphia mentioned our work, with one profiling the project in detail.[1] A few months later, the cover story in the *Philadelphia Inquirer Magazine* opened the past history and present controversy about institutional expansion to public scrutiny in a new way.

Penn still has its critics, including Walter Palmer. He thinks Penn should pay reparations to descendants of Black Bottom residents. Judith Rodin (then Penn's president) dismissed such talk out of hand. "If people think we need to be doing reparations, people don't understand what we're trying to do."[2]

The *Inquirer* article took the perspective that the university, by its then-current community relations practices, had corrected its past errors, without fully recognizing the effect of those dealings on the former residents of the Black Bottom, or taking seriously the community's interest in redress. While the writer did give lip-service to Palmer's dissenting point of view, Rodin got the last word. In this case, the *Inquirer*, in its seemingly neutral journalistic role, serves to support the official story, which sees urban planning driven by the priorities of large institutions and real estate developers as benign, or at least inevitable.

THE ROLE OF COMMUNITY-BASED PERFORMANCE IN PUBLIC HISTORY

Although material reparations were not achieved by the Black Bottom Association, the community's participation in the Black Bottom Performance Project yielded many positive outcomes.[3] Through the project,

but when I came back *from* **THE WAR**
...the Bottom as I knew it was
GONE

whole *FAMILIES...*
...were *uprooted*
my community gone
...the streets started to look
like a mouth full of
snaggled teeth

all the houses... gone.

172

one could begin to imagine a different kind of relationship between an urban university and the community in which it exists, one in which the relations of power are transformed and a culture of cooperation, exchange, mutual respect, and urban vitality is developed, where:

- the life stories of community elders become key texts for university students
- community youth become intimately familiar with the university and its resources, forming close relationships with university students, so that their sense is that the university is "theirs," not a foreign power to be resented and to act out anger upon, and it is a logical step for them to consider attending that university when they graduate from high school
- university students develop a loyalty and respect for the community in which they were educated, based in personal relationships and tangible results of projects they have contributed to and in which they acquired invaluable real-life experience
- university faculty and students develop long-term relationships with community leaders and young people in their shared fields of interest, which become working partnerships where university and community planning and cultural life are developed for the common good of all who share the land and its resources.

As the community told its history in its own voice—both the strengths of its cultural history, and its destruction—it challenged the official story of Philadelphia's urban planning history. The official version is represented in the current physical configuration of the area, in which the university-driven corridor of science buildings constitutes a kind of erasure of the Black Bottom, silencing its history architecturally as well as socially. And so the creation of the Black Bottom Performance Project was a counterbalance to this erasure. The seeming permanence of a brick-and-mortar displacement of a human community was thus challenged by a community-based theater process in which the power of people's stories, the relationships formed, and the cultural space thus established points toward a different future.

1 "The Drama of Black Bottom: Residents Lift Voices Anew," *Philadelphia Inquirer*, April 22, 1999.
2 "How Penn Got it Right," *Philadelphia Inquirer Magazine*, September 19, 1999, 42.
3 Dr. Pearl Simpson and I were invited to present about the Black Bottom Performance Project at the conference "Imagining America—Artists and Scholars in Public Life," in Chicago in 2000, on best practices in campus-community projects in the arts and humanities.

173

Listening Intently: Can StoryCorps Teach Museums How to Win the Hearts of New Audiences?

Benjamin Filene

I can count on Friday mornings for a good cry. I'm driving to work, listening to *Morning Edition* on NPR, when the familiar ascending notes on the guitar give the signal. "It is Friday morning," says host Steve Inskeep, "and time for StoryCorps, the project that records conversations between friends and loved ones."[1] I brace myself. "Last week we heard a conversation from Michigan between Colbert Williams and his son, Nathan. Colbert Williams was just 16 when his son was born.... Just before he became a father at age 16, he left home because his family was too poor take care of him. Today we meet the man who took Colbert in—his fifth-grade math teacher, Ralph Cantania. Ralph, who was divorced with no children of his own, became Colbert's legal guardian."

And then the voice shifts. It's Cantania himself now, asking in a steady, matter-of-fact tone, "Was there anything that you feared about moving in with me?" Williams's voice in reply is deep and jovial: "Oh my gosh, are you kidding me? Everything!" he chortles. "I didn't know what food you ate. I didn't know your background. All I knew was that you were a nice teacher, and you were going to take me in because my mother didn't have a place for me to go.... I didn't have any idea as to what to expect from you. I'm a young black man and you're a white man. And I'm like, 'I don't know anything about white people.'" They chuckle. Then they shift to remembering when Williams became a father and his determination to raise the

baby, and the tone changes. Cantania's voice gets a little thicker as he says, "I think what impressed me the most was your comment, 'My son is going to know who his father is.' And watching you walk past the waiting room at the hospital and him cradled in your arms. I will never forget that."

And then the kicker, out of the blue: "How have we impacted your life, Ralph?"

"My gosh," and there is a quaver in Cantania's voice. "You know, when you're single for a great period of time you become basically set in your own ways. And then somebody else comes along...." We feel the emotion surge now as Cantania says, "I have truly been blessed. There is. There is no other way." And the voice cracks and Cantania clears his throat. "There is no other way to explain it." Still steady, Williams says, "What you see in me is a reflection of what you put in me. And today I say thank you." And we hear just a sound—expelled breath—as Cantania gives in to the emotion of the moment. And my own resolve crumbles, too, and the music gently returns in the background and, sigh, the tears are, once again, running down my cheeks.[2]

What makes StoryCorps so powerful? Why do millions of people sob their way to work and come back for more? Does the project illustrate the power of letting people tell their own stories? Are they really telling their own stories? Should museums be taking notes about how to engage new audiences, or does the project offer a cautionary tale about what is lost when history moves into popular culture and historians lose control?

StoryCorps is an elegantly simple idea. Participants, usually in pairs, make an appointment to have a conversation in a soundproof recording booth.[3] A trained facilitator greets them, offers a sheet with potential questions, and asks which participant will act as interviewer and which as interviewee. The participants then sit across from each other at a table with a desk lamp and two microphones and talk. Kleenex is at hand. The facilitator runs the recording equipment, and, sometimes, inserts a question into the conversation. After forty minutes, the session ends; the facilitator takes a photo of the participants and hands them a cardboard sleeve containing a CD

StoryCorps founder Dave Isay. Photo by Harvey Wang, courtesy of StoryCorps.

copy of the interview. A second copy is sent to Washington, DC, to be archived at the Library of Congress's American Folklife Center.[4] Participants pay what they wish, with a recommended contribution of $10.[5]

The project started in October 2003, the brainchild of radio producer Dave Isay. First there was a recording booth in Grand Central Station. In 2005, with interest surging, two mobile recording booths, built into silver Airstream trailers, set up in front of the Library of Congress's James Madison building. Ten days later they set off to record in cities and towns across the country, usually for stints of two-to-three weeks, a tour that continues to this day.[6] Also in 2005, NPR began airing edited excerpts each week, and "Suddenly, we were a national project," Isay recalls.[7] "A year ago we had zero visibility," Isay marveled in 2006. "This past year when we pulled into Missoula, Montana, people on the street waved and applauded."[8]

Isay may have been surprised by the speed of his success, but from the start he had grand visions for the StoryCorps. "Help us make history," an early fund-raising brochure urges: "Become a part of the SC movement."[9] Like a movement, StoryCorps aspires to transform its rank-and-file members at several levels. Examining these aims can help us understand what drives the project's extraordinary appeal and, as well, can show how the project both draws on and departs from other history projects in key ways.

First, and most directly, StoryCorps sets out to spark a shift in historical understanding: it wants to demonstrate powerfully, viscerally, exhaustively that ordinary people shape history. This message was highlighted as one of the project's "simple assumptions" on its website even before the first booth had opened: "The lives of everyday people are as interesting and important as the lives of the rich and famous."[10] As StoryCorps archivist Taylor Cooper summarizes, "This is the history of America by America for America."[11] In the first press release promoting the project, Isay spoke of wanting "to tell the stories of ordinary Americans with dignity, celebrating the power and poetry in their words" and of helping Americans "appreciate the strength in the stories of everyday people."[12] In his collection, *Listening Is an Act of Love*, Isay wrote, "History is often told from a top-down perspective of politicians and the privileged. StoryCorps will instead create a bottom-up history of our country through the stories and voices of everyday Americans."[13]

Indeed, the edited StoryCorps pieces that appear on NPR and in the project's published anthologies depict ordinary people as actors in the events of our times, big and small. Virginia Hill Fairbrother offers a more powerful sense of the Great Depression than any textbook, remembering the pungent smells of her sixth-grade classroom in Parshall, North Dakota:

> A lot of people at that time still didn't have bathrooms inside, so they didn't wash as much as they should have or could have. All the little girls in those days, if you had a birthday you got a bottle of Blue Waltz perfume, which had kind of a vanilla odor. You got four ounces for ten cents. So every girl used perfume. The little boys used cough drops with a licorice odor.... We had a wonderful teacher who never said a word about the smell. We had to spend five minutes of the recess time outside, and then we could come in because it was so cold. While we were out, she raised all the windows, and when we got in, it was colder than you could believe, but there was no odor for a little while.[14]

Memphis in 1968 is remembered for the assassination of Martin Luther King, Jr., but retired sanitation worker Taylor Rogers in his interview recalls the working conditions that precipitated the strike that brought King to town:

> We had troubled working conditions, low salary. It was awful. You go deep back in these backyards, dump the garbage out of these fifty-gallon drums into these tubs, put that tub on your head or on your shoulder, bring it out to the truck, dump it, and move on to the next house. Most of those tubs had holes in them, and garbage would leak all over you.[15]

Sam Harmon reflects that the saddest day of his life came when he was in the Navy during World War II. Stationed in Norfolk, he drove to Washington, DC, for the day. After hours of of walking among the monuments, he decided to go the movies and approached the glass ticket booth: "I reached my hand (in) to get the ticket and lay down the money. (The ticket-seller) pulled it back.... She saw my black hand and refused to sell me a ticket. (In reflection on the glass) the Capitol dome was superimposed on her angry face...."[16]

Debra A. Fisher recalls how her father carried with him the legacy of his experience at Auschwitz. "He never waited on line. I remember that.... Because the line was for people to die, and that was how he framed his life."[17]

Other stories give voice to contemporary experiences—of homelessness or AIDS or domestic abuse.[18] Often, too, they call attention to less fraught parts of everyday life: the simple pleasures of a lifelong marriage, the pride in running a small-town post office, the life lessons parents learn from their children.[19] Through the hundreds of stories that StoryCorps has showcased, a collective portrait of America emerges—a citizenry of diversity and strength; committed to hard work and sustained by quiet pride; determined in adversity and imbued with an overwhelming decency.

In celebrating unsung Americans, StoryCorps builds on documentary projects that preceded it, particularly those launched during the New Deal era. The Federal Writer's Project (FWP), led by folklorist B. A. Botkin, threw the weight of the government behind collecting the stories of ordinary Americans—fishmongers, needleworkers, and copper miners. The FWP famously recorded the memories of enslaved African Americans, seventy years after emancipation. Also in the 1930s, Alan Lomax and his father, John, dramatically expanded the size and reach of the Library of Congress's Archive of American Folk-Song. The Lomaxes traveled thousands of miles to record the songs of Americans of all walks of life, particularly African Americans and Appalachian mountaineers.[20]

Dave Isay is well aware of this legacy. His book *Listening Is an Act of Love* opens with a quotation from Alan Lomax: "The essence of America lies not in the headlined heroes … but in the everyday folks who live and die unknown, yet leave their dreams as legacies."[21] In the project's first press release, Isay describes StoryCorps as "the spiritual heir to the documentary work created under the W.P.A. more than half a century ago … the most important social documentary archive ever created."[22]

The embodiment of the link between StoryCorps and the documentary impulse of the thirties was renowned interviewer and author Studs Terkel. Terkel got his start with the Federal Writer's Project before launching a radio interview show in 1952 (which ran in Chicago for over forty years), becoming a television mainstay, recording untold hundreds of oral interviews with Americans, and publishing a dozen oral history collections.[23] Terkel used mass media to advocate for the little guy (and, sometimes, gal)—the beleaguered hard-working American who, with plain-spoken wisdom and rueful humor, worked to keep his head up through the turmoil of the 20th century. To Terkel, StoryCorps was the fulfillment of his populist vision: "StoryCorps is history in the richest sense of the word. It is a bottom-up history, history that will make people feel like they count. Nobodies become somebodies."[24] At age 91, it was Terkel, in Grand Central Terminal, who cut the ribbon on the first StoryCorps booth, proclaiming, "Today we shall begin celebrating the lives of the uncelebrated!"[25]

178

In key ways, though, StoryCorps' ambition extends in directions that Botkin, the Lomaxes, and Terkel never recognized. Recording stories and editing and disseminating them is only part of Isay's vision. Importantly, he wants to open up not just a new way of understanding history but also new avenues for *participating* in it. With the sudden affordability and simplicity of digital technology, Isay feels, everyone can be his or her own oral historian. StoryCorps is dedicated, in part, to encouraging and enabling everyone to take advantage of this opportunity. "(O)ur dream is to make it possible for all Americans—regardless of their resources—to have the opportunity to preserve the stories of their loved ones and friends."[26] StoryCorps is "a nationwide initiative to instruct and inspire people to record meaningful oral histories with older family members and others."[27]

Beyond building a national collection of stories, then, Isay wants StoryCorps to engender a wave of storytelling. To share and save their stories, Americans don't need trained oral historians to guide questioning, ensure accuracy, or supply context. This is the "corps" in StoryCorps: millions of Americans—all of us—are deputized to fan out to create an oral history of America. "I joined the conversation," says the bumper sticker sent to participants following their interview.[28] In this sense, the project is less like the Federal Writer's Project than another New Deal program, the Civilian Conservation Corps (CCC), which enlisted three million underemployed young men to plant over two billion trees to reforest America.[29] StoryCorps believes in the power of collective energy more than in the expertise of specialists. The tools for saving America's stories, StoryCorps shows, are not complex; everyone should grab a shovel, and future generations will thank us.

StoryCorps makes a series of moves—both symbolic and practical—to position Americans themselves as the authors of this project. The first-person plural pronoun "we" dominates the project's promotional materials: "Join StoryCorps as we record our history, hopes, and common humanity"; "We *are* our history, individually and collectively."[30] The staff at StoryCorps recording booths are "facilitators," not interviewers. The people recorded are "participants," not interviewees. The project wants to empower people to take the lead in sharing and gathering stories. In addition to its permanent and mobile booths, StoryCorps rents out "StoryKits" that provide recording equipment and instructions for how to record interviews. These interviews, too, will be added to the Library of Congress archive. Free of charge, StoryCorps offers downloadable instructions for conducting one's own interviews, including a "DIY Instruction Guide" that shows you "how to start your own archive."[31] In effect, StoryCorps is applying what Web developers call "crowdsourcing" to the job of documenting America's heritage: inviting a mass of participants to create a

body of material larger than any single person or institution could manage on its own.[32] "We're asking you to take our job," Isay writes, referring to himself and other documentarians—"seeking out and recording the extraordinary stories of ordinary Americans, whether they come from your grandfather, neighbor or friend."[33]

This sense of collective authorship marks a departure from the work of the project's godfather, Terkel. Even as he reveled in the voices and viewpoints of America, the main character in Terkel's work was Terkel himself. The title of his collected works was *My American Century*, and indeed, for all of his democratic ideals, Terkel was possessive in his viewpoint.[34] He celebrated the lives he chronicled, but the vision of America was his. His own rasping voice—probing, exhorting, bemoaning America—may be his most lasting legacy. Ordinary people mattered, but they needed him, their advocate, to step in and share their stories. StoryCorps does trumpet Isay as a MacArthur "genius" and describes him (in his mid-forties) as a "legendary producer," but the overriding message of the project is that these stories were created, saved, and shared by the participants.[35] If, as Terkel believed, everyone has something to say, then Isay wants everyone to say it.

Yet "saying" is only part of the StoryCorps equation. Even as the project strives to bring recognition to ordinary people's stories and to position everyday Americans as storytellers, its biggest ambitions lie not in the telling but in the hearing. Most broadly, the project sets out to engender a new kind of national conversation, one in which everyone talks and everyone listens. Listening is the single dominant theme that runs through all of the StoryCorps promotional materials: "Our mission is to honor and celebrate one another's lives through listening"; "a movement around the power of listening"; "a nation of listeners."[36] StoryCorps not only wants people to record their loved one's memories but for them to *hear* each other differently. The project, Isay feels, will "teach participants to become better listeners."[37] "We want the entire nation to take the time to ask life's important questions of a loved one—or even a stranger—and *really* listen to the answers."[38]

The idea of a better life through listening, while inherently intangible, is, in its own way, political. Isay explicitly envisions "creating a change in our culture."[39] He wants to build community through honest communication and the recognition of Americans' common dignity. In pursuing this goal, he sees StoryCorps as challenging powerful destructive forces in contemporary society: "(I)f we spent a little less time listening to the racket of divisive radio and TV talk shows and a little more listening to each other," Isay writes, "we would be a better, more thoughtful, and more compassionate nation." StoryCorps

interviews, he feels, "remind us that, contrary to what we might infer from the media, we are not just a nation of celebrity worship and consumption but, rather, a people defined by our character, courage, and heart." Ultimately, the project is about "shaking us out of a reality TV–induced slumber and redirecting our energy toward careful listening, honoring our elders, and embracing our neighbors."[40]

This emphasis on cultural—even cognitive—change makes StoryCorps much more than an archival enterprise. The project posits that sharing one's story—*and being heard*—is an inherently beneficial experience for both speaker and listener, one that can reform contemporary relationships. Isay sees StoryCorps as "all about the act of interviewing loved ones, with only a secondary emphasis on the final edited product." The project "invert(s) the purpose of traditional documentary work from an artistic or educational project created for the benefit of an audience to a process principally focused on enhancing the lives of the participants."[41]

The project's graphics reinforce the message. Fund-raising brochures, for instance, feature a series of photographic close-ups of faces—a range of colors and ages, in pairs or threes—sometimes kissing, sometimes arm-in-arm, sometimes heads on shoulders. *Always* they are touching each other: StoryCorps —*listening*—brings people together, the images say.[42] By contrast, the cover of *The Studs Terkel Reader* (2007) shows just one image: a three-olive martini.[43] Terkel gives Americans a powerful kind of story—hard-bitten, undiluted, with a kick. StoryCorps, by contrast, offers us a different way of communicating. As Isay's book title reminds us, "Listening is an act of love."

But is it history? In some ways, StoryCorps' ambitions are familiar to historians. Ever since the "New" Social History flowered in the 1960s, academic researchers have dedicated themselves to understanding how ordinary people experienced the past, to telling history from the "bottom up." This impulse likewise reshaped the approach of history museums, which worked to reach beyond governors and generals to build collections and exhibitions about the lives of working people. StoryCorps may use a different medium, but its commitment to recovering ordinary people's stories is nothing new.

Yet in key ways, StoryCorps' approach to history is alien to historians—a difference in methods and priorities that may explain why the project emerged from outside the public history ranks and, significantly, may also account for its success. Professional historians have been trained to be wary of emotion. Years of graduate work and peer review inculcate the value of being dispassionate. We are supposed to gather evidence, evaluate preponderances, and track patterns, all with an eye toward creating balanced interpretations,

Interior of the Lower Manhattan StoryCorps recording booth, 2008. Photo by Benjamin Filene.

free of factual inaccuracies, that advance or overturn conclusions in the body of literature that precedes us. Moreover, we are trained to move beyond the scope of the individual. Local history is suspect as parochial; family history is subject to ridicule as self-absorbed. Context is king. The goal is to see how an individual event, action, or attitude connects to a wider web of forces that reflects its times. While few historians in our postmodern era would describe their work as a science, it certainly is a *discipline*. Trained professionals have dedicated themselves to a craft that involves gaining fluency in reading sources; advancing informed interpretations; and pushing beyond narrow, fleeting concerns to greater understandings.

StoryCorps simply sidesteps these issues. It wholeheartedly embraces emotion, for instance. Few historians would title their masterwork "an act of love." Following from Isay's belief in the cathartic power of conversation, StoryCorps treats emotional reactions as the surest sign of success. After opening a recording booth at the site of the 9/11 World Trade Center bombings, Isay wrote an excited update to Peggy Bulger of the Library of Congress's Archive of Folk Culture:

(One woman) told me that in the booth she saw her mother cry for the first time since losing her son. We have heard lots of other stories like this—survivors venturing down to the site for the first time since September 11 because they felt they simply had to participate, rescue workers finally starting to talk about what they witnessed that day, sessions so powerful and meaningful that they all but defy description. And this is all in week one![44]

The project's deputy director, Matt Ozug, characterizes the typical StoryCorps radio feature as "this tiny little highly crafted piece ..., very highly produced audio that's like genetically engineered to be tear-jerking and, you know, make people—I mean they (the production staff) really go for the jugular with the emotional content."[45]

Not only does StoryCorps set aside the historian's commitment to reason, it takes a very different approach to that bulwark of historical meaning-making: time. Change over time is how historians measure significance: before and after, compare-contrast. Historians divide and subdivide time into ever-shifting movements, periods, eras, and epochs. Historians see each moment in the past as shaped by unique sets of circumstances that need to be understood both on their own terms and in relation to what preceded and what followed.

StoryCorps, by contrast, tends toward a much less precisely peri-odized past. There is "now" and there is "then." Interviews almost always look back but they do not usually explore events beyond a single lifetime, and rarely do the forces of historical causation extend beyond the participant's own family. The people featured in the StoryCorps compilations remember farming or going to school or coping with cancer—or, more dramatically, committing crimes or fighting segregation or fleeing the World Trade Center in a cloud of dust. But, fitting the philosophy that everyone has a story to tell, these events—even the world historical ones—unfold within the field of vision of one person, the storyteller.

While historians painstakingly trace connections between people and their times, in StoryCorps people's stories stand on their own as self-explanatory, with little historical context to account for their actions. *Why* was your grandfather able to farm but your father forced to sell the land? What tax policies, technological changes, urban-planning assumptions, or consumer habits contributed to this situation? How were Virginia Hill Fairbrother's experiences (and memories) of the smells of her sixth-grade Depression-era classroom shaped by federal policies toward public education, by child labor laws, by shifting norms of cleanliness, by depictions of the noble poor in New Deal–funded photos of the era? In StoryCorps, every story stands on its own: people's lives are described, not explained, and to historians they feel unnaturally self-contained.

At the same time, StoryCorps implies that each of these stories stands for all of us, a universalizing move that equally challenges core assumptions of historians. The project's books and radio broad-casts suggest timeless values and enduring humanity. Isay divides *Listening Is an Act of Love* into sections on "Home and Family," "Work and Dedication," "Journeys," "History and Struggle," "Fire and Water." The volume *Mom* has three sections: "Wisdom," "Devotion," "Enduring Love." The broad themes offer everyone a way into the story: we all

183

have families; we are all on life journeys; we all yearn for wisdom. In choosing stories for radio, senior producer Michael Garafolo assesses whether they connect to enduring human issues: "Is the person talking about something, whether it be an emotion or an experience or something, that is really broadly experienced by people and something that will resonate with them? I think that's a first step, if it can strike a chord."[46]

Appropriate to StoryCorps' commitment to the transformative power of listening, these connecting points transcend societal boundaries. When math teacher Ralph Cantania, his student Colbert Williams, and Williams's baby son set up house together, they created a family whose racial, class, and gender configurations do not match traditional assumptions. When we radio listeners hear their story, though, these differences slip away: we simply identify with the power of family, even though the shape of Cantania and Colbert's family may be very different from our own. "These stories are a record of our shared humanity," Isay writes. "(N)o matter who we are or where we come from, there is much more in common that we share than that divides us."[47] People are people, StoryCorps suggests. Yes and no, historians would reply: people in 2011 are decidedly different than in 1911 than in 1811. The all-embracing sweep of StoryCorps challenges historians' allegiance to change over time and rouses their suspicion of generalization.

Perhaps not surprisingly, aspects of StoryCorps rankle professional historians and oral historians. Even as they generally appreciate the project's allegiance to ordinary people's stories, some professionals question its methods. The *Oral History Review* published a piece, entitled "What Is StoryCorps, Anyway?," in which four scholars struggled to find a disciplinary label for the project. In the end, while admiring the project's reach, they concluded it didn't fit into the discipline oral history:

> (T)he highly sculpted techniques of the interviews (in many cases eliciting an often-rehearsed moment, story, or memory) and the forty-minute time limit on the interview diverge from the current practice of oral history…. Oral history creates transcripts, and increasingly publications, that are unruly and reveal the tracks of the investigator. By contrast, the StoryCorps editing in *Listening* is so expert that it leaves no traces at all. There are, for example, no ellipses to remind the reader that this is an edited text, no false starts or digressions…. In our view, then, the StoryCorps interview is less an oral history interview than it is a highly ritualized performance that inserts the tellers into a larger public culture of affect and remembering."[48]

In this volume, Michael Frisch recounts how Isay faced hostile criticism for the project's "highly problematic, manipulative, even voyeuristic sensibility," with many professionals questioning whether StoryCorps "can or should ... really claim to be oral history at all."[49]

For all its eloquence about the power of archiving and its commitment to preserving the fleeting past, however, StoryCorps doesn't claim to be a work of history: "(I)t's called an oral history project," deputy director Matt Ozug reflected, "but we certainly don't compare it to most academic oral history, and actually we get in trouble sometimes from people who do this for a living or, you know, have a degree in oral history. We're not doing that.... This is very different.... (W)e tried to be fairly clear about the fact that this was not oral history in the traditional sense." Senior producer Michael Garafolo concurs in discussing the work of the production group: "I wouldn't call what me and my team do history."[50] Strikingly, none of the core creative or administrative positions in the organization are held by trained historians.[51]

In fact, in ways that hold important lessons for the public history profession, the success of StoryCorps may *depend* on breaking free from conventional historical expectations. Fundamentally, StoryCorps is not about accumulating knowledge and understanding of the past. Even as it records thousands of memories to be held in perpetuity at the hallowed Library of Congress, it is most powerfully for—and about—the ephemeral present. Questions about historical inaccuracies in participants' recollections, about emotional manipulation and the absence of reasoned interpretation, about the lack of context, about the absence of experts' viewpoints all miss the point. StoryCorps has power because it demonstrates, over and over, a much more fundamental lesson: the past exists and we carry it with us every day. More than a project for documenting or interpreting history, in other words, StoryCorps is a brilliant tool for inculcating *history-mindedness*—the realization that we live poised between something that came before and something that will come after.

Some of the project's simplest decisions reinforce this message. In the published anthologies, for instance, each story begins by giving just names, ages, and recording locations—no photographs of the participants. Only *after* reading the emotional tales of devastating loss or enduring love do we see, below the date of the remembrance, images of the speakers—smiling, face-forward, seemingly self-confident but unremarkable if we had passed them on the street.[52] Wordlessly, the photographs make us realize how much past lies just beneath the surface of people, all of us: Holocaust survivor, miner's daughter, Korean War veteran—one never knows what history people carry with them. As a memory project, then, StoryCorps looks both forward and back: it invites us to reflect on how much of the

186

present recedes into the past without a trace; and it helps us feel the past as a presence that ripples all around us.

In this sense, StoryCorps is akin to time capsules, another archiving form that instinctually resonates with the public (and another that carries meager credence with professional historians). When a time capsule is opened, it inevitably reveals more about the people who assembled it than about the era it purported to document. A time capsule looks to posterity, but really it is of us and for us in the present. Likewise, the power of StoryCorps stems from its ability to encourage people to take ownership of the past in the here and now—to claim history as their own and find personal meaning within it.

But how much freedom do StoryCorps participants really have? Again like a time capsule, the degree of freewheeling choice that StoryCorps allows is somewhat illusory: it, too, is a box with boundaries. For all its emphasis on participant empowerment, the StoryCorps experience is in fact tightly constrained. Participants are allowed exactly forty minutes to record. They are given a set of questions to consider in advance, mostly ones that encourage the kind of come-together emotional expression that StoryCorps prizes: "What was the happiest moment of your life?" "How would you like to be remembered?" "Do you have any regrets?" "Do you (as a parent) remember what was going through your head when you first saw me?"[53] The "What to Expect" orientation on the StoryCorps website notes that "Emotional questions like 'how does this make you feel?' often elicit thoughtful responses. Don't be afraid to ask." It adds, "(Y)ou can laugh or even cry with your storyteller.... (K)eep an open heart. Great things will happen."

Interview facilitators also shape the StoryCorps process. As participants record in the wood-paneled, soundproof studio, appointed

like a modernist den, a facilitator sometimes interjects with questions to help keep the conversation moving forward productively. As well, the facilitator keeps a log of key topics and, immediately after the interview, uses a checklist to track the subjects and subheadings addressed in the conversations: "Reminiscences: traumatic memories"; "Rites: birth of first child"; "Community life: corner stores"; "Education: schoolyard bullies."[54] The facilitator also decides whether any part of the conversation was particularly compelling. If so, the facilitator flags it, does an initial edit, and sends it to the StoryCorps production team in Brooklyn.[55]

While the full forty-minute conversation is archived in Washington, the most dramatic interventions to the stories occur in editing excerpts for radio and publication. There is, without doubt, a StoryCorps aesthetic: the publicly showcased pieces often feature humor, wry or rueful but rarely uproarious; the storytellers are usually articulate but not usually identifiably highly educated; the stories have a tight focus but don't get bogged down in details of geography or dates. Always, they build momentum, often to a tear-inducing climax. Asked what he looked for in a story, producer Michael Garafolo replied, "The simplest thing is that a story has a beginning, a middle, and an end.... (People in these interviews don't often tell things that way.... (F)inding the ending is often a big challenge. If there's no ending to a story we're just not going to use it. There's got to be a payoff of some sort."[56]

Comparing the edited stories to the full interviews in the archives reveals how crafting these pieces tends to shear the stories of some of their more thorny complexities. One particularly poignant tale of redemption in *Listening Is an Act of Love* is that of Eddie Lanier. The edited excerpt is a harrowing story, in which Lanier's alcoholism leads to homelessness and nearly death before a passerby (David Wright, the interviewer) connects with Lanier and, eventually, invites him into his home.[57] To give the story its shape involves significant rearranging. The edited version begins with Lanier saying, "My daddy was elected mayor of Chapel Hill twice," right off establishing Lanier as a fallen son. This detail, though, only emerges seventeen minutes into the original conversation, in response to a question from Wright: "Would you say you come from a good family, a predominant family?" While it is true that Lanier's father was mayor, Lanier initially identified him, nine minutes into the interview, as a student loan officer at the University of North Carolina who trained as lawyer.

The main thrust of the edited story is that a basic shared humanity connected Lanier with Wright and Wright's family. Editing helps keep the focus on this universalizing message. Recalling the key moment of their connection, Lanier in the edited story says, "On New Year's

187

Eve I had no family, nowhere to go.... You said, 'I'm going to take you home with me for New Year's Eve.'... And your wife was so nice. We had lots of things in common that we got to talk about."[58] The original audio does not contradict this statement, but gives additional details that could prove distracting: "And your wife and I had things in common, lots in common.... She was a shy thing. One of her hobbies was the search of the paranormal, the flying saucer thing, and I was into that, always have been. It's been one of my hobbies, the paranormal. And we got off pretty good on that in conversation." To encourage listeners to identify with the Wrights, the editing works to keep them somewhat nondescript. Instead of devotees of the paranormal, they remain relatively shapeless characters, allowing us the listeners to project ourselves into the story: that could be me; people are people.

Likewise, editing allows Lanier to stand more purely as a victim, a person with an inherited curse of alcoholism that led to self-destructive behaviors. The edited version does not shy away from the rocky road Lanier took—"I had just been released from my twenty-eighth treatment for alcoholism"—but it trims a series of examples that might cause readers to dwell on the damage Lanier caused to those around him. In the original interview, for instance, Lanier recalls that "When I got home in the afternoon from work to my first young wife I drank a fifth of hard liquor every night—*every* night." Then Lanier recounts how he shifted to drugs: "snowflake cocaine." He recalls working for the state as a child labor law investigator: "I was doing cocaine and drinking while I was on the job and had an incognito car with a pistol permit—too drunk to walk but drunk enough to drive." All of these details are eliminated from the edited story. Likewise the edited anecdote does not include mention of a cruel prank Lanier pulled on his father, gleefully recalled across eight minutes, in which Lanier slipped an entire box of Ex-Lax into his father's cereal: "He had diarrhea dripping out of his shoes, wing-tipped... (with) a three-piece suit and a necktie," Lanier chuckles.

Lanier's story is, on its merits, heart-wrenching. And, of course, turning forty-minute conversations into three-minute radio pieces necessarily involves editing. StoryCorps nowhere pretends that the excerpts are uncut.[59] The point, rather, is that these interviews are in no sense the unmediated "Voice of the People"—and that it doesn't matter. The power of an edited StoryCorps piece lies in its narrative arc and its emotional impact more than its factual precision. If editing distills a story's meaning and concentrates its strength, so much the better, StoryCorps would say, even if some flavors get heightened in the process. What matters to StoryCorps is that Americans feel that their voices are being heard, not whether project staff has fine-tuned and amplified the voices along the way.

Here is where history museums and public historians can learn from StoryCorps. Most directly, the project demonstrates the power of seeing history as stories. Colorful characters and dramatic tension and release are ingrained in history; only willfully (or blindly) do we overlook them. Likewise, the project shows that emotion powerfully conveys meaning and is meaningful in itself. If museums tell stories—rich, complex ones that engage emotions—then visitors will engage, reflect, and, likely, be moved to tell stories of their own.

Beyond these core lessons, though, museum historians can learn from StoryCorps' ability to navigate between untrammeled popular participation and highly filtered, "curated" contributions.[60] StoryCorps can help museums re-imagine their relationships with visitors who, increasingly, want to feel like active participants in making meaning. As historical authority relaxes, where do experts belong? If people can explore the wilderness on their own, is there still need for a zoo—and zoo-keepers? As it combines bold efforts to unleash the power of voice with steps to channel that power, StoryCorps suggests yes. The success of its blend of open access and tight control shows that audiences do not actually want to be cast out into the jungle of raw information to fend for themselves. While they want opportunities to make discoveries, to pursue their own interests, and to feel that those interests are being taken seriously, audiences operate most successfully within boundaries, and they seem to recognize that.

Allowing museum audiences to create meanings—what Tom Satwicz and Kris Morrisey in this volume call "public curation"[61]—does not mean tossing the curator to the lions. Where would StoryCorps be without Isay and his crew suggesting questions, running recording equipment, facilitating conversations, depositing recordings in the Library of Congress, selecting and editing the juiciest anecdotes, publishing books, and making the case across the country for the worthiness of the contributed stories? Audiences don't resent expertise; they just want to be active participants in conversations about meaning.

Envisioning opportunities for visitors to participate and make meaning requires *more* not less expertise from museum staff. We need the skill to shape historical content while leaving it fluid. We need the ability to inspire others to try their hand at crafting interpretations. We need the right touch to assist them if asked. Making history in the museum becomes not just an act of gathering evidence and constructing interpretations but of sharing the act of interpretation and inviting re-interpretations.

But hasn't it been that way all along? Perhaps when historical authority is unmoored it doesn't drift so far after all from historians' bedrock values. Historians know that history is a never-ending conversation about contingent meanings. The difference now is that the

experts don't always have the last word. Models such as StoryCorps remind us that there are always new stories to be told, full of meaning, told from the heart, and awaiting human response. Museum historians can play an important role in the conversation— if we are ready to listen.

1 National Public Radio, "A Boy Raises A Man—And Becomes One Himself" (broadcast February 26, 2010), http://www.npr.org/templates/story/story.php?storyId=124092252 (accessed June 2, 2010).

2 National Public Radio, "Teacher Takes in a Teen, and Gains a Family" (broadcast March 5, 2010), http://www.npr.org/templates/story/story.php?storyId=124321674 (accessed June 2, 2010).

3 Occasionally, individual participants are interviewed by the facilitators. See, e.g., interview excerpts from Ronald Ruiz and Richard Pecorella, included in Dave Isay, *Listening Is an Act of Love: A Celebration of American Life from the StoryCorps Project* (New York: Penguin Press, 2007): 86, 207.

4 "The StoryCorps Interview Step by Step," in "Ask Now, Listen Forever," ca. 2008, promotional brochure in author's possession.

5 Charisse Jones, "Story-Collection Project Brings Out the Extraordinary in 'Ordinary' Lives," *USA Today* (October 28, 2003), in StoryCorps Corporate Subject File, folder 2, Archive of Folk Culture, American Folklife Center, Library of Congress (hereafter AFC, LC).

6 "Media Advisory: News Conference to Announce Launch of Mobile StoryCorps Booths at Library of Congress," StoryCorps Press Kit (May 18, 2005), in StoryCorps Corporate Subject File, folder 1,AFC, LC.

7 Isay, *Listening Is an Act of Love: A Celebration*, 103.

8 In James Hardin, "StoryCorps Revised: Oral History Program on Its First Anniversary," *Library of Congress Information Bulletin* (July/August 2006), http://www.loc.gov/loc/lcib/06078/storycorps.html (accessed June 3, 2010)

9 "Help us make history," Fund-raising brochure, undated, in StoryCorps Corporate Subject File, folder 1, AFC, LC.

10 Printout of StoryCorps home page (October 3, 2003), in StoryCorps Corporate Subject File, folder 2, AFC, LC. The other assumptions given are that: "There is enormous value in recording and preserving our stories," "A microphone gives people the license to talk about issues that might otherwise never be explored," and "Listening is an act of love."

11 Transcript of author's interview with Desiree Leary (archives senior coordinator, StoryCorps) and Taylor Cooper (facilities and archives coordinator, StoryCorps), Brooklyn, NY, August 7, 2008, 12.

12 Dan Klores Communications, "National Oral History of America Project Kicks Off at Grand Central Terminal" (October 2003), in StoryCorps Corporate Subject File, folder 1, AFC, LC.

13 Isay, *Listening Is an Act of Love: A Celebration*, 163.

14 Isay, *Listening Is an Act of Love: A Celebration*, 166–67.

15 Isay, *Listening Is an Act of Love: A Celebration*, 190.

16 Isay, *Listening Is an Act of Love: A Celebration*, 184–85.

17 Isay, *Listening Is an Act of Love: A Celebration*, 174.

18 Isay, Listening Is an Act of Love: A Celebration, 114–19, 196–200, 83.

19 Isay, *Listening Is an Act of Love: A Celebration*, 264, 70–71; and Dave

Isay, ed. *Listening Is an Act of Love: Notes on Ten Beloved Stories—and How to Record Your Own* (New York: The Penguin Press, 2007), 10.

20 Today the Archive of American Folk-Song is the Archive of Folk Culture, housed within the Library of Congress's American Folklife Center. For a discussion of the Depression-era fascination with chronicling the lives of ordinary people, see William Stott, *Documentary Expression and Thirties America* (1973; Chicago: University of Chicago Press, 1986). For discussion of the period's fascination with folk culture and folk song (including the work of Botkin and the Lomaxes), see Benjamin Filene, *Romancing the Folk: Public Memory and American Roots Music* (Chapel Hill: University of North Carolina Press, 2000).

21 Isay, *Listening Is an Act of Love: A Celebration*, unnumbered front page.

22 Klores Communications, "National Oral History of America Project Kicks Off."

23 "Studs Terkel: Conversations with America," http://www.studsterkel.org/bio.php (accessed July 29, 2010).

24 "StoryCorps: Listen Closely," undated press kit material, ca. fall 2003, in StoryCorps Corporate Subject File, folder 1, AFC, LC.

25 In Isay, *Listening Is an Act of Love: A Celebration*, 3.

26 "Help us make history."

27 Klores Communications, "National Oral History of America Project Kicks Off."

28 Bumper sticker in author's possession, ca. 2009.

29 Neil M. Maher, *Nature's New Deal: The Civilian Conservation Corps and the Roots of the American Environmental Movement* (Oxford: Oxford University Press, 2008) 80, 54.

30 "Ask Now, Listen Forever"; dustjacket for *Listening Is an Act of Love: A Celebration*.

31 StoryCorps, "Door-to-Door Service" and "Can't Come to Us?" http://storycorps.org/your-community/door-to-door, and http://storycorps.org/record-your-story/cant-come-to-us (accessed June 8, 2010).

32 32. Jeff Howe, "The Rise of Crowdsourcing," *Wired* 14 (June 2006), http://www.wired.com/wired/archive/14.06/crowds.html (accessed July 30, 2010).

33 "StoryKit User's Guide" (printout dated 7/22/03) 2, in StoryCorps Corporate Subject File, folder 1, AFC, LC.

34 Terkel himself acknowledged as much. See Terkel, *My American Century* (New York: The New Press, 1997), 16.

35 StoryCorps, "Our Team," http://storycorps.org/about/our-team; StoryCorps, "Internships," http://storycorps.org/about/employment-opportunities/internships/communications-intern (accessed July 29, 2010).

36 "StoryCorps Memory Loss Initiative," brochure, ca. 2009, in author's possession; "Give the Gift of Listening," fund-raising brochure, ca. 2009, in author's possession; fund-raising letter sent to author, November 2009. In 2008, StoryCorps and NPR declared the day after Thanksgiving a "National Day of Listening." Thousands of American's interviewed each other, including President George H.W. Bush, who was interviewed by his sister Dorothy Bush Koch (National Public Radio, "NPR and StoryCorps Kick-Off First Ever National Day of Listening," http://www.npr.org/about/press/2008/112408.NationalDayListening.html, (accessed July 29, 2010).

37 Klores Communications, "National Oral History of America Project Kicks Off."

38 Dave Isay, *Mom: A Celebration of Mothers from StoryCorps* (New York: Penguin Press, 2010), 181. Emphasis in original.

39 Isay, *Listening Is an Act of Love:*

A Celebration, 269.

40 Isay, *Listening Is an Act of Love: A Celebration*, 269.

41 Isay, *Listening Is an Act of Love: A Celebration*, 255.

42 For instance, "Give the Gift of Listening," brochure, ca. 2009, in author's possession; see also http://storcorps.org/listen (accessed June 23, 2011).

43 *The Studs Terkel Reader: My American Century* (1997; New York: The New Press, 2007).

44 Dave Isay to Peggy Bulger, July 21, 2005, in StoryCorps Corporate Subject File, folder 1, AFC, LC.

45 Transcript of author's interview with Matt Ozug, Brooklyn, NY, August 6, 2008, 5.

46 Transcript of author's interview with Michael Garafolo, Brooklyn, NY, August 6, 2008, 5.

47 Isay, *Listening Is an Act of Love: A Celebration*, 269. In *Mom*, 2, Isay echoes that "the individual stories we've collected have taught us that as a nation there is so much more that we share than divides us."

48 Nancy Abelmann, Susan Davis, Cara Finnegan, and Peggy Miller "What Is StoryCorps, Anyway?" *Oral History Review* 36 (Summer–Fall 2009): 256–57.

49 See Michael Frisch, "From *A Shared Authority* to the Digital Kitchen, and Back," in this volume.

50 Transcript of interview with Ozug, 8, 15. Garafolo goes on to suggest that the project could be seen as "documentary journalism. It's some weird—I usually use 'documentary story telling' because … it's not quite journalism and it's not quite straight up documentary work. It's sort of a weird mixture" (transcript of interview with Garafolo, 7).

51 This assessment of the absence of historians dates from summer 2008, when I conducted interviews with core project staff.

52 On the project website, one does see photos before hearing the stories.

Presumably out of a desire to retain the primacy of voice, Isay has resisted the temptation to create video versions of the project. In summer 2010, however, the project began experimenting with producing animated versions of select stories, aired on PBS's documentary program *POV* (StoryCorps, "Animation," http://storycorps.org/animation (accessed July 15, 2010)).

53 StoryCorps, "Great Questions List," http://storycorps.org/record-your-story/question-generator/list (accessed July 15, 2010); "What to Expect," http://storycorps.org/record-your-story/what-to-expect (accessed July 15, 2010).

54 Transcript of author's interview with Desiree Leary and Taylor Cooper, 5, 11; transcript of author's interview with Kevin Oliver and Mike Rauch (facilitators, StoryCorps), New York City, August 6, 2008, 13. Subject-heading list provided to author by library staff in Archive of Culture, Library of Congress, August 2008.

55 Transcript of author's interview with Elaine Davenport (manager, Door-to-Door program, StoryCorps) and Rose Foreman (facilitator, Door-to-Door program, StoryCorps), Brooklyn, NY (August 6, 2008), 12–13.

56 Transcript of interview with Garafolo, 4–5.

57 All quotations from the edited version of the interview come from *Listening Is an Act of Love: A Celebration*, 114–19. An edited audio version, somewhat shorter and with slightly different edits, is at http://storycorps.org/listen/stories/edwin-lanier-jr-and-david-wright (StoryCorps, "Stories" (accessed July 15, 2010)). The original audio interview is held at the American Folklife Center, Library of Congress.

58 The editing somewhat sanitizes the offer by eliminating that Lanier actually recalled that it was "a New Year's eve *party*," perhaps a somewhat more complicated situation

for an alcoholic. The online edited audio version does include the word "party."

59 In fact, those who donate to StoryCorps at the "Angel" level ($5,000) are rewarded by having their interviews "edited by our Peabody Award-winning staff" ("Help us make history"). Isay discusses editing in his "Author's Note" for *Listening Is an Act of Love*: "We aimed to distill these stories without altering the tone or meaning of the original sessions" (Isay, *Listening Is an Act of Love: A Celebration*, 5.).

60 Steve Zeitlin describes his City of Memory project as striving for a similar blend, allowing users to contribute their own stories ("Where is my story?") while also offering them selected and edited stories ("Where are the best stories?"); see Zeitlin's "Where Are the Best Stories? Where Is My Story? Participation and Curation in a New Media Age" in this volume. Michael Frisch expresses frustration that StoryCorps fails to transcend the dichotomy between unedited "raw" interviews and highly edited or "cooked" ones (Frisch, "From A Shared Authority").

61 Tom Satwicz and Kris Morrisey, "Public Curation: From Trend to Research-Based Practice," in this volume.

The Question of Evaluation
Understanding the Visitors' Response

Sharing authority may sound like a good idea, but does it work? A great deal of research still needs to be done to assess the impact of the new cultural practices examined in this book:

Does putting authority in the hands of visitors and participants increase their enjoyment or enhance their learning?

Do audiences care about the opinions of other visitors or about alternate perspectives like those of contemporary artists? Do audiences and stakeholders miss the authoritative curatorial voice?

Do communities actually feel more attachment and commitment to institutions that experiment with these practices?

How can we measure the depth and quality of the visitor experience in these path-breaking projects?

Public Curation: From Trend to Research-Based Practice

Tom Satwicz and Kris Morrissey

The discussion of user-generated content takes place within the context of a restructuring of relationships between museums, content, and visitors—a shift from museums as *provider* of content and *designer* of experiences to the more complex role of *facilitator* of experiences around content. Opportunities for audiences to shape and add to the stories and messages museums present—to participate in the "curation of the visitor experience" (both their own experience and that of other onsite or online visitors)—have generated significant excitement, as well as corresponding criticism and fear. The enthusiasm seems to be based on an assumption that the shift from content provider to experience facilitator is a good thing, at least for audiences (or at least for some audiences). However, museums are just beginning to grapple with understanding, describing, and measuring how this shift affects the experience and the learning of audiences. How can the field move beyond what is primarily a philosophical or popular trend toward a more thoughtful and purposeful research-based practice?

"Public curation" is used here as an umbrella term to encompass "participatory design," "user-driven content," and the broad and creative range of ways public (or non-professional) audiences are increasingly and collaboratively involved in shaping museum products (e.g., exhibitions, websites, archives, programs, media), processes (e.g., design, evaluation, research, public discourse), and experiences.

While the title of this book suggests a process of "letting go," public curation is not an abdication of curatorial, educational, or design responsibility. Rather, it entails a different type of responsibility requiring an equal or perhaps an even greater level of expertise and knowledge. How can museums "hold on" to their mission-driven responsibilities as they shift from presenting content

to facilitating interactions between and among audiences and content within the context of museums as public institutions of learning? This essay suggests that the answer lies in the adoption of research-based practice, characterized by identifying and challenging assumptions and engaging in iterative cycles of innovation and research.

In the past few decades, the field of visitor studies has made substantial progress in studying and describing the complex interactions between and among visitors, exhibitions, objects, and programs,[1] leading to a greater ability to engage in research-based practice, particularly in the area of exhibit design. However, the aftershock of Web 2.0 as both a technological and philosophical "earthquake" has resulted in a disconnection between research and the innovative ideas and technologies that are emerging within the milieu of Web 2.0. The opportunities, the context, and the goals associated with public curation have advanced faster than research and theory have developed. The shift toward the range of practices associated with public curation not only requires more research, but it affords a unique opportunity to understand better and to enhance the relationships between audiences, museums, and society.

While there are many frameworks that could be used to structure this work, we assume that the core function of a museum is to facilitate "learning," a term used here in the broadest sense to refer to any desired changes within the individual, group, or community, including knowledge, disposition, attitudes, behaviors, relationships, modes of communication, and skills. The discussion is therefore grounded in learning research. The learning sciences are a multidisciplinary field that seeks to empirically understand the nature of learning. The discipline has roots in many different areas, including psychology, cognitive science, computer science, sociology, anthropology, linguistics, and education. While research on learning has a long history,[2] the last decade has seen a resurgence of popular interest in understanding the process of learning and applying that understanding to formal and informal learning environments.

TESTING ASSUMPTIONS

Public curation has emerged in the context of—and perhaps as a response to—many of the most complex and pressing challenges facing museums and society today. The excitement, innovation, and sometimes fear that the approach has generated stem in large part from the expectations about how this approach might shed light on the changing dynamics of authority, engagement, cultural difference, inclusion, and other issues residing at the interface between museums and society. This expectation makes it particularly important to test assumptions and ground actions in evidence-based decisions. This essay articulates some of those assumptions and suggests that understanding the implications of public curation requires expanding the research tools used to assess the relevance and impact of museums at a time when lines are blurring between museum and public, producer and consumer, expert and novice.

Assumption: Public curation is more democratic and inclusive
There is often an assumption or expectation that allowing for multiple voices and perspectives is inherently inclusive and promotes a social equality of voices. This assumption underlies efforts in which community members contribute content in the initial construction of a project (e.g., community-designed exhibitions at the Wing Luke Museum of the Asian Pacific American Experience), as well as open designs and participatory projects where anyone can contribute throughout the life of a project (e.g., City Lore's *City of Memory*). Does this approach engage a *broader* audience, or does it simply engage a *different* audience? How does including a range of voices affect subsequent audiences that consume (rather than contribute to) the content submitted by others? Do these audiences experience or process content differently when (or because) material comes from a range of contributors who are like them or, equally interestingly, are different from them?

Assumption: Participatory design is more engaging for the visitor
There is extensive research on engagement with exhibitions featuring museum-curated experiences. See, for example, Beverly Serrell's extensive research on exhibition engagement,[3] or the work of the Exploratorium and others that seeks to define, facilitate, and assess "Active Prolonged Engagement."[4] For a snapshot of studies assessing engagement, see the InformalScience.org database of exhibition evaluation reports. This work builds on and is aligned with decades of research in formal education that suggests that "time on task" is related to learning and enjoyment.

In what ways, though, does the opportunity to *contribute* content, objects, or ideas affect the level or the nature of engagement? How do visitors experience, interpret, and trust contributions by non-experts? What is the effect on visitor experience and engagement when opportunities for engagement are intermittent and spread across time? Does user-contributed content introduce or support bias in participants or content consumers?

Assumption: Participatory design is beneficial for the visitor and the institution
Perhaps the most basic assumption is that engaging visitors in contributing content has benefit. But in most cases, museums and designers have not articulated or assessed the actual benefit, identified who benefits (museum, current visitors, future visitors, contributors, or consumers), or articulated indicators of that benefit. Is the goal to increase learning (an educational goal) or to build community among current users (a social goal) or to entice new audiences (a marketing goal)? What is the range of possible interactions and outcomes? In what ways does public curation afford opportunities for new outcomes?

WHAT DOES LEARNING RESEARCH SAY ABOUT PUBLIC CURATION?

Strands of History Learning

Do the assumptions and practices of public curation align with what the research says about learning? In 2009, the National Research Council of the National Academies released a study from the Committee on Learning Science in Informal Environments that identified six strands of learning science in informal environments. The six strands (see table on following pages) reflect a perspective on learning that considers social aspects of learning in addition to the more traditional psychological aspects. This view allows us to consider how learning involves changes in how people see themselves and participate in cultural activities in addition to changes in what they know. In other words, they show changes in learners' participation as a central aspect of learning— just as it is a primary focus of public curation.

The strands are based on decades of research across a range of contexts (schools, workplaces, museums, etc.) and represent a consensus view of what is known about learning in informal science environments. While specifically related to science learning, these strands could be used as an analytic tool for thinking about learning in other domains, such as history. Recognizing the significant differences between the content and processes of history and science, below is an exercise in applying the strands derived from science to the field of history, offered here not as a guide but as an example of a framework for history learning that could be used to shape a research agenda about public curation.

The particular framework illustrated in this table draws on the current view of learning as change that occurs in many different areas. If public curation engages the public differently than has been typical in the past, then research using such a viewpoint should begin to articulate where we might observe and how we might describe the results of this engagement. This process would move the practice beyond optimistic assumptions toward an understanding of the learning processes taking place and ultimately a broader theoretical base for this practice. Currently, little research exists on the theories associated with public curation. However, a brief look at the wider field of research on learning does provide grounding for further research and experimentation with public curation.

199

Public Curation Research Framework [5]

Strands of Science Learning [6] *Learners in informal environments*	Strands of History Learning
(1) Experience excitement, interest, and motivation to learn about phenomena in the natural and physical world	(1) Experience excitement, interest, and motivation to learn about the people, ideas, and events of our world
(2) Generate, understand, and use concepts, explanations, arguments, models, and facts related to science	(2) Generate, understand, and use concepts, explanations, arguments, and facts to explain history
(3) Manipulate, test, explore, predict, question, observe, and make sense of the natural and physical world	(3) Manipulate, test, explore, predict, question, observe and make sense of change over time
(4) Reflect on science as a way of knowing; on processes, concepts, and institutions of science and on their own process of learning about phenomena	(4) Reflect on history as a way of knowing and learning about oneself, one's relationship to the world around one, and one's connections to worlds that came before
(5) Participate in scientific activities and learning processes with others using scientific language and tools	(5) Participate in historical research, interpretation, and inquiry with others using language and tools of historical inquiry
(6) Think about themselves as science learners and develop an identity as someone who knows about, uses, and sometimes contributes to science	(6) Think about themselves as history learners and develop an identity as someone who knows about, uses, and can contribute to the historical record and process

Unique Capabilities or Barriers Public Curation Affords

How does contributing or reacting to content affect interest or motivation? Who is interested in contributing or consuming others' contributions, and is interest related to assumed value of the expertise of the voice?

What do visitors learn about history while engaged using participatory media? How does the act of contributing or responding to content relate to conceptual understanding?

What explanations are shared among museum visitors with respect to the objects and information created with participatory media? Does the opportunity to contribute affect motivation to engage in processes of historical inquiry?

What knowledge of the historical process do visitors display when engaged in contributing content? How does contributing or consuming others' contributions affect understanding that history is a dynamic and interpreted process?

What tools and language of history are used while people contribute to or consume participatory media? How does contributing affect attitudes toward museum authority and toward historical experts?

In what ways are people using public curation opportunities to carve out new identities *of* and *as* historians?

201

NEUROLOGICAL ASPECTS OF LEARNING

Molecular biologist John Medina summarizes much of what is known about the neurological aspects of learning in a popular book titled *Brain Rules: 12 Principles for Surviving and Thriving at Work, Home, and School.*[7] Medina says that for learning to occur, individuals must exert some kind of force on the environment and see a response: they need to interact with others or the environment and see effects from that interaction. This principle may provide a theoretical grounding for considering how public curation—particularly the approach of "participatory design" that Nina Simon discusses elsewhere in this book—gives individuals the opportunity to make contributions and see their actions shape the product or process.

Research also suggests that "every brain is wired differently." What an individual experiences in life physically changes what their brain looks like—it literally rewires it. This principle, or "brain rule" as Medina calls it, provides a theoretical grounding for understanding the varied effects that can result when individuals contribute to a product or experience.

One final conclusion from Medina's summary is that cooperative activity is deeply rooted in evolution. Our ability to learn has deep connections to relationships and to the emotional environment in which the learning takes place. This concept relates to the work of Vygotsky and others who have demonstrated the role of cooperative communication in learning. An extensive amount of literature exists in formal education, for instance, on the role of peer-tutoring and cooperative learning. Research consistently suggests that we learn more when we learn with others and when we talk about what we are learning. Recent research in museums has similarly focused on the place of conversation both in promoting and reflecting learning and relationships.[8]

TAKE TWO: A CASE STUDY

The popularity of social media in public curation raises particular challenges for research. This essay concludes by describing a project, *Take Two: A Study of the Co-Creation of Knowledge on Museum Web 2.0 Sites,*[9] that offers a first pass at understanding engagement in the world of museums and social media and, as well, suggests some potentially useful research methodologies. Focusing on the Science Museum of Minnesota's award-winning social interactive website *Science Buzz*, the study explored the role social media play in the curation process and how to study its impact on museums and their visitors. The study addressed the following questions:

1) What is the nature of the community that interacts with Science Buzz?

2) What is the nature of the online interactions?

3) Do these interactions support inquiry and learning?

4) What is the impact on museum practice? As an institution chang-
es its approach to authority over content in its interactions with the
public online, how do practices within the museum on-site change?

One significant finding from this work provides guidance on the shifting role of museums from *provider* of content to *facilitator* of interaction with content. Analysis of strings of online *Buzz* conversations consistently showed the highest incidence of evidence of learning occurring when museum staff engaged in the online dialogue. When staff weren't part of the conversation, the evidence of learning was drastically lower. Given this sort of impact, the pedagogies and philosophies of facilitation of public curation warrant significant research.

Thesis research that grew out of these *Take Two* findings[10] postulates that the "facilitative moves" made by museum bloggers are influenced by their individual facilitative environments, facilitative frameworks, and facilitative strategies. In other words, the facilitation of museum blogs seems to involve much more than what may be apparent onscreen: the ways museum blog users shape and manage their own interactions and the interactions of others can only be understood by taking a broad view that includes users' surroundings (including the user interfaces of museum blogs), their beliefs and world-views (including what "facilitation" means to them), and their self-described approaches to museum blog facilitation. Further research can articulate the techniques of facilitation used within this collaborative environment, describe what is happening, and begin to identify principles that can be used to design facilitative frameworks and strategies to meet specific objectives.

203

CONCLUSION

New technologies and changing sensibilities have produced a period of rich experimentation in museums, including opportunities for the public to be engaged in activities and decisions previously controlled by content experts. How does this growth of interest in "public curation" advance, hinder, or change a museum's public mission? This essay calls for research on the impacts and implications of public curation and the role of museums as facilitators of visitor engagement with content. The authors suggest that research be based on a theoretical construct, and they present examples of research questions and frameworks, drawing on recent works from the learning sciences. Preliminary findings from the *Take Two* project support the hypothesis that successful public curation does not mean "abdicating responsibility" for learning. Rather, further research should explore how museums can facilitate meaningful self-directed engagement including contributing to as well as consuming content knowledge. As research builds a literature base in public curation, the field can better understand what actually takes place when museums allow public audiences to contribute content and chart their own directions.

1 Judy Diamond, Jessica J. Luke, and David H. Uttal, *Practical Evaluation Guide: Tools for Museums and Other Informal Educational Settings* (Walnut Creek, CA: AltaMira Press, 2009); J.H. Falk and L.D. Dierking, *The Museum Experience: Visitor Experiences and the Making of Meaning* (Walnut Creek, CA: AltaMira Press, 2000).

2 For an overview of advancements in learning sciences over the last several decades, see R. Keith Sawyer, ed., *The Cambridge Handbook of the Learning Sciences* (Cambridge: Cambridge University Press, 2006).

3 Beverly Serrell, "The 51% Research Project: A Meta-analysis of Visitor Time/Use in Museum Exhibitions," *Visitor Behavior* 10, no. 3 (1995): 5–9, http://historicalvoices.org/pbuilder/pbfiles/Project38/Scheme325/VSA-a0a1m1-a_5730.pdf (accessed November 22, 2010); Beverly Serrell, *Paying Attention: Visitors and Museum Exhibitions* (Washington: American Association of Museums, 1998); and Beverly Serrell, *Paying More Attention to Paying Attention*, Center for the Advancement of Informal Science Education (CAISE), http://caise.insci.org/news/96/51/ (accessed November 22, 2010).

4 T. Humphrey and J. Gutwill, *Fostering Active Prolonged Engagement: The Art of Creating APE Exhibits* (Walnut Creek, CA: Left Coast Press, 2005).

5 Adapted from the National Research Council report, *Learning Science in Informal Environments: People, Places, and Pursuits*, from the Committee on Learning Science in Informal Environments (see note 6 below).

6 National Research Council, *Learning Science in Informal Environments: People, Places, and Pursuits*, ed. Philip Bell et al. (Washington, DC: Board on Science Education, Center for Education, Division of Behavioral and Social Sciences and Education; National Academies Press, 2009).

7 John Medina, *Brain Rules: 12 Principles for Surviving and Thriving at Work, Home, and School* (Seattle: Pear Press, 2008).

8 G. Leinhardt and K. Knutson, *Listening in on Museum Conversations* (Walnut Creek, CA: AltaMira Press, 2004).

9 Funded by the Institute of Museum and Library Services, *Take Two: A Study of the Co-creation of Knowledge on Museum Web 2.0 Sites* was a collaboration between the Writing in Digital Environments Research Center at Michigan State University, the North Carolina Museum of Life and Science, the Science Museum of Minnesota, Selinda Research Associates, and the Museology Program at University of Washington. For information, see http://informalscience.org/project/show/1752; and https://sites.google.com/site/taketwoinitiative (accessed November 31, 2010).

10 Alex M. Curio, "A Conceptual Framework for Understanding the Impact of Contextual Factors on Museum Blog Facilitation," M.A. thesis, University of Washington, Seattle, 2010.

205

Constructing Perspectives
Artists and Historical Authority

What happens when artists step into the arena of historical inter-pretation? Perhaps more than any other exhibition in the last quarter century, *Mining the Museum* at the Maryland Historical Society (1992–93) changed the way museum professionals see their work and themselves. Collections ceased to be neutral assem-blages of objects and were revealed to be freighted with cultural and political baggage; curators and museums were shown com-plicit in an often insidious power structure. In the two decades since, artists have worked with historical collections and content in projects ranging from site-specific installations to illustrated rock operas, with many lively variants in between. Artists can be engaged to play many roles: interpreter and storyteller, providing access to untold stories and alternative narratives; provocateur, challenging the existing narratives; or critic of the institution and of the history-making process itself. The resulting work can offer new interpretive pathways for audiences and can challenge pub-lic history professionals to reexamine their own practice. But can collaborating with artists change organizations or the practice of public history more broadly? Reflecting on *Mining the Museum* and its legacy in his interview here, artist Fred Wilson himself says, "My artworks don't change museums, they change individuals."

207

Can artists be "trusted" to tell these stories? Should historical organizations embrace the power that art can have to create meaningful, resonant experiences for audiences, or does an art-ist de-constructing history leave it in shambles? Does the museum abdicate responsibility for interpreting certain histories when it invites an artist to address them?

What happens when this practice exposes difficult or controver-sial information about the founders, the organization, or the ways in which stories are being told (or not told)? After the artist leaves, and these issues have been laid bare, what is the next step?

Is there reason to continue this work, and, if so, what will move the practice forward? Could history organizations and artists learn more from one another by learning more about the other?

Peering Behind the Curtain: Artists and Questioning Historical Authority

Melissa Rachleff

A BACKGROUND SKETCH

The editors of this volume invited me to consider the ways artists have engaged with history and history museums over the past twenty years, positing artist Fred Wilson's project *Mining the Museum,* which opened at the Maryland Historical Society in 1992, as a starting point. What, they asked, has the history community accomplished with artists in the intervening period? The question is challenging to answer because there is no single repository for information about or records of artist–history projects. As I began to explore art produced since 1992, I was intrigued by the underlying issue of why artists would be drawn to history, history museums, and historic sites in the first place. What, if any, role did the history community play in fostering such exchanges? Why has the art community reaped so much of the credit for history-infused artist projects?

Artist–history projects like Wilson's tend to be critically analyzed by the art press and art historians, and the reception of an artist's work in a historical site becomes part of the art historical canon. Thus, although a project may have originated as an exchange with history, it ultimately resides in (and as) art. Academic and public historians may not grasp the significance of artist projects to their field because far less analysis has been published from their perspective. Therefore, a meaningful overview of artist–history museum interactions must begin with an understanding of the fundamental differences between the disciplines of art and history and of how their collaborations often result in critically significant projects. There have been huge shifts in artist–history interactions over the past two decades, in particular a turn toward audience and, sometimes, a move away from aesthetic concerns; as we shall see, we are in a post-aesthetic epoch. The changes in part reflect generational shifts. Whether the projects can be called successful or not also depends

Pedestals with globe. *Mining the Museum: An Installation by Fred Wilson.* Maryland Historical Society,1992–93 (MTM 022). All images courtesy of Maryland Historical Society.

on a variety of conditions. What might be a critical success for an artist might have other, perhaps unanticipated consequences, positive and negative, for the historical site. This essay suggests that we put aside concepts of success (and its opposite) to focus on deeper questions regarding historical content, audiences, and installation-based art practices.[1] My intent is to outline areas where art and history intersect and highlight places for historians to situate themselves and their institutions within this complex terrain.

A fundamental question has occupied critical history and art practices for twenty years: who possesses historical authority? Seemingly, the staff at a history museum would have the ultimate interpretive authority. However, the "culture wars" and the "history wars" of the 1990s demonstrated that the "public"—constituents with special interests—actually possess a great deal of power to define history and its meanings, and their views can shape museums' approaches, particularly in exhibition projects. Unlike at art museums, where battles about what to present and how have centered upon conceptions of "decency," the locus of history struggles has been interpretation. The apparent victors are the agitated stakeholders (the public), and the losers in this war scenario are the museum staff and their academic advisors.[2] Interpretation is a subjective process, connected to memory, and it has become a contested field, particularly as it has morphed into the core activity of public history institutions.[3]

These often very public debates, sometimes shrill, place interpretive staff at history museums in an unenviable position. When art museums have faced public discontent, they have asserted an authoritative institutional power in the name of free speech. At history institutions, though, interpretive authority is mediated via specific relationships to a given subject, including (sometimes) the perspective of academic historians. And whereas art museum curatorial and senior education staff must be academically credentialed, history insti-

tutions have always supported non-expert voices, including those of artists. There is a tacit understanding that the mission of history institutions is to tell and preserve community histories, and those histories are living, responsive to changing conditions and relations. Collections and archives preserve objects, largely donated by local residents, that document private and social experiences of the community. Staffs often include members of the community, particularly volunteer docents and retired school teachers. Such community ties further bind the history institution to local sensibilities. A breach of trust can shatter the credibility of the institution.

This essay attempts to "peer behind the curtain" (using the visual metaphor in Charles Willson Peale's iconic 1822 painting *The Artist in His Museum*) to reveal the intellectual issues that govern challenging interpretive projects from the perspective of the history museum field and from the perspective of artists, so as to better understand how artists have engaged with audiences' conceptions about historical interpretation. Artists, like a public constituency, operate outside of professional historical inquiry; history museum staff members know that an invited artist is not credentialed in their field. Yet there is likewise an "artist pedagogy" that embraces history, informed by issues of representation and attendant theories of memory. Public historians are usually not engaged in the pedagogies that inform contemporary artistic practice, but are invested in memory as a legitimate mode of inquiry. Academic historians tend to be antagonistic to memory's role in historical inquiry, and for many years largely avoided scrutinizing history institution projects. Bringing these three pedagogies—art, academic history, and public history—together, and acknowledging that they sometimes bump against one another, helps expand the possibilities for historical interpretation through *collaborative* work with artists. The viability of a partnership with an artist depends on the strength of the collaboration process. Rather than suggest that artists be engaged to add "creativity" to an interpretive project (a sentiment that drifts into positing a "creative" artist and an "uncreative" institution), I suggest that history institutions begin these partnerships by engaging with the methodologies that underlie the interpretive practices of the different fields that are mingling under the broad tent called "history."

The first half of this essay concerns why artists became interested in museums as a subject for their work—examining the influential project *Places with a Past*, an art exhibition that was held throughout the city of Charleston, South Carolina, not in a museum—and how socially situated projects led to new curatorial practices outside traditional art institutions. Concurrently with this development in contemporary art, history museums debated similar social concerns, particularly during the 1980s and '90s. This leads into a review of the impact of European cultural theory on the American academy beginning in the 1980s, and how theory has transformed art-making and the study of history since then. The second half of the essay focuses on the audience, as the public has become a greater focus for institutions and artists alike. Speaking

on this trend, contemporary art curator Nato Thompson spoke dismissively of the practice in which "artists fly in, have about a week to react to a site, bang out a project, and move on." [4] Rather, curators and museums have learned that "reacting" is not enough. From this perspective, Wilson's *Mining the Museum* was prescient about community response to socially pointed work.

Audience is complex, and the public, which includes the staff at collaborating institutions, is a crucial element in the realization of art projects. This focus on the public by artists necessarily complicates existing relationships for cultural organizations. Nato Thompson suggests that "a lot of artists are even ambivalent about using the word 'art.'" How did we get to this point? To understand the utter collapse of traditional artistic disciplines and how this situation impacts artist–history projects, the essay looks at socially–pointed work.[5] Looking forward, I conclude with a rationale as to why, intellectually and administratively, artist projects in history institutions must be structured as institutional collaborations, and with an exploration of the benefits of mounting them.

ART AND HISTORY

On a practical level, what do American history museums gain from involving artists in their interpretive projects, and why is this question worth thinking about? One simple reason is that most history museums own art, and art was a vital part of such collections in the early 20th century. One can argue that art is not apart from history: it has represented historical events and historical-philosophical concepts since the Renaissance. In turn, artists are perennially attracted to and inspired by historical museums. An early instance was painter Charles Willson Peale, who founded a museum in Philadelphia in 1784, and the immortalization of his collection in the aforementioned portrait *The Artist in His Museum,* which depicts the rich array of objects that Peale, an amateur naturalist, preserved and made public. Recently, artist/inventor David Wilson revisited the artist's deep engagement with museums through founding the Museum of Jurassic Technology, in Los Angeles, an institution devoted to natural history museology, particularly its antiquated interpretive methodologies (including a brilliant installation about memory and forgetting that is emblematic of the entire project).[6]

The subject of the artist exploring the museum enterprise is the focus of Kynaston McShine's 1999 definitive exhibition and book, *The Museum as Muse: Artists Reflect,* where Peale's painting begins the examination of two centuries of artists' reverential and simultaneously deeply critical engagement with the public museum.[7] McShine locates this engagement as part of a broader resistance to the explosion of the contemporary art market, where politically/socially engaged installation practices were not as easily commodified—at least initially. In the 1980s being an artist could be lucrative on a scale never before seen, and some artists challenged the role of the anointing institution. McShine observes:

For even as many artists have struggled to be included in the museum, others have resisted dependence on art world patronage structures and have developed intricate critiques of museum practices. As an outgrowth of these approaches, many artists have purposely made works that, due to their size, ephemeral materials or location, are not collected by museums (nor the common gallery system); still others have chosen to avoid the institution altogether.[8]

McShine's project takes as its starting point artwork, the heart of the artist–museum relationship. Furthermore, he reminds us why artists care about museums. Art museums are, after all, the ultimate custodians of their creative work.

Theorizing further about artists' engagement with museums, Douglas Crimp argues in *On the Museum's Ruins* that postmodernism, at the root of critique-based practices, undermined the art museum's authoritative, linear narrative, which privileged notions of aesthetic progress. Crimp and other art historians see museums as compromised sites, often serving moneyed interests. Whereas as some artists sought to work independently of museums, others challenged museums from within the gallery, installing artworks that offered institutional critique. Such critique-based artist practices operate in the public sphere, and critiques of the institution among artists led to new curatorial practices, ones that had implications for history museums and their relationship to artists.

THE PAST

Conceptions of the past are shaped by both societal beliefs and personal experience. Artists provoke accepted interpretations. Beginning in the 1980s, the inclusion of women and artists of color in major museum exhibitions also meant a change of aesthetic emphasis. A number of artists during this period became interested in making work that resisted linear historical narrative.[9] For instance, historical subjectivity became the focus of a very important project in Charleston, South Carolina, that grew out of conceptually based, socially engaged artistic practices. In 1991, Nigel Redden, director of the Spoleto Festival USA, invited independent curator Mary Jane Jacob to organize a concurrent visual art project. Jacob was an interesting choice because her curatorial work had at that point shifted from museum exhibitions to locations outside the museum context, in a form akin to public art but without permanence. Jacob invited twenty-three artists—from the well known, like Cindy Sherman, to the emerging—to create site-specific projects around the city in dialogue with the history of the community.[10] Jacob and the artists worked with community members and Spoleto organizers to select historical sites and capture the histories of Charleston from the residents' perspectives. Issues of personal memory, communal memory, and the ways these memories did or did not incorporate evidence of slavery and the Reconstruction era became the

focus of the eighteen installations ultimately mounted throughout Charleston in the project titled *Places with a Past*. Reflecting on it more than a decade later, Jacob noted, "'Places with a Past' dealt with historic places as not being hermetically sealed. History is our past and our present and in experiencing this place, through the art, we see the vitality of these subjects today."[11] Art's function in this context was to render visible subjective perspectives, the merging of community memories and the artists' reactions to these memories and to Charleston's history. The art projects offered new perspectives on historical content based on responses and reactions both personal and communal.

Not every artist in *Places with a Past* was as engaged in the specificity of place as the ambitions of the project suggest. However, the art was socially situated and premised on notions of history and, within that, the deployment of memory. On this tendency, art historian Monica McTighe, following the curatorial ideas of Lisa G. Corrin, observed that there is a critique of the "ideological limits of the institution of art and the gallery space"; installation art in particular is linked to history, and goes beyond the limitations of the institutional frame "because of its relationship to the archival practice of collecting ... [and] encourages a reflective viewing experience[;] it invites the viewer ... to ask questions about how they are seeing, the context of viewing, and what is being looked at."[12] This type of installation art, then invites an exchange between the perceiver (public) and the object (the work/installation), making them equal partners. Art is placed "off the pedestal"—uninterpreted, as in the archive (or art storage room)—and, as in those situations, there is no authoritative voice (via didactic panel) offering a conclusive interpretation. Viewers are asked to form their own interpretations through direct experience.

One of the reasons installation art is effective with the public is that it often appropriates existing objects and re-presents them in new contexts. Installations often take the form of site-specific environments, performance, and video. This parallels the practice of interpretation staff at history museums: to investigate the quotidian through research and community conversations and present findings as a physical experience. In Jacob's project, most of the participants (emerging artists) were influenced by the late 1960s/early 1970s conceptual approaches of Minimalism, earth works, and performance art, and by feminist and postcolonial cultural theories. *Places with a Past* did not shy away from difficult and sometimes divisive subjects, particularly racism. Jacob followed a broadly conceived curatorial strategy, as she summarizes:

> While art in the public sphere has been with us since the beginning of time, there's something particular ... that has flourished in the past two decades, making [installation-based art] a gravitational point for many critical issues. With this came an expansion of form and context, moving practices outside of the museum, and in doing so, engaging the audience as part of the creation and meaning of the work.[13]

Baby carriage
and hood. *Mining
the Museum:
An Installation
by Fred Wilson.*
Maryland
Historical Society,
1992–93
(MTM 033B).

Jacob's goal of engaged contemporary art in the 1991 exhibition was perhaps most strongly expressed in artist David Hammons's *The House of the Future*, a small structure made from discarded parts of homes in Charleston's East Side, the historically segregated black community. The piece reflects the bifurcated history of African Americans in Charleston, which can be traced as a series of "official" or published histories of the city juxtaposed with the personal histories of people who have lived there. Both histories are conditional, rooted in racial/social subjectivity. African American history in Charleston is physically present, and for Hammons it took the form of housing in the black neighborhood. Contrasted with the splendor of historic Charleston, Hammons's *The House of the Future* is an ironic gesture. The precarious two-story shingled structure was made entirely from sections of demolished houses found in the neighborhood. The future here is that there is no future, only the past recycled. Lives and materials circulate and recirculate in a clearly demarcated zone located entirely within actual geographic boundaries. *The House of the Future* is a poignant piece; yet Hammons's work is also a very pointed critique of the power elite in Charleston that has allowed socioeconomic disparities to endure, even thrive, thirty years after the civil rights movement. *Places with a Past*, therefore, engendered debate about the role of art, confronted community sensitivities, instigated local discussions, and demonstrated the ability of artists to publicly elucidate troubling histories.[14]

What role did the academy play in fostering resistance to traditional interpretive narratives, including those that incorporated voices traditionally left out of mainstream interpretation? Many critics realized that the mode of historical inquiry needed to change, not just the subject.

"A CRISIS IN HISTORICITY"[15]

Frederic Jameson's influential series of essays on American art and culture, published as a collection, *Postmodernism or, The Cultural Logic of Late Capitalism*, in 1991, identifies the fragment as the very source of our current cultural sensibility. Particularly in the volume's eponymous essay, Jameson argues that in the postmodern era, modernist styles from the late 19th and first third of the 20th century become supplanted by social "codes" in the postmodernist present; "class-factional" identities built around race, religion, gender, and ethnicity replace the once-dominant narrative of the upper-middle classes from which so much of the material collected in museums hails. Postmodernism, Jameson writes, means the "absence of any great collective project," including a master narrative; such narratives have been replaced by the jumble of what he terms the "pastiche." Numerous narratives act as referents to numerous "realities." Some are ironic; some are factual; all have at their root language, shaped by the subjectivities of the author and of the receiver of the text. We have, in sum, fragments without a whole.

> Pastiche is, like parody, the imitation of a peculiar or unique, idiosyncratic style, the wearing of a linguistic mask, speech in a dead language. But it is a neutral practice of such mimicry, without any of parody's ulterior motives.... Pastiche is thus blank parody.... [The] omnipresence of pastiche is not incompatible with a certain humor, however, nor is it innocent of all passion: it is at the least compatible with addiction—with a whole historically original consumers' appetite for a world transformed into sheer images of itself and for pseudo-events and "spectacles" (the term of the Situationists). It is for such objects that we may reserve Plato's conception of the "simulacrum," the identical copy for which no original has ever existed.[16]

Jameson suggests an interplay between the "real" and the "fake" (or simulacrum), and this dialectic has become the focal point for many artists working during the past decade, including several who have based their practice around historical sites. For them the question of the "real" in the midst of referents to the past is great. Equally important, postmodernist theory disrupted practices that favored dominant narratives.

Before examining several more signal artist–history encounters, it is important to grasp the effect of cultural theory upon pedagogical practices in fine arts and art history over the past two decades, and how academic history and museum history practitioners—the public historians—followed a different trajectory. This pedagogical shift influenced the trend of artists working with history museums and the (productive) tensions such collaborations yield.

Art initiatives of the 1980s and early '90s were influenced by the European sociological and linguistic theories that critiqued the social status quo. Instead

of perpetuating what was considered to be an elitist art historical concern with beauty and form or, in history, with great men and their deeds on the world stage, artists' focus turned to the idea of the "everyday" and the myriad relations that it comprises. In the art and academic analyses that emerged and cross-pollinated in the 1980s, semiotics, the study of signs and cultural symbols, became the primary basis of critique. Now that "truth" had to be placed in quotation marks—deemed merely a symbol of something else, something perhaps with a hidden agenda—the issue of what was "really true" was up for grabs. Art became a kind of semiotic activity, and history a particular kind of writing from a specific point of view. Inevitably, the way art and history intermixed—and were presented to the public—began to change.

In studio art, craft, the traditional focus of art-making, was replaced by programs in "poststudio practices"; in art history, courses in "theory" and its attendant methodological analyses proliferated. New interdisciplinary programs in cinema studies, performance studies, curatorial studies, queer studies, gender studies, and cultural studies, as well as ethnically based studies, and centers arose, folding into their curricula the heady critical work of the primarily French linguists, sociologists, and philosophers of the mid-20th century.[17]

Naturally, new art and new approaches to thinking about art-making and its significance required adaptation by art museums, especially those that presented contemporary art. Starting in the 1970s, non-profit "alternative" spaces for contemporary visual art opened with federal and state funding, providing artists traditionally left out of the mainstream as well as those who embraced social critique with a venue in which to test ideas that were at once rooted in avant-garde practices and reflections of the artists' own sociocultural position.[18] Museum curators frequented the alternative galleries and by the early 1990s began inviting many more women and artists of color into their institutions. Although not always greeted with enthusiasm by the public or by the traditional stakeholders, the exhibitions ultimately sanctified subjects once seen as outside aesthetics, particularly issues of race, gender, representation, and economic status as subjects of art. Programmatically, visual arts institutions expanded through the inclusion of voices that traditionally had been silenced.[19] Here cultural theory and multicultural identity converged. And during the 1990s, as these critical practices relied upon historical research, the contemporary art community began to look at history more seriously and the history museum came into view as a distinct ideological space.

In the field of history, the impact of cultural theory was decidedly more fragmented, and the push to reconceive historical pedagogy came from what Jameson termed the "micropolitical" challenges to the historical endeavor, particularly ethnicity-specific and issue-specific academic programs (as well as Hayden White's reconceptualization of historical inquiry as historiography, in which critical histories could be built).[20] The subfield of public history and programs in material culture, often resistant to cultural theory, hewed closely to traditional notions of interpretive historic inquiry, preferring the empiri-

cal to the epistemological. As one surveyor of the history museum field put it, "curators must constantly navigate the tensions between serving the identities of those whose story is missing and the devolution of the site into one of endless competing claims."[21]

There is, then, a practical challenge in applying critical theory in history museum exhibitions: how can a solitary narrative contain splintered subjectivities? There are also other tension points within the field of history itself. The differences between those who work as historians in the museum field (curators, interpreters, administrators) and those who work in academic institutions create something akin to what one museum historian, Jo Blatti, called "sovereign territories."[22] According to the prejudice, serious scholarship occurs in academia; the exhibition format is considered unmentionable, or worse, uncritically accepting of the public's memories of the past. Certainly Blatti's claim of bias has been proven by foundations, particularly the National Endowment for the Humanities, where the chief funding priority for more than three decades has been fees for academic expertise.

MINING MUSEUMS

Historical interpretation (from an artist, museum, or academic perspective) probes unresolved issues from the past, even the recent past, and how such investigations lead to debates about representing "the real." The fragmenting of historical "truth," coupled with artists' increasing interest in critiquing institutional authority, set the stage for a pivotal encounter between artist and history museum, Fred Wilson's *Mining the Museum* at the Maryland Historical Society.

In 1992, a year after *Places with a Past* closed, director George Ciscle and curator Lisa Corrin of the then-new arts organization The Contemporary, a non-profit space in Baltimore, invited artist Fred Wilson to instigate a similar dialogue in that city. His project *Mining the Museum* opened at the Maryland Historical Society in April 1992, timed to coincide with the annual American Association of Museums (AAM) conference. The project was a featured exhibition during the conference; hundreds of museum professionals from around the United States visited *Mining the Museum* through tours and a specially produced video, and in 1993 Wilson and the Maryland Historical Society were awarded the AAM's Curator's Committee Award for Exhibition of the Year.[23] In subsequent years *Mining the Museum* has come to be recognized as the quintessential artist–history exchange. Other contributions in this volume, including an interview with Wilson, bring the legacy of this project up to date. Here it is important to briefly revisit the work to demonstrate how Wilson made history and the Maryland Historical Society more relevant to two audiences: museum professionals, who embraced the project, and the local Baltimore community, who gave it a somewhat more mixed reception.

Mining the Museum was an art project, yet its form was entirely appropriated from the museum exhibition lexicon. The project appeared as an installation of the Maryland Historical Society's permanent collection and

217

occupied the entire third floor of the facility. Wilson selected objects that constituted a "past erased," at least in the "history" of Maryland presented by the Historical Society. In the collection storage area Wilson found, and then presented, objects such as a large wooden whipping post, shackles used to manacle slaves during the auctioning of human beings, a Ku Klux Klan hood, cigar store Indians, and other objects that had never been placed on public display due to their visceral connection to slavery, racism, and of course, to the descendants of both perpetrators and victims living in Baltimore.

Wilson's methodology involved extensive community discussions, especially with Baltimore's African American community and with the African Americans on staff at the society, particularly in the security department. Wilson thus gained a better understanding of the racial and social dynamics in Maryland, which informed the selection of objects ultimately included in the exhibition.

In the installation, Wilson deployed a classification system that followed museum standards. In "Cabinet Making 1820–1960," the whipping post, dating from the early 19th century and used as a form of corporal punishment for convicts through the 1950s, was situated with Chippendale chairs and other Victorian-era seating from the same period, the chairs facing the post like a macabre tableau vivant. The shackles were placed in a vitrine along with ornate silverwork (Baltimore *Repoussé* style) also dating to the early 19th century. Wilson's process and final installation engendered internal and external discussions about slavery's enduring legacy in the state and city.[24] Importantly, the project engendered dialogue among African American employees at the Historical Society as well in as the broader community, at least during the eleven-month period between 1992 and 1993 when the full exhibition was on view.[25] Wilson's process *mined* curatorial practices, but the ultimate design of the installation did not provide closure; rather, it raised questions and critiques about historical interpretation generally, and about the Maryland Historical Society's presentation of the past in particular. For Wilson, the project led to more than twenty other institutional commissions from museums desirous of a similar critique. Inadvertently, Wilson became for a time the museum community's welcomed flagellator, excavating very alive forms of discrimination in communities across the United States and abroad.

On the level of experience—the physical act of viewing—presenting such highly charged exhibits at the Maryland Historical Society was unavoidably polemical and raised issues regarding the role of traditional interpretation. What, the 1993 museum visitor might have wondered, is going on at this institution? It is important to remember that *Mining the Museum* occurred at the invitation of The Contemporary. The project came together under the guidance of curator Lisa Corrin, who would later go on to collaborate with Mary Jane Jacob; it was not originated by staff members at the Maryland Historical Society, who, not surprisingly, had never heard of Fred Wilson.[26]

As noted, such complicated layering had not previously been part of the Maryland Historical Society's or other historical societies' approaches in

organizing exhibitions even when the subject was slavery. This is another reason Wilson's project was so widely discussed and disseminated through critical texts by art critics, art historians, museum historians, and curators. Certainly Wilson's project was not the first attempt in the history community to reveal the troubled stories simmering close to the surface. The question is, why did the repressed dialogue that Wilson reconstituted resonate so powerfully and viscerally, particularly with museum professionals? One reason is that *Mining the Museum*, as its title indicates, makes the museum enterprise the subject, and museum professionals have an affinity for examinations of their profession. In most historical projects the host site is rendered separate from the subject of inquiry, reinforcing the museum's sovereignty. Wilson's installation demonstrated that a museum's exhibition practices are entangled in the ideological framework within which the museum operates.

Additionally, rather than conform to a linear narrative, Wilson's project was fragmentary, suggestive, theatrical/performative, and based in a dialectical rendering between the past (the objects) and the present (the installation/display). The design of the exhibition directly addressed the visitor through its play with museological tropes, including object labels, which are usually not thought of as ideological. However, Wilson does not see didactic information as neutral, and his questions—which are premised on looking at the object on display—were far more pointed. Noting that a painting of a young boy in hunting garb included an African American boy in a metal collar, Wilson asks, "Am I your brother? Am I your friend? Am I your pet?" prompting the viewer to speak about the interrelationships among African Americans and Euro Americans and how some areas of the past remain hidden from public discourse. Such an overt, racial discussion is why the project was so socially charged for the local audience.

Mining the Museum and *Places with a Past* emerged from a moment when postmodernism was adopted as a critical aesthetic strategy. Such socially and politically engaged artist–history interactions provokes an engaged spectatorship. Within this framework it is vital to acknowledge the *authority* of the artists relative to the projects they produce. Just because the museum ostensibly gives up its authorial role does not mean there is an absence of authority. As Wilson put it, "My work with museums is a critique on many different levels: a critique of traditional subject matter, of the notion of exhibition, of the museum as institution, and by extension, of the society in which the museum exists."[27]

"HIT AND RUN SOCIAL COMMENTATORS"
Wilson's project caused such a sensation because it resonated with the intellectual issues of the time and also because it seemed to offer history museums an avenue for making history appear human, more relatable for contemporary sensibilities. Artists using museology as material, however, operate under different sets of circumstances than public historians. They are not administrators

trained in appeasing various constituencies, including boards of directors, whose comfort levels and views of the past require balance. Some critics see museum staff as compromised actors, whereas artists can behave with relative autonomy. A history museum must acknowledge the "compromises" made in serving its community when entering into an artist project. Frankly discussing *with the artist* what the institution is and is not ready to investigate provides the forum necessary for free exchange of ideas. Some artists do not enjoy working collaboratively and might find such internal discussions tiresome. Therefore, before an artist is invited in to collaborate and/or to explore the collection for a possible project, the history institution must confront the internal and external conflicts that often arise in executing site-responsive artist projects.

That said, there is no question that artists can work effectively to engage the community and reveal new ways of thinking about local history. The success of a project depends very much upon the artist selected and the museum's ability to be cognizant of contemporary art or collaborate with curators experienced in critically engaged art. The project must gain the support of staff at all levels and of the museum's board. On this point, Pablo Helguera, an emerging artist (and museum educator) who has situated his history-museum work recently at the University of Pennsylvania Museum of Archaeology and Anthropology reflects, "[In the 1990s] the idea [was] that artists could become institutional diversity catalysts by working with communities to which the museum wants to reach out. While this certainly can happen, it is wrongheaded to transfer the responsibility of fulfilling the institutional goals of a museum to the hands of an invited artist."[28] Since the artist is not part of the museum staff, such expectations could never be met. Helguera elaborates:

> The negotiation between the museum's agenda, the artist's agenda, and the interests and needs of the community is extremely complex, and in many cases one of them goes unfulfilled. In certain circumstances, the role of the artist in this particular context can turn into the one of a missionary or a caregiver, or the community becomes an instrument of the artist's concerns and agenda, etc. For this reason, the institution that invites an artist to do a project needs to understand the dynamics that exist in this three-way relationship, and how to manage it.... One should never expect a problem to be solved by an artist. While artists who are involved in pedagogy, activism, etc. can open a dialogue with communities and enrich the context in which the exhibitions and collection of the museum are interpreted, artists usually problematize issues as much as they help shed light onto them.[29]

The risk in collaborating with artists comes in relinquishing responsibility by the museum. If ownership of the project lies squarely with the artist, rather

Installation view. Mining the Museum: An Installation by Fred Wilson. Maryland Historical Society,1992–93 (MTM 045).

than being a shared process, the museum misses an opportunity for mediated debate, including among staff and with outside stakeholders. Ideally, the boundaries between the commissioned work, the institutional voice, and the public become fluid in collaborative projects, and trust builds over time. For the museum (not only the historical museum), site-specific art that incorporates public input brings out a variety of local voices, and artists may find they have inadvertently taken on issues that are more properly the domain of the institution itself—its community relations. This set up can be attractive to public history administrators. If local residents become upset about a project, the institution can distance itself from the situation by pointing to the artist/author and disclaiming ownership. The fact that institutionally based artist projects may not actually transform the power structure in museums is a part of an ongoing critique in the art world.[30]

Fred Wilson's reinstallation of the Maryland Historical Society's collection neatly epitomizes how the intersection of conceptualist aesthetic strategies with multicultural philosophies can contain tensions. The interplay of objects recalls the Freudian "return of the repressed" in the confrontation of race and the legacy of slavery in Maryland. *Mining the Museum* fascinated academics and museum professionals, yet it also upset the stakeholders of the institution, an aspect of the project that remains underexplored, since most museum professionals are loath to revisit public critiques.[31] The literature on the project has mainly concentrated on the artist and the artwork itself.

Before examining what might compose ideal artist–history exchanges, it is important to look at how work in one more visual art realm over the past decade, performance, has revived debates surrounding the interpretive method known as living history.

221

PERFORMING HISTORIES

This essay has concentrated mainly on artists working within a framework of installation-based practices. Performance is another genre, and given its temporal base, constitutes a corollary to historical reenacting and living history interpretation. In particular the works of British artist Jeremy Deller, French artist Pierre Huyghe, and American artist Allison Smith suggest that living history is a rich form to appropriate. Their work converges as a form of secular ritual because, as in living history, their performances ultimately depend upon public participation. Reenactments are arguably even more populist than exhibitions because they draw spectators into the subject viscerally. Performance allows for an intimate relationship with the event represented. Yet professional historians often critique reenactment and living history for their tendency to be celebratory and because the work is often created by semiprofessionals or amateurs. Interestingly, artists are often intrigued by the form's low regard, treating its "kitsch" style as a starting point for critique. Deller and Huyghe have staged reenactments that use irony to explore troubling social conditions, while Smith extends craft-based "folkways" into projects that pierce the sentimentality that typically greets artisan laborers in living history sites.[32]

Although the artists noted resist being seen as part of an aesthetic movement, such practices have been termed Relational Aesthetics, a form of art in which the realization of the work is dependent upon public exchange.[33] The exchange is not neutral; as in life, the public is asked to participate in a situation overtly ideological. By participating, one actively engages the social position of the work, even if the participant disagrees with the premise. Australian historians Iain McCalman's and Paul A. Pickering's edited volume *Historical Reenactment: From Realism to the Affective Turn* concerns precisely this "uneasy relationship between realism, authenticity, and affect." McCalman and Pickering treat history museums and historic sites as public performative experiences that build communal memories.[34] Unable to historicize, to fix in time, to resolve history's implications, reenactment inevitably fails at recapturing the "real" past. Its aspirations are impossible.

More research clearly needs to be done on the long-term public impact of artist projects at history museums and living history sites. Among the questions we might ask are: What is the impact internally and externally of having a critical voice disrupt the agreed-upon interpretive goals? What dialogues does the history institution form with the community through the artist's project? Are there mechanisms in place to further any new dialogues/issues that might arise from an artist collaboration?

A hint of the fertile possibilities of artist, history, and community dialogues appears in a blog, part of the *Evoking History* project Mary Jane Jacob curated for the 2001–3 Spoleto Festivals. During the final year of the series, a three-day workshop was organized in collaboration with the Southern nonprofit Alternate ROOTS, and its Resources for Social Change program. The event included workshops and discussions that explored those "affected by the

intervention of politics and relationships of power; constructs of home, race and identity; community concerns; and the diverse roles of artists."[35] Neill Bogan, an artist involved in *Evoking History*, expressed his own discomfort with the temporary, site-specific installations, calling them "hit-and-run" social commentary."[36] Bogan, and other artists such as photographer Wendy Ewald and muralist Brett Dizney-Cook, incorporate local community collaboration in the actual making of their projects. Thus, nearly twenty years after *Places with a Past* in Charleston and Fred Wilson's *Mining the Museum* artists are far more cognizant about the efficacy of their practices at a local level. This discourse deserves greater exploration, and should form the starting point for future strategies in artist–history collaborations.

PARALLEL HISTORIES

In piecing together a twenty-year span of artists interacting with history it becomes clear that projects such as Fred Wilson's did not spawn a wealth of similarly self-critical, overtly questioning interpretive practices at history institutions. The "objective" narrative voice is still very much favored. Researching Wilson in historical periodicals and books, one notes a lacuna: historians have not claimed *Mining the Museum* in their field through publishing a sustained analysis for the history community. A parallel history is in operation, where art theorists and art museums recognize the import of Wilson's project while the history community has concentrated its critical efforts elsewhere. It is perhaps fairer to say that the past twenty years of artist engagement with history museums has been episodic, not driven by historians, and thus is hard to measure when focusing solely on the history community.

Making matters more challenging to academically trained history museum staff, the public history field has not incorporated working with contemporary visual artists into its pedagogy, usually the first indication of a theoretical shift. The occasions for the type of contemporary art project this essay explores—art projects that question historical methodologies—arose out of a confluence of factors, most frequently as part of a collaboration with public art organizations like the Spoleto Festival, contemporary art centers, and independent curatorial programs. Very few history museums, though, have active contemporary art programs. Surprisingly, and for reasons having to do with the artistic expertise of staff and management, Philadelphia has proven an important exception to the norm. Two history organizations, the Rosenbach Museum & Library and Eastern State Penitentiary, do have ongoing artist residency projects, and both represent significant cases to examine for the history field.[37] At the Rosenbach the director of education has an art background and oversees artist programs, and at Eastern State the site's program director guides contemporary art curators and also initiates programs. The public has come to expect visual art experiences at these institutions that reach beyond traditional historical inquiry.

Cultural theory brought to light the way history is experiential, diffuse, and subjective. With these insights in mind, we might now ask, with a bit of

trepidation, when is a good time for a history museum to partner with an artist or join in a broader public art collaboration? Certainly it is essential that the museum staff and board agree that their institution would benefit from an interplay of methodologies; they must appreciate how a non-literal, critically influenced approach can result in new ways of seeing a subject. As with any historical endeavor, however, an artist's project should never stand alone as the only perspective. Consider, for example, the evolution of Holocaust memory. Newer generations and current events spark projects that at first blush might appear radical, even disrespectful to a subject; over time, such projects have come to represent important pathways for intellectual re-visioning of memorial sites and museums.[38] The museums and memorial sites have learned that debate is vital to maintaining relevance.

An artist project can yield such subjectivities. But, as Pablo Helguera gently cautions: "There is a risk in engaging an artist within an institution.... [T]he institution should approach working with an artist as a relationship that evolves over time—they need to get to know the artist. Most importantly, the history museum staff needs to adjust to the creative process of the artist instead of providing rigid parameters of engagement."[39]

This exploration of the theoretical and practical issues that arise from artist–history collaborations reflects the different vantage points of the fields of art and history, particularly their differing pedagogies. What the community will make of such projects and its future relationship with the institution is an area in need of serious scholarship. And therein lies the challenge, as art museums know very well. Partnering with someone requires learning their language. When it comes to contemporary artists, a great first step for historians seeking to grasp the underlying critique at the heart of publicly situated work is to understand the role cultural theory occupies, the way memory is problematized through objects, and how site-specificity reflects contemporary art's move into social history. With such an understanding, artists and curators can more meaningfully involve history museum staff and community members. Artist projects can invite new audiences to the institution, but only if the museum has an outreach strategy. Even if audience is a part of the artist's practice, outreach is not the artist's job. By better understanding the theory and practice of contemporary artists, the history community can begin to build relationships in which the historical enterprise, local recollections, and the artist's process can exist simultaneously, creating a public dialogue that helps artist, historians, and community audiences alike see the past in new ways.

1 The distinction of socially based installation art is important. The work I discuss responds to history museum collections/sites, and is created to exist specifically at the commissioning site. Preexisting works of art that are installed in the manner of a traditional exhibition are not the focus of this essay.

2 See Edward Linenthal and Tom Engelhardt, *History Wars: The Enola Gay and Other Battles for the American Past* (New York: Metropolitan Books, 1996).

3 The growing importance of interpretation at a vast array of historical institutions is deeply tied to funding priorities in government and in private foundations. Collecting and collection management has received far less support. For more background on the impact of public/private philanthropy in shaping museum policy, see Gigi Bradford et al., *The Politics of Culture: Policy Perspectives for Individuals, Institutions, and Communities* (Washington, DC: Center for Arts and Culture; New York: New Press, 2000). Collections are not without their own controversies, particularly as they involve deaccessioning. For a pointed critique of deaccessioning activities, see cultural journalist Lee Rosenbaum's blog "Culture Grrl," http://www.artsjournal.com/culturegrrl.

4 Both Nato Thompson quotes are from Sarah Douglas, "Creative Time Goes Global," *Art Info*, March 23, 2010, http://www.artinfo.com/news/story/34217/creative-time-goes-global/?page=1 (accessed August 16, 2010).

5 For a more thorough analysis of socially situated performative art and history, see Iain McCalman and Paul A. Pickering, "From Realism to the Affective Turn: An Agenda," in their edited volume *Historical Reenactment: From Realism to the Affective Turn* (New York: St. Martin's Press; Hampshire, UK: Palgrave Macmillan, 2010), 9.

6 For a thorough exploration of the Museum of Jurassic Technology, see Lawrence Weschler, *Mr. Wilson's Cabinet of Wonder: Pronged Ants, Horned Humans, Mice on Toast and Other Marvels of Jurassic Technology* (New York: Pantheon, 1995); and the museum's website: http://www.mjt.org.

7 Kynaston McShine, *The Museum as Muse: Artists Reflect* (New York: Museum of Modern Art, 1999).

8 McShine, *The Museum as Muse*, 13.

9 Photography is a significant part of the analysis of institutional authority, particularly its use as critique by visual artists like Robert Rauschenberg in the 1950s and by artists such as Cindy Sherman and the "Pictures" generation artists during the 1970s–80s. See Douglas Crimp, *On the Museum's Ruins* (Cambridge, MA: MIT Press, 1993).

10 Some of the artists included in *Places with a Past* were Christian Boltanski, Chris Burden, Ian Hamilton Finlay, Ann Hamilton, and Lorna Simpson. A full account of the project was published in Mary Jane Jacob et al., *Places With A Past: New Site-Specific Art at Charleston's Spoleto Festival* (New York: Rizzoli, 1991).

11 Carolee Thea, "Bringing Art to the People: A Conversation with Mary Jane Jacob," *Sculpture* 22, no. 2 (March 2003): 52–57.

12 Monica Eileen McTighe, "'Epic Forgetting': Mapping Memory Practices in Installation Art of the 1980s and 1990s," Ph.D. diss., University of

Virginia, Charlottesville, 2005, 23, 35.

13 In McTighe, "'Epic Forgetting,'" 35.

14 *Places with a Past* was not universally embraced, and led to a major fissure between the composer/founder of Spoleto, Gian Carlo Menotti, and the US organizers along with Charleston city officials. Menotti described *Places with a Past* as "silly, sophomoric stunts" and ultimately forced the resignation of nineteen members of the festival's forty-six-member board, and the termination of director Nigel Redden at the end of 1991. By 1993 Menotti had resigned and Redden had been reinstated, but no further contemporary art exhibits were mounted until 1997, the year Menotti died. For more information on Menotti and the controversy surrounding *Places with a Past,* see "Front Page," *Art in America* 79, no. 7 (July 1991): 25; and "Art World," *Art in America* 79, no. 11 (November 1991): 176. Interestingly, Hammons's piece was one of only two that were preserved by the city of Charleston, an indication of the work's resonance with the African American community. Jacob was invited back to the Spoleto Festival in 2001 on the ten-year anniversary of *Places with a Past* and, with curator Tumelo Mosaka, initiated the three-year public art series *Evoking History: Listening Across Cultures and Communities.*

15 Frederic Jameson, *Postmodernism, or, The Cultural Logic of Late Capitalism* (Durham, NC: Duke University Press, 1991), 22.

16 Frederic Jameson, "The Cultural Logic of Late Capitalism," in *Postmodernism,* 16–18.

17 The author's understanding of critical theory and its impact on art is enriched and informed by, and indebted to, cultural theorist, photographer, and writer Virginia Liberatore.

18 Institutional histories published during the past decade are helpful, including monographs on Artist Space and Creative Time in New York City, as well as Hallwalls in Buffalo. See also Julie Ault, ed. *Alternative Art New York, 1965–1985* (Minneapolis: University of Minnesota Press in collaboration with the Drawing Center, New York, 2002); and Steve Rand and Heather Kouris, eds., *Playing By the Rules: Alternative Thinking/Alternative Spaces* (New York: Apex Art, 2010). Related to these are the Dia Art Foundation's series of publications of the early to mid 1990s investigating critical theory, cultural theory, and art. For more about federal support of visual art organizations, see Michael Brenson, *Visionaries and Outcasts: The NEA, Congress, and the Place of the Visual Artist in America* (New York: New Press, 2001).

19 Two exhibitions during this period stand out as particularly relevant to this discussion. In 1991 Robert Storr, then a curator at the Museum of Modern Art, New York, organized *Dislocations,* a project that examined site-specific work by a variety of artists, including artists of color, and work with strongly political content. The 1993 Biennial at the Whitney Museum of American Art, New York, curated by Elisabeth Sussman, John G. Hanhardt, Thelma Golden, and Lisa Phillips, featured predominately artists of color and women, and also included a non-art piece, the videotape recording of the Los Angeles police officers' beating of Rodney King. Catalogues published for both projects encapsulate the intellectual and creative concerns of the 1980s era.

20 Hayden White, *Tropics of Discourse* (Baltimore, MD: Johns Hopkins University Press, 1978).

21 Daniel J. Walkowitz, "Ellis Island Redux: The Imperial Turn and the Race of Ethnicity," in *Contested Histories in Public Space: Memory, Race, and Nation,* ed. Daniel J. Walkowitz and Lisa Maya Knauer (Durham, NC: Duke University Press, 2009), 149.

22 Jo Blatti, "Introduction. Past Meets Present: Field Notes on Historical Sites, Programs, Professionalism, and Visitors," in *Past Meets Present: Essays*

About Historic Interpretation and Public Audiences (Washington, DC: Smithsonian Institution Press, 1987), 9.

23 Kirsi Peltomaki, "Strategies of Institutional Critique in Recent Art," Ph.D. diss., University of Rochester, NY, 2001, 135.

24 Recently a student from Baltimore in the author's arts management course at New York University shared his recollection of the project as very upsetting to the mainstream community, who felt attacked by the installation. More research needs to be done to understand the local reception of the project and how the exhibition might not have had the positive catalytic impact on Maryland Historical Society commonly assumed by arts professionals.

25 Rather than de-install the exhibition entirely in 1993, the educators then on staff advocated for a semipermanent display, and funding was provided for Wilson to design a modified version that remained on view at least through 2001. See Peltomaki, "Strategies of Institutional Critique," 141–42.

26 See Lisa Graziose Corrin, "The Contemporaneous Museum," in *Conversations at the Castle: Changing Audiences and Contemporary Art*, ed. Mary Jane Jacob and Michael Brenson (Cambridge, MA: MIT Press, 1998), 168–73.

27 Maurice Berger, "Collaboration, Museums, and the Politics of Display: A Conversation with Fred Wilson, January 25, 2000," in *Fred Wilson: Objects and Installations 1979–2000* (Baltimore: University of Maryland/Center for Art and Visual Culture, 2001), 34.

28 Pablo Helguera, interview by the author, New York City, June 15, 2010.

29 Helguera, interview.

30 Hal Foster and Andrea Fraser take this stance in their writings.

31 At the time of publication the author has not heard from Maryland Historical Society regarding her request to discuss the legacy of Wilson's project.

32 Deller has drawn from recent social conflicts in his work. His 2001 piece *The Battle of Orgreave* focused on the 1984 South Yorkshire miners' strike during the Thatcher years. Professional re-enactors and miners involved in the original strike reperformed the police clash that led to the riot. See Katie Kitamura, "'Recreating Chaos': Jeremy Deller's *The Battle of Orgreave*," in McCalman and Pickering, *Historical Reenactment*, 39–49.

Huyghe's commissioned piece for the Dia Art Foundation was intended to forge communal identity for a new exurb located near Dia's Beacon, NY, site. The project, *Streamside Day Follies*, operated as an actual event, a book, and a film. See Pierre Huyghe et al., *Streamside Day Follies* (Paris: Presses du reel, 2003).

From 2005 to 2007, Smith traveled across the UK and US apprenticing in folk crafts with master folk-craft artisans based at living history museums. She also organized a community parade as part of her collaboration with the Freetown Village Living History Museum and the Herron School of Art & Design in Indianapolis. See http://www.allisonsmithstudio.com (accessed October 3, 2010).

33 See Nicholas Bourriaud, *Relational Aesthetics* (Paris: Presses du reel, 2002).

34 McCalman and Pickering, "From Realism to the Affective Turn," 9.

35 Frank Martin, "ROOTS Goes to Spoleto," *Community Arts Network Reading Room Blog*, October 2003, http://www.communityarts.net/readingroom/archivefiles/2003/10/roots_goes_to_s.php (accessed June 27, 2010). Frank Martin, a South Carolina native and former contributing art critic to the *Charleston Post and Courier*, participated in the event and chronicled the issues for Alternate ROOTS, including the problems that site-specific contemporary art installations can cause locally.

36 Martin, "Roots Goes to Spoleto."

37 For an analysis of the Rosenbach Museum & Library's artist-in-residency program, see my "'The Fever Dream of the Amateur Historian': Ben Katchor's

The Rosenbach Company: A Tragicomedy in this volume. Recently, artist Pablo Helguera was part of such an experience in the program "Out of Print," organized by Philagrafika, a Philadelphia-based contemporary art organization, which collaborated with five historical institutions to select five artists with the understanding that each would make a new work inspired by the site and by the collections. Helguera worked with the University of Pennsylvania Museum of Archaeology and Anthropology; his project is online at http://www.philagrafika2010.org/venue/out-of-print (accessed October 3, 2010).

In 2006 Lowery Stokes Sims, then the director of the Studio Museum in Harlem, curated *Legacies: Contemporary Artists Reflect on Slavery* at the New-York Historical Society, which included more than a dozen artist installations, most incorporating materials from the society's art and archive collection. See https://www.nyhistory.org/web/default.php?section=exhibits_col lections&page=exhibitdetail&id= 192668(accessed October 3, 2010).

Sims's project is an example of a history institution inviting an art curator to organize a project outside its internal expertise. Occasionally, historical museums will hire museum professionals with art backgrounds, as happened in 2005 when the venerable Brooklyn Historical Society hired Deborah Schwartz, the former director of education at the Museum of Modern Art and the Brooklyn Museum. Since her tenure began, contemporary art programming has become a vital aspect of society's calendar. See the interview with her in this volume.

Finally, the Lower East Side Tenement Museum offered two residency programs, one in their storefront museum and another digitally based on their website. Both programs were canceled soon after new leadership succeeded founding director Ruth Abram.

38 See Norman Kleeblatt, *Mirroring*

Evil: Nazi Imagery/Recent Art (New Brunswick, NJ: Rutgers University Press, 2002); Edward Linenthal, *Preserving Memory: The Struggle to Create America's Holocaust Museum* (New York: Columbia University Press, 2001); and James Young, *The Texture of Memory: Holocaust Memorials and their Meaning* (New Haven, CT: Yale University Press, 1993).

39 Helguera, interview.

Mining the Museum Revisited: A Conversation with Fred Wilson, Paula Marincola, and Marjorie Schwarzer

Rusty slave shackles frame a silver 19th-century teapot. Ornate parlor chairs surround a crude whipping post. A Ku Klux Klan hood lies in an elegant pram. These are enduring images from Fred Wilson's Mining the Museum *installation, presented at the Maryland Historical Society (MHS) in Baltimore from April 1992 to February 1993. Wilson, a New York-based artist of African American and Caribbean descent, was commissioned by curator Lisa G. Corrin and director George Ciscle of The Contemporary (now Contemporary Museum) in Baltimore to work with an institution of his choice to develop a site-specific work of art. He selected MHS because, as he recalls, "I felt really uncomfortable there."*

By unearthing and juxtaposing artifacts from one historical society's collection, Wilson exposed how museums frame a community's history by what they choose to display and what they omit. Mining the Museum *(MTM) rocked the museum field. As Randi Korn observed, "museum professionals who visited said it was a landmark exhibit; it made them feel humble and lost; they were dazed by the heartfelt questions it raised about history, truth, values, ownership, interpretative perspective."[1] MTM "stimulated so much enthusiasm within the profession," wrote Corrin, that all types of museums "suddenly wanted 'Fred Wilsons' of their own; they were encouraged to look at their own collections with a renewed sense of purpose and possibility."[2] To this day, MTM remains a touchstone for how artists can challenge curatorial and institutional authority.*

In May 2010, Paula Marincola, executive director of The Pew Center for Arts & Heritage, and Marjorie Schwarzer, professor of Museum Studies at John F. Kennedy University, sat down with Fred Wilson in his Brooklyn studio to discuss MTM's legacy and explore Wilson's thoughts on how his artistic process intersects with history museum practices. The following is excerpted from that conversation.

Paula: Some people in the museum field believe that *Mining the Museum* (*MTM*) has been a model of how history organizations can become more comfortable with the problematic potential of shared authority. Others feel it has made history museums more anxious because of its provocative stance, and, I think, because of the license that you, as an artist, felt free to take with conventional museological techniques. What do you think the impact of *MTM* has been on history museum practice? Are you aware of that? Do you see that?

Fred: I can't say I have knowledge of that because history museums are not where I usually go. I wish I had a grant to go around to museums around the country, around the world, and see what the impact has been, but I have not had the time or the opportunity, to really understand, even to know, what happened in Baltimore. I get snippets from people, but I really don't know. I've been back once in recent years, and it was interesting to see the data, what had changed. I was only involved in two other historical sites. One was a site in Old Salem, North Carolina, which had a huge impact, and the other was The Museums of History and Ethnography and the National Gallery of Jamaica. I have some idea of the immediate impact, but I don't know what the long-term impact is. I'm always involved in the next project, and I really haven't gone back to a historical site besides Jamaica and Old Salem. So that's also why I haven't really focused on that.

As you know, I'm a visual artist, and I came to this from both directions, from the museum field, but also as an artist. So what I'm looking to do is not wholly prescribed by the mission of the institution or the reason why they bring me in. I'm interested in expanding my understanding of things, and uncovering whatever kind of denial the institution has or the perceptions that maybe I have a different view; and not doing the same thing over and over. I've done things about slavery several times, and unless there's a real different take on it, I don't want to go down that road again.

I don't like to do what I've done before. So often I'm invited by a particular museum because they know what I've done in the past, and they think that I'm some kind of a museum consultant. I know that's harsh, but I do think museums are looking for something new and different and somebody to look at the collections. If I'm not really jazzed by some way to get at it that is new to me, I'm not going to go there.

Marjorie: Let's talk about what an artist brings to the table when working with a history museum. Traditional historians analyze past events in order to tell stories so that we may bear witness, commemorate, and perhaps in the best of cases, re-imagine the present and future. How do artists connect to this practice?

Fred: Before I get to that I have to say that you cannot ignore the racial dimension of this. I'm a black man, and I went to an institution

about the 19th century where they had basically nothing [on display] about black people in a city that was majority African American. You can't ignore that what I saw was not being seen for more than one reason, not only conservatism. It was obvious to me because it was germane to my existence.

So perhaps part of this conundrum that museums find themselves in is that they can't wrap their minds around something that perhaps they, no matter what they do, could not see, and I'm not talking about the slavery. Once it's out of the bag, obviously, it's completely visible, but what I'm talking about is how personal it is when artists make works, how extremely personal it is. The racial thing is not the most personal part of it, but how artists go towards an extreme personal thing. You are going deep inside, and you're letting whatever comes out, come out. You don't hold back, and this is something that the larger population would really rather not do.

Paula: So you're saying that what artists do is investigate and express their own highly specific responses to given situations. Can you tell us a bit about how you go about doing this?

Fred: I talk to people and look at everything. I try to find out about the things that I'm interested in and follow that path.

Paula: What you do as an artist then is look for truth that is yours—

Fred: I look for truth that's mine.

Paula: —as opposed to factual recapitulation.

Fred: Factual yes, recapitulation

no. Context determines everything for me. Projects are different from one another because of it. Perhaps that gets lost when people try to unpack what I do to find a system. It changes from place to place because of the environment I'm in. I have to absorb where I am.

Paula: In terms of your working methods, do you read traditional historical texts?

Fred: No.

Paula: Oral histories?

Fred: No.

Paula: So the research you do is archival?

Fred: Put "research" in quotations.

Marjorie: It sounds like your "research" is to go somewhere and "absorb where you are."

Fred: That's right.

Marjorie: What does that look like?

Fred: I'll first say it simply and then get more complex. I meet everybody, look at everything, and then make it work.

Marjorie: Who's everybody?

Fred: As many people as I can in the museum top to bottom. I try to include everybody, because in the end it becomes real important. I also try to speak to many people outside the museum, to get different perspectives of the museum. This is particularly important when I am working outside of the US, but as museum people do have similar training in the US it is important to speak to the locals for a different, nuanced view.

I usually look in the archives— but not deeply. I look through as many things as I can. I respond to

Globe. *Mining the Museum: An Installation by Fred Wilson.* Maryland Historical Society,1992–93 (MTM 028). All images courtesy of Maryland Historical Society.

"the visual" first and foremost. I look at the collection, and then I also look at files or whatever form it's in. If it's vast, it's a process of meandering. I may not get a master narrative of what the place is about, but [I do get] a snapshot. I'm not looking for anything in particular, at first. I do read bits and pieces of texts, first-person documents, and oral histories once I have questions or get excited about an artifact or artwork. The art and the objects drive the bus for me. I call it "research," but it's not what anyone else would call research. I do take liberties, poetic license, if you will, but it's usually obviously so. I am very concerned that what I end up with cannot be discounted on factual grounds, so my research and my conversations with curators, scholars, and graduate school research assistants are important, no matter how tangential they are.

I have one notebook for each project in which I write down everything that strikes me. I write down ideas, but also comments that people make in conversation, just offhand comments. Things that interest me, I'll write them down. In the archive, when I see things that are interesting—I write them down. Things that I think I'll need, I write down.

Then I speak to lots of people outside the museum. I ask the Public Relations or Education Department, "Can I speak to groups of people that might come to the exhibition?" It is ethnographic, but I don't make borders between friendship and information gathering. In ethnography, there are real issues about that, but I'm not in that dialogue, and don't want to be. I'm both ethnographer and native informant.

By the end of the research period I look at what I have, and see if my early ideas for the final project still seem germane. Sometimes they do because you come into a

233

situation and you're so new that you see something no one else is seeing. Other times you realize that, well, everybody knows that. You're just new to it. So the ideas are no longer of interest. That's part of the process.

Of course, curators' scholarship influences me—I'm not doing deep research, so I rely on them for what they know about their collection. I think a reason why museums don't mind my projects is because they see a lot of what they know reflected in what I end up with. I may have a different point of view, but I take very seriously what curators have to say, the hard information, their scholarship. So, I think they're not wholly upset about what I end up doing.

Paula: So you're like an ethnographer/historian?

Fred: Yeah, I don't deny the ethnography aspect of it because I do talk to people and look at everything, and try to find out about the things that I'm interested in and follow that path. Of course, just because I'm African American doesn't mean that I knew what the response of people in Baltimore would be to their own history. I learned later that there were things that were more specifically meaningful than I thought when I ended up doing the project. It happens all the time, but luckily in my work there I realized how much I could push that environment.

Paula: You give yourself permission to follow your informed instinct.

Fred: I try to inform myself as much as I can. It's the story of my life. My family moved every five years within New York City, and, in order to exist in these different environments, I had to become a different person, realizing that people saw me in a particular way according to the environment. I had to fit in as a black child in an all-white school in suburban Westchester County.

Then we moved into this black and Latino neighborhood in the Bronx. Looking like everybody else but not having the same experience was another negotiation that I had to do. So, I'm always negotiating environments, and context has always been important to me as a way to survive. When you are on the fringe of environments and not central to what they're about, you hit the edges. You hit the hard edges.

I figured out how to negotiate in life from a very young age, understanding that people are not necessarily seeing you for who you are, and you may not understand them entirely. That has completely informed my exhibition-making and my projects wherever I go.

Paula: When you do a project, how much active negotiation with organizations takes place for you? How do you arrive at the level of trust that you need?

Fred: I make friends with the people that I work with, the curators and everyone. The other thing is that I only do projects if I have the director and/or the chief curator's complete and undivided support. *MTM* was great because the directors and chief curators of the Contemporary Museum—George Ciscle and Lisa Corrin—and of the MHS—Charles Lyle and Jennifer

Goldsborough—made sure things happened. I'll say it again and again; I learned a huge amount from the Contemporary Museum about dealing with communities, dealing with museums, and I replay a lot of what I took from the experience of doing *MTM* in different situations.

So, it's a combination of talking to everybody and having the support of those in power so those conversations happen.

Marjorie: Where else are you drawing your inspiration from? You said your core idea and the core reaction you had was visceral, emotional, very deep—

Fred: Yes.

Marjorie:—and you had to almost mine yourself and your reactions to the pieces.

Fred: Right.

Marjorie: Where I'm going with this is that historians will typically be inspired by a nugget, an artifact, something they've read, a conversation.

Fred: Those things are similar in my case. But historians are dealing with a particular time period or subject and the nugget they find is within that. My focus is the museum.

Paula: Maybe what you mean is that you don't have a theory beforehand that you're looking to.

Fred: What I mean is I am looking at the ramifications of the museum's collecting and selective display, how that affects the collections, the history, and the meaning; and what it is communicating to the viewer, especially to me. Plus a myriad of other questions that fan out before me while I am making the exhibition. The exhibition is the vehicle for this investigation and the product, the art. But in the end, for me, the museum is the subject. I try to come to each museum as a blank slate, because I won't discover anything new if I arrive with preconceived notions. So, no, I don't have a theory.

Paula: You didn't go to Baltimore thinking, "I'm going to transgress the Historical Society."

Fred: That's right. I had no idea. Even after it was done I didn't really realize how far I'd gone.

Marjorie: A historian's approach is to tell a story. You say "I'm going to tell a story and if I'm really good at it, I'm going to tell it in a new way." How is that different from your practice?

Fred: I never would use the word "story." I'm not trying to tell a story. Obviously, each tableau in *MTM* had a particular organization. These things do kick in, but it's not where I start. The project starts with the research; the more time I have to research better. Then I pull out nuggets of interesting things, and ask myself "what is the thread for all this stuff?" What am I feeling excited about, upset about? Is there an overarching relationship between these things and the environment I'm in?

The third part is putting it together as an exhibition. I get more specific as I go. For *MTM*, the wall color of the rooms had a great deal to do with what I wanted people to feel, and how I was feeling about the information as I laid it out. I was particularly interested in historical colors and how I could squeeze color for emo-

235

Cabinetmaking. *Mining the Museum: An Installation by Fred Wilson.* Maryland Historical Society, 1992–93 (MTM 037B).

tive meaning. I think the first space was gray. I can't remember now. Isn't that funny? It was an orientation space. I wanted people first to understand how to read the exhibition. Nobody that I met outside the museum had ever been to MHS or maybe they went as a kid. It's that kind of place. So, the audience, as far as I knew, was going to be Historical Society people. And, here I was changing the form of display.

I even went to the lengths of making an impressionistic video of me going through the galleries. This videotape was the first thing I had in the front downstairs, one of the few things I had in the entrance. In one sequence I had my shirt off and was walking through the galleries, saying things like, "I dreamt I was at the Maryland Historical Society, and everything was the same but different."

I did that because I wanted people to understand—well, some-

thing's going to be odd about this exhibition. Also, I put myself in there. It's me and not the institution, and of course, you see that I'm not a white American. So there were lots of things I wanted people to, at some level, have in their thoughts as they went into the exhibition. I didn't tell them what the exhibition was about. I just made this impressionist video because that's basically what the exhibition was going to be: impressionistic.

The Historical Society made a big banner for me. I told them I wanted it to be red, black, and green. So, they did that, and unfortunately, I should have designed it. I should have controlled everything, but I didn't.

Marjorie: This is what happens when you share authority, eh?

Fred: Exactly!

Paula: So, you're not for shared authority.

Fred: No, I'm not. I mean, as an artist you're not really sharing. I don't think people should share authority to the degree that you devalue your own scholarship, your own knowledge. That's not sharing anything. You're not giving what you have. That is highly problematic. You have to be realistic about your years of experience, what you can give, and what others can give.

That's why I respect curators; they have information that I don't know and I could never know and I don't necessarily want to know. *(Laughter)* I respect that. Anyway, I gave up authority completely about the design of the banner, and as I think about it, I should have designed it myself. I thought I was clear, but the way it was designed, if you don't have the colors in a certain way, it's just three colors. So, I was disappointed with the banner, but I had so much happening at that moment that I just let it go.

The exhibition itself, the first space was really about these questions, asking these questions, people asking themselves questions. In the first gallery, there are a lot of weird things, funny things in that space with no explanation. So that, to me, was the introduction to how one might have to deal with this exhibition. At that point, you may not realize that your questions are what the whole thing is about, but you have these questions that are lingering. That was my thought about that space and the things I was finding. I thought that the globe was just so unusual, an amazing object.

Marjorie: The globe?

Fred: The silver truth trophy, a silver globe, with the word TRUTH across it. Fascinating object, bizarre, and so I thought it was a great thing to start the exhibition with because what I was doing was not anti-connoisseurship. It wasn't anti-visual. It wasn't anti-beauty because I think beauty is one of these wonderful things that museums and artists have in their arsenal to engage people nonverbally.

You either got it or you didn't get it. Basically, the whole exhibition was like that. It's what I'm giving up, what I'm trusting. What I'm giving up is that there are people who will not get it, scratch their head, and keep on going. As an artist, that's the way it works, you know.

It's an internal experience that you can take or leave, and that's fine for me. I think institutions really want a certain amount of information to be understood by all— they have a certain goal, and they want this goal to be hit as best it can. Exhibitions are not perfect vessels for that, so I just go with that. It's a perfect vessel for art as far as I'm concerned. Within that, I'm pushing these things and not knowing if people are going to run out screaming (I'm joking, of course). I assume that people would enjoy it or have an experience with it, but you really don't know. It's like any artwork. I've done as much as I can to sort of put all my feeling into this thing, and what happens, happens.

I just put it all in there, and let the chips fall where they may.

My artworks don't change

237

museums; they change individuals. This is what art does. If you have a personal experience with the artwork, it's safe because you can have it inside you. Nobody has to know that you didn't notice that this museum you've been going to all these years said nothing about slavery.

I really was thinking about the people that were coming to the institution that I was used to seeing. When I came there one day people were all dressed in antebellum outfits. It was like—

Paula: Re-enactors.

Fred: Yes, and I was looking for my free papers [from slavery] all the time. *(Laughter)* Anyway, that's the audience that I saw as coming to the museum, and so I didn't want to lose them entirely.

Paula: So they were in your mind in part?

Fred: They were totally in my mind. I really wanted people to walk a certain direction so they experienced *MTM* in a certain way. So, that's as close to a story as I get. I wanted them to have this experience in a linear fashion because I had different areas of engagement with the subject, and I wanted them to first try to grasp the language of this exhibition, how to negotiate it, how to read it. Before I got them to other issues, that they understood the language, like it or not, and that they were reading these things with that language.

Marjorie: I remember when I went to see *MTM*. I walked in cold, meaning "let's go for a nice after-noon stroll," and I came up the elevator, and there it was. I have to say it knocked my world apart, honestly. I remember the lighting on the canvases.

Fred: Oh yes. That was very important.

Marjorie: I'd seen antebellum paintings many times, and suddenly the lighting was turned to highlight the slaves.

Fred: Yes, yes.

Marjorie: That's when I started to shake, because, Fred, I grew up in Maryland and in the third grade, we were explicitly taught that Maryland never had slaves.

Fred: Oh, that's bizarre.

Marjorie: I'm giving you my personal reaction to how meaningful that exhibition was to me.

Fred: Wow. The historical dimension is important for me, the scholarship of others, but then there's this whole personal thing, people's experiences where I know that I'm only touching the surface.

Paula: Do you think that viewers need to see themselves in the museum?

Fred: I don't know. What I try to do is … all artists like a conversation with a person on whatever level they can grasp what you're putting out there. You are speaking your language and hopefully they can grasp something from that language. I just want engagement.

Paula: But you know you can't control that, right?

Fred: I cannot control it. No curator can control that. No educator can control it. I mean, history museums are more concerned than

238

art museums about audience experience. I think I am a little more in that direction, but I don't want to lead anybody in any kind of didactic way. That's kind of where I draw the line. I have a problem with educators who want to lead it to the degree where they [visitors] are not having their own real experience.

Paula: In an article that Marjorie sent me this past weekend from *Curator: The Museum Journal*, there was something apropos of this whole notion of shared authority that I thought was interesting. The author, Ken Yellis, writes: The "distortion of museum time and related techniques in Wilson's arsenal—especially his use of legerdemain, his counterintuitive juxtapositions of objects and his satirical employment of curatorial nomenclature—constitute, I think, the key to *MTM*'s mind-altering power. The techniques are, however, it seems to me, also directly linked to the museum field's equivocal response to his work. To accomplish what Wilson does, we would have to violate every rule we have learned in our entire experience. And those of us who cut our teeth in the museum education trade would have to forego one of our most hard-won achievements: the increased emphasis on visitor orientation and preparation in exhibition planning and museum interpretation."[3]

Fred: So first let me ask you: what he's saying is all about, "Dammit, we just thought we were able to control everything again, and now he's telling me we can't.

We're not in control." To me it's like that's just so problematic, I can't even—

Paula: Can't even go there?

Fred: It would be lovely for one person to have this kind of impact alone, but to me, it's really about who has control.

Paula: Or who can let go of control.

Fred: Yeah, letting go of control yet again.

Paula: Right.

Fred: Redoing the paradigm seemed to be good for the public, but in happenstance, by accident, I'm revealing that there are still control issues even in museums' refiguring out how to deal with the public.

Paula: I picked that quote out because, for me, what artists do is assume their own authority in the situation.

Fred: Exactly, but what is most freeing is that people told me—museum directors told me and other people at the American Association of Museums [conference held in 1992 in Baltimore]—that they saw the whole museum, and then they went to my exhibition. It was obviously so subjective, what I did, but because of the history of slavery, *MTM* had meanings beyond just me. But when they went back through the museum, they realized that the museum was not as objective as they thought, and that it was just as subjective as what I was doing.

So that, to me, is the money shot. That, to me, is the—you know, that is what is important

239

Metalwork. *Mining the Museum: An Installation by Fred Wilson.* Maryland Historical Society, 1992–93 (MTM 010).

240

to me. Not the history of slavery, particularly because a lot has been written about slavery. It's the museum's framing of slavery and the narrative that one gets used to that is kind of curious to me. Also, in this particular institution, the total negation of a crucial part of Maryland's history that has impacted so many of its citizens was kind of outrageous to me, but I realized that after I got the piece done. It was not what I was thinking about, and certainly doing the project, I had no concept that it would have any far-reaching—

Paula: I was just going to ask you that.

Fred: I mean, I didn't do this thing, "I'm gonna change the world!"

Paula: Did you have any idea?

Fred: No. I had no idea. I was doing what I do.

What I did with this project within the art world, as you know, has been going on since the late sixties. Clearly, the notion of institutional critique and site specificity and looking and revealing through visual terms was going on. I added a racial scenario in museum exhibitions in a more specific way than other people may have done, but, you know, it was part of a continuum. It was part of a continuum as an artwork, and like the Lone Ranger, you walk off into the sunset after you've done your thing.

Paula: (Laughter)

Fred: I mean, I don't want to be the Lone Ranger, but maybe Tonto.

Paula: What do you think is left to do in terms of how institutional narratives are overturned or undone or questioned?

Fred: I think there will always be another layer that can be looked at because they are institutions, just like the government. That's why there are all the checks and balances of the government, because there's always something that can

be looked at and made better. It's
the nature of these institutions to
kind of control and cover.
 Paula: It's power.
 Fred: That's the nature
of power.

*Condensed and edited by Marjorie
Schwarzer with Paula Marincola and
Benjamin Filene.*

*Thanks to Mia Breitkopf, executive
assistant at The Pew Center for Arts
& Heritage, for her organizational
and technical skills in helping to
realize this conversation.*

1 Quoted in Ken Yellis, "Fred Wilson,
 PTSD, and Me: Reflections on the
 History Wars," *Curator: The Museum
 Journal* 52, no. 4 (October 2009): 353.
2 Lisa Corrin, "Mining the Museum:
 an Installation Confronting History,"
 Curator: The Museum Journal 36,
 no. 4 (October 1994): 311.
3 Yellis, "Fred Wilson, 337–38.

"The Fever Dream of the Amateur Historian": Ben Katchor's *The Rosenbach Company: A Tragicomedy*

Melissa Rachleff

> The Jew is not a museum specimen to be admired on Sunday afternoons. Like all social beings, he is subject to constant change and development—a creature of his surroundings. It is this subtle ongoing metamorphosis that we endeavor to study.
> —*Ben Katchor,* The Jew of New York[1]

> Initially the idea was to have Ben write a comic book history of our founders, also the founders of the Rosenbach Company, as a way of observing the fiftieth anniversary. The concept was to explore what had become the museum by looking back on our longer, more or less hundred-year history. And we saw Ben as someone who was inventive and playful and quirky in all the right ways. And those are words we use when we think about our founders too. The kinds of collections they acquired and sold and kept, and the reputations that they clearly had devised for themselves—they were certainly characters.
> —*Derick Dreher, director,* The Rosenbach Museum & Library[2]

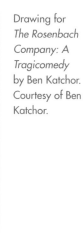

Drawing for
*The Rosenbach
Company: A
Tragicomedy*
by Ben Katchor.
Courtesy of Ben
Katchor.

Over the past decade, the Rosenbach Museum & Library, a midsized museum founded in the city of Philadelphia in 1954, has garnered increasing attention for its innovative approach to the interpretation of its collection. Part of this recognition is due to its artist-in-residence series, a program begun in 1998 by the museum's former educator, Bill Adair, which focuses on rethinking objects in the collection. Adair, like the current museum director, Derick Dreher, and the collection curator, Judith Guston, was hired as part of the institution's reinvention in the late 1990s. Prior to this period, the Rosenbach Museum was known mainly to literature scholars and bibliophiles, having been founded to preserve the personal collection of art, antiques, and rare books assembled by the brothers Rosenbach. The younger, Dr. Abraham Simon Wolf (A.S.W., or Abe) Rosenbach (1876–1952), was internationally renowned as a dealer in rare books and manuscripts. With his older brother Philip (1863–1953), he ran The Rosenbach Company, which sold books and manuscripts, as well as decorative art and artist prints. The museum is located in the final home occupied by the brothers, in Philadelphia's Rittenhouse-Fitler historic district, an enclave of elegant 19th-century townhouses surrounding the stately Rittenhouse Square park.

 The most ambitious project created in the museum's artist-in-residence program was the 2004 production titled *The Rosenbach Company: A Tragicomedy*, by renowned artist/graphic novelist Ben Katchor. This musical theater piece, originally commissioned in

2002 and completed in time for the museum's fiftieth anniversary, instigated an internal dialogue about the museum's identity and history, and their public representation.[3] This resulted in an institutional ambivalence in the ownership of the project despite its overwhelmingly positive critical reception in the media. Understanding Katchor's artistic goals in devising *The Rosenbach Company* and the institution's goals as its producer highlights critical issues involved in collaborative programming between artists and museums.

MUSEUM ASSIMILATION

The Rosenbachs' rise to the wealthy Rittenhouse neighborhood in the 1920s reflects the successful assimilation by Jews into upper-middle-class Philadelphia society. The Rosenbach brothers' erasure from popular memory speaks of another kind of assimilation, that of museum professionalization. The Rosenbach Museum & Library was founded by deed of trust in 1950 and opened to the public in 1954, with the aid of the personal and business collections left by the brothers in their wills, as well as their home, as a way of perpetuating the Rosenbachs' legacy as esteemed local businessmen and solidifying A.S.W. Rosenbach's reputation as one of the leading rare book dealers in the United States. His clients included America's industrial elite, particularly J.P. Morgan, Henry E. Huntington, and Harry E. Widener. Rosenbach sold such rarities as the Gutenberg Bible and 16th-century Shakespearean folios. His record of acquiring such rarities—and paying extraordinarily high prices—attracted international attention, as his prowess greatly influenced the market. After he purchased the manuscript of *Alice in Wonderland* at a Sotheby's London auction, much to the chagrin of the British nation, *The New Yorker* wrote a profile of Rosenbach in 1928.[4] Although most of Rosenbach's conquests were in the service of private clients, he maintained an enviable collection for himself, which he left as a founding collection to the museum that bears the family name. Among these treasures are James Joyce's manuscript for *Ulysses*; Lewis Carroll's photographs of Alice Liddell, the child who inspired *Alice in Wonderland*; Thomas Jefferson's handwritten slave inventories; and first-edition copies of *Poems on Various Subjects, Religious and Moral* (1773) by Phillis Wheatley, the first book of poetry published by an African American. Beginning in the 1960s the museum acquired hundreds of original drawings from Maurice Sendak, who has continued to support the museum and build that collection ever since.

The Rosenbach Museum & Library never preserved the living space of the two bachelor brother founders; this was not provided for in the Rosenbachs' founding documents. The museum addresses this absence by referencing the Rosenbachs and their social position in

244

the form of a few objects and portrait paintings of Rosenbach ances-
tors. Otherwise there is very little in the museum (and on its website)
that addresses the brothers' relationship to Judaism.[5] Today, the
museum is no longer solely dedicated to furthering the reputation
of the Rosenbach brothers. Rather, its mission is "to inspire curiosity,
inquiry, and creativity by engaging broad audiences in exhibitions,
programs, and research based on remarkable and expanding
collections."[6] The statement suggests *what* the Rosenbach brothers
(particularly A.S.W.) collected, not *why* they collected, is the focus of
the interpretive programming.

As the museum educator, Adair defined his task as "to make col-
lections physically and intellectually accessible to a wider audience
in Philadelphia, and establish for the museum an audience that was
more culturally diverse, reflecting the full spectrum of age groups."[7]
A graduate of the urban cultural planning program at the University
of California, Los Angeles, with an undergraduate degree in history
from the University of Pennsylvania, Adair had worked in a broad
array of museums—from anthropological to contemporary art—and
was familiar with the critical art practices of the 1990s, particularly
the work of Fred Wilson, whose 1992 reinstallation of the Maryland
Historical Society's collections offered the museum field a pointed
critique of museum culture. Adair saw the Rosenbach collection
as underexplored, and perhaps off-putting to those outside literary
circles. Engaging non-experts was important to Adair's conception
for the education program, leading him to develop an ongoing
artist program that made commissions in response to the collection.

Rosenbach artist projects have ranged from performance work by
the Headlong Dance Theater inspired by James Joyce's epic novel
Ulysses to sculptor Teresa Jaynes's installation of dress fragments set
in one of the period rooms. In that project viewers gazed up at the
ceiling and viewed the underside of the dresses. Those succumbing
to this provocative gesture were rewarded with embroidered quotes
sewn into the dresses, all drawn from books in the Rosenbach Library
and which revealed biases about feminine social expectations. Such
site-specific projects exposed audiences to the depth and breadth
of the collection, but some on staff found these exhibitions prob-
lematic, if not disrespectful, and saw the entire artist-in-residence
concept as suspect. During the late 1990s and the early 2000s, those
not persuaded by this program and other outreach efforts began to
leave the institution. To Adair, debate regarding the efficacy of the
artist commissions was a healthy part of the process, particularly as
he did not conceive of the program as prescriptive. Adair recalled:

As long as the proposed project is rooted in the collection,
the museum can take the risk and try something new.

Sometimes the idea appears on its face to be out of bounds
and causes debate among the staff. As you can imagine,
not everyone will be uniformly enthusiastic about a par-
ticular artist's interpretive process or installation idea. But
this internal debate is an important part of the residency
program and causes us to confront our own biases and
assumptions regarding the role and function of the collec-
tion. In the end, the dialogue mainly comes down to this: as
long as the collection and facility are not in any physical
danger, how the collection is interpreted is up to the artist.[8]

Rosenbach director Derick Dreher affirmed Adair's approach
and noted other efforts taking place at the museum concurrently:

Our idea was basically to turn the historic house concept on
its head—to see ourselves as facilitators of experience rath-
er than as arbiters of taste and great authorities. We start-
ed to reconsider our exhibition program, and Judy (Guston,
curator) joined us at about this time (1999), and we started
talking with neighbors, eventually forming focus groups so
we could create exhibitions that were desired by our com-
munity, instead of just things we thought were interesting.[9]

The new Rosenbach staff also involved the museum's board in all
programming decisions. One board member contributed approxi-
mately $50,000 toward the cost of initiating innovative education

programs, including the artists-in-residence, evidence of the level of enthusiasm for Adair's ambitious interpretive effort. While Adair recalls the donor's wishes to support the program, Dreher noted that in actuality, the artist-in-residence program was allocated modest financial resources. According to Dreher, the direct cost paid to artists ranged from hundreds of dollars to a maximum of $2,500 prior to the Katchor project.[10]

The idea for commissioning Ben Katchor was entirely Adair's. In 1998 he came across Katchor's newly published graphic novel, *The Jew of New York*, and was intrigued. Adair traveled to New York for several years to attend Katchor's lectures (his promotional tour for *The Jew of New York* involved lectures as an homage to 19th-century popular entertainment) and forays in musical collaboration. Ultimately, Adair introduced himself to the artist and persuaded him to visit the museum. Adair recalls, "I was drawn to Katchor's work in terms of its playfulness and quirkiness, his sensibility of serious play. His work is often very funny and serious at the same time. Serious play is one of the sensibilities I was trying to introduce to the Rosenbach as much as possible. That hybrid of playful and smart." Moreover, Adair believed the museum's collection would appeal to Katchor's sensibility. "There was something Joycean about Katchor's celebration of the complex and rich life of the city. The city is a primary character in Katchor's work, and I was drawn to him in terms of the urban content and because of his knowledge and interest in Jewish American culture." Adair was correct about Katchor's attraction to the museum, and after a tour of the collections and archives, Katchor agreed to work on a project. But *Ulysses* would not be the subject. "Ben made it clear very quickly that of everything he was seeing, the subject matter that he was most excited about and drawn to was the story of the brothers themselves," Adair noted. In the spirit of the program as a dialogue, the museum allowed the artist to choose his subject.[11]

THE HIDDEN TRANSCRIPT

Jewish assimilation and its attendant contradictions are motifs that run through the work of Ben Katchor. Born into a Yiddish-speaking household in Brooklyn in 1951, Katchor became part of the 1980s "comix" scene, started by Art Spiegelman and Francoise Mouly, publishers of *RAW Magazine*.[12] Katchor, a contributor to *RAW,* is perhaps best known for his serial comic strip *Julius Knipl, Real Estate Photographer*, which captured the wandering and fragmented musings of an urban archeologist, what the French critic Jean-Claude Glasser summarized as the "anachronistic, paradoxical, false pretences" of the world as seen by a Jew.[13] *Julius Knipl* was published

in alternative newspapers, and in the Jewish weekly *Forward*, from 1988 through 2001.

Katchor became fascinated by how the Rosenbachs sublimated their origins in their journey from the middle-class Jewish neighborhood of their youth to successful businessmen of cultivated taste. Katchor was compelled by the countless minor tragedies in the Rosenbachs' self-invention process and set out to explore *why* the brothers collected what they did. Here might have been another tension point with the museum, which had shifted its mission away from the Rosenbach brothers due to their public obscurity. For Katchor, that contemporary obscurity, despite a museum having been created as a legacy, is part of what makes the story tragic. The ultimate failure to capture the past, to seize it as an object, reflects an emotive double bind. A dead past carried into the present would make the story a tragedy; its retelling (as Marx's oft-quoted comment on history suggests) is comedic.[14]

On the weekend of September 10–12, 2004, the museum opened *The Rosenbach Company: A Tragicomedy*, a two-and-a-half-hour illustrated concert. The program featured a four-member band and three singers. In addition to writing the libretto, Katchor drew more than 800 still and animated images to coincide with original music by composer Mark Mulcahy. As one might imagine, Katchor's formation of the Rosenbach brothers is less lighthearted than Derick Dreher's concept of "quirky" introduced at the opening of this essay. Katchor infused the story of the museum's genesis as a Jewish tragic/comic dialectic—a narrative that anyone visiting the Rosenbach Museum & Library would be hard-pressed to find. In effect, *The Rosenbach Company: A Tragicomedy* functions as the institution's unofficial history, its "hidden transcript (a term borrowed from historian James C. Scott).[15] Such sublimated stories are challenging to represent using traditional museum methodologies. They can be brought out, however, in other types of projects, particularly artist investigations, which are less literal as a form/process. The museum's hidden transcript (in this investigation) is in part Judaism, and in part the assimilative behavior manifested in the largely non-Jewish material culture assembled by the Rosenbachs, upon which the entire institution is premised. Katchor's pursuit of Jewish assimilation in *The Rosenbach Company* reconstitutes the meaning of the institution and opens up new interpretive possibilities. Whether the production fulfilled the aspirations of the Rosenbach Museum & Library on its fiftieth anniversary is another issue.

FUGITIVE INTERPRETATIONS

Those familiar with Katchor's work know it shows a resistance to narrative. His books, strips, and musical productions are all built around

tangents and forays into paradox. This is also how Katchor saw the actual lives of the Rosenbach brothers. As the songs unfold in the "illustrated musical," they describe the circumstances surrounding the formation of The Rosenbach Company, the brothers' different personalities, their dependence upon each other, and their various romantic liaisons. The forty songs and more than eight hundred projected drawings act as an archive, an accumulation of information that refrains from imposing any interpretive logic about motivational impulses or desires. "People think that they have to make a life into a story, but that kind of simplifies it," Katchor reflected. "Most people's lives are complete chaos, there is no story. You're born, you die, and it's all unresolved. And everything is a mess. I thought, especially in musical theater, you could evoke that kind of messiness of their lives. There doesn't have to be a neat aim; the Rosenbachs reached their aim by Act Two. To make their lives into a story would have been completely false."[16]

Katchor's resistance to creating an overarching narrative means the production privileges the episodic, and the fragments represented are linked not necessarily in plot, but by the objects the brothers acquired. The logic is that of the archive, where items are preserved without regard to their significance. Katchor remarked, "Everything that happened to (the Rosenbach brothers) rolled off their back." A narrative would fall prey to romantic sentimentality and thus be false to the material origin of the production.

249

At one point, Katchor referred to the archival process that the Rosenbachs enact in *The Rosenbach Company* as a futile attempt to stave off death. The object possessed comes to be associated with the possessor, who, so embodied, can survive into posterity. This interpretation comes directly from Katchor's experience in the archive. He recalled:

> I read everything about (Abe) and then I spent time looking through things, particularly the visual things they had, photographs, things like that. Initially, I didn't know what this piece would be about—a very specific part of the museum? a life story? I didn't know yet, so I was looking at a lot of things. And the Rosenbachs saved everything. There's more than you could possibly want to read. They have the most thoroughly documented lives. Their mother didn't throw anything away, neither did Abe, nor his brother Philip. They were sort of hoarders of things, receipts, bills, just reams of material.[17]

Katchor mined the preservation (or hoarding) impulse in his Rosenbach characters. The portrayal recalls the bereft businessmen

Drawings for *The Rosenbach Company: A Tragicomedy* by Ben Katchor. Courtesy of Ben Katchor.

who populate his comic strip, *Julius Knipl*, who, like the Rosenbach brothers, deals in objects that take on a mystical aura. One scholar described these characters as engaged in "mysticism as commerce," an interpretation to which Katchor assented, seeing in religious identification an impulse "spurred by poverty and commercial, or worldly, failure."[18] This lack of escape from a commodified culture even in the realm of the spiritual is a modern condition examined by cultural theorists dating back to the German critic Walter Benjamin in the 1930s.

Unlike Katchor, composer/musician Mark Mulcahy did not undertake preliminary research on the Rosenbachs. "Being distanced from the history enabled me to find what would make good material for a song," Mulcahy recalled. Katchor advised on what could not be cut; Mulcahy advised on lyrics. And in going through Katchor's text Mulcahy looked for lines that could be made to rhyme. The process is similar to editing. "I find things worth repeating and say it in one line, and leave the rest out. In shaping the text into songs, I never ask Ben what things mean. I take what Ben writes at face value."[19] The songs further abstract the "real" Rosenbachs from their representation, and the historical figures become characters—part history, part poetry, part visual art, with all parts coexisting equally.

In chronicling the Rosenbachs, Katchor confronted the same challenge the museum faced in extending their legacy to current times. The Rosenbachs did not *make* anything; their achievement resides solely in the objects they assembled.[20] In and of themselves, the objects are not coherent as a story. Rosenbach's rare books and manuscripts are indices of an impulse, and for Katchor, "It became clear the story was more about the feeling of mortality that Abe had. And that had a lot to do with thinking about old things that passed through hands, through people who came and went, and you know, that's a life, that's the story of his mortality, that's the story."[21]

In the play, the Rosenbachs' worldview—a life of objects and things—is introduced at the outset, although its significance is not recognized until the end. The first song describes Philadelphia in the 19th century. In a soothing, rhythmic intonation, the singer asks, "What do books taste like in the 19th century?" For Katchor, this question is at the heart of Abe Rosenbach's obsession:

> Old books have smells. The song gives the piece some kind of sensory reality. Bibliomaniacs are addicted to the smell of books, or the taste. That was Abe's theory. Abe also thought that bibliomaniacs aged slower than others because they were surrounded by old books. They almost ingested them just by being in libraries and something got

into their system. That had to be part of the story. The physical story, the physical qualities of books. And how a child gets to know books. First you get to taste the book, then you get to read it, but reading comes later.[22]

For Adair, the obsessive aspect of the Rosenbachs' book collecting, and the notion that a book's posterity can be linked to human posterity, was an entirely new way to consider the founders:

We began to talk about the brothers in terms of obsession and the sacrifices they made emotionally for the sake of being these obsessive, passionate collectors. They had these really tragic and fragile personal lives in both cases. They never made serious connections with other people because they were making such intense connections to objects. And that was a really new perspective on them for me, and I know that other people felt the same way. The DVD (the museum made) of the piece is used to train the docents at the Rosenbach, so they get Katchor's perspective on the brothers, and that really complicated view of them with its dark and bright side is one that continues to resonate.[23]

253

Other museum staff saw the founders differently. Rosenbach Museum & Library curator Judith Guston objected to *The Rosenbach Company*'s "avoidance of death" as a motivator in the brothers' lives. For Guston, the preoccupation with death—if indeed it existed—was not neurotic, but part of being cultivated:

I think what Dr. Rosenbach was doing was not only for himself but for his clients. They were building libraries and they were essentially building memorials for themselves. And Dr. Rosenbach was doing the same thing in a way, that this is what he wanted to leave after his own death. So it is in a large way about death, but also about perpetual life, that these people were building something to leave of themselves after they died. A lot of them were thinking about death, but I don't think in a morbid way, but in a constructive way. I don't know if it was the way Ben was thinking about it ... he is a little bit darker.... Victorians thought kind of darkly too, but it's "What's going to be left after I die?" And certainly Dr. Rosenbach did think about what was going to be there. They left instructions—this is what you are supposed to do with this stuff after I die. And we follow that seriously.[24]

Guston situates the Rosenbachs within their historical context, as a part of American material culture. In other words, she is a trained historian and employs a different frame in which to analyze the Rosenbachs—a frame that does not problematize their Jewish origin.[25] Guston's role is as faithful to the founding documents as possible. Fanciful interpretations are not given as much credence in academia; museum training in history and collection management rejects the speculative.

THE FAÇADE

"When you invent the story it's a façade that you construct," Katchor notes about his working method, "and behind that the audience or the reader imagines the rest of the world." Katchor continues:

> In this case, I had the whole world and I had to sort of pluck out things to build this fictional façade. Once you start writing history, there is an element of fiction involved. You're interpreting facts. I didn't know the Rosenbach brothers, I wasn't there. To me it's all mythology. There's tons of material: events hinted at and "true stories." I had to prune it down to arrive at something that would work.[26]

Katchor's fiction conceals what one critic called the "ruins of some fantastic scheme...nothing is exactly what it seems."[27] Indeed, Katchor's reading of A.S.W. Rosenbach's transformation from scholar to leading dealer of rare books in the early 20th century is a façade made manifest:

> Abe constructed the idea of himself as the world's foremost rare book dealer.... It was a piece of theater on his part. Abe made the public believe that he was willing to pay more money than anyone else for a book he wanted. The truth was that he had to put together a group of investors, and in the end, had trouble paying some of these people back. He really overextended himself sometimes. But the fact is that Abe's life was like a light operetta filled with completely crazy, hare-brained schemes. That stuff lends itself to musical theater.[28]

The play's drawings and music introduce audiences to a genre that historians have labored to quell—the self-aggrandizing, sensationalistic memoir. One example of Rosenbach's self-promotional skill is his book *A Book Hunter's Holiday: Adventures with Books and Manuscripts*. Written with the aid of a ghostwriter, Rosenbach's tales

254

of book buying are remarkable for their breathless style, embroidering ordinary incidents into adventures. In one episode, Rosenbach notices a rare pamphlet (written by one of the first convicted murderers in colonial America) in the disheveled home of a rival collector. Using a style more common in pulp fiction, Rosenbach declares,

> What a terrible temptation was mine! This young book-lover, who had a wild, queer gift for obtaining great books—did he even know that he possessed this volume? How could he, in all that confusion—a confusion of years? If I did accidentally take it, who would suspect me? And, even so, who would think to accuse me? For a few moments my mind worked in and out of channels as slippery as any criminal's.[29]

Katchor's Rosenbach is less breathless but similarly obsessive about books. "Abe" sings about an overriding love of auctions, using language that could be lifted directly from Rosenbach's tales. Katchor's self-conscious, segmented approach to telling an anecdote surfaces midway through the play. After purchasing a collection of rare Shakespearean folios, Rosenbach has the treasures packed up in specially designed trunks (Katchor's illustration helpfully diagrams this detail for the audience) for safe transport back to Philadelphia. Along the way, a porter inadvertently drops one of the trunks onto the train tracks. There it lies, and Katchor's illustration shows the vulnerable trunk, sitting on the track with a "whoo, whoo" caption signifying a train approaching. As the character Abe, paralleling his literary conceit, sings a series of Shakespeare's curses at the hapless porter, alternately crying, "Oh, won't somebody help me?!" the images on the screen create an air of desperate suspense. The trunk on the tracks, the approaching train, and the folios flash before us—will these priceless 16th-century texts be demolished?—and then intermission comes, creating a cliffhanger.

"It's a story found in (Rosenbach biographer Edwin) Wolf's book that Abe told to get a rise out of people," Katchor explained. "Abe was in this predicament and maybe he was going to lose these books." But, as Katchor also noted, Abe himself was in no danger. "There was no chance that he would be killed because he didn't stand on the tracks. It was the trunk." At this point in The Rosenbach Company, the audience has come to understand that the objects are, in the world of the Rosenbachs, the equivalent of people. "Well, rivaling people," Katchor asserted. "People, they objectified. People were just accessories, especially for Philip.... They were customers, or they were another commodity. They'd come into their lives, they'd go out of their lives."[30]

When the play resumes, a porter arrives in time to pull the trunk off the tracks—problem solved! The anticlimax gets perhaps the longest laugh in the piece. "It was the perfect cliffhanger you could just deflate at the next moment," Katchor recalled. "You can really build it up into him cursing his fate. Yes, I made more out of it than he probably ever did."[31] And in so doing, Katchor reconceives a Rosenbach story hour, where rare books and ordinary inconveniences combine to create an epic tale.

POLEMICS

Farrar Fitzgerald, a new employee in the education department at the museum in 2004, was struck by the closeness of this portrayal of the Rosenbach brothers to Katchor's own work:

> It made sense to me how Katchor interpreted the Rosenbachs, how it followed a thread of his work. It was exciting to see (Katchor's) interpretation of our founders, people that would typically be on a pedestal.... (I)t was a conversation that we could have again, not that it wasn't one that we were already having. We were always interpreting the brothers and their personalities; it is very much part of the tour of the museum. But I think it became more conversational in Katchor's work, and very invigorating too.... I was very excited to be part of an institution that would put on a show like that, part of the Fringe Festival.[32]

Indeed, the Rosenbach Museum & Library reached an entirely new public by having the piece included in the Philadelphia Fringe Festival for a sold-out, four-performance run at the Adrienne Theater. However, Derick Dreher did not see this association as particularly significant in the long term. Analyzing the impact locally, he found the project limited:

> There were only four performances in Philadelphia. And we had a real burst of activity, and members, trustees, stakeholders, and other members of the public went to see the performances and were engaged by them. There were a lot of discussions around that time, but then it subsided again because the performances weren't there.... If we had thirty performances you might have seen that spike in interest, but I don't think it was sustained enough to see that.[33]

Dreher is absolutely correct that there were too few performances in Philadelphia; however, doing more would have required finding a coproducer with expertise in theater production, a task that would

256

have necessarily involved not only Dreher but also the museum's board and other outside experts.

Fitzgerald's comments, though, help us better parse the dichotomies between Katchor's Rosenbachs and the museum's interpretive mission. The guided tour, which this writer took in 2004 and in 2009, does indeed delve into the Rosenbach brothers' biographies, and the tour becomes a conversation between the visitor and the docent. How that docent might reflect on the significance of the Rosenbachs in Philadelphia, how tidbits from their own past might attest to the Rosenbach Company's presence, and whether their own thoughts about prominent Philadelphia Jews might influence the tour is entirely subjective. Unlike actors or costumed interpreters (the historical site equivalent), the docents do not restrict their impressions to a script, and in this, their approach is similar to Katchor's in personalizing aspects of the Rosenbachs' biographies that correlate to their own lives and sensibilities. Indeed, more than Katchor's production, the Rosenbach Museum & Library's docent tour is the embodiment of conversational, though I understand Fitzgerald's point to be more about the tone of Katchor's *The Rosenbach Company*. Nonetheless, Katchor's production is quite the opposite, as it appears in a mode that is fixed, scripted, and subject to critique.

Not surprisingly, Katchor's interpretation of the brothers felt unfamiliar to some of the staff, and the project caused internal discord. His repositioning the Rosenbachs off the pedestal, as Fitzgerald acutely observed, prompted debate within the staff and with their stakeholders—particularly the board (some of whom were family members)—about the appropriateness of Katchor's representation. No one presently at the museum would speak directly about specific objections. At best, Fitzgerald's comments underscore the difference between the museum's interpretive approach (which takes historical expertise very seriously) and Katchor's questioning of the entire historical enterprise as attainable.

This tension is evident in a different debate involving Katchor. In the early 1990s, as he began the comic strip later to be compiled into his book *The Jew of New York*, the editor of *Jewish Currents*, Morris U. Schappes, published an attack on the strip as historical fabulism. In particular, Schappes cited Katchor's use of questionable sources to describe the actual Mordecai Manuel Noah (1785–1851), the nonexistence of the New World Theater in New York (where a portion of the story takes place), and, more troublingly, the fact there was never a play called *The Jew of New York* based on Noah's life. Katchor responded to Schappes' criticism with a letter that poetically asserted his right to operate between fact and fiction. Later, Katchor reflected on the episode and his own letter:

My polemic. Our pitiful little controversy. But it is really true
what I wrote him: I came upon Noah in a footnote—that's
all I knew about him. I didn't know anything about him,
which is why I did the strip. Knipl is everything I know; "The
Jew of New York" was everything I don't know. And those
were indeed the dreams of an amateur historian: he did a
little research, he went to sleep, and those were his fevered
imaginings.[34]

The historian must meet the artist halfway and typically that is
easily accomplished. But matters are made prickly when the artist
steps into the historian's terrain. Is the very historical enterprise being
undermined by an artist interpretation?

In terms of public audiences—the ostensible focus of the
Rosenbach Museum & Library—very few people were distressed by
Katchor's representation of the Rosenbach brothers. Only a small
minority could be said to be invested in representations of A.S.W.
and Philip Rosenbach, particularly during the early 1990s when
the future of the museum was in peril.[35] One indicator of the lack of
public interest is the dearth of publications. The definitive account
of A.S.W. Rosenbach's life as a dealer remains an out-of-print 1960
biography written by Edwin Wolf and John F. Fleming, Rosenbach's
acolytes, and books about collecting penned by A.S.W. Rosenbach
throughout his life.[36] It would certainly seem a Sisyphean task to
make the Rosenbachs relevant now.

But Katchor's The Rosenbach Company: A Tragicomedy does
exactly this by recuperating the sublimated and telling a story that
splits authorship of the work among Katchor's drawings, the perform-
ers, and the Rosenbachs, both actual and Katchor's interpretation.
Katchor and Mulcahy represented the unresolved dynamic between
art and history by eschewing formal acting. The singers—or "picture-
narrators," to use Katchor's term—tell the story because "it was better
to show how it is contemporary people (the performers) talking about
the Rosenbachs. It's more like a lecture in the Rosenbachs' voices.
The whole thing is in quotation marks(:) 'Abe said,' but it's not really
him saying it. I think if we tried to really dramatize it the whole thing
would not work as well. There's enough remove from the actual
people for someone to reinterpret their lives in an interesting way."[37]

When I interviewed them, both Guston and Dreher were exceed-
ingly careful to offer a balanced analysis of the Katchor project;
however, they were troubled by what they saw as an incomplete
view of the museum's founders. And because Adair's management
of the artist-in-residence program gave the artists free rein, no one
at the Rosenbach Museum had any idea as to the content of the per-

formance until rehearsals began. Asked why he never had Katchor speak with the staff about his ideas/development, particularly given the scale of the project, Adair responded:

> That is the critical question, the heart of all of the angst. I made a decision for better or for worse to give the artist free rein and no feedback from us as part of the process. And other people, in the end, really disagreed with me. They felt as though the project would have been a lot better if the staff (like the archival staff and other people that knew a lot more about the brothers, including the family) had had an opportunity to dialogue with Katchor as the project was being created. And in the end, they felt it would have made a better project. And maybe they are right, I don't know. It certainly would have defused the tension, although what would have happened if there had been violent disagreements at that point? I don't know how that would have shaken down. In the end what happened was Katchor presented this larger-than-life picture of the brothers that most people responded to very positively, including the family members once they saw it, but there were tremendous amounts of concern about it as it was opening.[38]

All agree that once fears of a disrespectful portrayal were allayed, *The Rosenbach Company: A Tragicomedy* was embraced. However, Dreher's criticisms of the process suggest that the internal debates were also about the scale of the expression. For Dreher, inaccuracies in Katchor's rendering of the Rosenbach brothers laid not the work's morbidity but the institution's vulnerability:

> Katchor's vision showed the Rosenbachs with all of their human foibles, and then some, and that is probably what made it so interesting for us, and also challenging, frankly, at the time. Unlike any other artist project we commissioned before or since then, that one was very personal. We weren't asking Ben to tell us what he thought about a book in our collection or a painting in our collection. Or some other artifact. We are asking him what he thought about our family, about us. And, as I said earlier, he saw the story as a very dramatic one (that) lent itself to theatrical interpretation, and came up with something very compelling, and in some ways very surprising. We envisioned the brothers to be not quite as dramatic as they appeared on stage.[39]

Dreher's heavily qualified appraisal and use of the familial can be seen as a response to Katchor's status as a national figure, and because of it, The Rosenbach Company's authority over the museum to publicly define the founders. The museum's own portrayal of its founders is less known, if not obscure, by comparison. This placed the museum at a disadvantage, at least for Dreher, and his carefully crafted remembrances reflect how he (and perhaps others) experienced Katchor's piece as a critique, which, given the way Katchor's work operates on a cultural level, was the point.

For Fitzgerald and Adair, Katchor's "illustrated opera" offered a starting point for a new dialogue about the museum, but for Dreher and Guston the dialogue was marred by an absence of ownership. Dreher and Guston's opinions are important because they reflect the proprietary position staff occupy in most interpretive processes. Greater ownership by the museum might have been possible had the residency process incorporated staff dialogues with the artist— not to direct the artist, but to recognize the staff's own obligation to the institutional mission and other kinds of projects that might be necessitated by the artist's work.

Sharing interpretive authority with non-experts, the basis for the Rosenbach's artist-in-residence program, requires trust in the process. A lack of trust on the part of some staff (and some board members) resulted in an institutional ambivalence about The Rosenbach Company. The success of the work at Philadelphia's edgy Fringe Festival brought renewed attention to the museum by a public that had never visited, but, did they actually visit? Collecting such data was beyond the scope of the project, and one can either trust the staff that embraced the project regarding its impact, or trust the staff whose opinion was less certain. What can be stated with certainty is the Rosenbach Museum & Library has not pursued grants to mount similarly large-scale productions. The residency program returned to its modest scale and underwent revision under a new director of education hired in 2009.[40]

THE LONELY MAN THEORY OF HISTORY

Since the Philadelphia premiere, Katchor has restaged The Rosenbach Company independently elsewhere, including New York City and Berkeley, California. No one from the museum was on hand to introduce the piece or claim ownership of the production.[41] The Rosenbach Museum asked Katchor to donate a selection of drawings to the collection, but Katchor declined. This is disappointing given the complementary drawing collections at the museum, particularly the Maurice Sendak collection. Dreher recalled:

Remember we knew nothing about Ben's specific plans until just before opening night, so we had no chance to write anything into the contract relating to working drawings, etc. (Even if we'd had months of notice, I can't imagine any artist would willingly hand over his or her creations just because they were funded by another entity.) Our contracts with artists who create original works always cede copyright to the creators.[42]

In this author's experience, many artists would relish the opportunity to have their work in an important museum collection because it enhances their reputation and ensures their work is preserved for posterity. While some artists would indeed donate artwork resulting from a commissioned project, other artists would expect to be paid additional fees for what they would perceive as items that went beyond the original commission. Museum donors, curators, and the director are regularly involved in such negotiations, most especially in art museums.

However, Katchor did agree to lend drawings for a complementary exhibition held just after the four performances at the Adrienne Theater, and thereafter ended its formal association with *The Rosenbach Company: A Tragicomedy.*

The Rosenbach Company, therefore, ultimately has acquired a history distinct from its institutional derivation. In this the Rosenbach Museum & Library's artist-in-residence program is similar to many other high-profile artist projects in history museums: the scales inadvertently tip toward control by the artist and the artist's constituencies. Indeed, the relation to Rosenbach Museum recedes from view as the production is performed farther afield. To claim *The Rosenbach Company*, the museum would need to build upon the interpretive themes Katchor's piece invoked and allow for a greater exchange about the complexities of contemporary secular Jewish yearnings, assert the validity of a construct that might look like history but is really fiction, and confront the perils in letting go of interpretive authority. It is more accurate to see *The Rosenbach Company* as an extension of Ben Katchor's body of work than as an historical study about Rosenbach brothers.

The Rosenbach Company's theme is the impossibility of fixing an identity, of transcending your origin. This sort of lonely man view of history is indelible in Katchor's work. As novelist Michael Chabon observed about *Julius Knipl: Real Estate Photographer*, "In the end it isn't nostalgia but loneliness, of an impossible beauty and profundity, that is the great theme of Knipl."[43] One might offer the same tribute

to the Rosenbachs, particularly Katchor's Abe, a figure crafted as so solitary and singular in his bibliophilic pursuit that notions of realism must be set aside for the symbolic.

What can museums learn from the artist-in-residence program conceived by Adair, and from Katchor's *The Rosenbach Company*? One important lesson is that a work of art will have its own life apart from the institutional framework. Because artists can resituate their work, it is important to determine institutional ownership prior to the project commencing. In this project there was not enough discussion regarding the legacy of the project for the museum's collection. Secondly, dialogue between the artist and stakeholders does not automatically result in the curtailment of the creative process. Institutions must let artists decide for themselves if collaboration is problematic. One might ask whether history and culture museums create more autonomous situations for artists than art museums, where parameters and boundaries are negotiated with the artist prior to undertaking a project. The third lesson is to be aware of the scale of the endeavor. Katchor's project introduced the museum to a level of artistic undertaking that it could not sustain. For the public attracted to the museum by the performance, this could set up a disappointment. Those wishing for the next large-scale, nationally recognized contemporary art piece will not find it commissioned by the museum, and that poses problems in maintaining new audiences eager for similar experiences.

In the end the differing opinions among board and staff regarding the interpretive accuracy of *The Rosenbach Company* prompted a new look at a subject the museum thought esoteric. Katchor's portrayal, though symbolic, humanized the past. Katchor's Rosenbachs are experienced by audiences as people. Moreover, the critical success and new productions elsewhere raised the museum's public profile. Finally, Katchor's work confronted an underexplored aspect of the museum, its roots in Jewish assimilation, and far more could be done to mine that history. Katchor's interpretation resonates as an emotional truth about Jewish culture in America during the height of Jewish migration from Central and Eastern Europe. Early in the piece, Abe's life embodies the tragic, signified by the abandonment of intellectual pursuits at the university for a place in his brother's commercial enterprise. Isabella Rosenbach (Abe's mother) asks in a song, "Who will cry for the scholar that is lost to the world?" This lament colors *The Rosenbach Company: A Tragicomedy*; its melancholic strains wend their way through the production. Yet within this personal tragedy, the audience found much to laugh about and marvel at in Katchor's construct. This says something about comedy's analytic capacity, and why artists offer an interpretive mode for history museums to embrace.

1 The quote from Katchor is in Alexander Theroux, "Ben Katchor (Interview)," *Bomb Magazine* 88 (Summer 2004);/ http://bombsite.com/issues/88/articles/2668 (accessed July 5, 2010).

2 Ben Katchor, *The Jew of New York* (New York: Pantheon, 1998), 85; Derick Dreher, interview by author, September 18, 2009, Philadelphia. This article is a revision of the author's previously published review, "Museum: The Musical!" *Museum News* 84, no. 4 (July/August 2005): 29–31; 67.

3 *The Rosenbach Company: A Tragicomedy* was funded by a $70,000 grant from the Pew Charitable Trust's Philadelphia Exhibition Initiative program.

4 Avery Strakosch, "'Napoleon of Books,'" *The New Yorker* 4, no. 8 (April 14, 1928): 25–28.

5 Strakosch, "Napoleon of Books,'" 26–27.

6 The *New Yorker* magazine profile, written by Avery Strakosch, underscores an othering of Judaism that the current absence of Jewish history at the museum does not serve to erase. In the following passage note the incursion of Jewish ritual amid the self-consciously assembled bourgeois Christian splendor of the Rosenbach townhouse: "With his brother Philip, who deals and is a connoisseur of English and American furniture, paintings and old silver, Doctor Rosenbach keeps shop. They live in a fine early nineteenth-century brick house on De Lancey Street which they have restored and furnished with a delicate taste and an eye always to comfort.... Four days each week in the City of Brotherly Love the brothers Rosenbach solemnly carry out the Mosaic laws. They eat kosher food prepared by an excellent Irish Catholic cook, and each Friday evening celebrate Shabbas amid fine old mahogany and Waterford glass lighted by seven candles. Some of George Washington's own silver reflects the ceremony from the mantelpiece." Passages such as this validate Katchor's assimilation motif in *The Rosenbach Company*. Avery Strakosch, "'Napoleon of Books,'" *The New Yorker* 4, no. 8 (April 14, 1928): 26–27.

7 Rosenbach Museum & Library mission statement, http://www.rosenbach.org/ (accessed July 6, 2010). According to Dreher, the Rosenbach brothers gave a collection of thousands of items of American Judaica to the American Jewish Historical Society in 1932, shortly after the *New Yorker* profile was published. The Rosenbach Museum & Library does hold a collection of Jewish manuscripts that date to the 15th century, Jewish ritual silver, and other objects. The Rosenbach Museum & Library explored this collection in the exhibitions *At Home* (2000) and *R is for Rosenbach* (2004). They currently have a hands-on tour that focuses exclusively on Judaica. Derick Dreher, email exchange with author, January 4, 2011.

8 Bill Adair, phone interview by author, November 19, 2004.

9 Adair, interview, 2004.

10 Derick Dreher, interview by author, September 18, 2009, Philadelphia.

11 Dreher, interview.

12 Adair, interview, 2010.

13 "Comix" is a neologism championed by Spiegelman to distinguish between the socially and culturally positioned critique comic form being produced by artists associated with *RAW Magazine*, and their commercial progenitors. In addition to Spiegelman's *RAW*, other publishers supported comix,

263

including *Drawn and Quarterly* and Fantagraphics Press. Book-length stories done in the comix style are called graphic novels.

14 Literary scholar Jesse S. Cohn cites Jean-Claude Glasser's essay, "*Magie de l'errance*," in *Cahiers du Musée de la bande dessinée* 8 (January 2003) to frame a post-modern analysis of Katchor's work. See Jesse S. Cohn, "'I Revive, Renew, Reestablish': Mimetic Catastrophe in Ben Katchor's *Jew of New York*," *Critique* 50 (Summer 2009): 368.

15 Adair was familiar with and interested in Katchor's "rich interpretation of Jewish culture" based on his reading of *The Jew of New York*. From my own conversations with the other Rosenbach staff, I do not believe an exploration of conditional identities as part of the Jewish assimilative process was much discussed. As Dreher's quote at this essay's opening indicates, the Rosenbach Museum & Library leadership was hoping to honor the brothers' achievement. Katchor's stature as a recipient of a John D. and Catherine T. MacArthur Foundation fellowship thrust the modest artist-in-residence program managed by Adair into a much brighter spotlight.

16 Scott defines the "hidden transcript" as that which is not spoken as part of uneven power relations. I use it here to reference the sublimated Jewish sensibility Katchor's work confronts. See James C. Scott, *Domination and the Arts of Resistance: Hidden Transcripts* (New Haven, CT: Yale University Press, 1990).

17 Ben Katchor, interview by author, New York, November 16, 2004.

18 Katchor, interview.

19 Theroux, "Ben Katchor [Interview]."

20 Mark Mulcahey, phone interview by author, November 19, 2004.

21 The Rosenbach Museum & Library staff argued that collect-ing is creative. They wrote that the Rosenbachs collected "not only for themselves but for the customers who went on to make them famous as advisers, not just salesmen…. You went to the Rosenbachs because you knew they could help you build a library…. Similarly, though the collection today definitely has peaks and valleys, there is remarkable coherence in most areas of the collection: English literature of the 15th through 19th centuries (and within that, huge holdings on Shakespeare, Burns, Dickens, Dodgson, Conrad, Joyce and more); American history of the 17th through early 20th centuries (and within that, huge holdings on founding fathers, civil war, manifest destiny and more.)" Dreher, email.

22 Katchor, interview.

23 Katchor, interview.

24 Adair, interview, 2010.

25 Judith Guston, interview by author, September 18, 2009, Philadelphia.

26 Correspondence from the Rosenbach staff was emphatic on Guston's creative approach to the Rosenbachs that simultaneously investigated their Judaism. Dreher wrote, "Judy has created speculative exhibitions (including in the same year 2004 "R is for Rosenbach," a playful romp through the collections that posited unusual connections for over 150 items) despite her academic training. I would also argue that every exhibition or interpretive effort she has undertaken involving the Rosenbachs has celebrated their Jewish heritage." Dreher, email.

27 Katchor, interview.

28 Cohn, "'I Revive, Renew, Reestablish,'" 372.

29 Katchor, interview.

30 A.S.W. Rosenbach, *A Book Hunter's Holiday: Adventures with Books and Manuscripts*, 2nd rev. ed. (Freeport,

NY: Books for Libraries Press, 1968), 54.

31 Katchor, interview.

32 Katchor, interview.

33 Farrar Fitzgerald, interview by author, September 18, 2009, Philadelphia.

34 Dreher, interview.

35 Katchor's "fever dream" was also mentioned in his more recent interview with Alexander Theroux cited at the beginning of this essay. The "fever dream" might also be a reference to the early-20th-century comic strip called the *Dream of the Rarebit Fiend* by Windsor McCay, a serial known for its poetic, fragmentary, surrealistic (before Surrealism), and beautifully rendered panels. Lawrence Weschler, "A Wanderer in a Perfect City," *The New Yorker* 59, no. 25 (August 9, 1993): 66; http://archives.newyorker.com/?i=1993-08-09#folio=066 (accessed July 3, 2010).

36 According to Adair, the only members of the board who objected to *The Rosenbach Company* were Rosenbach relatives. Their concern was that a "comic" artist would make the founders appear "silly," a notion that was dispelled after they saw the piece in 2004. Adair, interview, 2010.

37 In addition to numerous pamphlets that reflect a curatorial eye about literary masterpieces, Rosenbach wrote about collecting rare books and manuscripts. See Rosenbach, *A Book Hunter's Holiday*. The definitive biography of A.S.W. Rosenbach remains Edwin Wolf II and John F. Fleming, *Rosenbach: A Biography* (Cleveland: World Publishing, 1960). Derick Dreher laments the quality of Wolf and Fleming's text, in which there is an abundance of undocumented assertions. He wrote of the Rosenbach biography, "I wouldn't call it definitive, though its length,

and the absence of other biographies, make many people assume that. Its authors were part acolyte and part detractor. There were dozens of reviews when the book came out and some critics saw it as an attempt to even the score by two disgruntled former employees." Dreher, email.

38 Katchor, interview. Katchor also remarked in another interview about the differing fictional façades on the page and on stage: "the blatant juxtaposition of drawings and real people forces the viewer to participate in the construction of a fictive world in the way that a three-dimensional stage set doesn't. The story, incidentally, tries to reconcile the trend toward immateriality in the commercial world—digital reproduction, miniaturization, et cetera—and the fact that we're physical beings." See Theroux, "Ben Katchor (Interview)."

39 Adair, interview, 2010.

40 Dreher, interview.

41 Dreher (email) notes, "It was actually Bill who began to undertake the formalization and potential revision of the program, securing a grant from Pew in 2008 to study how future interactions with contemporary artists might best function.... The process continued under the new director of education starting in 2009.

42 Katchor's credits acknowledge the commission by the Rosenbach Museum & Library and the funding by the Pew's Philadelphia Exhibition Initiatives Program.

43 Dreher, email.

44 Michael Chabon, "Introduction," in Ben Katchor, *Julius Knipl: Real Estate Photographer: Stories* (New York: Little, Brown, 1996).

Embracing the Unexpected: Artists in Residence at the American Philosophical Society Museum

Laura Koloski

The practice of inviting a contemporary artist into the process of creating an interpretation of history appears, at first glance, to be radical. Not only is historical authority being shared, but it is being shared with someone who could do … anything. The practice raises the possibility of leaving behind concerns about accuracy and context, as well as the specter of the unknown. The work might be offensive to visitors; it could raise controversial issues that the organization does not want to be associated with; it could be merely unintelligible to visitors. This kind of authority sharing may seem to be the riskiest of all. This must be, at least in part, because as public historians, most of us don't really understand what artists do. We may understand and even appreciate the work they make, but we don't really understand the process they use and it seems therefore, unpredictable.

What is the potential value of this kind of collaboration—for the visitor, and for the organization? The assumptions I've made are that including artists in the process of interpreting history can potentially do two important things. First, that it can provide visitors with new ways of understanding the historical content and themes of the project—a different access point to the intellectual content. Second, that it can provide the exhibition or organizational staff with a new perspective on the material, possibly even influencing the choice

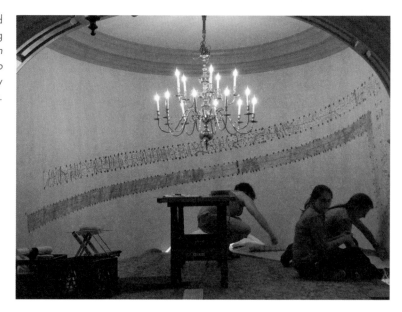

268

of themes or storylines for the exhibition. Using the case study of the Artist in Residency program at the American Philosophical Society Museum, I want to take a closer look at these assumptions, to consider the extent to which authority is actually shared between public historians and artists in projects like the ones described here, and to suggest that further sharing of authority—or as I've called it, "combined expertise"—might provide opportunities for developing more compelling experiences for visitors.

The American Philosophical Society (APS) was founded in Philadelphia in 1743 by Benjamin Franklin as an organization dedicated to the promotion of "useful knowledge." The Society's early membership included founding fathers and other 18th-century luminaries: George Washington, John Adams, Thomas Jefferson, Thomas Paine, Benjamin Rush, and many others. In the 21st century, the membership continues to be populated with men and women of significant accomplishment—from historian Laurel Thatcher Ulrich to Noam Chomsky and Stephen Hawking, and including a host of Nobel prize winners.[1]

The first museum at the APS was opened in 1794 by Charles Willson Peale. The APS Museum today, launched in 2001, is in Philosophical Hall, the same building that housed Peale's museum. It is located at Fifth and Chestnut Streets in Philadelphia, on the grounds of Independence National Historical Park, just around the corner from Independence Hall. Under the direction of Sue Ann Prince, the APS

Museum has produced a substantial program of exhibitions using their remarkable collections as well as an increasingly ambitious artist-in-residence program. The exhibitions at APS are intellectually rigorous and fairly traditional. Prince, who has a background in art history, has used the artist-in-residence program as an avenue for pushing the limits of what's possible within the constraints of a conservative organization located in a primary tourist destination. Her first artist in residence, in 2003–4, was Mark Dion, who created the *Urban Field Station* in conjunction with the exhibition *Stuffing Birds, Pressing Plants, Shaping Knowledge: Natural History in North America 1730–1860*. The work was a site-specific installation which Dion called "a platform upon which activities can happen."[2] In fact, the field station became the location of a series of public programs developed by then–education director Mary Teeling, which invited visitors to examine the flora and fauna of the urban landscape in Philadelphia. The success of the Mark Dion project allowed Prince to continue her work with artists in subsequent projects. In 2004 and again in 2006, she commissioned works by performance artist Brett Keyser which he performed in conjunction with the *Stuffing Birds* show and with the exhibition *The Princess and the Patriot: Ekaterina Dashkova, Benjamin Franklin, and the Age of Enlightenment*. In 2005, she invited Sue Johnson, chair of the art department at Saint Mary's College in Maryland, to create a group of small pieces that were incorporated into the gallery space in *Treasures Revealed: 260 Years of Collecting at the American Philosophical Society*.

269

In 2007, the APS Museum received funding from the Heritage Philadelphia Program for the implementation of five artworks connected to the exhibition *Undaunted: Five American Explorers, 1760–2007*. The show considered the work of five "explorers" working over four centuries, all of them members of the APS: David Rittenhouse, maker of surveying and astronomical equipment; artist John James Audubon; 19th-century zoologist and artist Titian Ramsay Peale (who was born in Philosophical Hall); Arctic explorer Elisha Kent Kane; and pioneering ecologist Ruth Patrick. In addition to the work and legacy of each explorer, the show was an investigation of the nature of exploration itself. The related artists' projects were to be a much larger and more complex residency than Prince had yet undertaken at APS. She had several goals for the project, including: attracting new audiences, working with the National Park Service on installing work within Independence National Historical Park (INHP), and creating a series of works that would be staged over the eighteen-month duration of the exhibition.[3] Conceptually, the museum hoped that the projects would illuminate the theme of exploration, including in your own backyard.[4] The projects, together called *Unexpected:*

Contemporary Artists at the APS Museum, were on view from June 2007 through December 2008 and included two installations on the grounds of INHP and one in the foyer of Philosophical Hall; a performance that took place in and around the park; and a video piece located in the gallery space. This case study will focus primarily on the three installation pieces.

Early in the project, Prince and the APS Museum staff began a series of conversations with the National Park Service (NPS) staff at INHP. The NPS was open to working with the APS, and to allowing the installation of work on park grounds, but with some reservations. They had questions about how the park would be interpreted through these projects, and concerns about the level of intrusion in the landscape. Many of these concerns informed Prince's search for potential artists.[5]

Prince commissioned Brett Keyser, with whom she had worked before, to create a performance piece. Inspired by the idea of exploration itself, including how and where it takes place, he developed *You Are Here*, a performance which cast him as the leader of an "expedition" through the grounds in and around INHP. Audience members followed Keyser through the urban park and were invited to participate in the examination of both the built and natural environment. On their "expedition" participants used surveying instruments, made observations about their surroundings (including pushing on the historic Second National Bank building), and joined Keyser in role-play.[6] Video artist Roderick Coover used footage from Keyser's expeditions along with other images of the APS Museum and INHP to create *Outside/Inside: Virtual Panoramas of Independence National Historical Park*. The piece, which also served as documentation of Keyser's *You Are Here* performances, was available at a computer in the exhibition gallery. Visitors could scroll through the panoramic photograph of the national park and access video clips or photos of Keyser's "expeditions" embedded in the panorama—in other words, placed digitally in the locations where the performances were located in real space.[7]

Three installation pieces were created by Winifred Lutz, an artist who describes her work as site-integrated rather than site-specific. Lutz says she thinks of herself as someone who incorporates history into her work, but not "in the sense of text so much as history in the sense of how a site evolves."[8] When identifying artists, Prince had approached Lutz and several other artists to discuss the project. During these initial conversations, Lutz and artist Stacy Levy both mentioned that they had worked together before, and would be interested in doing so again. Prince eventually decided to commission Lutz and Levy to develop the projects together, believing it would be an effective collaboration.

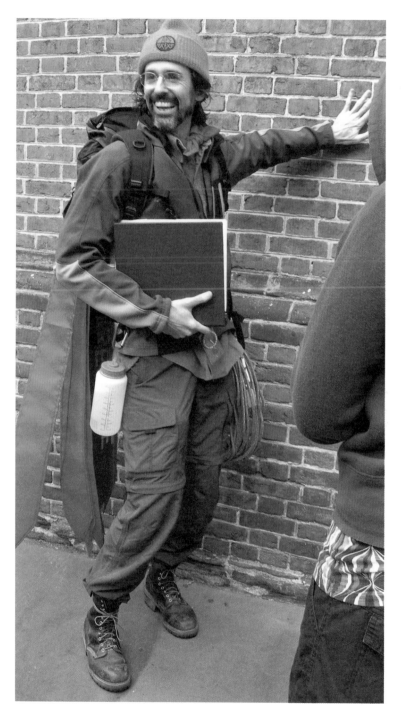

Brett Keyser during a performance of *You Are Here*. Courtesy of American Philosophical Society (APS) Museum.

The two artists began their initial research, including discussions with Prince about the exhibition themes and ideas. Lutz in particular spent time doing research at the museum's archives, as well as those of the INHP. Exhibition staff suggested other reading materials as well, which she used in developing her ideas for the pieces.[9] In addition to thinking about work that would respond to the themes of the exhibition, there were other constraints the artists had to keep in mind, having to do with their location within INHP. At one point during their planning, they proposed a piece that proved to be impossible because it would have interfered with the Lights of Liberty, a sound-and-light show that is projected on the exterior of Independence Hall at night. Not long after APS received funding for the projects, Stacy Levy had to drop out because of scheduling problems, and Lutz took the projects on alone.

The first of the installation pieces was *Mason-Dixon Lines, Past to Present*, which responded to the exhibition themes of mapping and boundaries. In creating this piece, Lutz was interested in examining the idea of boundaries. She wanted to highlight the idea that the Mason-Dixon Line was, in a sense, imaginary, and to illuminate the enormous amount of physical work that went into making that line observable in the landscape and on maps. Installed in the foyer of the museum, the piece itself consisted of three hand-drawn maps of the Mason-Dixon Line on Japanese paper. The installation required the fabrication of a complex scaffold in the building's staircase. Each map was drawn at a scale of one inch to one mile, resulting in maps that were six inches wide and thirty-five feet long. Each of the three maps illustrated the same location, at different times and incorporating different features. The first was the original 1768 map by Charles Mason and Jeremiah Dixon, which did not include the topographical features of the landscape, but was primarily a map of the boundary line itself. The second was a contemporary survey of the same land, including the contours and other features of the terrain. The third was a contemporary road map, which revealed the dense development on the land today.[10] Visitors to the exhibition encountered the installation on the second floor balcony, where they could use a pair of binoculars for viewing across the staircase.

Celestial Garden/Invisible Sky[11] was installed in the Jefferson Garden near the APS Museum. It was on view November 2007 through March 2008. According to Lutz, the idea for *Invisible Sky* came out of her research for *Mason-Dixon Lines*. As she came to understand the process of mapping used by surveyors like Mason and Dixon, which relied heavily on locating the nighttime stars, she became interested in the idea that this kind of surveying would be impossible today because of light pollution.[12] The resulting piece

was a star map of the constellations containing the stars most frequently used by Mason and Dixon during their survey. It consisted of glass lenses lit by LEDs set into the lawn of the garden. The piece could be seen from the sidewalk adjacent to the garden even when it was closed. During the day, viewers saw the sky and surroundings—including buildings, birds, and people passing by—reflected in the globes. At night the lenses were beautifully illuminated. In Lutz's words, "It was a surrogate for the starry sky that municipal light pollution has made invisible."[13] During the installation process, Lutz and Prince encountered a challenge in the form of an irate member of the APS who was convinced that Lutz was installing the map using the wrong orientation, not realizing that she understood the typical orientation of such a map, but had deliberately chosen to orient hers that way—to represent the stars as though they had been "pulled down" from the night sky.

Drawing Dock Creek was the largest in scale of Lutz's works, covering about two city blocks. The piece revealed the now-buried Dock Creek, a waterway that was gradually covered over as the city of Philadelphia developed around it. The piece brought together ideas of mapping that were present in Lutz's other works with the work of Ruth Patrick, whose contributions were very influential in the developing field of ecology. By observing microscopic organisms, she established a set of aquatic indices that could be used to describe the health of water systems and the impact of industrialization.[14] The idea of marking Dock Creek was one the APS staff had identified early in their thinking about the project, and suggested to Levy and Lutz in their initial conversations. The project was reworked by Lutz after Levy left the project, at least in part because of logistical considerations that only became clear as the implementation phase began.

The piece was installed in stages between March and September 2008. In the first phase, Lutz and her assistants used soccer-field paint and whitewash to outline the creek and its tributaries on the grass, brick, and cobblestones in the park. In the second phase, the grass between the outlines was allowed to grow (this obviously required the cooperation of the groundskeeping staff at the park). As it grew, the grass formed a sort of living creek. In the final phase, Lutz used about 17,000 feet of blue bungee cord to indicate the last section of the creek to be covered over. She described the blue elastic as "an analog for water … it appeared opaque from a distance, but dissolved into transparency as it was approached…. It seemed fitting to remember the last part of Dock Creek left open not with an image of the pollution damage, but with an analog for its last lost beauty."[15] Because the whitewashed sections were painted directly

on the ground, there were places where viewers/visitors could walk on the piece itself, following the former path of the now-underground waterway. At the elastic sections, one could stand above the swale and look down at the "stream," or stand in the grass at its "banks." Lutz recalled seeing some viewers jump over sections of the work, as though jumping the stream.[16]

The return on the enormous logistical challenges of the outdoor installation was the serendipity of passersby (and there are many people, both locals and tourists, who walk along these blocks) discovering the installation by accident. During the process of installation, Lutz and her assistants got so many questions that it became impossible to answer them all and keep working. The APS trained guides to answer questions about Celestial Garden/Invisible Sky so that at least occasionally, the serendipitous visitors could learn more about the pieces. Because Drawing Dock Creek and Celestial Garden/Invisible Sky were in this public space, it was impossible for the museum to collect any kind of accurate visitation numbers, but it's safe to say that these artworks were seen by hundreds of thousands of people.[17] Anecdotally, the museum knows that encountering the outdoor installations did draw some visitors to the museum to see the exhibition in the museum.[18] Visitors who had attended You Are Here or seen Drawing Dock Creek expressed a high degree of interest in visiting the exhibition when asked by evaluators.[19] Visitors to the exhibition numbered just over 123,000, all of whom had access to both Mason-Dixon Lines and Outside/Inside, but there are no data on how many visitors actually spent time experiencing either piece.

Of course, in evaluating the success of the project, there's more to consider than just how many people saw the artists' works and the exhibition. Did viewing one or more of the artworks contribute to the visitors' experience or understanding of the ideas and themes of Undaunted? Evaluation results suggest that they did. The museum hired an evaluator to collect qualitative and quantitative information from visitors, using surveys, questionnaires, and telephone interviews throughout the project. All of the survey participants were asked to respond to the prompts: "Performances/tours like this one help me interpret history/science" and "Performances/tours like this one make history/science more fun and interesting." On a ten-point scale in which one equaled strongly disagree and ten equaled strongly agree, the average of the responses to the first prompt (help me interpret history/science) was 8.6. To the second prompt (make history/science more fun and interesting), the average response was 9.0. Interestingly, the responses to both prompts were higher for local residents than for tourists.[20] Similarly, visitors asked to respond to the statement "The artwork of Drawing Dock Creek added to my knowl-

274

edge about human impact on the environment" responded positively, with an average response of 8.8. Here, too, the average response from locals was higher (9.7) than that of tourists (8.6).[21] The performances and interventions in the landscape appear to have been more meaningful to those for whom the park was already familiar. Indeed, when participants were asked to rate the importance of several factors in deciding to attend an installation or performance, the average response from locals was highest for "See Philadelphia in a new way" at 9.7 (tourists only rated this an average of 7.2).[22] It is interesting to note that Lutz has described a primary impetus behind her work as "how you allow people to see what habit and familiarity have made invisible."[23]

For the APS Museum, this response from local audiences was important. Their location within Independence Park has meant that tourist audiences have been comparatively easy for them to attract—often, visitors waiting for their chance to tour Independence Hall will come in to "fill time."[24] Building a local audience base has been somewhat more challenging for the organization. The evaluation responses indicate that this kind of project can be useful in continuing to build interest among local residents, which for the APS could be thought of as building new audiences.

275

When asked to rank their agreement with statements intended to capture their personal interests and attitudes, the response was highest for "I am an 'arts and culture' person" (average 8.3) as opposed to "I am a 'history' person" (average 7.6) or "I am a 'science' person" (average 6.2).[25] The people who attended these installations and performances identified themselves most strongly as being interested in arts, more so than history. For a collections-based museum located within Philadelphia's "historic district," this is compelling evidence that these programs attracted "new" audiences in more than one way.

The Unexpected projects were successful in many ways. They fulfilled the museum's goals of reaching new audiences and working with the Park Service to bring artistic interventions into the park. They provided the kind of compelling visitor experience the staff had hoped for: in qualitative evaluation, visitors commented on the beauty of the installations, as well as specific information they recalled learning as a result of engaging with the work.[26] The projects raised the profile of the organization within the community, including very positive response from the local press. The projects also created room for Prince to continue this kind of project and even push the boundaries of what's possible within the larger organization of the APS.[27]

How do the Unexpected projects adhere to or deviate from the assumptions I articulated earlier about artists' interpretive projects?

The evaluation results seem to indicate that the artists' projects did indeed provide visitors with compelling ways of seeing or understanding the exhibition themes and ideas. They provided visitors multiple access points to the intellectual content of the exhibition. Certainly, each of the installation pieces allowed for an aesthetic experience. Of *Celestial Garden/Invisible Sky*, one visitor said "It is beautiful. It reminds me of dew in the morning."[28] Visitors might have had a social experience taking part in role-play during the *You Are Here* performance; or a kinesthetic experience "pushing" the Second Bank building; or jumping over Drawing Dock Creek.

But did including artists in the development of their project (here, the overall project of the exhibition, programming, and the artist residencies) allow the APS staff to visualize new ways of approaching or presenting information for their audience? To be clear, this was not one of APS's goals for the project, but as it's a question I've developed about this kind of work, I'm interested in thinking about how it did or did not do this.

The project was not structured in such a way that would make this kind of learning or exchange possible. The themes and ideas of the exhibition were established long before the artists joined the project, so that their input on those ideas was not feasible. Rather, the artists were presented with the content and themes and asked to create work that responded to them. In Prince's words, "We knew that we were going to suggest the…themes that we would like the artists to think about. But we were open to having them suggest something else."[29] The artists responded to the information in the exhibition, but the exchange was not set up to work in the other direction. The exhibition project and the artist-residency projects were treated as separate from each other. The process did allow for the artwork to inspire some programming, however: the APS provided programming for the Schuylkill River Sojourn, a seven-day canoe trip along the river that flows through Philadelphia. The programming included nightly dramatic readings by Brett Keyser, who served as "Expedition Team Leader" for the journey. And *Drawing Dock Creek* was the inspiration and stage for Keyser's second performance, *Tann, Horn, & Dead Dogs,* as well as the inspiration and centerpiece for Water Walk Weekend, a collection of free activities exploring water through art, science, and history.[30]

Prince is clearly open to the ideas the artists brought to the *Unexpected* projects, and she demonstrates a deep respect for the work they do. But, in part because of organizational limitations on the kinds of exhibitions that can be done (as she says, "the APS is a certain kind of place"), the process chosen allowed the artists to contribute only to the interpretive content of the project, and not to

276

The Philadelphia sky and surrounding buildings reflected in the glass demispheres used in Winifred Lutz's *Celestial Garden/Invisible Sky*. Photo by Gregory Benson.

the intellectual content.[31] The process, when structured in this way, doesn't allow for the kind of potentially fruitful exchange between the museum and the artists—the "combined expertise"—that I'm suggesting may be possible.

The process of making an exhibition is similar in some ways to the process of making an artwork, at least an installation such as the ones discussed here. Each starts with an idea, or set of ideas that form the content, and the challenge to the exhibition staff and the artist is similar—how to translate these ideas into a physical form? In describing her process, Lutz explained it this way:

> The "technical bits"[32] are part of the idea. If you don't figure those out, and you don't integrate them with the process of the thinking, that's where you get a lot of bad public work. Because there a separation between a sort of idealization about the concept, which is primarily verbal, and then there's realization. Realization and idealization have to have a meeting point. You keep changing things until the last minute…. Things have to keep being adjusted to the circumstance because the more you are on the ground in the middle of the circumstance, the more you realize what the contingencies are…and they are a very important part of the project.[33]

In spite of these similarities, the impetus behind each kind of work is very different, and this can have an important effect on the path

the projects take. In Mary Teeling's words, "Curating and art-making are similar processes in some ways, but different: one becomes administrative, the other anything but."[34]

Artists and public historians often don't use the same language when talking about their work, which is part of what makes their working together difficult. In describing her process for identifying artists to include in her residency projects, Prince said that the artists she talks with don't necessarily understand what she means when talks about interpretation:

> There's a huge tension with the artists over our telling them we want them to interpret something. What does "interpret" mean versus their going off and doing their own thing, which they want the artistic license to do.... It is really hard, because in their minds, once they get going on it, they lose that piece, sometimes, in terms of interpretation, and they get involved in what you're involved in when you're creating a work of art, which is not necessarily wanting to be called to "illustrate" historical themes.[35]

What the exhibition staff and the artist think is most important about these projects is going to, almost necessarily, be divergent. Negotiating these differences can be difficult work, and the opportunity to learn from one another in the negotiation may fall victim to the pressure of the schedule. In the worst case, the museum staff might find the artists' work unusable for the project because it doesn't adequately convey or illuminate the ideas of the exhibition. But, more likely, the result of the different sets of goals will be smaller-scale disagreements: difficult negotiations over the title of a piece, or how much information should be conveyed to the visitor about the artwork, and in what way, as occurred in the *Unexpected* projects.

Even though the results of the *Unexpected* projects were so positive, I find myself wondering what else might have been possible if the process had allowed for a deeper engagement between the staff and the artists, and what could be done in the future. What might be possible in a project that allows for a true sharing of authority between practitioners in each discipline? For public historians, the opportunity to shrug off our own assumptions about what is important about a particular historical moment, an exhibition, or a text panel can be freeing and even inspirational. Allowing ourselves to see, from an artists' perspective, what is interesting or compelling about the story we're trying to tell can be enormously useful. It's possible to argue that, even in a project like *Unexpected*, in which the artists are brought in after the exhibition is well underway, this

benefit of working with an artist—seeing the many perspectives one might bring to bear on the interpretation—might stay with the museum staff after the project was over, and influence the way they approach the next project. But it seems to me that another attribute artists can bring to the process has to do with developing ways to allow visitors to become engaged in the content. Artists don't merely bring a new way of "seeing" the subject to museum staff, they also have the technical expertise to translate that perspective into something the visitors can also see (or feel, or do).[36]

What if the expertise of the visual artist, whose work wrestles with the challenges of making ideas take physical form, were to inform decision-making throughout an exhibition-making process? If the entire process were a collaboration, the choices made at each decision point might look very different. Perhaps, as I've suggested earlier, this would better be described as combined expertise rather than shared authority. What this would require is a serious commitment on the part of museum staff and artists to engage deeply with one another, allowing for the time and the intellectual "room" to learn our different languages, as well as allowing room to understand and resolve the conceptual and logistical challenges to this kind of work.

Is it possible for the exhibition-making process to be less administrative and more inspired? If so, perhaps the resulting visitor experience would also be more inspired. Australian museologist Andrea Witcomb describes the potential for project development that includes an artist as a core member of the team:

> The project becomes not so much about the delivery of information (and a kind of very simplistic communication model that underpins that) but a process where you can use the senses and aesthetic practices to think about different ways of achieving the exhibition's aims, in a way that's not simply about the provision of information. I think what I'm on about is what an Australian critic by the name of Ross Gibson calls "palpable history." If you involve a creative kind of person, history can be made to be palpable—you can feel it. And I think that makes for a much stronger response on the part of the audience to what it is that they are seeing and experiencing, because you're actually requesting something from them, not just providing (information), you're actually seeking their engagement with the material.[37]

Now that the practice of incorporating artists into history projects is at least two decades old, perhaps it's time to begin thinking about

designing artist-in-residence projects that investigate ways of truly combining expertise. Creating genuinely interdisciplinary experiences for our visitors could be one way forward as we seek to engage their curiosity, and in the end, provide them with greater access to deeper and more potent historical and cultural experiences.

1 American Philosophical Society website, member information, http://www.apsmuseum.org/members (accessed August 2010).
2 APS Museum, http://www.apsmuseum.org/stuffingbirds/dion1.htm (accessed August 26, 2010).
3 Interview with Sue Ann Prince, August 12, 2009.
4 Interview with Mary Teeling, November 18, 2009.
5 Teeling interview.
6 Keyser later developed a second performance, *Tann, Horns & Dead Dogs* which took place at the installation *Drawing Dock Creek*.
7 *Inside/Outside* is archived on the APS website at http://www.apsmuseum.org/undaunted/coover/index.html (accessed August 26, 2010).
8 Interview with Winifred Lutz, August 24, 2010.
9 Lutz interview.
10 Project descriptions by Winifred Lutz, courtesy of the artist.
11 The naming of this piece was a difficult negotiation between the staff of the museum and the artist. The APS preferred the name *Celestial Garden* while Lutz preferred *Invisible Sky*. The museum's signage and marketing materials referred to it that way, but Lutz continues to refer to it by the title she preferred.
12 Lutz interview.
13 Lutz project description.
14 APS website, http://members.amphilsoc.org/webLinksPublic.php?MemberId=3686 (accessed August 27, 2010).
15 Lutz project description, October 2008.
16 Lutz interview.
17 APS final report to HPP, submitted January 30, 2009.
18 Prince interview.
19 Oberg Research, "*UNEXPECTED: Contemporary Artists at the APS Museum* Summative Evaluation Final Report," October 20, 2008, 17.
20 Oberg Research, "*UNEXPECTED* Report," 12. For the first prompt (help me interpret history/science), locals responded with an average of 8.9 and visitors with 8.2. For the second (make history/science more fun and interesting), the response from locals averaged 9.3 and tourists averaged 8.5. Local was defined as ZIP codes within a 20-minute drive of the museum.
21 Oberg Research, "*UNEXPECTED* Report," 22.
22 Oberg Research, "*UNEXPECTED* Report," 13. The lowest motivating factor for both groups was "Learn about exploration/explorers" with an average response of 6.5. It's worth noting that specific learning goals were not significant motivators for audiences attending this kind of program.
23 Lutz interview.
24 Prince interview.
25 Oberg Research, "*UNEXPECTED* Report," 12.
26 Oberg Research, "*UNEXPECTED* Report," 21.
27 Prince interview.
28 Oberg Research, "*UNEXPECTED* Report," 22.
29 Prince interview.
30 APS final report. The Sojourn is organized by the Schuylkill River

Heritage Area. The APS collaborated with them to provide programming throughout the trip, which concluded with a visit to the exhibition.

31 Prince interview.

32 Here Lutz is echoing my own clumsy phrasing when trying to find a shorthand for the materials and techniques she had to research and understand in order to implement each installation, such as LED lighting and electrical circuitry for *Invisible Sky*, or sod staples for *Drawing Dock Creek*.

33 Lutz interview.

34 Teeling interview.

35 Prince interview.

36 The APS Museum is planning a new series of artist projects for an exhibition in 2011 that would involve a greater degree of interaction and collaboration between the artists—potentially another interesting way of thinking about combined expertise.

37 Interview with author, September 14, 2010. As examples of projects that have used this approach, Witcomb cites No. 1 Pump Station at Mundaring Weir, and Greenough Hamlet, both National Trust of Australia sites. See http://pcah.us/hertiage/news-press/report-from-far-afield-andrea-witcomb.

Sanford and Sun

Otabenga Jones

The following was commissioned by the editors as part of the book's exploration of the relationship between contemporary artists and historical practice. It was created by Otabenga Jones and Associates, an artists' collaborative based in Houston, Texas, whose work critiques cultural and media images of African Americans and other marginalized people.

We speak to you from the lower frequencies. Vibrating from the Earth's core, reverberating out through the cosmos, to furthest edges of the universe, scraping the planes of thoughts yet to be. We are Otabenga Jones and Associates.

In 1974 Gil Scott-Heron scribed the poem "The Revolution Will Not Be Televised." It was an epic screed against the limits of the new television consciousness. And though he belted out this tune with an assured confidence in the failings of TV and film alike, our illustrious leader, Mr. Jones, had not yet become so convinced. Otabenga Jones, a figure walking the shadows of many of our black nation's brightest moments, had begun to consider the medium of film and television as a pathway to unknown worlds. He watched the slow demise of both

the Civil Rights and Black Power movements. Left in their wake were ripples in the public consciousness, being quickly filled by interlopers and masqueraders. The visage of Angela Davis gave way to Foxy Brown, and the courage of Bobby Seal gave way to the relentless masculinity of Shaft. (Was there ever a more reductive title for a black figure?) Watching the power of these images wash over the minds of the black masses, Otabenga set out to counter what he could. He wrangled, through a series of old contacts, and connections to writer Ilunga Adell, a writing gig on the *Sanford and Son* show on NBC. He was fired after penning only one episode.

The pages that follow hold his only produced script, and a few stolen wardrobe sketches he managed to escape from LA with. It is the story of a chance meeting between the title character, Fred Sanford, and cosmic jazz great Sun Ra. This script was filmed but ultimately withheld from the American TV audience. Never aired, the episode was presumed destroyed by the executives at NBC who deemed it inappropriate for their viewers due to its "radical" content, and Otabenga stashed the script away in his aunt's attic for the next few years, and more recently transferred it to our archives system.

Although this was a project done years before the formalized organization of Otabenga Jones and Associates, it still offers an anecdotal example of how we wrestle with history to become one of its primary framers.

283

One of the ideas Otabenga Jones and Associates organized around was to become a repository for alternative accounts of history, and to then interject these accounts into a public discourse. Inserting Sun Ra's *futurism as black past* into Redd Foxx's fictional junkyard of black treasures connects the remnants of those declining black social movements to a progressive black future, all in an easily digestible half-hour comedy program. This subtext did not go unnoticed. Otabenga's firing and the subsequent cease-and-desist letters to stop any attempt to publish this script highlight the inherent conflict of such an undertaking.

This has been our struggle. Not only to participate in the discussion of history, but to even prove that there is an alternative account of things. That some other things happened, and some other types of people existed, and were present at pivotal past events.

SCENE 1

*Lamont, Rollo, and their three visiting guests from out of town walk into
the door.*
[*pause for audience applause*]
Lamont: I have to admit that was one baaad performance you sistas put
on tonight!
Rollo: I told you jack, three celestial bodies in perfect alignment. The
sun, the moon, and the star!
[*light laughter*]
Lamont: Right on! [*Lamont and Rollo slide a cool five to each other*]
China: Thank you. Like we said before, it's our invitation for you to be
of our space world.
Lamont: We were really digging those dance moves you all performed
on stage tonight. You sistas studied professional?
China: Yes, but not the way you think.
Lamont: How so?
China: Well, my profession is astrobiology, Jette and Ethiopia's are
both in stellar astrophysics.
Ethiopia: What she means is that our work is a part of our
performance. What you saw were choreographed configurations, not
dance moves. The forms can be somewhat indecipherable if your spirit
is unacquainted with its own existence.
Rollo: Um, I think I'm a bit "unacquainted" with what you just said.
[*laughter*]
Jette: These rituals unlock inner space chambers; it unlocks us from
conformity.
China: Basically, it breaks you out of your house Negro training.
[*laughter*]
Rollo: Yeah, what if your audience is white?
Ethiopia: It breaks them out of their house Anglo training. [*laughter*]
In essence, we're not performing dance but rather various star chart
patterns rituals.
Rollo: Hold up jack, a "star chart ritual"?
Ethiopia: Dig brotha, you have to internalize the stars and planets.
S.P.I.—Stars and Planets Internal. Take that "spi" and place it at the
beginning of "ritual." To perform a ritual, is to internalize patterns and
cycles of celestial bodies. That unlocks our inner space.
Jette: Can't get spiritual without ritual.
Lamont: So why not do these rituals anytime, why only to music with
your backs turned to the audience?
Ethiopia: Our sun emits vibrations just as the other billions of stars do.

284

We are a billion year old species made of stardust thereby inheriting a vibratory composition. Music is vibration. We emit vibrations through instruments but naturally through our throat. The human voice is the most advance complex instrument. Your mother's voice is the first vibration you heard in the womb. We face east because that's the direction vibrating sun rises. Unfortunately this stage just happens to be facing west, that's why our backs faced the audience.

Rollo: Don't worry, none of the brothas were complaining. [*laughter*] You may have "unlocked their inner space chambers" but you had their focus remained locked. [*laughter*]

Lamont: That's some heavy stuff. How 'bout I put a record in rotation for some mo' demonstration of constellation vibrations. [*laughter*]

Jette: The "lunar" the better brotha. [*laughter*]

China: But where's the elbow room in your house? You know we're big on space. "Space is the Place." [*applause*]

Lamont: Hey you three are the experts on the twinkling diamonds in the sky. This may not be as spacious as the Taj Mahal but I know you all can still get down with some heavy jewels.

Fred [*interrupting Lamont as he walks out the kitchen eating crackers*]: ...yeah, but none of my jewels better end up in Rollo's pocket or Ali Baba is going to find himself a thief short. [*applause and laughter*]

Lamont: Aw Pop, what are you doing here?

Fred: I got home early.

Lamont: I thought you were going to catch the late feature with Grady.

Fred: We did, son. It started off real good. *The Wolfman Meets the Creature from the Black Lagoon.* [*laughter*] It was suppose to be the scariest movie of the year. But I couldn't make myself stay and finish it.

Lamont: Don't tell me it was too scary for *"Fright Film Fanatic"* Fred.

Fred: No, that's just it son...see I've become immune to all kinds of fear after years of over-exposure to your Aunt Esther's radioactive face. [*laughter*]...so we left early.

Lamont: Look Pop, you ruining our plans man. You can't go over to Grady's place to watch TV or something?

Fred: The picture on Grady's TV roll too much.

Lamont: What? You were just over there yesterday watching the baseball game.

Fred: Yeah, but the picture rolled so much, we couldn't tell if Doc Ellis was trying to pitch the ball or bowl it. [*laughter*]

Lamont: Hah, hah, very funny.

Fred: Look here, why don't you introduce me to your lovely friends?

Lamont [*reluctantly*]: Sistas, this is my father. Pop this is China, Jette and Ethiopia.

Fred: That's Fred G. Sanford.

China: It's a pleasure to meet you Mr. Sanford.

Ethiopia: I detect some heavy wit in this house.

Fred: Oh, that'll be the "wit" I had in the leftovers.

Ethiopia: Leftovers?

Fred: Yeah, salt bacon "wit" collards, oxtails "wit" mash potatoes, fried okra "wit" hog snout. [*laughter*]

Lamont [*with a smirk*]: Pop.

Fred: I know, I know, I'm only kidding. It's good to meet you ladies.

Lamont: Say Pop, they're here to perform with the jazz musician Sun Ra at the Watts Towers. China, Jette, and Ethiopia are all a part of his Arkestra.

Fred: Arkestra?

Lamont: Yeah, dig Pop, an Ark and an Orchestra as one. Music that takes people high up to the outer reaches of new gardens.

Fred: I don't think it's the music that's getting them high. It's probably something growing in those "new gardens." [*laughter*] Sun "Raw" might be Sun "Rotten." [*laughter*]

Jette: No, Mr. Sanford. It's Sun Ra. It's part of our heritage. Ra is the sun god in African Egyptian culture. Surely you know of the pyramids and the ancient Egyptian mummies.

287

Fred: All I know is the ghetto and the ancient Watts auntie named Aunt Esther. [*laughter*]

Lamont: Would you stop it? Just stop it! You're hopeless. You always have to go and make fun of things you don't understand. You don't know anything about African culture.

Fred: Are you kidd'n? I'm the one that tried to get you to watch a program just the other night on Africa.

Lamont: The African Queen staring Humphrey Bogart does not count Pop. [*laughter*]

Jette: Mr. Sanford, why don't you come down to our show tomorrow and check it out for yourself?

Ethiopia: Yeah, that's a great idea.

Lamont: Oooh NO! That's a bad idea.

Fred [*with a pitiful frown*]: Maybe my son is right. An old man like me with a bad heart condition would just get in the way.

Ethiopia: Lamont this is your father. Mr. Sanford, we are giving you a personal invitation. Come on Lamont, it's only right.

Lamont: I can dig it, but my father's nature is to sabotage everything. He can't stand to see anything go "right." Even when he drives he only bring himself to make left turns. [*laughter*]

Jette: Lamont, everybody is invited to the space ways…

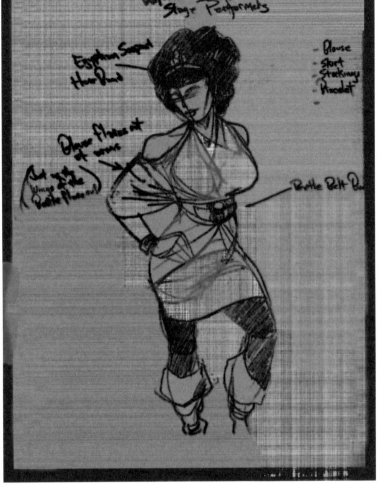

288

Fred: Yeah Dummy; "the space ways." [*laughter*]

Jette: …and everybody is an instrument in this vast cosmos…

Fred: That's right, "COSMOS." [*light laughter*]

Jette: …and each of us have a part to play in it.

Sanford: Everybody's an instrument with a part to play, you big dummy. [*laughter*]

Lamont: With all the hot air you blow, you should make a perfect fit in the woodwind section. [*laughter*]

Fred [*holding up his fists*]: How would you like a "do" and a "re" across the lips by "mi" leaving you to "B flat." [*laughter*]

China: On the outside you two may appear to be disharmonious but in actuality you all are rhythmically in sync. A little fine-tuning is all that's needed.
Fred: That's why I always sing when coordinating the office space. [*Lamont rolling his eyes*] [*laughter*] It brings peace in the home.
China: Mr. Sanford, you can sing?
Fred: Like a bird.
Lamont: Yeah, a strangled one [*laughter*] [*Fred showing a scowl*]
China: Why don't you sing something for us Mr. Sanford!
[*Jette and Ethiopia concur*]
Fred: Alright then. [*gesturing to Lamont*] Back up dummy.
If I didn't care / more than words can say
If I didn't care / would I feel this way
[*laughter, applause*]
Fred: You know, I think I would like to meet Solar Rays.
Lamont: That's SUN RA! [*laughter*]
Ethiopia: Right on, Mr. Sanford! I know you two will hit it off. Look, it's getting late and we have to get back to the group.
Rollo: I'll take you sistas back.
[*China, Ethiopia, and Jette each giving Fred a peck on the cheek*]
Jette: So we'll be seeing you tomorrow Mr. Sanford?
Fred [*smiling*]: I'll be there.
China: The show starts around five. Bye Mr. Sanford.
Fred [*singing "Five O'Clock Whistle" as he waves to them*]: Bye-bye girls.

> *The five o'clock whistle didn't blow*
> *The whistle is broke and whadda'ya know?*
> *If somebody don't find out what's wrong*
> *Oh my Pop'll be workin' all night long*

[*applause*]
[*Fred closes the door while Lamont is looking at him in disapproval*]
Fred: *Oh, who's gonna fix the whistle?*
Won't somebody fix the whistle
[*finishing his cracker; pushing out a weak whistle, blowing cracker bits on Lamont*]
Lamont: You better not mess this up, that's all I got to say.
Fred: Awww, you worry too much.
Lamont: Yeah and I got good reason to.
[*knocking at the door*]
Lamont: Just don't mess things up.
Fred: You're nothing but a prophet of doom. Stop thinking so negative.
[*Fred opens the door and Aunt Esther walks in looking at Fred with a scowl*]

Fred: See son, all your prophet of doom talk summoned the Grim Reaper. [*laughter*]

Aunt Esther: Watch it sucka!

Aunt Esther [*walks over to Lamont*]: Hello Lamont. [*giving Lamont a peck on the cheek*]

Lamont: Hello Aunt Esther.

Aunt Esther: I was on my way back home from Bible study, and thought I'd drop by to say hello. But then lo and behold, I see that ol' sneaky Rollo leaving here with three jezebels. So I wanted to make sure Fred's ol' heathenish ways wasn't corrupting my favorite nephew.

Fred [*looking out the window in worry*]: Oh no, they didn't see you as they were leaving did they?

Aunt Esther: No. Why?

Fred: Good, cause I wouldn't want them to get turned into stone. [*laughter*]

Lamont: Pop why don't you just lay off. Can't you be nice to Aunt Esther for once?!

Fred [*dismissive gesture*]: Oooh…

Aunt Esther: It's alright Lamont. I know better than to stoop to the level of this ol' fish-eye fool heathenish foul philistine. [*laughter*]

Fred: Listen Esther, I would offer you a drink before you leave, but I don't have a horse trough. [*laughter*] So get going, you bringing my good evening down.

Aunt Esther [*moving closer to Fred*]: Oh yeah? Well it ain't your evening you should be worried about being down. It's your teeth you should be worried about picking up! [*roaring laughter*]

Fred [*raising his fist*]: Esther, how would you like a left hook across your tusks? [*laughter*]

Aunt Esther: Fred Sanford, the few times you do show up at church, you go to sleep. How would you like to stay asleep at your wake? [*laughter*]

Fred: Oh yeah? Put 'em up. Come on, put 'em up!

Esther: Let's go sucka!

[*Fred and Esther start swinging at each other*] [*laughter*]

Lamont: Stop it! Will you two stop it!!! Every time you two get in the same room it's nothing but mayhem! Aunt Esther, please, let me walk you down the street to the house.

Aunt Esther: Thank you baby, but I'll manage. I just wanted to make sure you were ok. I'll pray for you and that ol' heathenish Fred. [*throwing her hands up*] Oh, Glory! Hallelujah!

[*Esther walks out*][*applause*]

Fred: That's right, get back to your crypt before daylight you ol' bat! [*laughter*]

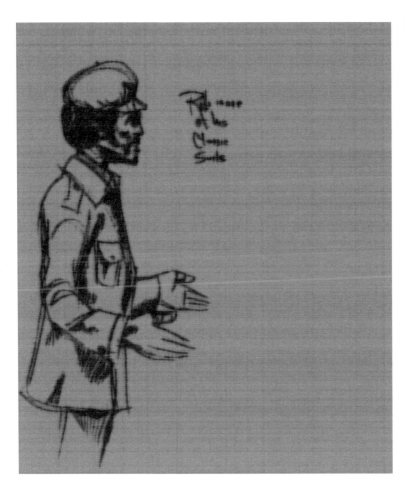

Lamont [*as Lamont walks into the kitchen with Fred*]: You see what I'm talking about?! That's exactly what I'm talking about! You are always starting trouble you know that?
Fred: Says you.
Lamont: Yeah says me. [*opening a pot on the stove top*]
Fred: It's not my fault. Your Aunt Gorilla is to blame. [*laughter*]
Lamont: Never mind, I don't want to talk about it anymore. Is there anything here to eat, I'm starving?
Fred: Just some leftovers I was warming up before you came.
Lamont: WHEEEEW! What is that in the pot?! It smells horrible!
Fred: I told you it was leftovers.
Lamont: We didn't have this last night. We had collards, beef roast and dinner rolls.

Fred: Yeah, but the night before that we had neckbones, cornbread, string beans, and sweet potatoes; and before that we had smothered pork chops, black-eyed peas, oxtails, and Rice-o-Roni.

Lamont: Yeah, so?

Fred: So…leftovers. [*laughter*]

Lamont: You mean to tell me you mixed together ALL the food from this entire week?

Fred: Yeah, I call it, "smothered oxtail black-eyed collards and beef bone-o-Roni. [*laughter*]

Lamont: Yeah and if you eat that you're going to be "dead dirt-smothered Fred." [*laughter*] You're impossible. I'm going out to eat something that has one name to it.

Fred: Good. More for me. [*laughter*]

SCENE 2

[*Fred walks down the stairs; Lamont is in the mirror putting on cologne*]

Lamont [*admiring himself pop'n his collar*]: Ha, ha! When you got it, you got it.

Fred: And by the smell of it, you should be quarantined before someone else gets it. [*laughter*] What's that stuff you stinking the whole house up with?

Lamont: Well for your information, it's what's happening. It's a new cologne all the uptown dudes are wearing.

Fred: More like uptown fumigators. [*laughter*] Why you getting ready to leave so early anyway?

Lamont: Rollo and I are going to help out with stage setup. You might as well head up there with us since you're going to be there anyway.

Fred [*rubbing his stomach*]: I got a bit of stomachache from last night's meal. I'll have to pass.

Lamont: You mean pass out. I can't believe you pulled a stupid stunt like that. It's a wonder that you don't have one foot in the grave and the other foot on a banana peel. [*laughter*] Pop, our bodies aren't made for eating pig, not the long ones nor the short ones. That's why we think like slaves cause we still eat and live like slaves.

Fred: Well I ain't no slave. I like to eat good food.

Lamont: Pig snout, oxtails, pork chops? That's slave food. How are you ever going to vibrate on a spiritual frequency.

Fred: I don't want to vibrate on spiritual frequencies. That's your Aunt Esther always getting the shakes and vibrating when she watches all that church TV stuff. [*laughter*] I prefer to watch Super Bowl Sunday on VHF frequencies. [*laughter*]

292

Lamont: Dig yourself Pop I'm talking frequencies of the consciousness, not television. I'm talking "transcendental" experiences.

Fred: I didn't know your teeth could have different genders. [*laughter*]

Lamont: What? You're ridiculous. Talking to you is like talking to a rusty bucket of sand.

Fred [*holding up a fist*]: Watch your mouth or you'll be having a "hands-in-dental" experience. [*laughter*]

Lamont [*Lamont putting on an African dashiki in the mirror*]: Never mind. I'm through with this conversation.

Fred [*looking bewildered*]: What's that?

Lamont: Forget about it. You'll only have some smart remark to make.

Fred: No I won't. I think it's perfectly normal to walk around in a Zulu picnic blanket. [*laughter*]

Lamont [*looking fed up*]: You only show how ignorant you are of the dashiki.

Fred: Die chicly? Not in that…you'd be dying ugly. [*laughter*]

Lamont: I give up.

[*knock at the door*]

Lamont: That must be Rollo. [*opening the door*] Hey Rollo.

Rollo: What's happening Lamont, you ready?

Lamont: Yeah, step in, let me run upstairs and get my jacket.

Rollo: What's happening Pop, what's the word?

Fred: The "word" was *abracadabra*, but you still here. So I have to figure out a new one. [*laughter*]

Rollo: Aw, Pop, man you cold.

Fred: If I stand next to your jewelry I'm not. [*laughter*]

Rollo: You got it all wrong jack. This ain't stolen, I paid for this…cold hard cash.

Fred: You mean you'll pay cold hard time. [*laughter*]

Rollo: Aw Pop, every time I come around you always got some gag.

Fred: Well it suits you since the last place you left, someone is still tied up and gagged. [*laughter*]

[*Rollo waves his hand in a dismissive gesture*]

Lamont: Alright I'm ready let's split.

Rollo: Solid.

Lamont: Later Pop.

Rollo [*teasingly*]: Later, "Pop."

Fred [*mumbling, biting lip, clinched fist*]: I'll later you, you ol'…

[*As Fred almost makes it to the couch to have a seat there's a knock at the door*]

[*Fred opens the door, it's Grady*]

Grady [*walking in*]: Hey Fred. I just saw Larry and Rothko walking off. [*laughter*]

293

Fred: That's Lamont and Rollo.

Grady: Oh yeah.

Fred: Come on in Grady.

[*Both have a seat*]

[*Fred groans a bit*]

Grady: What's wrong with you Fred, you look like you half dead?

Fred: I think I got some stomach trouble from last night's supper. It could be the "big one." The "big one" might be trying to sneak up on me from my stomach this time. [*laughter*]

Grady: You don't have a bad stiffness in your back do you?

Fred: Yeah, right between my shoulder blades.

Grady: Do you feel a slight shortness in breath when you bend over?

Fred [*worriedly*]: Yeah...yeah, I do.

[*Grady slowly shaking his head out of concern*]

Fred [*still worried*]: What, what is it Grady?

Grady: You have the same symptoms my cousin had. He went to see one of those doctors that cure all your ailments with natural herbs and stuff.

Fred: Well, don't just sit there watching me suffer, what combinations of plants he take for it?

Grady: A funeral wreath. [*laughter*]

Fred: Grady, you're suppose to be my friend. Whatchu go and say something depressing like that for?

Grady: I'm sorry Fred, I wasn't thinking.

Fred: You make me feel like if I lay down to sleep, I'm never going to open my eyes again.

Grady: Oh no Fred, the coroner got to check your eyeballs. [*laughter*]

Fred: Oh, shut up Grady. Why don't you go find someone else to depress. They ought to call you *"Gray Cloud"* Grady.

Grady: I'm sorry Fred. I was just trying to help...but you can't keep on eating like that. It'll kill you. They say more people die from their food-related sickness than homicides.

Fred: That's the same stuff Lamont always saying. You all don't know what you're talking about. "Cut out the pork, cut out the cigarettes, cut out the wine." How's someone going to look eating healthy their whole life then on their deathbed, they die of nothing? [*laughter*]

Grady: You do have a point Fred. I had a cousin that became Muslim and cut out all the pork and wine from his diet. He was perfectly healthy. He ate nothing but vegetables...and wouldn't you know it, it turned out vegetables took him to his grave.

Fred: See, that's my point exactly.

Grady: Yeah, one day he was crossing the street and got hit by a

produce supply truck. [*laughter*] [*Fred looks at Grady with a scowl*] Well, I have to get going. See ya Fred.

Fred: Alright, see ya Grady.

[*Fred walks Grady to the door*]

[*On his way back to the couch he sees a Sun Ra album Lamont left on one of the counter tops*]

Fred: One of Lamont albums. Hmmm [*reading the title,* Sun Ra: Nuits de la Fondation Maeght] Sun Ra: Nutes de la fondashun...mate? [*light laughter*] Let me see what this sounds like. [*Fred places it on the record player. The music begins to pulsate from within Fred's head.*] I guess it wouldn't hurt to kick my feet up a bit. Well I guess it wouldn't hurt to take a little nap so I can be well rested for the show. [*Fred drifts off to sleep*]

[*Hours later a knocking at the door*]

Fred [*slowly waking up*]:...Alright, alright, I'm coming.

[*Fred opens door and a person with a huge ibis head mask of the Egyptian god Thoth breaks the door's threshold*]

[*Fred backs up clinching his heart going into a fit*]

Oh, no! [*laughter*] Ohhhh! It's Rodan! [*roaring laughter*] He finished eating Tokyo, Japan, now he wants Watts, California! [*laughter*] Oh Elizabeth! Elizabeth, I'm coming to join you honey! This time Polly wanna nigga! [*laughter*]

Sun Ra [*steps through the door dressed in elaborate ancient ceremonial garb*]: Mr. Sanford? [*pause for applause*] Mr. Sanford are you alright?

Fred [*coming out of shock*]: Ohhhh...Hunh? What?

Sun Ra [*coming to Fred's aid*]: Are you alright Mr. Sanford?

Fred [*looking up and down at Sun Ra's clothing*]: Am I alright? A black Liberace and Yul Brynner in a Big Bird mask are standing in my living room...do I look "alright"? [*laughter*] Who are you?

Sun Ra [*spreading his arms*]: I...am Sun Ra.

Fred [*scanning Sun Ra from head to toe*]: You. Are. Sun Ra?

Sun Ra: I apologize if I startled you.

Fred: The way you're dressed, you'd startle Monty Hall. [*laughter*]

Sun Ra [*shaking his head in amusement*]: These space suits are signature clothes worn by your great ancestors both on Earth and on Saturn.

Fred: And all this time I thought junkies were only on earth. [*laughter*]

Sun Ra: Mr. Sanford, all catalysts at one time or another were criticized for their eccentric ideas.

Fred: Well, those "cattlists" probably had the wrong type of cattle. [*laughter*] They probably started off like you trying to herd bird people instead of cows. [*laughter*]

Sun Ra [*with a chuckle*]: You don't understand Mr. Sanford. I'm just

going to have to show you. As the ambassador of the intergalactic Opposite: Fred, Ibis, and Sun Ra
federation, please accompany me on a journey to the diamonds in the
sky. [*with a courtesy gesture*]
Fred [*grabbing his baseball bat*]: You see this Louisville Slugger? It's
known for its batting average on the diamond on the ground. [*roaring laughter*] If you don't...
[*strange pulsating sound starting coming from Fred's yard interrupts*]
Fred: ...what's that sound?
Sun Ra: Those are the natural minors of vibro-ion accelerator engines.
Fred [*walking to his door*]: Engine?
[*Fred looks out the door and sees a space ship*]
Fred [*clutching his heart*]: What [*gulping*] is that?!
Sun Ra: I told you Mr. Sanford, I'm an ambassador from the
intergalactic federation of outer space.
Hereby,
our invitation
we do invite you
be of my space world.
Fred [*slowly falling into a hypnotic state as Sun Ra's entourage escorts him
into the ship*]: ...be of your space world?
Sun Ra: Rhythmic equations...
Fred: Rhythmic equations...
Sun Ra: enlightenment is my tomorrow...
Fred: enlightenment is my tomorrow...
Sun Ra: ...has no plane of sorrow
Fred: ...has no plane of sorrow
Sun Ra: ...be of my space world
Fred: ...be of my space world

297

SCENE 3

Fred: Where am I? What is this place?
Sun Ra: You are riding sacred sounds, the sounds of enlightenment by
way of strange mathematics and rhythmic equations.
Fred: Sounds of what-ment? Wh-What you mean riding sounds of
enlightenment? [*laughter*]
Sun Ra: You are flying in a space craft propelled by the depths of
wisdom upon vibratory star patterns. Enlightenment enables us to defy
the oppressive weight of ignorance.
Fred: You mean we're in the air?
Sun Ra: We're in space.

Fred: Put! Me! Down! [*laughter*]

Sun Ra: "Down" Mr. Sanford? In the vastness of space "down" is relative. It's only when earth lie beneath your feet that the direction of "up and down" has any significance.

Fred: Oooh! [*Fred stumbles back clutching his chest*] Oh no! This is the biggest one yet! You hear that Elizabeth? I'm with a "Junky" from Jupiter and I don't know if I'm coming to join you honey! I can't tell which way is up! Oooh! [*laughter*]

Sun Ra: You are perfectly safe Mr. Sanford. Everything is as it should be.

Fred: Listen, are you for real?

Sun Ra: I'm not real, I'm just like you. You don't exist in your society. If you did, your people would not be seeking equal rights.

Fred: Oh, yeah? Try driving through Beverly Hills at night and see if you don't exist to the police. [*laughter*] You'll end up being non-existent. [*laughter*]

Sun Ra: That's just my point Mr. Sanford. See your existence is that insignificant. If you were real you'd have some status amongst the nations of the world. So we're both myths. I do not come to you as a reality, I come to you as the myth because that's what black people are…myths.

Fred: This is all crazy, it has to be a dream. That's it I'm dreaming. It was that food I had last night. That has to be it.

Sun Ra: I came from a dream that the black man dreamt long ago. I'm actually a presence sent to you by your ancestors. I understand why this is difficult for you to comprehend. Your entire life you have been veiled from the fiery truth of enlightenment. You believe the extent of your existence is the role of an ex-slave, an Afro-American. But what were you before that?

Fred: A Bald-Headed African? [*laughter*]

Sun Ra [*smiles with amusement*]: Please try to stay focused brother Sanford. You see, you have both an outer space and an inner space to explore. One should never exceed the other. Inner development prepares you spiritually, while external works help society. When you abandon either, you suffer the consequences of subjugation. This is why you become dependent and beg for jobs from the system. This is why you beg them for "rights."

Fred: We don't beg, we deserve those rights.

Sun Ra: To "deserve" means you are "worthy of." Whoever determines you to be "worthy" of something wields the power to administer judgment. You have to define your own worth, not empower someone else to decide that. Coltrane determined his worth; Garvey determined his worth. You've only made a partial journey from the inner space

298

of the womb to the outer space or out cast of society. Your new inner space is the inner city. Control that and explore the outer world beyond your country land.

Fred: Couldn't you tell me that without showing up as the ghost of Kwanzaa past? [*laughter*]

Sun Ra: You had to obtain this through vibrations, through rhythmic equations. You are an instrument Bro. Sanford and I treat everybody as such. We all have a part to play in this vast "Arkestra."

[*the engine change frequencies*]

Fred: What was that noise?

Sun Ra: Not noise, music. Look out the porthole; we've arrived at the Black Sanctuary. As soon as we land we can go to the gardens to nourish our spirits.

Fred: Just so we're clear about things. When you say "nourish our spirits" in this garden, are you talking about picking and eating or rolling and toke'n? [*laughter*]

Sun Ra [*laughing*]: Picking and eating Mr. Sanford. Knowledge expands through the rigorous discipline of science, not through mind-altering stimulants. We haven't time for that and the intellect is sacred and in our tradition we guard it.

Fred: Yeah, well in our tradition if you're caught with that you will end up being "guarded" while doing "time." [*laughter, applause*]

[*Later after nourishing their spirits, electrons begin to charge a rollicking polyrhythmic frenzy within their very being*]

Fred: What's that knocking sound, that beating going on in my head?

Sun Ra: Inner percussion Mr. Sanford. Vibrations are in you. Bare the tones of life. Be a baritone. The sharps and the flats, the ups and downs. ELECTRIFY.

299

> *The sound of joy is enlightenment*
> *The space fire truth is enlightenment*
> *Space fire*
> *sometimes it's music*
> *strange mathematics*
> *rhythmic equations*
> *The sound of thought is enlightenment*
> *the magic light of tomorrow*
> *Backwards*
> *out of the sadness*
> *forward and onward*
> *others of gladness*
> *Enlightenment is my tomorrow*

it has no planes of sorrow
Hereby,
my invitation
I do invite you
be of my space world
This song is sound of enlightenment
the fiery truth of enlightenment
vibrations
sent from the space world
is of the cosmic
starring dimensions
Enlightenment is my tomorrow
it has no planes of sorrow
Hereby,
my invitation
I do invite you
be of my space world
Hereby,
my invitation
I do invite you
be of my space world…
Fred [singing in his sleep]:
Hereby,
our invitation
We do invite you…

Sun Ra [*touching Fred on his shoulder*]: Mr. Sanford…Mr. Sanford.
Fred [*coming out of sleep*]: Hunh? What? Who, who… [*looking at Sun Ra standing above him he gives a hard swallow*]
Sun Ra [*touching Fred on his shoulder*]: Mr. Sanford…you were singing to the record in your sleep. I cut it off.
Fred: You…how did we get back so fast? Where's Lamont?
Sun Ra: Back from where Mr. Sanford? And Lamont, China, Jette, and Ethiopia are following right behind. He told me to come on inside the house and meet you. I had been knocking at the door. You didn't really answer you just started singing.
Fred: So it was all just a dream?
Sun Ra: I suppose so. We missed you at the show so when our set was over I insisted on still meeting you.
Fred: So you don't want me to take you to my leader or anything? Even though he's kind of tied up with some tapes. [*laughter/applause*]
Sun Ra [*light laugh*]: No Mr. Sanford, I don't need to see your leader.

300

[Lamont walks in the door with China, Jette, Ethiopia, and Rollo]
China: Oh, hey Mr. Sanford. I see you two have met.
Sun Ra: Yeah, but I think I gave him a bit of a fright at first.
Lamont: Let me guess, my Pop had one of his routine heart attacks?
[laughter]
Fred: As a matter of fact, no. It's just that Sun Ra had these two giant birds, and we all got on this space...all forget it. It was just a dream anyway.
[Aunt Esther walks through the door]
Fred: Now it just turned into a nightmare.
Aunt Esther *[pause for laughter]*: Watch it sucka! I just stopped by to see... *[looking surprised at Sun Ra]* Sonny? Sonny Ray? I ought to beat your behind. You didn't tell me you were going to be in town.
Sun Ra *[with surprise]*: Esther I'm sorry, I've been touring for some weeks and misplaced your number.
[giving each other a big hug]
Fred: Wait, you know Esther? How did you meet her when she first invaded Earth? *[laughter]*
Aunt Esther: Fred Sanford, why would you insult me, I didn't insult you. I could've called you a PICKLE-HEADED EVIL-DOING HEATHEN but I didn't. *[laughter]* AND I could've called you a FROG-EYED FISH EATING FOOL but I didn't. *[laughter]*

Fred: And I could've called you a MONKEY FACE FAT BOTTOM GORILLA *[laughter]* but I didn't so now I will, you FAT BOTTOM GORILLA-FACED APE. *[laughter]*
Aunt Esther: That's it sucka! *[laughter]*
Lamont: Aunt Esther, please!
Fred: Let that moose loose Lamont!
Sun Ra: Wait a minute! Wait a minute. Esther, you mean to tell me this is St. Louie Red that married your sister Elizabeth?
Esther: That's him, you must remember them same bugged-eyes he had when he was younger.
Fred: How do you know Elizabeth?
Sun Ra: Man I go way back with all the Andersons. Elizabeth was like a sister to me and so is Esther.
Fred: You're blessed, see at least you can pretend. Unfortunately for me, Esther IS a sister to me.
[Esther looks at him with a scowl]
Sun Ra: Now I remember you. You Elizabeth and Esther use to come to see me play.
Fred: I think I remember... "Zoot Suit" Sonny! You use to be with the band at Club Riviera.

Sun Ra [*sings*]: *It makes no difference if it's sweet or hot!*
Fred [*joins in*]: *Just give that rhythm everything you got!*
[*both laughing and hugging*]: Hahahahaha!!!!
Sun Ra: Man you look good. Say Fred, do that song you used to do so well.
Fred: Oh you remember? Well, if you insist. [*clearing his quote*]
If I didn't care more than words can say
If I didn't care would I feel this way
If this isn't love…
[*laughter applause*]

FINAL SCENE

[*Fred and Lamont sitting down as Fred relaxes finishing up his drink*]
Lamont: Well, Pop, it was good having Sun Ra at the house.
Fred: Yes it was son.
Lamont: Wow, to think we know personally a famous musician.
Fred: Yep, old "Zoot Suit" Sonny Ray. Good times. [*taking in the last of his drink*]

Lamont: Oh yeah, almost forgot, Sun Ra told me to tell you that perhaps some day we can ride rhythmic equations and all meet up at the Black Sanctuary.
[*Surprised, Fred spits out his drink before he could take down another swallow*] He said you would understand what he was talking about.
[*laughter*]
Fred [*swallowing pushing his heart back down his throat*]: Black Sanctuary?!
[*Fred looks at Lamont in shock as Lamont gestures confusion*]
[*Credit music comes in*]

A London Travelogue: Visiting Dennis Severs' House

Mary Teeling

I WILL FIND THE HOUSE

It's June and sunny. Shop doors are flung open to capture early summer breezes. Neighborhood streets are alive with people out in the warm, surprisingly dry weather. I'm lost now. I've walked too far past The Royal Bank of Scotland and realize I'm going the wrong way on Bishopsgate, the main thoroughfare in the Spitalfields section of the city. The young Victoria entered London on this street in 1838 on the way to her coronation, where she wore a gown of golden silk woven for her in this very neighborhood that she passed through. I turn myself around and retrace my steps, returning three blocks.

I've come to Spitalfields, once the center of a thriving London silk industry, in search of a house that doesn't want to be found—at least not easily. I've heard it's a historic house visit like no other.

At the entrance of a modestly prosperous-looking London townhouse, a leafy vine grows from a crack between red brick and the worn marble stoop. For a moment, I imagine the vine stitched in various shades of shimmering green upon ivory silk. In the past few weeks, I've been thinking about silk in anticipation of investigating this house with silk as a central part of its story. Or is it history? The slippery question "story or history?" is central to my investigation and to why I am visiting this house.

A black door shines with linseed oil. Brass fixtures, tarnished with age, look curiously arranged, like a quirky face upon the door. Freshly painted brick-red window shutters greet passersby. Surprisingly, there is no sign that promotes the house, but I know I've found it: *Dennis Severs' House*. I remember the shutters from the website image of 18 Folgate Street. It's a good thing I triple-checked the hours on the website. They're not the regular opening hours

Photo by Rebecca Miller. All photographs courtesy Dennis Severs' House.

I've come to expect from visiting historic houses and sites. A visit to this house is not a drop-in type of experience. No sign out front, odd hours, and definitely off the beaten track by anyone's standard! I'm curious and ready.

I step onto the stoop and reach for the bell. I also can't resist the pleasure of knocking. The door opens and I'm welcomed into Dennis Severs' House and into a dark world. There are no electric lights inside—or none that I can see. It's nearly black in the hallway, though I instantly notice the painted checkerboard floor. My first thought? I can't imagine living in a house without lights!

> It became, as he described it, "a famous time machine" in which those prepared to enter his empathetic historical imagination and to suspend disbelief (never mind mundane considerations of historical fact, conventional museum practice or conservation philosophy) could find themselves transported into a dream, which illuminated the complicated and poignant social history of that ancient part of London.
> —*Obituary for Dennis Severs*, Guardian *(London)*, *January 10, 2000*

I arrived in London with intentionally little information about Dennis Severs' House. I wanted to encounter the house directly, record my own observations, and not be overly influenced by the impressions of others. Here's what I knew: an American artist named Dennis Severs bought a house in London and up-ended the traditional historic house visit. I'd heard that the restoration of the house was influenced by 17th-century Dutch paintings of interiors and still-life arrangements. The concept of the house was that it was "still being lived in" by the Jervis family, members of which were never seen, but whose movements and possessions were in full view. I knew a visit to the house would not be like visiting a house in Colonial Williamsburg, in Virginia. And there would be no one in period costume, speaking as an historical character.

A SELF-GUIDED TOUR

Once inside, I expected an orientation, perhaps something about the Jervises, the Huguenot silk merchant and his family who supposedly live in the house; and maybe a word or two about Dennis Severs himself. I'm still a little confused by just whose house it is—is it the Jervises' house or Dennis Severs's? I realize that I want this explained to me. I also anticipate that I will be given the historical background on the Huguenots in London and silk manufacturing in Spitalfields, and then tour the house with a docent to learn about

the way the family lived. To my surprise there is no orientation. I am quietly instructed by the greeter at the door to descend into the cellar kitchen and begin my own exploration of the house.

The information I thought I wanted no longer seems essential. I begin to realize that letting go of expectations is what the house itself instructs me to do. It's more about the eyes and looking than it is about accumulating information; especially since it is so dark that, if I am not careful, I might trip up or down the stairs as I make my way around.

HOUSE OF IMAGINATION

> I will get the 20th century out of your eyes, ears, and everything. With every room we visit, we will be governed by a spirit.
> —*Dennis Severs*

Only one point of introduction is offered: "Leave the world behind you and use your imagination. That's the game." Now I get it: I'm a participant in this experience. I'm asked to engage in the practice of active imagination. I'm not just a passive listener, observing at a distance behind a rope barrier. But I'm *in* the house, at one with it and even conversing with it.

The English kitchen basement is a specialty of the London townhouse. Although tucked into the house below the street level, typically there is a wide stairwell built out from the foundation that allows light into the kitchen through full-size windows. But it is the evening now, so candles light the room. I've walked into the kitchen just as dinner preparations are being considered. Freshly purchased *real* potatoes, carrots, onions, cauliflower, and turnips wait to be cleaned and cut. Butter sits out, melting at room temperature. A cup of tea and a glass of port (or Madeira?) are in the midst of being sipped. A giant sideboard displays dozens of china teacups hanging on tiny hooks, teapots, plates, and covered dishes. All sorts of great 19th-century transfer ware china are stacked together.

On the worktable, I notice a worn copy of a Beatrix Potter children's book, opened to an illustration of a kitchen, one that looks magically like the one where I now stand. I hear distant voices in the house. Outside, a horse passes by. The kitchen smells earthy and warm. On my way back upstairs, I pause briefly in the root cellar next to the kitchen. The dirt floor is packed tightly and I realize this room is the very source from which this earthy smell rises.

Back up the narrow stairs, I go to explore the dining room, in the front of the house. The woodwork is painted a dark, glossy, olive

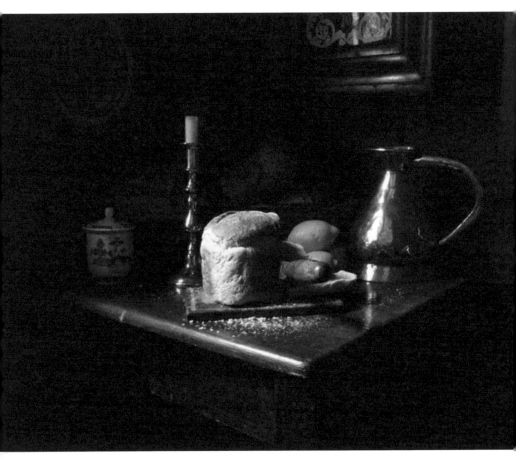

Photo by Stephanie Wolff.

Teeling, A London Travelogue

green. It looks beautiful against the flat white plaster walls. The table has the debris of a recently enjoyed repast. I have to walk around the table so I can notice everything. Goblets of red wine are nearly empty—but not quite. Knives and forks are scattered about and look as if they were just put down. My favorite is the fresh pomegranate that sits on a plate—the fruit is torn open and ruby seeds are being pulled out by a fork, jabbed spearlike into its flesh. Next to it is a white damask napkin, stained red by someone's fingers as they wiped their hands clean. There are fresh peaches on the table too. On a sideboard is a potpie that's been cut into. The crust is real, and the edge formed by hand—just as my mom makes her pie crusts: soft dough pinched between thumb and forefinger.

I love this room and want to move in, or at least re-create it in some way in my house in Philadelphia. That's the great thing about visiting historic houses: there's all the cool history, antique furniture, and interesting architecture; but they're also filled with inspiration about new ways to imagine living in the present. It's this combination that energizes me about visiting old houses and historical sites.

The dining room reminds me of a Dutch painting of a dark interior, where sunlight makes a dramatic appearance through a window. Objects on a table and silk clothes are lit up and made radiant. I continue to examine everything on the table. No one hurries me or speaks to me. I'm on my own adventure, in this house. I hover to admire every detail of the human mess that has been temporarily abandoned.

On the fireplace mantel across the room, I almost miss noticing a freshly nibbled strawberry next to a glass of nearly consumed wine. There is a birdcage by the window and a *fake* bird inside! I'm now seeing a funny playfulness at work. Some things are surprisingly real, while at the same time other things are humorously, even oddly, fake. But the bird makes me smile and I decide not to be critical, but instead to allow my imagination to see a real bird in its place. Wait a minute... did I hear a bird chirping somewhere? And I wonder who was eating the pomegranate... was it Mr. or Mrs. Jervis? Outside I hear horses clomp and carriage wheels roll over the cobbled stones as they pass by the house.

LAYERS OF HISTORY

Dennis Severs' House sits on a narrow side street in Spitalfields, on the edge of London's East End. This was the center of Huguenot silk manufacturing in the 17th and 18th centuries. The industry collapsed when new cheaper methods of silk weaving were introduced, eventually undermining the Huguenots' advantage.

Strolling through the galleries at the Victoria & Albert Museum after visiting Dennis Severs' House, I unexpectedly came upon extrav-

agantly embroidered silk flowers and vines, their three-hundred-year-old threads still colorful and vibrant against the shimmering fabric. These botanicals meander and bloom upon bolt after original bolt of silk, highlighting London's role in the once-thriving production of some of the most costly and sumptuous dress-making fabric ever produced.

Now a newly trendy section of the city, Spitalfields is a rich mix of 18th-century houses and streets, modern office buildings hosting international banking and law firms, small boutiques, and restaurants, including the Indian and Pakistani restaurants on Brick Lane. Many layers of history coexist. Like all of London, one engages with history everywhere in Spitalfields—one easily feels the layers of the past mingling with the present and history in the making.

In the 1970s, one could buy a house here for a song, which is what Dennis Severs did. He bought his 1723 five-story house in 1973 for $42,000. He lived and dreamed in the house until his death in 1999.

> I bought the house not so much to restore it, but to bring it
> back to life as my home.
> —*Dennis Severs*

To this day, his New York Yankees baseball cap sits on the hall table. It's as if he just returned home and put it there. Indeed, his spirit is felt throughout the house, as if on some level, he still lives there with the family he created—their spirits all entangled across time. I was startled at first when I noticed the cap. It looked out of place in an historic house. It is both anachronistic and yet oddly at home with the Jervises' period belongings surrounding it. In other parts of the house, one even finds photographs of Dennis Severs. His memory is affectionately kept alive in an unobtrusive, though shrinelike, way.

How does it work, I ask myself, that an invented family called Jervis and a real person, all now deceased, one recently, can coexist? It is fascinating to think of Dennis Severs as both inhabitant of the house and the storyteller-artist who created the entire world of the Jervis family over several generations. Each room tells the family's story and that of the artist in mixed tenses: the remote past, the recent past, and the new past, all in one. During my meanderings, I keep noticing the real and imagined. And it happens all at once: fact and fiction; the 18th and the 19th centuries—and the 20th and 21st centuries too. The telling of history is wonderfully blurred.

> For him, emotionally understanding the past was vital and
> his vision was holistic and therapeutic, almost spiritual. He
> felt able to summon-up past eras not through history books,

but through empathy for objects and places, to tell a fictional, true story "aimed at those who want to make sense of the whole picture of being alive."
—Guardian *obituary*

As I walk through the house, the Jervis family seems as real as Severs himself. I realize I've entered into an elaborate vision—a stage set, an entire house occupied by characters who cross in and out of the now and various past times. While I read very little about the house before seeing it for myself, I suddenly recall something on the website that makes sense to me now: the great game being played is that the inhabitants of the house—various members of the Jervis family— have left the room for a moment, but will most certainly be returning.

He then had a vision, that "the material things I had been collecting all my life were really a cast of characters, and the house was destined to be their stage."
—*Obituary for Dennis Severs,* New York Times, *January 31, 2000*

There is stuff everywhere—the kind of things that fascinate us at collectible stalls and junk shops, at antiques stores, and in the great official warehouses of stuff, like London's Victoria & Albert Museum or the Smithsonian museums in Washington, DC. There is glassware and china, clothing and furniture, and pictures of every kind. And a lot of just the ordinary stuff of life, like a laundry basket, in this case a willow basket with rags to be washed, sitting in a corner of the hallway landing. The dining room objects bring to mind a painting by the Dutch artist Vermeer. Another room is right out of a scene in a Charles Dickens story—Miss Havisham's dining room in *Great Expectations,* cobwebs and all.

On the one hand, perhaps things seem real because they are real. But there is contrivance as well—an artistry in the backdrops for the telling of the story of the Jervis family. There is genuine antique furniture, but curious inconsistencies too. For example: Is that fabric glued onto the frame of the baroque hallway mirror? It's strange-looking, but I have to admit I like it anyway. Best of all, on the second-floor landing I notice red-and-white plastic roses glued onto the walls as a decorative motif at the corners of an authentic-looking Gothic Revival wall stencil. Somehow the plastic flowers work. Fun! I begin to enjoy the playfulness, the unorthodoxy, and the free-spirited "I'll do it my way" voice of the artist Severs.

Next I enter the master bedroom and am entranced by the massive four-poster bed festooned with bed draperies. It occupies the

middle of the room like a ship under full sail. But the headboard looks somewhat curious to me. I think I see a plastic scallop shell glued onto the center. And on the top floor there are haunted-house cobwebs, somewhat artificially applied to the bed drapes. Is this evidence of a spray can from a Halloween store at work?

> He could have been an inspired theatre-designer, for improvisation was his watchword. Things were rarely what they seemed: velvet was usually Dralon, not sewn together in swags around the four-poster bed, but stapled, the pillars were taken from nearby fruit market pallets.
> —*Edward Greenfield, neighbor of Dennis Severs*

THEIR LIVES, MY LIFE
The house is packed with the quirky and unexpected. Sounds and smell come my way, church bells toll, scones are baking, and the dishes not cleared. A small leather child's shoe and a toy sit on the steps waiting to be taken upstairs. Despite the appearance of a maid, the Jervis family seems a lot like my family—not too neat. In fact, they are quite comfortably human and downright messy. Great, I thought happily: another family that doesn't consider it a mortal sin for the beds to be unmade.

I return to the master bedroom to continue looking about. I've always wanted a dressing table, so I give serious study to Mrs. Jervis's, which is placed by the window, the better to see her reflection in the looking glass. A freshly watered potted geranium sits on the windowsill. Hairpins are scattered about, beads are tossed into boxes, and pots of this-n-that sit about. My favorite is a mussel shell filled with bright red rouge, rich with oil and ready to be applied. I'm near enough to the dressing table to catch a momentary glimpse of myself in the mirror. I think I look pale today, and I imagine sitting for a moment to apply some color.

Now, for a moment, I'm tempted to sit down and start fussing with the flotsam and jetsam of my gender. The debris and accoutrements of feminine beauty is scattered in all of its picturesque disarray. I'm transfixed and reminded of a verse from a Jonathan Swift poem I have just been introduced to. Written in 1732, the same period as the house, the poem is scandalously irreverent. Yet, I do not suggest for a moment that the genteel Mrs. Jervis bears any resemblance to Swift's "Celia," whose own dressing table is partially described by these lines:

312

Top photo by
Stacey Shaffer,
bottom photo by
David Milne.

Photo by Rebecca Miller.

314

In calling *Celia* sweet and cleanly.
Now listen while he next produces,
The various Combs for various Uses,
Fill'd up with Dirt so closely fixt,
No Brush could force a way betwixt.
A Paste of Composition rare,
Sweat, Dandriff, Powder, Lead and Hair.

At the very top of the house, still in the stairwell, I encounter ladies' and children's undergarments hung up to dry in the sunlight and air from the open window. I'm struck by how much work it was to do the wash. And then there would be all the ironing still to accomplish!

Looking around at all the stuff of life, I began to pity those visitors less accustomed to clutter than I am. If one subscribes to a modern aesthetic of minimalist interiors, it could be a little overwhelming. As for me, my house in Philadelphia shares much in common with Dennis Severs' House. My tiny historic house is fairly dark, cluttered, very much in need of constant dusting, and looks instantly better in candle light.

In the candlelight, the magical look was what mattered.
—*Edward Greenfield, neighbor*

CONTRADICTIONS, SURPRISES, AND SOME CONFUSION TOO
I've returned down the stairs to enjoy the master bedroom again. Suddenly I encounter a luxuriously lounging black cat licking its paws amid the bedsheets and tossed-back blankets of the four-poster bed. It is unconcerned by my presence and decides to nap. For the moment, the bed is clearly his. Have I ever seen a real animal inside an historic house? In another room I suddenly notice a portrait of a woman. A piece of white paper is cut into the shape of a cartoon bubble and taped next to her mouth. Inside the bubble is written "Shhhhh....," a humorous reminder to keep the almost monastic silence that is mandatory. So obviously out of place, I surmise that it could only have been put there by Dennis Severs himself. So shockingly fun! I did a double take when I saw it and I couldn't help but laugh, quietly, of course. I wanted to call out to the other visitors and show them this little joke. But I refrained, realizing that everyone's exploration is uniquely their own, shaped by their own view and imagination, just as Dennis Severs imagined his house and tells its story.

315

One of the strangest and most wonderful ways that I experience the house is by coming upon the idiosyncratic surprise messages that are strategically placed in every room. Some remind people not to handle objects, others discourage mindless chatter. Another says: "You are here-ish." I watch people stop and read these sayings and messages. Eyebrows raise a bit, and small smiles begin to form. Other visitors are taken aback too.

Unlike labels at museums that one comes to expect, the sayings aren't professionally produced. They're written in a personal voice, so they "speak" when you read them. What makes them fun, rather than stern and forbidding, is their do-it-yourself look and the simple, often humorous statements, typed on a computer and printed out on white copy paper. At the bottom of each page are the birth and death dates of the artist: "Dennis Severs (1948–1999)" in a font size so small that I almost missed this. The messages and instructive say-

ings are communiqués from the land of the dead to the land of the living—from Dennis Severs to those of us who are wandering around and experiencing his great work—the house he inhabited, along with an imagined family. It's no wonder that the BBC produced a documentary entitled *The House that Wouldn't Die*.

> As an artist, your imagination is my canvas.
> —*Dennis Severs*

Dennis Severs' House is deliciously, crazily mixed-up. Now I'm mixed-up too. A part of me loves being transported back in time. But another part of me rebels and wants to know more background on the house. As a visitor who knows something about historic houses and the challenges of being in the role of a public historian, I both get what's happening and yet I'm unsure about the experience as it is taken in by a broad general public. I admit to myself that I too am conditioned to expect pristine period rooms with perfect examples of furniture—nothing but the best and finest. An interior decorator's dream.

I also wonder, as I watch visitors to the house, if they will know what they are looking at. Will they realize they are looking at many different periods of furniture and decorative arts that span two hundred years? For example, will they realize that the wingback chairs in the upstairs parlor come from the 18th century, and the curvy Victorian loveseat from the late 19th? Will they know or care that each piece is from a different period in design history, and that each comes from a different historical era, and that events that are told through the Jervis family story? And then I wonder if visitors can tell the difference between what is *real* old stuff and what is the stage set, what is fake? Will they leave the house knowing what was authentic?

I'm considering all of these questions as I walk through the house. But then I ask myself: does it matter? Perhaps it is all about the experience of imagining what it was like to actually live in the old days, without getting ensnared by the need to keep it all straight.

> Historical accuracy was no more important to his presentation than it would be in a low-brow historical novel. The feeling of being in a different century was what mattered to him. "If you want to learn, read a book!" Mr. Severs often shouted.
> —New York Times *obituary*

I continue to contemplate these questions as I sit in an antique chair in the second-floor front parlor. The attendant in the hallway invited me to sit—explaining that sitting was exactly what they hope

visitors will do. It is the first time I've touched an antique in an historic house visit, let alone sat in one. It's a damask-covered Queen Anne chair from the early 18th century. Other people see me sitting and figure "Why not?" and they sit too. Suddenly a number of us are sitting quietly in the front second floor parlor, sinking into the experience of a candlelit room in the early evening.

Church bells are chiming again, and I imagine Old London. Are they the bells of Christ Church, Spitalfields? I hear a mantel clock ticking, and a baby's sleepy cry is heard in a distant room. Suddenly I hear a frantic, modern-day police siren pass by, but I'm now so much enjoying the house, that my mind pushes away the present reality. For the time being, I'm in a different era. But not quite. My imagination is weaker than I thought, for I'm captured by the stylish pair of orange sneakers that my eyes follow as they make their way across the Turkey carpet.

Still sitting, I breathe in deeply. The smell of the dripping candle wax fills my nostrils. The entire house is lit by candles. I ask myself if I've ever visited an historic house where every room was lit with candles. I was once in Williamsburg, and I recall the taverns were candlelit, but they were restaurants, not historic houses. What insurance company in the States would permit candles to burn regularly in an historic site that offered self-guided tours?

I sink into the chair even more and people-watch for a bit, while I enjoy the early evening light through the windows. The china and silver, the gilded frames and the dark oil portraits are aglow with the warm light. Being able to sit in the room was a nearly perfect experience. Still, I'm distracted and cannot completely suspend the present. I'm somewhat overwhelmed by the scented candles, which remind me a little too much of the cinnamon smell that fills the air in that all-American theme store, the all-year-round Christmas shop. Just now I hear floor boards creak above me. Someone from long ago runs up the stairs.

I'm nearing the end of my time here. I've wandered all through the house, and finally make my way back downstairs to the back parlor, the last of the ten rooms. This is the room that completes the visit, and is the chronological end of the nearly two-hundred-year story of the Jervis family. It is a Victorian-era parlor and functions quite festively as an homage to Queen Victoria. Wallpaper with big pink and red roses covers the walls. Lots of tchotchkes with her image are set out all over the room. That crazy curvy Victorian sofa sits proudly across from the fireplace. The room is a little over the top and overdone, as every proper Victorian interior would be.

My self-guided tour is about to end. It's clear now that Dennis Severs intentionally disregarded all the usual rules and "best prac-

tices" of historic site management in order to tell a story—a story that included history. But history itself is only the starting point in the creation of 18 Folgate Street.

The other starting point is Dennis Severs the artist—and his passion for the dramatic. At a certain point, the house surpassed its creator, and became its own complex organism. The more Severs played with the house and the more places his imagination took him, the more the house evolved into its own being. The house is both an artist's installation and an historic house in one. The vision kept evolving and growing, and, like all wondrous works of art, there's a bit of the obsessive—the moment when much is almost too much. But that is the great pleasure of the house. Everything is heightened, and all is somewhat exaggerated. One might say the experience itself is baroque, filled with dramatic contrasts, engaging all the senses, a living chiaroscuro where natural light and candle light play off extreme darkness. Theatricality is everywhere at work. Thus, there is a creative tension that exists between telling a story that is imaginative and authentic, but not exactly factually true. As with most conceptual pieces, one either gets it or one doesn't.

I notice a pair of gas-lit sconces flanking the mantel. No more candles. From candles and the 18th century to gas fixtures and the late 19th, from room to room, I've journeyed a long way in time. Over on the windowsill, I greet a photograph of Dennis. We're on first-name basis now: "Hello, Dennis!" I feel I've come to know him well—through his house, of course.

A TRAVELOGUE POSTSCRIPT

During my trip to London, I went to Dennis Severs' House three times. Since my return to Philadelphia, I've been thinking about my visits, the house, and my varying responses to my different experiences. I've been considering how the house functions and how visitors experience it. I offer the following reflections.

During my sojourns, was I transported back in time—experiencing the house as Dennis Severs imagined it—in a "time machine"? Though we wish historic houses could, they cannot furnish instant communication with the past. They represent the past, and we interpret them. I'm not sure that the notion of a time machine, the sense of traveling backwards to encounter the past, captures the experience of visiting Dennis Severs' House. Rather, walking through the rooms seemed more like a meandering, a walk through time in a non-chronological, non-linear way. Sometimes I stepped back to meet the past or the past stepped forward to me. Like the back-and-forth glimmers of flickering light, I could see fleeting, but very real, glimpses into another time, and different periods.

It occurs to me now that the image that may best capture the experience is that of a daguerreotype. You hold one in the palm of your hand—it is an intimate encounter. You turn it this way and that way in the light in order to get a glimpse of the image or the identity of the person held within the small frame. In rotating the hand, the light reveals a silvery, ghost-like image, a flickering spirit reaching out to you across time and space. Visiting the Dennis Severs House is a splendid, if imperfect, quest to discover the past. One wants to experience history directly, but history emerges for a moment and then retreats; it can't be fully seen or captured. Like the image held within the daguerreotype's frame, the past quickly disappears into a silvery haze. History manifests for a moment and is gone the next.

Would those of us in the field of public history be responsible if we presented history in ways that have as much to do with creative storytelling? Are we responsible if we intentionally confuse the public? In other words, can we play with the historical facts in the dual service of historic house preservation and public engagement in history? The case of the Dennis Severs House proves that this is possible. Nowhere does the house pretend to be anything other than a work of the imaginative mind of Dennis Severs and, therefore, it truly is *Dennis Severs' House*. Still, history comes alive for visitors, and the experience allows them to engage with history in a direct and exciting way. I propose this is one of the agreed-upon goals of all historic house sites. Some already do it well. Others could learn a great deal from Dennis Severs' House without attempting to imitate it.

I'm also intrigued by the number of ways the house can be read or experienced. During each visit, I was aware of how many different ways I was experiencing and thinking about the house—and how it related to my own life. In his multiple role as artist, house-holder, preservationist, curator, and historic-site educator, Severs created an organic whole that is multilayered, and which allows for many different ways to approach and understand the house. A large part of what impressed me most was the myriad ways that visitors can respond. People of different ages, with different backgrounds and interests, are allowed to bring their own life to the experience. I could not help, for instance, looking at the clutter and reminiscing about the clutter in my own house, thereby making a personal connection.

A visit to Dennis Severs' House is a chance for a brief moment to experience the past, however incompletely or imperfectly. Imperfect and incomplete still work, especially when imagination and history intersect and become the heart of the experience. Perhaps visitors think about their great-grandparents or other ancestors and feel a sense of connectedness to history through very personal channels. Perhaps they think about the history of the city of London as

they hear a recording of a cannon firing, a horse passing on the street, or a distant train passing through the city. Perhaps they don't think of anything at all, but just enjoy the dreamlike quality of the interiors, or what may even be called the artistry of the house that Severs created. Some people take pleasure in looking around the rooms, or simply being in the house, with all of its sensory power and its idiosyncratic unexpectedness. The house evokes history, without being exact in the telling.

Photo by David Sinclair.

In the early stages of planning and shaping what is known as "the visitor experience," curators and interpreters spend considerable time discussing the question "What is 'the take home message' of the visit?" I suggest the take home message of Dennis Severs' House is more about the feeling of history rather than the facts, and about how one re-enters the present after brief moments of immersion in the atmospheric sense of the past's presence. Maybe the message isn't a message at all, but a memory that clings, one that we take home with us when we return to our own time and place. Sometimes the evocative has more power and lasts longer than that which is merely informative.

321

CONTRIBUTORS

Bill Adair is director of the Heritage Philadelphia Program at The Pew Center for Arts & Heritage. He worked for more than twenty years as a museum educator in history and art museums; he has a BA in history from the University of Pennsylvania and an MA in Urban Cultural Planning from the University of California, Los Angeles.

Randal Dietrich was project manager for the Minnesota Historical Society's five-year Greatest Generation Project.

Tom Drube's and his daughter Ali's film *My Grandma Lucy* was in the Minnesota Historical Society's Greatest Generation festival in 2006.

Matt Ehling is a filmmaker whose *Coming Home* was in the Minnesota Historical Society's 2007 Greatest Generation festival.

Benjamin Filene is associate professor and director of Public History at the University of North Carolina Greensboro. Prior to UNCG, he was at the Minnesota Historical Society for nine years, where he served as senior exhibit developer.

Matthew Fisher is president and cofounder of Night Kitchen Interactive, which produces online exhibits and interpretive installations for museums of all kinds. He is passionate about creating interactions that engage visitors in meaningful dialogue, with the goal of transforming our shared understanding of, and relationship to, museum exhibitions and collections.

Michael Frisch is professor of American Studies and History/senior research scholar at University of Buffalo, SUNY, where he also directs an oral history digital consulting office, The Randforce Associates, in the university's Technology Incubator. He is a recent president of the Oral History Association, and previously served as president of the American Studies Association.

Laura Koloski worked as a museum educator for historic sites and local history museums before joining the Heritage Philadelphia Program, where she is currently senior program specialist. She holds a BA in American History from Villanova University and an MA in Public History from Northeastern University.

Matthew MacArthur is director of new media at the National Museum of American History. He is the author of "Can Museums Allow Online Users to Become Participants?" in *The Digital Museum: A Think Guide* (2007).

Paula Marincola is the executive director of The Pew Center for Arts & Heritage, Philadelphia.

Kathleen McLean is a museum exhibition designer and principal of the consulting firm Independent Exhibitions. She is author of *Planning for People in Museum Exhibitions* (1993), co-editor of *Visitor Voices in Museum Exhibitions* (2007), and co-author *of The Convivial Museum* (2011).

Kris Morrissey (PhD, Educational Psychology, 1989, Michigan State University) is director of the Museology Graduate Program at the University of Washington and editor of the journal *Museums & Social Issues.*

Melissa Rachleff is clinical associate professor of Visual Arts Administration at New York University. Prior to this, she was a program associate at the New York State Council on the Arts, an education manager at Brooklyn Museum, and an assistant curator at Exit Art; she is also a contributing writer to *Exposure*, a journal devoted to photography.

Tom Satwicz (PhD, Learning Sciences, 2006, University of Washington) is a user experience researcher at Blink Interactive and a part-time lecturer in the Museology Graduate Program at the University of Washington.

323

Deborah F. Schwartz is president of the Brooklyn Historical Society. Previously she was the Edward John Noble Foundation Deputy Director for Education at the Museum of Modern Art, New York; vice director for Education and program development at the Brooklyn Museum; and in 2002 was curator of *Art Inside Out* for the Children's Museum of Manhattan.

Marjorie Schwarzer is author of *Riches, Rivals and Radicals: 100 Years of Museums in America* (American Association of Museums, 2006) as well as numerous essays and articles about the museum field.

Liz Ševčenko was founding director of the International Coalition of Historic Site Museums of Conscience, a network of historic sites that foster dialogue on contemporary issues. She is currently working on a project to build public awareness of the long history of the US Naval Station at Guantánamo Bay.

Nina Simon is the executive director of The Museum of Art & History in Santa Cruz, California. She is the author and publisher of *The Participatory Museum* (2010) and author of the blog Museum 2.0 (www.museumtwo. blogspot.com).

Pete Stathis is a comics artist who is the creator of the *Evenfall* Trilogy. A resident of University City, Philadelphia, he also works as a freelance painter and illustrator.

John Kuo Wei Tchen is a historian and cultural activist working on the impacts of racial exclusion in the US. He is founding director of the Asian/Pacific/American Studies Institute at NYU and a cofounder of the Museum of Chinese in America, His books include *New York before Chinatown* and the forthcoming *"Yellow Peril": A Critical Archive of Essays, Documents, Images*.

Mary Teeling is curator of education for public programs at the Philadelphia Museum of Art. She previously worked at several historic sites, most recently at the American Philosophical Society Museum, after growing up in Annapolis, Maryland, with a mother who was a historical house docent who entertained (and sometimes even educated) her children at the family dinner table.

Billy Yalowitz, playwright/director/choreographer, has directed community-based performances in several Philadelphia neighborhoods. Named "Best Unclassifiable Theater Artist" by the *Philadelphia City Paper in* 1997, he is an associate professor at Temple University's Tyler School of Art and codirector of the Community Arts Program there.

Fred Wilson is an artist who lives and works in New York City.

Steve Zeitlin is a folklorist, filmmaker, writer, and cultural activist. He is the founding director of City Lore, an organization dedicated to fostering New York City's—and America's—living cultural heritage, and the author of several books on America's folk culture, including *Because God Loves Stories: An Anthology of Jewish Storytelling* (1997) and three books for young readers.

ACKNOWLEDGMENTS

This project began several years ago as the brainchild of Paula Marincola, then Director of the Pew Center's Heritage Philadelphia Program, its goal the marking of exciting and effective trends in the public history field. Thanks to her creative instigation and encouragement, it has evolved into its current incarnation.

We are endlessly grateful to our supporters at the Pew Charitable Trusts, especially to our friends and colleagues in The Philadelphia Program and the Pew Culture Program: Greg Rowe and Doug Bohr are both rudders and propellers. None of this work would be possible without their enthusiastic support.

Early on in the process, we met with a group of project advisors who brought great wisdom and practical experience to the project. Thank you Joy Bivins, Susan Ferentinos, Sojin Kim, Kathleen McLean, Ang Reidell, Dan Spock, and Patricia West for your time, enthusiasm, and sage advice.

Our thanks to Sharon Holt and Bob Beatty for reviewing early outlines and providing clear and honest feedback. Our book is consequently more thoughtful and insightful.

A tireless crew assisted us with research, logistics, and unreasonable demands. Great thanks go to Mary Gen Davies, Jacque Liu, Nina Morrison, Claire Schmieder, Mia Breitkopf, and Daniel Fuller. Thanks to Sue Ann Prince, Mary Teeling, and Winifred Lutz for their time and willingness to share their expertise.

Our deep gratitude goes to editor Joseph N. Newland and designer Anthony Smyrski, who have acted as alchemists and engineers, transforming our ideas and words into a real-life book of which we are extremely proud. Our thanks to Jennifer Collier at Left Coast Press for her generosity and guidance.

Bill Adair is grateful for the ingenious companionship of his colleagues at the Pew Center for Arts & Heritage, for the incessant support of his family, and for Andy, who makes him laugh every day.

Benjamin Filene is grateful to his creative and inspiring colleagues at both the Minnesota Historical Society and UNC Greensboro and for the support of Rachel Seidman and Eliza and Hazel Filene.

Laura Koloski is grateful for inspiration from colleagues at and constituents of the Pew Center for Arts & Heritage, for the encouragement of her parents and her husband, and for her children, Alice and Benjamin.

Our greatest debt goes to our contributors—writers, practitioners, thinkers, experimenters, and critics. They've offered insights at every turn, and helped illuminate how everyone is, or could be, a participant in making history.

The Editors

INDEX

331

333

Front cover images
(left to right, top to bottom)

Villa Grimaldi Peace Park, a Site of Conscience near Santiago, Chile (photo: Corporación por la Paz Villa Grimaldi)

Salvaging signage in New York's Chinatown (see p. 85)

In a California history gallery in the Oakland Museum (p. 76)

A performance of *The Rosenbach Company: A Tragicomedy* (p. 246)

Boxed sets of films in the *Moving Pictures* film festival (p. 98)

The Frascones on the porch at 470 Hopkins Street (p. 151)

Bedside candles in Dennis Severs' House (p. 311)

About The Pew Center for Arts & Heritage

The Pew Center for Arts & Heritage, established in 2005, is dedicated to stimulating a vibrant cultural community in the five-county Southeastern Pennsylvania region. The Center makes grants in seven areas—dance, visual art exhibitions, heritage, cultural management, music, theater, and individual fellowships—supporting area artists and organizations whose work is distinguished by excellence, imagination, and courage. Each year, the Center's grants make possible more than 800 performing arts events, as well as history and visual arts exhibitions and other public programs for audiences in Philadelphia and its surrounding counties. Beyond its work as a unique and exemplary grantmaker in the arts, the Center is also a hub for the discussion and exchange of ideas concerning artistic expression, cultural interpretation, and audience engagement, organizing and presenting a lively host of activities that aim to build programmatic and management capacity among constituents. Highlights of Center professional development events include trips, symposia, lectures, reading groups, master classes, and workshops. The Center also commissions and publishes scholarship and research on issues that grow directly out of its experience funding cultural practice. For more information, visit the Center's Web site: www.pcah.us.

The Pew Center for Arts & Heritage is funded by The Pew Charitable Trusts and administered by The University of the Arts, Philadelphia.

About the Heritage Philadelphia Program

Heritage Philadelphia Program (HPP) is a think tank and funding organization in support of excellence and imagination in public history practice in the Philadelphia region. We believe that the future of public history depends on our willingness to take risks—to challenge audience expectations, push beyond hushed reverence and nostalgia, wander outside our comfort zones, and allow for healthy organizational dissonance. At HPP, we strive to support such risk taking within history organizations (and others) and are aiming to create a regional ecology—a laboratory—in which dynamic and thoughtful risk-taking can flourish. We strongly believe that the safe and predictable approaches to public history interpretation no longer work for most audiences. Traditional house tours, exhibitions, and other passive experiences don't engage the audiences we need to stay alive and fresh and relevant as a field. When we speak of imaginative and even playful approaches, we do not mean that we discourage projects with serious subject matter. We understand that public history interpretation includes the full range of the human experience, from the amusing to the everyday to the traumatic.

Paula Marincola, Executive Director,
The Pew Center for Arts & Heritage

Heritage Philadelphia Program
Bill Adair, Director
Laura Koloski, Senior Program Specialist
Jacque Liu, Senior Program Associate

THE
PEW
CHARITABLE TRUSTS

The Pew Charitable Trusts is driven by the power of knowledge to solve today's most challenging problems. Pew applies a rigorous, analytical approach to improve public policy, inform the public and stimulate civic life.